Never was there such an improvident author — Flaubert would turn in his grave.

You see I am in the predicament of a shy talker, rather; I have nothing to say ... cant go. I have everything to say. The children here bring me their dolls to mend, & I am planning a sentimental Expedition; I shall take them to the sweet shop, & let them choose. The Nervy here sleeps in a hole in the wall, with a window the size of a slate, & a basin like a pudding bowl. A candle burns perpetually in a corner of the stair case, & there are banisters of carved oak, & great balls on the landings — & womans husband says that there is good deal more of the gentleman about Gorst man about Hans: twa nale boy with white heads Hoffe is on the road to day & asked if had a Bear?

Well, goodbye, my honeybee; tell me Julian's witticisms. You have a touch in letter writing that is beyond me. Something unexpected, like coming round a corner in a rose garden & finding it still daylight. B.

A VERY CLOSE
CONSPIRACY

by the same author

MOON IN ECLIPSE
A Life of Mary Shelley

A VERY CLOSE CONSPIRACY

Vanessa Bell and Virginia Woolf

Jane Dunn

JONATHAN CAPE
LONDON

For
David and Ellinor Thesen
adventuring still

920

First published 1990
© Jane Dunn 1990
Jonathan Cape Ltd, 20 Vauxhall Bridge Road, London SW1V 2SA

Jane Dunn has asserted her right
to be identified as the author of this work

A CIP catalogue record for this book
is available from the British Library

ISBN 0-224-02234-2

Phototypeset by Computape (Pickering) Ltd, North Yorkshire
Printed in Great Britain by
Butler and Tanner Ltd, Frome and London

Contents

Preface

A Very Close Conspiracy is the story of a relationship between sisters. It is not a joint biography of Vanessa Bell and Virginia Woolf. There are excellent biographies of each already: among them, Quentin Bell's of his aunt Virginia wears its research and learning with great sympathy and wit, while Frances Spalding's *Vanessa Bell* is illuminating and scrupulously fair. But the essential reciprocity in the sisters' natures cannot be revealed in an individual treatment where each has to stand alone. Wherever you cut Virginia Woolf – open her diaries, her letters, her fiction – there is Vanessa. And when Vanessa faced the depths of despair and doubted her existence, it was Virginia to whom she turned.

It was this ever present influence in each of their lives that drew me to the idea of exploring the complicity between them. For in all close relationships there is a conspiracy of sorts, a 'breathing together' – with the added sense of concealment, of closedness, where the rest of the world cannot come.

With sisters, there is the possibility of the most intimate and enduring of relationships. A sister survives parents; she is there long before lovers and husbands and children. She shares the same gender and generation, the same house, often the same room, sometimes even the same bed. Each travels through life alongside the other and shares as a contemporary the experiences of school, of independence, of love affairs, work, marriage and motherhood. More often than not, she is there in old age, when lovers or husbands may have deserted or died; when children have left to make their own way.

For many there is the longing to be one and, at the same time, the struggle to be two. In this way, the relationship of sisters has the potential for intense rivalry, competitiveness, suppression, conspiracy, and fierce protective love. Yet it is given so little weight, is barely

even discussed.

The sources and dynamic of the relationship between Vanessa and Virginia are what fascinated me. By accepting the closeness of their bond and allowing them to stand together, new light can be thrown on their individual characters, the extent of their interdependency and the forces that shaped them.

Because *A Very Close Conspiracy* is not a joint biography, it does not have the built-in structure of a chronologically linear narrative. After the first four chapters, which bring the sisters to adulthood, I have pursued themes in their lives, as, for instance, the tension between the demands of life and their art, and so weave back and forth through time and place. There are incidents in each life which are not mentioned, there are others which appear more than once, where they illuminate different strands of this multifarious story. While writing it, I have felt at times like the small weaver before a great loom, in whose hands are thirty, forty, colours of such delicately graded shades, all of which have to be kept within my grasp, to be recalled at the exact point and woven into the vast and abstract tapestry of Vanessa's and Virginia's shared interior life. It is not their material journey from birth to death, the record of external life, that I have sought to plot, but this hidden landscape of impulse and attraction, of prejudice, influence and passion; of what is not quite said.

Any reconstruction of another's life – even of one's own life – can only ever be a version of the truth, but I have tried to come to Vanessa Bell and Virginia Woolf with few preconceptions. At first I had thought I would rescue Vanessa from the shadow of her brilliant, articulate, younger sister, but very soon I realised that Vanessa did not need rescuing, that Virginia's luminosity was real. I have wanted always to have their voices come through the narrative, distinct and clear, and while I have stage-managed the players and manned the lights, the script has been largely theirs. I hope I have brought enough humility and sympathy to the work to let them speak.

Acknowledgments

I am grateful to the staff of various institutions for access to material in their possession and for their kind assistance: the late Dr Lola Szladits at the Berg Collection, New York Public Library; the Tate Gallery Archive; the Tate Gallery Library; Dr Michael Halls at King's College Library, Cambridge; Mrs Inglis at the University of Sussex; The London Library.

I am indebted to Anne Olivier Bell for her immaculate edition of the Virginia Woolf diaries and to Nigel Nicolson and Joanne Trautmann for their equally impressive edition of her letters. For permission to quote from these and Virginia Woolf's other published work I am indebted to the Executors of the Virginia Woolf Estate, and The Hogarth Press.

I am most grateful to the following people for permission to use extracts from unpublished material: Quentin Bell for Vanessa Bell's letters and Julian Bell's papers; Angelica Garnett for Vanessa Bell's letters and memoirs; Henrietta Garnett for the Duncan Grant papers in her possession; Trekkie Parsons for the Monk's House papers; Nigel Nicolson for Vanessa Bell's letters to Vita Sackville-West.

The family of Vanessa Bell and Virginia Woolf have been unfailingly courteous and good-humoured, offering help and hospitality as if I had been the first rather than the five-hundred-and-first researcher to stumble through their pasts. I am particularly grateful to them for such generosity.

The following individuals have offered me help or encouragement at various stages in the writing and bringing to publication this book. To them my thanks: Ann Baldwin; Judith Collins; Caroline Cuthbert; Patric and Sheila Dickinson; Karen and Paul Feldwick; Sarah-Jane Forder; Sue Greenhill; Beryl Hislop; Hugh Lee; Sandra Lummis; Tricia Neaverson; Barbara Prete; Hilary Prowse; Peter Shephard; Richard Shone; Vera Taggart; Liz Thesen; Millicent Witherow.

The team at my publishers Jonathan Cape has been exceptional and has my particular thanks; Liz Calder (though long since gone to co-found Bloomsbury Publishing); David Godwin; Georgina Capel; Maggie McKernan; Anne Chisholm; Helen Armitage; Pascal Cariss; Margaret Clark; Peter Dyer and Cathie Arrington. Thanks also to my American publishers, Little, Brown, and to Ray Roberts.

Acknowledgments

My agents Charlotte Sheedy in New York and Deborah Rogers in London have been tireless in their support of me and in their enthusiasm for the book; Sheila Murphy has been with this work all the way, bringing her redoubtable skills to bear in every area: agent, editor, publicist, friend. To them all heartfelt thanks.

My family and friends have put up with my absorption, my inaccessibility when writing, my guilt when not. My love and thanks to everyone who has been with me along the way, but particularly to Ben and Lily, of whom I'm prouder than anything – and to Nick, of course.

Picture Credits

The author and publishers are grateful to the many institutions and individuals who have provided photographs for reproduction in this book.

The following list acknowledges photographic sources other than the owners specified in the captions, and also additional credits for certain works.

Berg Collection, New York Public Library (Stella Duckworth's photograph album) – endpapers, pls 3, 4, 5, 8, 9, 10; The Charleston Trust – pl. 13; © The Condé Nast Publications Ltd (reproduced courtesy of *Vogue*) – pls 16, 49 (photograph by Maurice Beck and MacGregor), 61; Hulton Picture Company – pls 1, 2, 11, 12, 14, 15, 51; The Provost and Scholars of King's College, Cambridge – pl. 59; National Portrait Gallery, London – pl. 52; Anthony d'Offay Gallery, London – pl. 31; Sotheby's – pls 27, 30, 32; The Tate Gallery Archive, London (Vanessa Bell's photograph albums) – pls 6, 7, 21, 22, 24, 25, 26, 28, 38–41, 57, 58; Washington State University, Leonard and Virginia Woolf Library (courtesy of The Hogarth Press) – pls 43–48; Cecil Woolf Publishers (from *Virginia Woolf: Life and London* by Jean Moorcroft Wilson, London 1987) – pls 17–20, 37, 53.

Works by Vanessa Bell (all colour plates, and black and white where stated) are © Angelica Garnett. Works by Duncan Grant are © Henrietta Garnett.

Chronology

1878 Marriage of Leslie Stephen and Julia Duckworth.
1879 Vanessa Stephen born 30 May.
1880 Julian Thoby Stephen born 8 September.
1881 Leslie Stephen discovers Talland House, St Ives, and takes lease.
1882 Adeline Virginia Stephen born 25 January. Leslie Stephen becomes Editor of *Dictionary of National Biography* in November.
1883 Adrian Leslie Stephen born 27 October.
1895 Julia Stephen dies 5 May, aged 49. Virginia has her first breakdown in the summer.
1896 Vanessa starts attending drawing classes at Cope's School.
1897 Their half-sister Stella Duckworth's marriage to John Waller Hills 10 April. Stella dies, 19 July, aged 28.
1899 Thoby enters Trinity College, Cambridge, in October. Other freshmen include Lytton Strachey, Saxon Sydney-Turner, Clive Bell and Leonard Woolf.
1901 Vanessa enters the Royal Academy Schools in September.
1902 Leslie Stephen created KCB in June. Adrian enters Trinity College, Cambridge, in October.
1904 Sir Leslie Stephen dies 22 February. Virginia's second breakdown begins in May, not fully recovered until the end of the year. Vanessa, Virginia, Thoby and Adrian move into 46 Gordon Square.
1905 Thoby starts 'Thursday Evenings' at 46 Gordon Square, beginnings of the 'Bloomsbury Group'. Vanessa organises 'Friday Club' in the Autumn for the painters to discuss art and exhibit.
1906 Vanessa and Virginia go to Greece with Violet Dickinson in September, to meet Thoby and Adrian. Vanessa and Thoby ill on their return. Thoby dies of typhoid fever, 20 November, aged 26. Vanessa agrees to marry Clive Bell, 22 November.
1907 Vanessa marries Clive Bell, 7 February; they live in 46 Gordon Square. Virginia and Adrian move into 29 Fitzroy Square in April.
1908 Julian Bell born 4 February.
1909 Lytton Strachey proposes to Virginia, is accepted and then extricates himself, 17 February.

1910 Quentin Bell born 10 August. 'Manet and the Post-Impressionists', first Post-Impressionist exhibition, organised by Roger Fry at the Grafton Galleries, November–January.

1911 Virginia changes London address from 29 Fitzroy Square to 38 Brunswick Square, shared with Adrian, Duncan Grant, Maynard Keynes, and Leonard Woolf at the end of the year.

1912 Leonard proposes to Virginia in January. Virginia has another episode of instability during February and March. Virginia accepts Leonard, 29 May. Virginia and Leonard Woolf married, 10 August. 'Second Post-Impressionist Exhibition' October–December.

1913 Vanessa founder member of The Omega Workshops, established by Roger Fry at 33 Fitzroy Square in July. Virginia has very serious breakdown in summer and is not fully restored to health until the end of 1915. Virginia attempts suicide 9 September, Vanessa and Leonard nurse her through.

1914 War declared 4 August.

1915 Virginia and Leonard take Hogarth House in Richmond and decide at the end of January to buy a printing press. *The Voyage Out* published March.

1916 Vanessa and her household move to Charleston, Firle, in October.

1917 Printing press delivered to Hogarth House in April. First publication – *Two Stories: A Mark on the Wall and Three Jews*. Virginia starts in October to write the diary she keeps for the rest of her life.

1918 Armistice Day 11 November. Birth of Angelica Bell at Charleston on Christmas Day.

1919 *Kew Gardens* published by Hogarth Press in May; written by Virginia with a woodblock by Vanessa as frontispiece. Virginia and Leonard Woolf move to Monk's House, Rodmell, on 1 September. *Night and Day* published October.

1922 Vanessa has one-artist exhibition at the Independent Gallery in June. *Jacob's Room* published by The Hogarth Press in October. Virginia meets Vita Sackville-West in December.

1924 Virginia and Leonard move from Hogarth House to 52 Tavistock Square in March.

1925 Vanessa gives talk on art at her son's school, Leighton Park, in January. Vanessa moves her London house from 50 to 37 Gordon Square. *The Common Reader* published in April. *Mrs Dalloway* published in May. Virginia collapses at Charleston in August and is unwell for most of the next four months.

1926 Vanessa founding member of the London Artists' Association, exhibited at Leicester Galleries May–June. Virginia depressed during the summer.

1927 Vanessa spends the summer in Cassis in S. France and buys the lease of La Bergère. *To the Lighthouse* published in May. New edition of *Kew Gardens* with each page illustrated by Vanessa. Julian Bell goes up to King's College, Cambridge, to read History.

1928 *Orlando* is published in October. Virginia, accompanied by Vanessa and Vita, has her two papers (which were to become *A Room of One's Own*) enthusiastically received by her audience at the women's colleges at Cambridge.

1929 *A Room of One's Own* published in October.

1930 Virginia first meets Ethel Smyth in February. Vanessa has important one-artist exhibition at the Cooling Galleries February–March. Catalogue introduction by Virginia.

1931 Virginia sits for the sculptor Stephen Tomlin in July. *The Waves* published in October.

1932 Lytton Strachey dies 21 January. In February Virginia declines the Clark Lectures at Cambridge.

1933 *Flush* is published in October.

1934 Vanessa's one-artist exhibition at Lefevre's in March. Roger Fry dies 9 September.

1935 Vanessa, Quentin and Angelica in Rome for the summer. Virginia and Leonard on a European tour meet them there. Julian Bell leaves for China at the end of September.

1936 Virginia finishes *The Years* and collapses at beginning of April. Unable to work until the end of May. Unwell again from the end of June until October.

1937 Julian Bell returns from China in March intent on enlisting in the International Brigade in Spain. *The Years* published in March. Julian leaves on 7 June to drive an ambulance in Spain. Julian dies on 18 July.

1938 Hitler invades Austria in March. *Three Guineas* published in June.

1939 Britain declares war on Germany 3 September. Vanessa and Virginia permanently living at Charleston and Monk's House, respectively.

1940 *Roger Fry: A Biography* published in July. Blitz of London begins at the end of the month. Vanessa's studio in Fitzroy Street destroyed by an incendiary bomb in September. Virginia and Leonard's flat in Mecklenburgh Square severely damaged when bomb explodes in the square in September.

1941 Virginia finishes *Between the Acts*. She becomes ill in March with anxiety and depression. She drowns herself in the River Ouse on 28 March. Her body found three weeks later and cremated 21 April. Vanessa Duncan and Quentin embark in the summer on their decorations for Berwick Church.

1961 Vanessa Bell dies on 7 April at Charleston.

Introduction

'There was a likeness between them. As they gazed at each other each felt: here am I – and then each felt: But how different ... Broken asunder, yet made in the same mould, could it be that each completed what was dormant in the other?'

Virginia Woolf, *Flush*

THE SISTERS' RELATIONSHIP was a complex, many-layered thing. It came to be symbiotic, in the sense that each relied on the other to express abilities and experiences that the other tacitly had taken for herself. From an early age Vanessa and Virginia divided the worlds of art and of experience into two. Each presided, sometimes jealously, over her domain. Vanessa claimed painting as her own, Virginia writing; Vanessa took sexuality and motherhood, Virginia intellectuality and imagination. Each sister, although generous about and admiring of the other sister's talents, was inhibited too by her mastery in her own world. Vanessa felt 'painfully incompetent to write letters & becoming more & more so as I see the growing strength of the exquisite literary critical atmosphere distilled by you',[1] while Virginia recognised that Vanessa's genius flowed as readily into her life as into her art: 'Nessa has all that I should like to have,'[2] a largeness, a physicality and fecundity that extended beyond her creativity in canvas and paint.

Vanessa Bell and Virginia Woolf were exceptional women, artists and sisters. Their relationship aroused the curiosity of their contemporaries with its power and variousness, its intimate binding of two apparently opposing temperaments and geniuses. Previously, as the Stephen sisters, Vanessa and Virginia had also been the animating force, the heart of 'Old Bloomsbury'. They had the iconoclasm, feminine sensibility, common sense and practical energy, to galvanise the circle of their brother Thoby's Cambridge friends. Left under the influence of the philosopher G. E. Moore, most were likely to have

I

remained emotionally immature, intellectually arid, sententious and reserved. Without these two young women, the circle might well have dispersed a few years after leaving Cambridge, cast out into a secular world. As it was, Vanessa and Virginia provided a sense of family feeling and easy scepticism which bound them all in lasting friendship.

The group evolved as 'Bloomsbury'. It enlarged, broke ranks and changed character and constituents for ever with the advent of the First World War but continued to have as its focus the two sisters, then married women, Mrs Clive Bell and Mrs Leonard Woolf, at whose hearths old friends and new gathered still. 'We are merely wild, odd, innocent, artless, eccentric and industrious beyond words'[3] was how Virginia once described that peculiarly potent mix of friends, but she was describing most truly the Stephen sisters, the cynosures of Bloomsbury.

To begin with, however, Vanessa and Virginia Stephen presented a uniform front to the world, revealing little of their individuality or the resources of the relationship that sustained them. While still young unmarried women, they were seen by those outside the family as an indiscernible unity: the Stephen sisters, beautiful, silent, remote. There was a poignancy in their motherless state, a curiosity about their life with an ancient and venerable father.

At the turn of the century, their marmoreal beauty and the conventions of dress and formal behaviour enhanced this impersonality, and heightened the apparent similarity. Leonard Woolf wrote in his autobiography of his first sighting of Vanessa and Virginia, at twenty-one and nineteen respectively, and referred to them oddly as if the two were one: 'It was almost impossible for a man not to fall in love with them, and I think that I did at once.'[4] The sisters, in full Edwardian dress, inspired from him an uncharacteristic encomium:

> In white dresses and large hats, with parasols in their hands, their beauty literally took one's breath away, for suddenly seeing them one stopped astonished and everything including one's breathing for one second also stopped as it does when in a picture gallery you suddenly come face to face with a great Rembrandt or Velasquez.[5]

Leonard went on to compound this sense of the Stephen sisters' homogeneity. We have his word that he had fallen in love with both of

them on sight but had subsequently found Vanessa's fuller, more earthy beauty the more appealing. On hearing, while in Ceylon governing the natives, that the presumptuous Clive Bell had proposed to Vanessa and had been accepted, he switched his hopes to Virginia. With slight acquaintance these young women appeared to the unwary to be thus interchangeable.

In middle age Virginia remembered that her husband's affections had been aroused initially by them both: 'He saw me it is true; and thought me an odd fish; and went off the next day to Ceylon, with a vague romance about us both.'[6] In fact, as Leonard and their intimates were to discover, the Stephen girls' apparent demureness of mien, their beauty and seeming acquiescence was a polite veneer over the more intractable qualities (then so much less desirable socially in women) of great discriminatory intelligence, irreverent wit, personal ambition and a seriousness of purpose. The relationship between Vanessa and Virginia was a powerfully complementary one. Each shared family attitudes, a physical likeness and a dedication to work which disguised the polar dissimilarity of their characters and fundamental approach to the world; a disparity which their intimate friends were to recognise with fascination.

Clive Bell too had fallen under the spell of the two sisters, but found himself increasingly drawn to Virginia. Eventually he wooed and married Vanessa, yet continued to be attracted to her younger sister. Even Lytton Strachey was excited by both the Stephen girls and idly (and fleetingly) imagined himself married to each of them at susceptible moments in his youth. Yet again they were a joint phenomenon. 'The two most beautiful and wittiest women in England!'

But whether admired or ignored, desired or reviled, these sisters were seen to be in conspiracy together, with an interdependency and self-sufficiency which alarmed, frustrated and fascinated those excluded by it. Even after Vanessa's marriage the intimacy did not diminish: their younger brother Adrian, always the outsider, was stung into saying he thought it absurd that she and Virginia should write to each other every day. And for Clive Bell, in marrying the one sister, there was an inevitability about his desiring the other. Close as they were, however, there were polarities in their characters and distinct stresses in their relationship.

Vanessa never doubted their separateness. She had enjoyed her first three years of life without Virginia and as the eldest of the Stephen

children bore a mantle of distinction and responsibility. Throughout their childhood, it had been she, too, who had suffered unfavourable comparisons with her irresistible younger sister, and so had striven all the more to establish her own identity. Nevertheless circumstances and their own natures combined to make the bond between them a potent one. For each, this bond could be both inhibiting and inspiring.

Virginia, however, was never as certain of her separateness from Vanessa. 'Do you think we have the same pair of eyes, only different spectacles? I rather think I'm more nearly attached to you than sisters should be,'[7] she wrote to Vanessa when they were both nearly sixty. This attachment was at times fiercely demanding, if life-sustaining in a truly umbilical sense; throughout their adult lives, Virginia was to remind her sister that she was Vanessa's first-born, asking 'Why did you bring me into the world?'.[8] Her intimacy, her need and love for Vanessa infused every one of her days.

For Virginia there was always Vanessa. There from the beginning of consciousness, she was there too, barely five miles away, when fifty-nine years later Virginia drowned herself in the River Ouse. Virginia had never known a day which had not been underpinned with the knowledge of the existence of her sister. She pined for her when they were apart, felt 'parched', 'dried up'; her language is full of desert imagery in which Vanessa became the longed-for fountain of water, of life itself. Everywhere, in her letters, her diaries, her fiction, there is evidence of the central importance of Vanessa to Virginia: 'There is no doubt that I love you better than anyone in the world.'[9]

Vanessa's feelings for Virginia were much less explicit. Admiration, exasperation and a strong maternal solicitude were the surface currents, but deeper and more obscure was her own emotional dependence on her sister; there were periods in her life when she was as desperate for the sisterly devotion that Virginia had demanded always so candidly for herself.

As extraordinary women, as pioneering artists, as sisters, the fifty-nine years of their relationship were rich in letters, jokes, jealousies, conspiracies, shared houses, and for a time, the shared love of their men. During these years they offered each other emotional and financial support, mutual artistic inspiration, admiration and love. The whole was based on a common core of familial inheritance and experience and seamed through with both sisters' resolute and absolute dedication to their art; from the start, they were serious and

4

thoroughly professional. Virginia wrote virtually every day of her life and in a memoir reflected, 'I feel that by writing I am doing what is far more necessary than anything else.'[10] Vanessa, having experienced both marriage and motherhood, returned time and again to the opinion that 'Art is the only thing; the lasting thing, though the others [marriage and motherhood] are splendid.'

Work was at the centre of the sisters' lives and each had a distinctive influence on the art of the other. Virginia wondered whether her fiction was not more truly autobiography; certainlyher central figure, more often than not, was inspired by her need to explore her fascination with the character of Vanessa.

Pacific, civilised, from rooms with views, and views into rooms, Vanessa's and Virginia's work shared a certain perspective. Virginia's writing at times was so visual that Vanessa found herself wanting to paint the images which sprang from the page. Virginia's physical beauty too inspired a series of portraits in which Vanessa deftly and economically captured her younger sister's stillness and grace, her faceless portraits suggesting the mystery of Virginia's inner life. Their artistic collaboration in The Hogarth Press produced the illustrated *Kew Gardens* and the exuberant Bell dust jackets, which sent Virginia's books with some bravado to meet her critics, wrapped, as in life, in sisterly protection.

In her peculiarly sympathetic biography of Elizabeth Barrett Browning's dog, *Flush* (a book written for her own entertainment and light relief, and particularly true to her own feelings), Virginia expressed something of the devotional nature of her love for Vanessa. She explored too the pain of rejection when that sister fell in love with someone else. Her nephew and biographer Quentin Bell points out that Flush embodies Virginia's own spirit; possessive, as the dog was, of his mistress's love, terrified of abandonment, jealous of her attachment to another – yet ultimately reassured that there was a continuing place for himself in her new life.

It seems not too fanciful that Virginia, in her description of the attraction between Flush and his mistress, expressed something of the complementary intimacy of her relationship with Vanessa: 'Broken asunder, yet made in the same mould, could it be that each completed what was dormant in the other?'[11]

Although Vanessa Bell and Virginia Woolf were distinguished above all as individuals, they and their contemporaries saw their relationship, complementary and impassioned, as the source at times

of an almost mythic power. But despite being so successful and influential – pioneers in their chosen arts – Vanessa and Virginia never unburdened themselves of their childhood. It is there that their relationship with each other and the world began.

I

Oneness

'So now about V: well, V. does equally for I and for
Vanessa – but I am surfeited with Vanessa.'
 Virginia Woolf, 13 December 1906, *Letters*, vol. I

IN 1878 LESLIE STEPHEN married Julia Duckworth, formerly Julia
Jackson. They were both widowed and both parents, and thus two
families of children were installed under the one roof of 22 Hyde Park
Gate, just south of Kensington Gardens. Laura Stephen, a mentally
retarded girl of eight years, was united with the three Duckworths,
George aged ten, Stella nine and Gerald seven. Physically and tem-
peramentally the adults' union might have seemed an unlikely one.
Leslie, at forty-five, already had the mien of an ancient prophet. He
was a noted mountaineer, philosopher and journalist with an intellect
that was forceful, unpretentious and incorruptible. As yet his great
work, editing the *Dictionary of National Biography*, had not begun.

He was fond of pointing out how thick-skinned was his nature and
using it as some justification for his irascibility and constant hunger
for female sympathy. Apart from an extraordinary blindness to his
own behaviour and the effect it had on others, he had a vigorous and
humane approach to his family and to life. Leslie Stephen possessed
also a deeply devotional nature and, as a young man, having cast
orthodox religion from his life he found a most suitable substitute in
the beautiful grieving figure of Mrs Duckworth. During his courtship
of her he was perfectly honest about this reverential aspect to his love,
'You see I have not got any Saints and you must not be angry if I put
you in the place where my Saints ought to be.'[1]

Fortunately their marriage and the intimacy of family life allowed
him to remove her halo, to produce four more children, to share with
her the unpredictable responsibilities of parenthood and to seek her
sympathy over the minutiae of his health; writing, from Grindelwald
in the Alps where he had gone for some vigorous mountain walking,
in not uncharacteristic vein, '[I] have been quite well, except that I was

a little constipated two days ago, but I have been making up for it yesterday and today.'[2]

Julia Duckworth was just thirty-two when she married Leslie Stephen, but she felt that already life had awarded her the greatest happiness, followed by the profoundest unhappiness, it was possible to endure. Family tradition had it that the short period of her first marriage to Herbert Duckworth, a handsome good-hearted barrister, had been so happy in its perfection, so perfect in its ecstasy that everything that followed could only appear pale and mundane in comparison. Her beauty was still remarkable, classically fine-featured, but severe too and shadowed with a melancholy she would never lose.

Each brought to the marriage private worlds of happiness and grief the other could never hope to share, and indeed each had felt on the death of their first partner that life had all but ended for them too. Leslie had been 'crushed . . . hope all but vanished from my life'[3] and Julia's life had disintegrated, she told him, like a wrecked ship. In order to survive she had become increasingly busy to prevent her from thinking or feeling too much, 'And so I got deadened.'[4] Their marriage awakened lost love, revived hope and brought together the generations of literary and judicial Stephens with Julia's more romantic Pattle relations, on her mother's side, with their celebrated beauty, sentimentality and artistic and aristocratic connections.

Vanessa, born on 30 May 1879, was the eldest child of this marriage. Just over a year later, on 8 September 1880, the hoped-for son, Thoby, joined her in the nursery. And with this well-matched pair of babies, Leslie and Julia Stephen intended to round off their extended family, making their combined total of six children.

Such hopes were peremptorily dismissed by yet another pregnancy and Virginia was born on 25 January 1882, quickly followed by a second brother, Adrian, on 27 October 1883. And so in barely four and a half years another four children were added to the Stephen household. Their parents, having temperamentally long left their youth behind (both had entered their grief-stricken widowhood expecting not long to survive), now found themselves with a young family of eight children, all under fifteen years, to bring up.

All four Stephen children were conceived and born in the large marital bed, 'the sexual centre'[5] of the family, as Virginia recalled, and where she imagined the walls to be impressed with the tremendous images of their life. Love, sex, birth and death were there, for in that

same bed too her mother died and then, nine years later, her father. From that big marital bed in the front bedroom on the first floor of their family house, the baby Virginia was installed in the nursery two floors up at the top of the house, along with Vanessa and Thoby.

Vanessa was just over two and a half years old and Thoby not yet one and a half when Virginia entered their lives. Vanessa had already begun to enjoy the pleasures of her brother's company. There was a similar matter-of-factness in their natures and a robust puppy-like energy. They did everything together and as life was lived almost entirely in those two top rooms, the day and night nurseries, the children relied particularly on each other for entertainment. Virginia's advent ended the harmonious symmetry of life in the nursery, and jealousy and possessiveness entered their snug, enclosed world. Vanessa remembered that Thoby was 'the brother both Virginia and I adored ... But he and I had had an intimate friendship before she came on the scene.'[6]

At times there was undoubted rivalry between the sisters for his affection and comradeship. Already Virginia could counter her elder sister's practical, steady charms with a far more sophisticated blend of coquetry and abuse. Stella reported to their mother what sounds a particularly characteristic incident when Virginia was just two and already in impressive command of her language: 'This morning Ginia wanted Thoby to give her something, which he had, but he wouldn't so she went up to him and gave him a hug and said "Please Thoby give it, Darling Sweetheart Boy" but Thoby still said "No I won't". Then she went up to him and tried to bite him and said "Nasty, Pugwash horrid, disgusting boy" and afterwards he gave it to her.'[7]

Their natural sisterly competitiveness was enhanced by their father who seemed to find it amusing to speculate as to which child the grown-ups preferred. In his surviving letters to Julia during the children's early childhood the subject arises surprisingly frequently: 'I want your mother to tell me frankly and honestly which she likes best ... is she not delighted with Ginia? Of course, everybody must love Nessa and old To [Thoby] has admirers enough.'[8] Leslie Stephen's favourite was Virginia: he saw a strong likeness to himself in her, he delighted in her quickness of mind, her fluency and was enchanted by her affectionate, insinuating ways: 'Little Ginia is already an accomplished flirt. I said today that I must go down to work. She nestled herself down on the sofa by me; squeezed her little self tightly up against me & then gazed up with her bright eyes through her shock of

hair & said "don't go, Papa!" She looked full of mischief all the time. I never saw such a little rogue."[9] She was just over two years old.

There was a natural intellectual affinity between Virginia and her father from the first. He understood her talents and abilities and found her extraordinarily responsive and rewarding. 'Yesterday I discussed George II with Ginia. She takes in a great deal and will really be an author in time,'[10] he wrote to her mother, whereas his attempts to teach history to Vanessa and Thoby could often be deflected away from the abstract world of ideas to more pressing everyday concerns. He wrote rather plaintively to Julia: 'Nessa and To [Thoby] read about Charles I. I told them that he was a bad man but they did not seem to care much and went off to question about the ocean and whether it was made by rain, as To thought, or by rivers as Nessa argued with [illegible] authority. I don't know what this had to do with Charles I.'[11]

Although Leslie Stephen could be a most affectionate father, willing to take his children on expeditions to the museums and park, to explain the mechanics and theories of the natural world, happy to listen to their childish stories and answer their questions; although he would draw delightful little animals and figures on the margins of letters to amuse them, he was blind to art and oblivious to delight in the appearance of things. Vanessa recalled with wry humour that on all his climbing expeditions to the Alps never once did he descend from the austere mountains to the sensual feast below that was Italy. Vanessa's own absorption in the visual world and her interest from the beginning in drawing met no answering enthusiasm in her father. A letter sent to her mother when she was nearly five contained a characterful and very competent drawing of a small, stout dog and the simple message, 'DEAR MOTHER WE WENT OUT IN KENSINGTON GARDENS VANESSA STEPHEN.'[12] All in capitals, it was laid out like a sampler with every E and R decorated with curlicues. Already the appearance of the message communicated more than the literal meaning of the words.

At about the same time she was given some chalks by her half-sister Stella and spent hours on the floor drawing pictures, much to her father's irritation. He thought it all a waste of time and the results distinctly uninteresting. Much as he loved Vanessa, as he did all his children, perhaps something in her uncompromisingly clear gaze unnerved him. He saw a likeness to his sister Milly and feared his daughter would become a Quaker like her. Perhaps Vanessa would

not so easily offer up affection whenever he demanded it, had never so readily snuggled up to him and gazed into his face with undisguised coquetry as had his darling Ginia. She also reminded him poignantly of the shadowed, suffering side of Julia, to which he knew uneasily his own self-centred temperament and demands contributed. Perhaps Vanessa reminded him of his guilt: 'Dear little Nessa has too much of you in one respect: her beautiful eyes look as sad as yours do; & I suppose at her age you looked more cheerful.'[13] Such profound sadness in the eyes of both wife and daughter could be interpreted too easily as silent reproach.

Virginia remembered that youthful face of her elder sister with the dreamy melancholic expression in her eyes: 'It may not be fanciful to discover some kind of test and rejection in them as though, even then, she considered the thing she saw, and did not always find what she needed in it.'[14] Perhaps it is not entirely fanciful either to consider that her elderly father with his quivering sensibilities, lively self-pity and uncertainty as to his own lovableness should look into those candid eyes of his child and find himself wanting.

Vanessa's and Virginia's mother and her feelings for her two young daughters are subjects of great importance and even greater elusiveness. The emotions she aroused in her family and friends were unequivocal, laudatory and much proclaimed. But the person within this paragon of womanly virtues insisted on slipping away, even at times from her daughter Virginia's analytical pen. 'I see now that she was living on such an extended surface that she had not time, nor strength to concentrate, except for a moment if one were ill or in some child's crisis, upon me ... Can I remember ever being alone with her for more than a few minutes? Someone was always interrupting.'[15]

The 'extended surface' over which their mother's energy was dispersed consisted foremost of her extensive household of husband, children and servants. She had under her care three elder children of her own, Laura, her husband's mentally handicapped daughter who lived with the family until the 1890s, and then their own four young children, still in the nursery. Julia Stephen's energies were much exercised also by her exacting and egotistical husband, who required her constant sympathy and consolation, even admitting often (and only slightly sheepishly) that sometimes he exaggerated his illness or misery in order to extract extra helpings of her life-giving balm. The entire organisation of this large household with its eight children and seven servants fell to her. The family finances too became Julia

Stephen's sole province and for a time she shared responsibility with her husband for educating their youngest four children.

On top of these immediate domestic concerns there was her own mother, crippled with rheumatism and utterly dependent on her daughter for practical nursing care while with her, and continual sympathy and emotional support while apart. Leslie Stephen tells us that Julia had not been Mrs Jackson's favourite daughter and, it would seem, as if to redress that balance, she set out to make herself indispensable to her invalid mother and so became her confidante of 'every sorrow and pain'.[16] Julia never failed to respond immediately to every plaint of her mother's, often neglecting her own needs and sometimes, Leslie felt, those of her husband and family in order to do so. Certainly just six months after Vanessa's birth Julia Stephen had no hesitation in answering her mother's summons to nurse her through rheumatic fever, even though she herself had been unwell after her confinement and had barely recovered.

Then there were the relations: Duckworths, Fishers, Vaughans, Stephens, all to be honoured, entertained, corresponded and sympathised with, and given their due. If this heterogeneous and matriarchal Victorian family, with its traditions and never ending demands, did not exhaust every resource of energy and compassion in her, Julia Stephen had yet to fulfil her own demanding vocation. She had a true gift for nursing and a need to pursue it. When in London she would travel by omnibus and tram, to visit the old, the ill and the poor, and while the family were in Cornwall, staying at St Ives, she would walk down the steep road to the town, with her basket on her arm, to distribute comfort and what food and clothes she had to spare to any especially needy family there. She was remembered with real affection, even reverence, by people in that town long after she had died and the family had ceased to spend their summers there.

This is the woman who managed a large household and its servants, who made order out of chaos for her children, who protected her husband, who presided over a welcoming drawing-room for their friends, and combined all into an harmonious whole. In everyone who rejoiced in her creation, she inspired reverence, gratitude and love. Her organisational and ministering qualities were made all the more memorable by her striking, if austere, personal beauty and air of natural authority. It is little wonder that elderly men, lovesick youths and the daughters of friends should fall under her spell. But there was a price which Julia paid; so, to a lesser extent, did her daughters.

This 'extended surface' on which she was forced to operate neces-
sarily denied her two young daughters a more personal mothering,
time to be spent with her not always crowded out by the demands and
presence of others. It is true that this detached maternal relationship
was not uncommon amongst the families of the Stephens' time and
class where servants and nursemaids freed the mistress of the house
from the messier, more commonplace aspects of family life. But for
Virginia and Vanessa the peculiar force and attraction of their
mother's character with its unfathomable secret side, together with
her philanthropic commitments outside the family and the tragedy of
her premature death, left her younger children, particularly her
daughters, with an aching, irreparable sense of loss. Virginia tells us
she was haunted by her mother until her forties. Then, in writing *To
the Lighthouse*, she managed to exorcise at last the sense of her
presence, at times more real than the living; that longing that could
never be assuaged; 'the old horror ... to want and want and not to
have'.[17]

Only George Duckworth, her eldest son, and Adrian Stephen her
youngest – 'my joy' as she called him – enjoyed a special intimacy.
They were both, for different reasons and in different ways, her
favourites. Leslie Stephen recognised it and felt at times excluded and
jealous. He was capable however of getting his own back, as when
writing to his wife, 'Lowell says that the children are beautiful, wh. is
no news – I mean his opinion. I think they are – except Adrian.'[18] And
of course, like Mr Ramsay in *To the Lighthouse* with his privilege of
absolute knowledge, perhaps he knew too how to puncture his
younger son's joyful conspiracy with his mother as his fictional
counterpart did, frustrating his longing for the trip to the lighthouse
with the autocratic words, 'But ... it won't be fine.'

Vanessa and Virginia also knew that George and Adrian were
somehow special in their mother's affections; and felt ... what? That
their adored and most wise mother valued her sons more than her
daughters, men more than women? Intelligent and capable as she was,
Julia certainly put her name to a petition opposed to the suffrage of
women; she certainly treated her eldest daughter Stella with unneces-
sary harshness which her other two daughters noticed and wondered
at. She was equally hard on herself, sparing nothing in the service of
others. 'My mother believed that all men required an infinity of
care,'[19] Virginia remembered. And that care was to come from
women. To Julia Stephen men were more interesting, more important

13

than women; an attitude that her elder Stephen daughter absorbed into the deepest layers of her being, and her outraged younger one rejected out of hand.

But, above all, the ultimate inequality within the family and one which rankled, with Virginia at least for the whole of her life, was that the boys were given the benefit of a proper education and the girls expected to search out for themselves what scraps they could at home, far removed from the stimulation and comradeship of school or university. Vanessa and Virginia were no worse off in this respect than the majority of girls of their class, but as Virginia especially, and so obviously, was more clever, more avid for knowledge and more able in her use of it than any of her brothers or half-brothers, her parents' compliance with that particular social custom appears peculiarly conforming. Money may well have been a consideration, but it is nevertheless a surprising oversight, given Leslie Stephen's recognition and delight in Virginia's intellectuality and in her similarity to him. He had proclaimed an interest in the education of women in a letter written to Julia before they married, 'I chiefly hold that women ought to be as well educated as men, indeed a very great deal better than men are now.'[20]

Certainly, on a rational level, Leslie Stephen deplored the waste of potential of any human intelligence, be it male or female. He, as an impressive product of the finest educational system in the world, could not but hold formal instruction in the highest esteem. Yet amongst the rankness of his emotions (their primitiveness and lack of cultivation, Virginia declared, due largely to the narrowness of that pre-eminent intellect) was obscured an uneasy prejudice that brains did not become a woman. His first and much loved wife, Minny Thackeray, was thoroughly unintellectual, a woman who 'remained, in some ways, a child through life',[21] and admirably so in her husband's eyes.

Vanessa's and Virginia's mother had a far greater native intelligence, but she deferred in non-domestic matters to Leslie and taught her children to do likewise. His idolising love of her was centred on her physical and moral beauty, her apparently illimitable capacity for comforting, for consoling, for making his barrenness fertile. Her individual view of the world, her divergent opinions, were incongruous in their relationship. Their hypersensitive and watchful younger daughter perhaps had sensed this prejudice in her father and compliance in her mother, for she made Mr Ramsay, in *To the*

Lighthouse, reassured by his wife's lack of intellectual equality. In fact her lack of intellect seemed to be linked in inverse proportion to her desirability as a woman:

> [He] exaggerated her ignorance, her simplicity, for he liked to think that she was not clever, not book-learned at all. He wondered if she understood what she was reading. Probably not, he thought. She was astonishingly beautiful. Her beauty seemed to him, if that were possible, to increase.[22]

This tacit parental view of the incompatibility of intellectuality and femininity was to cause Virginia – who exhibited both these qualities supremely – to falter at times in her own estimation of both her womanliness and her intellect. Such a pervasive family influence may well have also contributed to Vanessa, garlanded with all the feminine virtues, retreating from the challenge of the intellectual. In her fifties, the centre of her kingdom at Charleston, her country house in Sussex, she had retreated so far that she could feel miserable and inadequate still at her inability to enter the worldly polemic of certain clever young male guests: 'I feel the only refuge is to become quite abstracted. Unfortunately they notice this & get quite uneasy & Clive blew me up in public for finding their talk such a bore – which was rather uncomfortable & made me wish I could disappear.'[23] Of course, in such company Virginia could be Vanessa's complete opposite, coruscating in her wit, outrageously amusing and more entertaining than anyone else present.

Even as infants these temperamental differences were evident, and in this family of eight children of various ages and mixed parentage, with its stresses and inequalities, its pleasures and strengths, Vanessa and Virginia soon found there were great possibilities in their own sisterhood. For Virginia of course there was always Vanessa. Her first memories of the sister who was to loom so large in her life belonged to the secure and orderly world of the nursery. There, in the vast and mysterious land under the nursery table where the children often roamed, she came across Vanessa in the firelight.

' "Have black cats got tails?" she asked, and I said "NO". '[24] The meeting remained vividly in Virginia's memory, for the solicitous, grown-up elder sister had demanded of her a piece of crucial information and had valued her reply. A conspiracy was born among the legs and skirts of unsuspecting adults, excluded by the boundaries of

the folded table-cloth. 'I've been in love with her since I was a green-eyed brat under the nursery table, and so I shall remain in my extreme senility,'[25] a fully grown Virginia recalled.

From an early age Virginia was aware of an unswerving integrity in Vanessa. In their childhood games of cricket she batted straight to Virginia's demon bowling. In her relationships with her younger brothers and Virginia she was affectionate and responsible. With adults she was courageous and true, 'She might not see all, but she would not see what was not there.'[26] And as the eldest of the four, she naturally provided some of the every-day maternal solicitude, the soothing of hurts and answering of questions which nurse or their busy and often absent mother were unable to dispense. It was the very literal side to Vanessa's character, a tenacious insistence on truth, that earned her Virginia's wounding epithet 'the Saint'. And yet it was this rock-like dependability which Virginia so appreciated.

Vanessa's first memories of Virginia were characterised by astonishment. Astonishment at her beauty, for she was a particularly attractive and bonny child with green eyes and a bright apple-cheeked face: 'I was as much aware as anyone of her brilliance and loveliness to look at. She reminded me always of a sweet pea of a special flame colour.' Vanessa felt astonishment too at Virginia's ability suddenly to summon up an atmosphere of 'tense thundery gloom',[27] which would descend solely upon her poor elder sister and imprison her in spiritual blackness while everyone else seemed to continue in unruffled normality.

When an elderly woman, Vanessa attributed this devastating effect on her childish spirits to a natural rivalry between the sisters over Thoby. Perhaps Virginia already had begun to practise her consider-able charms on him, as again she was to exercise them, when both sisters were adults, on another male whom Vanessa loved. That time the jealousy was all the more dumbly suffered and deeply felt, because Vanessa could only agree with the consensus of their friends that her sister was indeed irresistible, the most admirable woman she knew.

Then again, Vanessa was more than astonished, shocked even, by an analytical intellectual curiosity in her younger sister which did not admit to normal taboos. When she was just eight and Virginia six, the two girls were leaping about naked in the bathroom at 22 Hyde Park Gate when Virginia suddenly enquired which parent her sister pre-ferred, father or mother. 'Such a question seemed to me rather terrible; surely one ought not to ask it.' Vanessa recoiled, but

answered all the same: '"Mother," I said, and she went on to explain why she, on the whole, preferred my father.'[28] She realised even then that whereas her reply had been an instinctive unconsidered matter, Virginia's had been the result of a certain critical process. Their opposing answers were truthful and important. Vanessa remembered the incident all her life and the sympathies and antipathies that existed already in herself and Virginia as children were to lay the foundations of their adult lives.

It seemed to Vanessa that this terrible question had released other subjects for discussion. After all, what could you not say if you had already enjoyed the freedom to criticise your own parents? It is interesting that just before this revelation in the bathroom, Vanessa noticed a physical and intellectual change in Virginia. All the young Stephens had suffered a communal attack of whooping cough which left them weakened and thin. Everyone was restored quickly to robust health, except for Virginia, who seemed to her observant sister to remain leaner and more transparent-skinned, never quite to recover her childish softness and innocence. She had 'moved on', Vanessa believed, to a new stage of critical awareness, another level of consciousness.

These instances of sudden recognition of the significance of things, however, and their place in a greater pattern, were only a minute but memorable part of Vanessa's and Virginia's childhood. Their early years were orderly and secure, spent for ten months of the year in the familiar spaces of the nursery and nearby Kensington Gardens. Twenty-two Hyde Park Gate was terraced and tall, its five storeys becoming seven in response to the growing family's need for space. Inside was dark, the paintwork black, the curtains heavy. Virginia creeper obscured the dining-room window and the household's furniture and decoration became increasingly shabby as one ascended. The children inhabited two rooms on the third floor, the day nursery where they ate most of their meals, took their lessons and played, and the night nursery where all four Stephen children and their nurse slept. Here, with open fires in winter, it was snug, at times stuffy, confined and enclosed. Their daily walks were conducted in Kensington Gardens where, although it was wilder than now, there was nevertheless an inevitable formality and predictability about the radiating walks, the flower beds and the Round Pond on which they sailed their boats and in winter skated.

The long dreary winter expeditions were enlivened by the telling of

stories, at which Virginia always excelled, talking as they walked with gravel crunching beneath their boots. Vanessa and Thoby, with the advantage of age and greater experience, often told Virginia of the time when the area called the Swamp was really a swamp before she was old enough to join them on their explorations. In those far off days they had come across the corpse of a little black dog, lying in the undergrowth, and had gazed on it with awe and fascination. It had provided many hours of happy speculation on the nature of its demise. Starvation and drowning, Vanessa deduced, revealing even then her unsentimental, unflinching view of life.

There were reminders too of the grotesqueness and suffering in the outside world. There was the time when a desperate boy leapt out in front of Virginia in Kensington Gardens: subnormal, neglected, red-eyed and whimpering, he extended his hand to her. Speechless and appalled, she could only pour into that hand her bag of toffees, always to be haunted by the intensity of his need and the incongruity of her response. Later that evening, sitting in the bath with Vanessa, the horror returned and she cowered at her end of the tub, unable to explain even to her sister placidly washing herself at the other end, her sense of hopelessness and utter vulnerability, 'as if I was passive under some sledge-hammer blow'.[29]

But reminders of pain and madness entered even the inner sanctum of their family life. There at the heart lived poor Laura Stephen. Nine years older than Vanessa, she was kept largely separate from the younger Stephens with her own nurse, but ate with them and was unpredictable and disturbing in her behaviour. She was given to fits of hysteria and, even when she was as old as twelve, terrific howls of frustration which used to haunt her father. 'If she could only know how she tortures me!'[30] was a characteristically self-centred reproach. Leslie Stephen had cared for his daughter lovingly but, perhaps misunderstanding her behaviour and seeing perversity where there was more likely grief, unhappiness and a congenital lack of ability, his treatment of her was at times unwittingly harsh. He had attempted in vain to teach her and tame her when her mother's death had left them alone. His letters to Julia, before their marriage and in the early years of their life together, are full of his genuine love and concern for this child, but punctuated on occasions with remorse at losing his temper with her. Victorian children were expected to conform to rigid standards of behaviour. There is little doubt that, until Leslie accepted that his eldest daughter was not going to be able to perform socially

and intellectually as he had hoped, there was a battle of wills between them and much suffering on both sides.

Although, by the time Vanessa and Virginia were old enough to judge the situation for themselves, Laura was already living in her own quarters, her torment must have been evident to both her younger half-sisters, infecting the atmosphere of the house and trying even further their conscientious, controlled and over-extended mother. There is barely any mention of Laura in either sister's memoirs of their childhood (Virginia dismisses her as an idiot), but she loomed as a suffering presence until her removal to the country, and then to an asylum, when Vanessa and Virginia were eight and five respectively. She was to live on for another fifty-eight years as a haunting reminder of the pain and madness so close to them – an awful warning, too, perhaps of what befell young women whose behaviour meant they could be labelled, by a greater authority, as 'insane'.

The sisters were also involved, dramatically though spasmodically, in the mania that afflicted their handsome and gifted cousin, the classicist J. K. Stephen, after a railway accident that injured his brain. He once stormed into their nursery and in an extravagant gesture stabbed a loaf of bread. Again in a state of manic energy he carried Virginia off to his studio in order to paint her portrait on a piece of wood. But most unsettling for the household was his amorous pursuit of Stella, which necessitated Julia's reluctant instruction to Vanessa and Virginia and the other children that they were to deny Stella was at home should 'dear Jim' ever call. Eventually he died in 1892 at the age of thirty-three, leaving his family with a sense of tragic loss. No one at 22 Hyde Park Gate would ever forget the morning when he appeared at breakfast and announced with macabre amusement that Dr Savage had just told him that he faced either madness or death.

A thread of madness and death was woven through even the earliest and happiest portion of the childhood of Vanessa and Virginia. Immoderate behaviour and inappropriate desire too existed in unhappy combination; in J. K. Stephen's case the one was the cause of the other, in the case of Vanessa's and Virginia's brothers, the inappropriate desire was the cause of a confused intensity of emotion in the heart of the family that was to prove more destructive. Years later Virginia claimed this was largely responsible for the most intractable difficulties in her own life – and for the enhancement of Vanessa's capacity for silent suffering. Their much adored half-brothers,

George and Gerald Duckworth, sons of their mother's first marriage, were eleven and nearly nine years older than Vanessa, thirteen and eleven years older than Virginia and lived in the same house as the younger children. They, particularly George, were the darlings of their mother.

Although, as they grew into young women, Stella Duckworth was to become increasingly intimate with the Stephen girls, in the early days there was a clear feeling of divide between the two families. Vanessa, Thoby, Virginia and Adrian were 'us four' and the Duckworths were 'the others'. It is quite likely that there was some envy of them too, for they were born of the marriage that had made their mother 'as happy as it is possible for a human being to be'.[31]

The period of abject unhappiness she endured as a result of her first husband's death was never discussed by their mother and acquired therefore in the minds of her younger daughters something of the weight of mythological tragedy. Virginia was told by Stella once that their mother used to lie full length upon her dead husband's grave, in what seemed to Virginia to be a terrific and tragic expression of grief in one so naturally undemonstrative. So the 'demi-gods & tyrants', as Virginia dubbed her Duckworth half-brothers, held a position of privilege in the family and a power over their much younger siblings. This they were to abuse in their treatment of both half-sisters.

The first instance related by Virginia occurred when she was about six and the family were on holiday in St Ives. Gerald, who was about seventeen at the time, lifted her on to a ledge in the hall that was used for 'standing dishes upon' and began to explore her body.

> I can remember the feel of his hand going under my clothes, going firmly and steadily lower and lower. I remember how I hoped he would stop; how I stiffened and wriggled as his hand approached my private parts. But it did not stop. His hand explored my private parts too. I remember resenting it, disliking it – what is the word for so dumb and mixed a feeling?[32]

It was a feeling that was so powerful that memory of it endured till her death. In her fifty-ninth year, two months before she drowned herself, Virginia wrote to her stalwart friend the composer Ethel Smyth, 'I still shiver with shame at the memory of my half-brother . . . exploring my private parts.'[33]

It is the difference in age – for Gerald at seventeen was virtually a man – which brutally underlined the helplessness of the child. His trusted position in the household and his heroic status in the eyes of his half-sisters was the betrayal with which such incestuous abuse poisons the heart of a family. This recoil from the abuse of power, her sense of vulnerability and powerlessness in the face of the sledge-hammer of fate was to recur in Virginia's experience.

Vanessa was never explicit about what she suffered at the hands of her half-brothers and it is unlikely that she was involved in any similar incident so young. However, she did endure, less protractedly than Virginia, something of the emotional bullying, the fondling and invasions of privacy which their elder half-brother George imposed on them after the death of their mother. It was also painfully evident that Vanessa and Virginia could tell no one at the time, apart from each other, and were themselves confused by the conflict between George's grotesque private behaviour, exposed to them alone, and his much admired and heroic public face. Friends and aunts continually praised their sainted brother, generous patron and loving friend. And Virginia, again more intensely so than Vanessa, had her own am-bivalent feelings towards him; she admitted her love for him, existing alongside disgust and shame, in a confused and potent brew. In the light of this and the girls' own acute vulnerability, it is easier to understand Virginia's startling description of 'the others' as 'beings possessed of knives'.[34]

Perhaps Vanessa's and Virginia's insistence on the ritual story-telling in the nursery at night was not only an imaginative escape, an hypnotic prelude to sleep. Perhaps also it was an attempt to put order on confusion, a reassurance that they were in control of their fictive world, even if beyond the fire-lit room the helplessness of the child was everywhere immanent. Certainly, night after night, the ritual held sway: 'Clementé, dear child,' Vanessa's voice would call out in an affected drawl and Virginia, as Clementé, would begin. The dramatis personae were the commonplace Dilke family who lived next door and were envied by the Stephen children for their conspicuous wealth, and mocked because they could not pronounce their Rs. Hidden treasure and endless supplies of favourite food – well-fried eggs as it happened – seemed to be the major rewards. And the story ran and ran. Eventually, if Vanessa fell asleep first and the nursery fire was still burning, Virginia, made anxious by the flickering shadows on the walls, would call to her sister, 'What did you say Nessa?'[35] in order to

wake her and have the comfort of her company, if only for a few minutes more.

But the confinement of these two rooms, cramped with growing children and their possessions, pressed upon by the presence of their Duckworth brothers and sister on the floor below and their father's study above, at times – and for Vanessa particularly – seemed almost unendurable. Interned high up, so far removed from the street and its activities, with their back garden an unprepossessing overshadowed plot and Kensington Gardens not entirely enticing, Vanessa was deprived of the variety of visual images that had already become her secret drug. The spur to her painterly imagination, sight of any countryside, of wide horizons, of dark reflecting water, a sky filled with light, all were denied her during those ten months in London. 'I used sometimes to feel it almost unbearable so seldom to be in a wood in the spring – in the early summer, never,'[36] she recalled over half a century later. There was, however, St Ives, the paradise of their youth. Here the two months' celebration of freedom and life made the remaining months of the year seem merely existence.

Just before Virginia was born, her father, on one of his walking expeditions, discovered Talland House on the outskirts of the village of St Ives on the North Cornish coast. Although it was such a very long way to transport a large young family and its entourage, and suffering some guilt that he was being wilfully selfish again, he felt nevertheless quite confident that the position and the surrounding countryside could not be bettered and bought the lease without his wife seeing the place.

The summer after Virginia's birth was the first of thirteen summers the Stephen family were to spend on this wild and beautiful coast. From the start it proved to be 'all that we have hoped' and in fact was to become the most precious gift Leslie Stephen could have given his children. Vanessa and Virginia were to recall vividly the exalted times they spent there. It was impossible to exhaust the brimming resources of their memories and impressions, and in their adult lives they attempted to recapture in their own country houses some of the essential qualities of life at Talland House. Throughout their lives, a word, a glance, a sensation would conjure up in both sisters that great shared past, a richly coloured skein of memories that united them in profoundest conspiracy.

Virginia's first memory was of sitting as a baby on her mother's lap, perhaps on a train, perhaps, more fancifully, returning from their

summer at St Ives. The journey by train took virtually the whole day, departing as they did on the Cornish Express from Paddington Station and eventually tumbling out at St Ives's little station. Everyone was tired and dishevelled, yet revived by their excitement and anticipation at seeing the house again after an absence of almost a year.

Talland House stood behind its escallonia hedge on a hill just outside St Ives with a perfect view of the sea. A solid square-built white villa, it was surrounded by gardens sloping away in lawns and terraces. Hedges and its natural topography divided the garden up into a series of smaller gardens, named by the children: the coffee garden, the love garden, the fountain, the kitchen garden, the cricket lawn, providing spaces for family communal activities or for shady escape and the promise of mystery. The sound of the sea could be heard in every room and the Godrevy lighthouse, with its pulsing light by night and distant presence by day, became a totem for them all.

Virginia described the ecstasy of that first morning at Talland House when, half-waking, half-sleeping, she could hardly believe she was there, listening to the rhythmic sibilation of the sea on the beach, watching the light through the blind. The sound of the waves and of the acorn at the end of the blind's cord trailing across the floor in the breeze took on a mystical significance for her, what she called 'a moment of being'. The memory became a base on which her life was balanced; her life, the bowl 'that one fills and fills'.[37]

In 1893 Vanessa and Virginia went down on the train with their father and Adrian while their mother stayed behind to nurse Stella through mumps. Thoby was to join them later from school. Vanessa's propensity for being sick on trains saved her from having to eat the sandwiches they had brought for their lunch which had been accidentally soaked with lemonade. Virginia and Adrian were not so lucky and the repulsiveness of this soggy picnic was remembered by Adrian into his middle age. Vanessa, according to her father, sat for the whole journey demurely reading and, not surprisingly, 'declining food'.[38] Her own unique combination of obstinacy and passivity achieved for her what no amount of charm and argument could effect for Virginia and Adrian.

Leslie Stephen's letters home show how the enchantment settled on him too.

Here is another beautiful day ... yesterday we went to Tren Crow. The children had their inevitable nets; for they are quite mad about

bugs ... a high wind was blowing & several butterflies hovering about just on the rocky slope ... the wind distracted them and the chn. had to rush up and down the rocks. I at last called them off: but luckily they caught one at the end and so came home in triumph. They are all very well, I think; and doing very little work.[39]

But although they were not working, in their father's definition of the word, Vanessa was painting, experimenting; silent about her aspirations and her passion for the visual world. Only to Virginia could she haltingly, shyly, confess a little of the thoughts behind her mute conversations. 'Once I saw her scrawl on a black door a maze of lines, with white chalk, "When I am a famous painter —" she began, and then turned shy and rubbed it out in her capable way.'[40]

Their time at St Ives was filled with endless activity and delight, clambering over the rocks, chasing butterflies by day and moths by night, climbing trees and playing games of cricket. Their father complained that while at St Ives they could never be found. But he was most receptive to the enjoyment of his children and their activities during these carefree summer months when family and friends jumbled together in jolly propinquity at Talland House. 'We are wonderfully fortunate to have such a set'[41] was his general verdict. His children revelled in a freedom that was much more than physical. Life at St Ives was necessarily informal, the rules and conventions could not be maintained in a holiday house such as theirs with its shabby, sparsely furnished rooms, its overcrowding, the constant comings and goings. Doors were continually ajar. Light, fresh air and the sound of the sea entered everywhere. Childish spirits could soar where at 22 Hyde Park Gate they were restrained by the dark furnishings, the closed doors, the obscured horizons and the weight of adult expectation. What entertaining there was at St Ives inevitably had to be relaxed; there were no formidable aunts at hand to insist on the rites of the tea table.

The four young Stephen children were sufficient unto themselves. They did not play with the local children, they rarely had other children to stay. Even 'us four' was more usually, us three, for when Adrian was young he was not considered robust and much preferred his mother's company, a preference she returned, for 'she had a very marked and tender sentiment about her "Benjamin".'[42]

Inevitably summer had to end. And with that end came the shaking

out of sand, the collecting up of relics, the packing away, the farewell to friends, the closing of windows and locking of doors, the return to London. 'Children don't forget. Children don't forget,'[43] Mrs Ramsay, the mother in *To the Lighthouse* repeats to herself this creed. She was a re-creation, a critical examination, a celebration, by the adult Virginia of her and Vanessa's own mother, and the first part of the novel was a vivid painting of the St Ives summers none of her children would ever forget.

Julia Stephen angered her husband by saying of Thoby, when a child, 'He will never be so happy again';[44] Mrs Ramsay is as certain.

They were happier now than they would ever be again . . . She heard them stamping and crowing on the floor above her head the moment they woke. They came bustling along the passage. Then the door sprang open and in they came, as fresh as roses, staring, wide awake, as if this coming into the dining-room after breakfast, which they did every day of their lives was a positive event to them; and so on, with one thing after another, all day long, until she went up to say good-night to them, and found them netted in their cots like birds among cherries and raspberries still making up stories about some little bit of rubbish – something they had heard, something they had picked up in the garden. They had all their little treasures . . . And so she went down and said to her husband, Why must they grow up and lose it all? Never will they be so happy again.[45]

In a sense sibylline words, for those children were so deeply im-printed with memories of their summers at St Ives that they were to carry always a yearning nostalgia for a time when perfect happiness had seemed possible and been theirs.

Back in London, life for Vanessa and Virginia settled into its old routine. After Thoby, at the age of ten, went to Evelyn's Preparatory School for the January term of 1891 (looking much like a 'calf going on a sledge to the butchers',[46] his father imagined), his two sisters became even more closely dependent on each other. They had their lessons together, rather unsatisfactorily and unhappily taught by their parents. Latin, French and History relied on their mother's skills and the dreaded mathematics on their father's, much to his and their despair. 'Virginia all her life added up on her fingers and I am very little better,'[47] was Vanessa's summary of that well meaning but painful attempt.

A much more satisfactory element of Virginia's education was being supplied with books to read by her father who would then quiz her about the merits and demerits of the work. As she grew older, she was given the run of the unexpurgated library, a challenge which she set to with a will. Virginia read continuously and critically; it was an education enclosed between two covers, experienced within four walls. Years later, on turning down the request of the Master of Trinity to deliver six Clark lectures at Cambridge, she wondered at her intellectual progress: 'Think of me, the uneducated child reading books in my room at 22 Hyde Park Gate – now advanced to this glory ... Yes; all that reading, I say, has borne this odd fruit. And I am pleased.'[48]

Certainly, both sisters could share their general bafflement at the principles and practice of mathematics, as taught by their father. But for Vanessa to share lessons with a sister who, although younger, was nevertheless intellectually precocious, avid for knowledge and articulate and acute in her opinions and expositions can only have reinforced her frustrated admiration for Virginia and the sense of her own intellectual inadequacy. This feeling of being inarticulate and lacking in wit shadowed Vanessa throughout her life. She refers to it many times in her letters, particularly in those to that acme of articulacy and wit, her own younger sister: 'I feel a hopeless fool here – ignorant and badly educated. However it cant be helped. It's what I am';[49] 'How odd that [Father] should have had me and Adrian for children. I often feel singularly boorish and crude.'[50]

Once Thoby went to school the insularity of their daily lives became significant to them only with the perspective of age. Vanessa remembered how the singing class was entertaining largely because there were other children there. Even if she and Virginia were liable to be scathingly critical of their fellow pupils, they at least provided some stimulation, some standard to measure themselves against, some comparisons outside their own family; the possibility that there were others who could be better than Virginia and worse than Vanessa. But Virginia too suffered from this want of confidence: 'Was I clever, stupid, good looking, ugly, passionate, cold —? Owing partly to the fact that I was never at school, never competed in any way with children of my own age, I have never been able to compare my gifts and defects with other people's.'[51]

Thoby's return from school one day, and his shy retelling of the Greek legends, as he and Virginia tramped purposefully up and down

the stairs at Hyde Park Gate, was perhaps the first time that Virginia realised there was an extensive world of intellectual and social education outside the home; a world which, due to her sex, was closed to her. This glimpse of what formal education offered the sons of the middle and upper classes was the beginning of a lifelong envy and anger at what had been denied her. She saw clearly, however, and with witty acuity decried the intellectual narrowness and arrogance it could foster. But it was Thoby's edging open for her of the door to the delights of the classics which determined Virginia to learn Greek.

Vanessa and Virginia was expected to stay at home, where they were to be given a rudimentary education and become practised in the feminine accomplishments of music, dancing and presiding over the tea table. For young women of their class, these were all necessary preparations for the great adventure of marriage and motherhood. The attempts to teach them piano were numbingly tedious and doomed to failure. The singing lessons were more successful in that there were other girls to laugh at and admire, but Vanessa and Virginia soon discovered the Achilles heel of their singing mistress, Miss Mills. This respectable lady, with a high reputation for her 'tonic Sol-fa system' of teaching, was intensely religious, an attitude that the atheist Stephen family had never learned to respect. When Miss Mills, with hushed reverence, asked the assembled girls who could tell her the meaning of Good Friday, Virginia began to giggle. She and Vanessa had not the slightest idea, 'being little heathens'.[52] On hearing that the day was called Good Friday because Christ had been crucified then, Virginia could no longer contain her mirth and, in fits of laughter, was banished from the room.

The social skills of the tea table were a different matter. They were just as alien to Vanessa's and Virginia's temperaments as the practising of musical scales, but were acquired not so much by conscious learning as through an osmotic process of daily exposure to their mother's supreme example, and through having to respond to the orthodox versicles of older friends and relations who regularly gathered at that Victorian shrine. The tea table affirmed the civilised values of Victorian middle-class society, of which the family was a microcosm. There order, harmony, a concern for others (particularly that they had enough to eat and drink) and a subtle fostering of male egos were presided over by a paragon of feminine grace and bounteousness. There the liturgical language was small talk of a finely discriminating kind. Neither argument nor gossip was appropriate to

the service, rather a polite, mannered, responsive conversation whereby young women laughed (with decorum) at old men's jokes, attended to young men's interests and congratulated them on minor triumphs. Buns were passed, ill health commiserated over and mundane disappointments soothed. They were expected always to skim and smooth, never to plunge beneath the surface or soar into the dialectical blue. Young women were not expected to draw particular attention to themselves through their behaviour or their conversation. (If they had this effect passively, through their physical beauty, however, so much the better.)

Both Virginia and Vanessa acquired there 'that "manner" which we both still use',[53] Virginia wrote towards the end of her life. It was to provide them with a civilised and formal framework of social behaviour that was to help them entertain disparate groups of people with a distinct grace and authority, organise their households and direct servants. But it also hindered, Virginia felt, the expression of her art: 'When I reread my old Common Reader articles I detect it there. I lay the blame for their suavity, their politeness, their sidelong approach, to my tea-table training.'[54]

Vanessa does not mention the effect of this manner on her life or work, but it is very likely that this well-learned restraint and denial of self, both influential threads in her education, foreshadowed her insistence on 'reasonableness' at all costs in her adult relationships. Despite her deliberate outrageousness in behaviour and conversation, particularly as a young woman setting out in the world, her tea-table training reinforced, on a more profound level, her unwillingness to express spontaneously and appropriately the everyday emotions. It was a constraint which led to tragic repressions, sudden collapses and overwhelming paroxysms of feeling.

And so the Stephen sisters passed most of their day at home, where their happiest hours were spent in a small room that led off from the drawing-room. This retreat gave them much-needed privacy from the rest of the household, but was almost entirely composed of windows from which Vanessa and Virginia had a panoramic view of their back garden, the sky overhead and an unobserved look-out on the activities of the drawing-room. Here Vanessa would paint while Virginia read aloud, making her way through the great Victorian novelists. In her old age, long after Virginia's death, Vanessa still could not read George Eliot or Thackeray without hearing her sister's distinctive voice.

Here, too, much of the family newspaper 'The Hyde Park Gate News' was produced, probably between 1891 and Mrs Stephen's fatal illness in 1895. This was largely the work of Virginia. From her earliest years she needed to attract attention and admiration to herself, and this amusing and lively production provided her with an early and public outlet for her humorous and literary skills. Their parents' reception of the latest issue was always the crucial test. Vanessa remembered how she would put the paper on her mother's table in the drawing-room while their parents were at dinner, then both girls would withdraw to their sanctuary and await the parental verdict. Virginia would be 'trembling with excitement' while unobserved they watched their mother sitting in the firelight reading. At last she noticed the newspaper, which to Virginia must have been incandescent with significance as it lay by her elbow. Both girls strained their ears for some comment. 'Rather clever, I think,'[55] they heard their mother say drily to her husband sitting across the fire from her. But that comment, however lacking in effusion, was enough for Virginia. Her efforts, her sensitivity to criticism, her painful anticipation, all were rewarded; she had been called clever.

Vanessa's memoir of their early years expressed both explicitly and allusively a deep-rooted competitiveness between herself and Virginia and a sense that, in adult eyes, she was usually unfavourably compared with her younger sister. From the first the two little girls had decided their fates. Virginia was to be a writer, Vanessa a painter: 'It was a lucky arrangement, for it meant that we went our own ways and one source of jealousy at any rate was absent.'[56] This tacit designation of roles was to continue into their adulthood, involving most aspects of their lives, where as long as each sister confined her talents and interests to the arena she had taken for her own, the old jealousies were subdued and the affection and admiration each felt for the other unobscured.

But as girls this designation of Vanessa as the painter, Virginia as the writer, whilst removing an arena of personal competition, left Vanessa (as far as family tradition went) with the less noble profession. The Stephens were writers, it was a talent that ran directly down the male line, for Leslie Stephen, his father and grandfather were all judiciary and literary. Writing was the family business and Leslie Stephen was pleased that Virginia seemed, from the first, so able and keen to carry it on.

Painting on the other hand was something young women dabbled

in as part of their social accomplishments, on a par with flower arranging and needlework. While her family realised that Vanessa's was a more profound and enduring interest, that she had a talent, only Virginia knew of the strength of that passion and commitment to her art, and there was not the family tradition to endow her aspiration with the same significance: no solid inheritance through the male line. On her mother's side there was their great-aunt Julia Margaret Cameron, the pioneer photographic portraitist, and a second cousin, the painter and Royal Academician Val Prinsep. They were both reputed artists, but Julia Margaret Cameron's eccentricity and sex and Val Prinsep's charm and enervated paintings meant they did not inspire quite the necessary *pietas* to be set against the monumental judicial and literary achievements of three generations of Stephens. And so Vanessa became possibly more silent and secretive in the practice of her art than even her natural reticence would have ensured.

As Virginia observed, 'talk of art, talk of her own gifts and loves was unknown to her.'[57] In her novel *Night and Day*, Virginia set out from the start to explore her sister's character through her portrayal of Katharine Hilbery – 'Try thinking of Katharine as Vanessa not me'.[58] Vanessa reluctantly accepted the characterisation: 'I am the principal character in it & I expect I'm a very priggish and severe young woman but perhaps you'll see what I was like.'[59] Katharine, like Vanessa, practised her art in silence and secrecy. A love of mathematics was her secret vice and like painting it was,

> directly opposed to literature. She would not have cared to confess how infinitely she preferred the exactitude, the star-like impersonality, of figures to the confusion, agitation, and vagueness of the finest prose. There was something a little unseemly in thus opposing the tradition of her family; something that made her feel wrong-headed, and thus more than ever disposed to shut her desires away from view and cherish them with extraordinary fondness.[60]

Vanessa's feeling of being an artist outside the Stephen family tradition was echoed in her childhood by the sense that she had been unfairly dealt with in the choice of titular godparents. Whereas her godparents were to her eyes extremely dull, 'a decrepit old cousin in Ceylon and Lady Vaughan Williams the judge's wife, whom I couldn't bear', Virginia seemed unfairly favoured in being awarded

the American Ambassador, James Russell Lowell, a man of culture and charm and a figure of distinguished glamour to the Stephen young. He produced his chain purse and distributed threepenny bits to Vanessa and the boys and sixpence to Virginia. Far more inequitably, however, he once gave Virginia a real, live bird in a cage, an incident that Virginia does not mention anywhere in her memoirs and yet caused Vanessa to recall more than fifty years later the 'evil passions'[61] this preferential gift aroused in her.

From the moment the baby Virginia entered the world, Vanessa had to accept the responsibility of being the eldest, with a brilliant and enchanting younger sister always determined to catch up. She had to watch her closeness with Thoby invaded, her father's interest captured, the whole adult world entranced. 'Her appearance and her talk had obviously the greatest success with the grown-ups',[62] Vanessa remembered without rancour, for Virginia equally delighted her and the rest of the nursery with her antics. But there was pain and it was inflicted on young impressionable children, longing to please, by insensitive adults who made unnecessary, wounding comparisons. Vanessa saw the one great advantage of being an only child as opposed to a member of a big family was that she would then not have been exposed to the demoralising effect of such idle estimation: 'No one ever says how nice Mary is or how lovely Jane; but always Mary is nicer than Jane and Jane prettier than Mary ... comparisons are the easiest form of criticism, no doubt, but it may lead to trouble.'[63] There is a strong sense that she was speaking from experience.

Although Virginia was very ready to compare her adult self with Vanessa, so often to her own detriment, in Virginia's extensive autobiographical writings on her childhood such parental comparisons are not mentioned. When Virginia and Vanessa were children, it was Virginia's abilities and character which were approved and applauded – quite frequently at the elder sister's expense. Certainly as a young child she was extraordinarily pretty, as an infant was called 'Beauty'[64] for a while by her family, and when she acquired speech she enjoyed a most amusing and seductive way with words. Vanessa in her womanhood was to come into her own, but as a sturdy, serious child she suffered. She suffered the sarcasm of the adults who took up Virginia's wounding epithet for her, ridiculing 'the Saint' for her dogged insistence on the truth, and her literalness of mind.

There was a caustic, ruthless side to their mother who was also consistently harsh in her treatment of her eldest daughter Stella (so

noticeably so that Leslie Stephen and some of her friends chided her on the point), who, as she explained, was 'part of herself'[65] and therefore born to sorrow. Her nickname of 'Old Cow' for the same daughter bears an ineradicable shade of disparagement, however charitably and affectionately one imagines it applied.

Virginia, who was to struggle all her life to understand the ambivalence in her feelings for her mother, enjoyed hearing the author and actress, Elizabeth Robins, describe the Julia she had known in early womanhood as 'the most beautiful Madonna & at the same time the most complete woman of the world . . . She never confided. She would suddenly say something so unexpected, from that Madonna face, one thought it *vicious*.'[66] It was not an entirely comfortable attribute, this thorn on the rose. And then there was the ultimate betrayal: their mother preferred and valued men above women, her sons above her daughters. The complicated passions aroused by Julia in her two younger daughters were not to become definable until Vanessa and Virginia were grown up and embarking on their own adult lives.

Vanessa the child, however, as she later remembered, could not but love and admire Virginia too. The only way for her to claim an inviolable identity and to moderate the competition between them was to withdraw from the verbal and intellectual worlds where Virginia was queen. Thus she came to concentrate on the practical and maternal elements in her own character. And to practise covertly her art. Vanessa knew too that these characteristics and abilities, which from the earliest age she made distinctly her own, fascinated Virginia and bound her to her elder sister in dependence and admiration, with a passion which at times bordered on the obsessive. As a girl Virginia had a habit of fingering a necklace of Vanessa's and with each bead naming someone who occupied a place in her sister's affections. Such adoration bestowed its own power.

But these are peculiarly significant details which fixed in the memories of two young girls and the people who knew them, and endured there with enough tenacity and radiance for them to be committed to paper many years later. They are fleeting illuminations of some of the shadow and turbulence beneath the largely sunny surface of Vanessa's and Virginia's early childhood, 'the common life of the family, very merry, very stirring, crowded with people',[67] as Virginia described it, which carried on with the figure of Julia Stephen triumphantly at its centre. There, all disparate elements were secured by their mother and any calamity given proportion by her presence.

Despite their mother's absences and distractedness, despite the advanced age and intractability of their father, despite the unequal treatment of themselves as daughters, of their own filial jealousies, despite even intimations of incest, while Julia lived the darkest forces were held at bay. Family life rolled on and Vanessa and Virginia, growing into their womanhood, were free to experiment a little, to dream and plan, in a family whose agnosticism and intellectuality meant its daughters suffered less constraint than would have been so in many a more conventional and prosperous one.

However good his intentions, however successful the marriage, Leslie Stephen did not shoulder familial responsibility alongside his wife. In practical and emotional terms, he was a daily drain on her energies; her largest, most demanding and most difficult child. It was Julia alone who made it all work; she who held it together. So when the unthinkable happened and Julia Stephen died prematurely and unexpectedly at forty-nine of suspected rheumatic fever, Leslie and the family were uneasily aware that she might more really have died from exhaustion: 'no doubt her unsparing labours for us and for others had produced that weakness of the heart,'[68] Leslie admitted remorsefully. His favourite daughter Virginia was much less equivocal: 'His health was her fetish; she died of overwork easily at forty-nine: he found it very difficult to die of cancer at seventy-two.'[69] Whatever the cause or contributory factors, their mother was dead, the centre gave way and the young Stephen children were cast defenceless and half-formed into the world.

2

The Chrysalis is Broken

'Her death was the greatest disaster that could happen.'
Virginia Woolf, *Moments of Being*

JULIA STEPHEN DIED on 5 May 1895 in the marital double bed at
22 Hyde Park Gate. Her death came rapidly, easily and undramati-
cally. 'Hold yourself straight, my little Goat,'[1] were her last words to
Virginia; it was as if dying was no different in essence from living.
'There was scarcely any superfluity,'[2] Virginia had written and, just as
in life she had been undemonstrative, exacting and to the point, so in
death she concerned herself with the immediate problem of her
youngest daughter's deportment. It was preferable to facing the
quagmire of disorderly sentiment in contemplating her own tragically
unfinished business, her daughters' irremediable loss.

Virginia's powers of evocative description deserted her in her
memoirs of this fateful day. She recorded only the barest, most
oblique details. And Vanessa remained silent. Julia died without her
children being able to say goodbye. Escorted to her death bed in the
early morning by their half-brother George, the sisters met their
father stumbling grief-stricken from the room. The thirteen-year-old
Virginia instinctively put out her arms to him, but he brushed past and
she and Vanessa were led to their mother's bedside. They kissed her
still-warm cheek. A nurse was sobbing somewhere. The sun was just
coming up.

The nature of this disaster was manifold and only revealed fully
during her daughters' lifetimes. The first and most pronounced effect
was the shattering of their daily family life. And truly it seemed in
those first dark weeks that 'everything had come to an end.'[3] Suddenly
the family became public property. A phalanx of female relations with
too much time and little-used lives descended on 22 Hyde Park Gate
ready to luxuriate in the bereavement of the tragic Stephen family.
These aunts and cousins and various friends trooped through the front
door offering their weeping faces, pious condolences and inappro-

priate exhortations to the band of wan children. Doors were shut, windows closed, the heavy scent of cut flowers adding to the sense of stagnation and claustrophobia.

While the adults indulged in outpourings of sentiment, the heavy weight of mourning stifled and cramped the youngest children in an atmosphere of misery and constraint. Even the family's mourning writing paper was so overburdened with the broadest black bands that there was barely any room left for human communication. It was a time Vanessa and Virginia would always shrink from remembering.

Leslie Stephen had suffered 'a blow which shattered my life'[4] and was rapt with grief and morbid guilt. His anguish was self-centred, self-pitying and noisy. Behind closed doors and at meals in company his anchoritic groans made his children recoil. While Leslie Stephen wept and raved, his children were silent, confused and subdued. 'Made to act parts that we did not feel; to fumble for words that we did not know,'[5] they felt duty-bound to concern themselves with their father's recovery from a loss to which they were much the more vulnerable, and to support him through a tragedy they were themselves ill-equipped to endure.

Looking back at this time more than a decade later Virginia recalled 'the effect of death upon those that live is always strange, and often terrible in the havoc it makes with innocent desires.'[6] Leslie Stephen had been robbed of his beloved saintly wife whose central concern always had been his happiness and welfare. He had expected, with justification, for she was fourteen years his junior, to be cared for by her until death, but here he was, cruelly widowed for a second time. For a cranky and hypersensitive man in his sixties to be deprived of such uxorious love and support was indeed a tragedy.

However, his children – Vanessa the eldest still only fifteen, Thoby, Virginia thirteen and his youngest Adrian, a gangling and weedy eleven year old – were deprived prematurely and absolutely of the central, protective and directive force in their progression to maturity. Although one can marry another, one can never recover a lost mother nor the example and protection she affords on the precarious road to independence.

Virginia likened her fearfully defenceless state, and implicitly that of Vanessa, to the butterfly or moth which they had watched many times emerge from its chrysalis, with 'its sticky tremulous legs and antennae ... [it] waits beside the broken shell for a moment; damp, its wings still creased, its eyes dazzled; incapable of flight'.[7] Such

shell-less, flightless creatures were these two adolescent girls. They were stranded powerless between childhood and adulthood, their mother's bewildering and catastrophic death depriving them of familial security, on the one hand, and, on the other, the confidence and freedom to enter the world and learn to fly.

The tragedy of their loss found quite different expression in each sister. Vanessa, 'always the eldest', known for her practicality and good sense, became increasingly sensible and self-contained. More instinctive, less analytical and expressive than Virginia, she attempted to absorb her grief, to hide her deepest feelings behind an implacable quiescence. She, even more so than Virginia, was appalled by this sudden eclipse of the sun, the physical and spiritual blotting out of light. The drabness and darkness of their surroundings was unbearable to her painterly instinct; their shuttered lives and narrowed horizons, the weighty formality of mourning, left her spiritually stifled, visually bereft, gasping for light and air.

Faced with the maudlin sentiments of well-meaning cousins and aunts, she retreated still further into herself, making any spontaneous expression of grief increasingly unrealisable. Not only was the flood of her emotion denied its natural outlet, and thus dammed gathered in force, but also the initiation into womanhood that a good mother affords her daughter was snatched from Vanessa as she stood on the brink of life. Virginia, always so watchful, ever aware, appreciated the impact of this loss on her elder and vulnerable sister:

> Perhaps once or twice she looked steadily in the glass when no one was by and saw a face that excited her strangely; her being began to have a definite shape, a place in the world – what was it like? But her natural development, in which the artistic gift, so sensitive and yet so vigorous, would have asserted itself, was checked.[8]

Vanessa too, unlike Virginia, had always identified more closely with her mother and had little in common, little true sympathy, with her father. His self-absorbed grief, his histrionic outbursts of remorse, his hunger for female commiseration and absolution, Vanessa, in her unequivocal way, found repellent. Into old age she would shudder at mention of *The Mausoleum Book*, her father's memorial to his grief, which intriguingly she kept under her bed. Her heart turned stony in the face of his relentless emotional demands. She was to be paralysed always by demands for expressions of affection; Virginia was to

complain of it often as did Roger Fry too, to whom Vanessa replied: 'You say I'm not ordinarily polite to you and that I'm self-absorbed but it is only a kind of involuntary self-defence because I know I cant give what you want that makes it impossible to give what I want to give ... very often I am acutely conscious of your misery and simply cant help you.'[9]

Her father's anguish had been less mutable, his need more ravenous, his demands more ruthless, and Vanessa, still only a girl, learnt then the expedient but baleful lessons of passivity, silence and withdrawal. By detaching herself as much as she could during the subsequent months of misery, 'that awful underworld of emotional scenes & irritations & difficulties',[10] by seeking solace in her painting, Vanessa managed to survive, apparently intact.

Virginia, however, was much less uncompromising, much more equivocal in her response to her father. She understood him, she loved him and she revered him. He aroused the strongest feelings in her. But she despised too his overweening egotism and the domestic tyranny he was capable of exercising over his daughters, quite blind to their needs and suffering. Yet Virginia knew also how he could be 'the most lovable of men'; wise, sane, stimulating, thoroughly incorruptible, made so much to a large and noble plan. Ever since she had been a small child gazing up at him through her shock of hair, they had both recognised their intellectual and temperamental bond. After the death of her mother, in the midst of all that confusion, family grieving and emotional turmoil, she would return a book to him in his study and they would talk and Virginia remembered 'feeling soothed, stimulated, full of love for this unworldly, very distinguished, lonely man'.[11]

Being the second youngest, Virginia was more sheltered from the adults' demands and expectations than Vanessa. But she was more open to influence, more willing, more able to lift the carpet and examine the sweepings. There she found the painful disparity between the appearance of things and their reality, the hypocrisy of mourning which obscured and distorted her own and Vanessa's true feelings.

The tragedy of Julia's death was not so much her children's acute sense of loss and resultant unhappiness, but the 'conventions of sorrow' which made their mother's character become unreal to them. Her vivid individuality had evanesced into the mere stock paragon of Victorian female virtues, more an unattainable standard for her daughters than a comfort and resource. More than thirty years later,

Virginia was to write in *The Waves* of that cloying sentimentality which robbed them of a chance to feel: 'Let us commit any blasphemy of laughter and criticism rather than exude this lily-sweet glue.'[12]

For Vanessa the heavily draped rooms, the proscription of colour and light was her punishment; for Virginia it was the silence. To this most honest and perceptive of persons, the obfuscation, hypocrisy and taboos were almost unendurable. This lack of clarity demanded the highest price, perhaps, in the area of her relationship with her Duckworth half-brothers. George and Gerald, the 'demi-gods and tyrants' of the sisters' childhood, were the heroes they looked up to and tried so hard to please. But George, more so than his younger brother, was to his half-sisters also that being 'possessed of knives':[13] minatory, erotic, ultimately destructive.

When Julia Stephen died George Duckworth was twenty-seven. Her death inspired an intensity of feeling in an already highly emotional young man; it removed a legitimate focus for his affections and removed too the moderating presence, the equilibrium of the family. George's emotions were vested passionately in his mother. He was her eldest son, her favourite, and a constant reminder of her first and greatest love, his father. He had become the natural provider to his mother of the lover-like qualities of selflessness and emotional extravagance, while Leslie Stephen, elderly, overworked, irascible and increasingly melancholic, played the demanding husband to the hilt.

Virginia recognised George's reluctance to marry and placed part of the reason at their mother's feet: 'The Duckworth temperament I believe likes these temperate ... relationships. Sisters and mothers but not wives.'[14] Wary of marriage yet burdened with an over-emotionalism that verged on the ridiculous, George had only his sisters to turn to now that his mother was gone. For the following nine years George continued to live at 22 Hyde Park Gate, unmarried and 'in complete chastity', until his marriage finally at the age of thirty-six. During that time his emotional and amatory needs were expressed largely within the family (apart from occasional erotic skirmishes with society hostesses of mature years) and his vulnerable half-sisters bore the brunt. Their attempts at voicing disagreement were met with embraces, 'Kiss me, kiss me, you beloved' was his cry. Virginia graphically explained the anxiety and emotional claustrophobia that underlined his years of familial despotism, 'One felt like an unfortunate minnow shut up in the same tank as an unwieldy and turbulent whale.'[15]

Most of his behaviour was undoubtedly well-intentioned and affectionate, if ill-judged. His overbearingness in matters of dress and social conduct was no worse than the majority of Victorian males would have exercised over the younger female members of their households. But on many occasions after their mother's death and until his marriage, George crossed, perhaps unwittingly, the point beyond which his caresses became over-intimate and his attentions repugnantly invasive to the young Stephen sisters.

There is no evidence as to how far George's erotic transgressions extended and it is worth remembering that Virginia and Vanessa were particularly reserved and reticent young women (Virginia recalled how they never kissed Thoby, much as they loved him, rarely touched him, and never talked of personal matters). However, there is no doubt that what did transpire had a profound and disturbing effect on Virginia, an effect she maintained remained with her for life. Vanessa as always was less vocal, but she too was subject to unwanted caresses from her elder half-brother. While staying in a country house with him, she reported to Virginia: 'George embraced me and fondled me in front of the company – but that was only to be expected.'[16] It was as if by then, in 1904, something routine and tawdry rather than tempestuous; an embrace that lingered perhaps, a hand that habitually strayed.

Virginia, in a dazzling and acerbically funny memoir of George Duckworth, stated that he, in public the sainted brother and benefactor of the Stephen girls, was in private their lover too. This startling fact may owe its darkest meaning to justifiable artistic licence, coming as it did at the very end of the memoir of her life when she was about twenty and living at 22 Hyde Park Gate, and written as entertainment to be read out loud to her oldest and closest friends in 1920 or 1921. But, in much more intimate moments, in letters and conversations and entries in her diary, where she was straightforward and truthful, she consistently maintained that her relationship with 'my incestuous brother'[17] was long-standing in its irregularity and far-reaching in its damage. She related to Vanessa a conversation with her old Greek teacher Janet Case:

She has a calm interest in copulation ... and this led us to the revelation of all George's malefactions. To my surprise, she has always had an intense dislike of him; and used to say 'Whew – you nasty creature', when he came in and began fondling me over my

Greek. When I got to the bedroom scenes, she dropped her lace, and gasped like a benevolent gudgeon. By bedtime she said she was feeling quite sick.[18]

The bedroom scenes which made Miss Case gasp were described by Virginia in the above-mentioned memoir. In a piece whose tone is glitteringly sardonic, the simplicity of these few lines, the menace (and guilt) implicit in the phrase, 'And don't turn on the light,' evoked forcefully her sense of being trapped by someone more powerful than she:

Sleep had almost come to me. The room was dark. The house silent. Then, creaking stealthily, the door opened; treading gingerly, someone entered. 'Who?' I cried. 'Don't be frightened,' George whispered. 'And don't turn on the light, oh beloved. Beloved—' and he flung himself on the bed and took me in his arms.[19]

But there was, perhaps, some ambivalence too, a confusion of emotion which spread its poison of guilt and unworthiness right through Virginia's life. She was a motherless girl, always hungry for love, with a finely sensitive, sensual side which craved 'pettings' that Vanessa was required to supply. Perhaps George's embraces aroused some reciprocal and shadowy desire in her and her body's betrayal seemed to her damnable and shaming. From the earliest incident, when she was a child and Gerald the younger of her half-brothers explored her private parts, she recognised the confusion of feeling. Virginia herself suggested this incident as a possible reason for her shame and fear of her own body, her life-long hatred of looking-glasses, her vivid memory of the horrible animal face reflected behind her own in the mirror in the hall at Talland House (was it illusion, fact or dream? she wondered), where once Gerald had subjected her to this sexual interference.

This powerful sense of shame and helplessness was reinforced in her during her adolescence and early womanhood by George's illicit desires; George whom she blamed subsequently for her earliest breakdowns, George whom she also loved and admired and longed so pathetically to please, who roused in her the most intense confusion of emotion. Decades later, in her despair just days before she took her own life, Virginia was talking about him still, haunted by him she said, the half-brother whom, her doctor friend Octavia

Wilberforce reported, she had 'evidently adored'.[20]

And so in the great shuttered house where the Stephen and Duckworth families were enclosed in mourning, Vanessa and Virginia were drawn into an even closer alliance. To Vanessa alone Virginia could confide some, perhaps all, of 'George's malefactions'. Vanessa was to be less susceptible than she was to emotional pressure, less affectionate, less greedy for love, and therefore more resilient to George's manipulation.

Vanessa thus became her younger sister's confidante and her comforter as far as she was able. There was little doubt that the girls were thoroughly disturbed and threatened by George's behaviour, so much so that on Virginia's breakdown after her father's death Vanessa, young and shy as she was then, felt compelled to broach, to Virginia's specialist Dr Savage, the extraordinarily difficult subject of George's indecent behaviour. He must have thought it extreme enough to raise with George, who excused himself by saying he was merely comforting Virginia during their father's illness. Perhaps that satisfied Dr Savage; after all, were they not both men of the world and Vanessa and Virginia mere innocent girls who were quite likely to have got things wrong? At the very least, however, Vanessa had broken the sisters' long-enforced silence on the matter, impelled by Virginia's desperate mental state and her own acute anxiety for her at the time.

During the confusion and misery of mourning their mother's death, one person within the family brought back some normality, some sense of continuity, something of the maternal power of healing. Stella Duckworth heroically stifled her own anguish and stepped into the gaping breach. Vanessa and Virginia recognised the trials and sacrifices involved for their beautiful, suffering, half-sister and extended their gratitude and devotion to her. It was Vanessa particularly who was drawn to Stella's side, and it was natural that Stella should turn to her increasingly for companionship and support.

Stella Duckworth shared Vanessa's birthday but was ten years older. A common birthday, the difference in age, Stella's position as the only girl in the Duckworth family, Vanessa's as the eldest of the Stephens; all would have prepared the ground for an affinity between them, an idolisation of the elder by the younger. But Stella's heart and mind had long been fixed exclusively on her mother. The only Duckworth daughter, she had borne the brunt of her mother's desert years of widowhood when Julia had insisted 'that death would be the

greatest boon that could be bestowed upon her.'[21] From the time when Stella was one year old, until Julia's second marriage, when she was nearly ten, the little girl lived in closest intimacy with a mother who had become indifferent to life.

Not surprisingly Stella came to exhibit the most exquisite sensitivity to the needs of others. 'She possessed one of those beautiful feminine natures which are quite without wishes of their own,'[22] Virginia noted with gentle irony. Stella's every thought and feeling was for her mother. She became preoccupied with Julia, identifying so strongly with her – but as her inferior, her shadow – that the individuation of her own self seemed not fully to have been completed. While her mother had lived she showed no interest in marriage. She found physical separation from her traumatic, and paled visibly and grew anxious at the contemplation of a journey away. Enduring the ultimate separation with the advent of Julia's death, Stella grew increasingly pallid and ghostly. In fact, Vanessa was to believe always that Stella's death, two years later, was due to the fact that she could not face life without her mother. Meanwhile, she accepted her duties as surrogate wife and mother with fortitude and unswerving self-sacrifice. The only thing, perhaps, that kept Stella anchored, however precariously, to life was her conscientiousness and care for others. Her aged step-father needed her so patently, her young half-sisters and half-brothers were pathetic and mute.

Her sensitivity towards her younger half-sisters' needs during the misery of the days following their mother's death revealed an extra-ordinary and touching sensibility. Virginia, on being taken by Stella to kiss her mother for the last time, had recoiled at the incongruous hardness and granular cold of her skin and 'when Stella asked me to forgive her for having given me that shock, I cried ... and said, "when I see mother, I see a man sitting with her."' Virginia realised her words had frightened Stella momentarily, but rather than any remonstrance or denial Stella said simply, after a moment's pause in which perhaps she thought of her own long-dead father, 'It's nice that she shouldn't be alone,'[23] thus offering the child the most graceful acceptance, the most consoling explanation of her vision.

So Stella naturally and without question took up where her mother had left off. The greatest of her burdens, as had been her mother's, was Leslie Stephen himself. Regardless of her own shattered being, she sat cloistered with him for hours on end, hearing the agonised confessions of his failings as a husband and reassuring him time and again that he

had not been as neglectful and as grossly egotistical as had Thomas Carlyle. The spectre of Carlyle's insensitivity to his own remarkable wife, Jane, rose in Leslie Stephen's darkest hours to torment him with inescapable comparisons.

Stella's ready sympathies and assurances were called daily to his aid and sometimes against all her own instincts; she, with more concern than Leslie, had watched her mother grow increasingly harried and careworn. Leslie acknowledged her heroic efforts in *The Mausoleum Book*: 'You my darling Stella, have helped me more than anyone ... in grief like mine a woman can do more ... can give me all the comfort of which I am susceptible.'[24] But his own daughters seethed inwardly at the monstrous emotional demands he made on his womenfolk. His greed for female sympathy and blindness to his own tyranny, Virginia laid at the door of his mother who had indulged and spoiled him, and of his wife who had devotedly sacrificed everybody else's needs to his, giving her life in the process.

The young sisters thus accepted with relief that Stella was prepared to become the central, organisational, maternal presence in the household; albeit a softer and more pallid version of their mother. They accompanied her on errands and social visits, occasionally joining her in visiting the poor and needy. She dealt with all the household arrangements and with Vanessa's and Virginia's social and educational needs, their clothing necessities and menstrual inconveniences (Stella's 1896 diary noted their periods as well as her own and it is highly likely that Virginia's menarche occurred in the October of the year following her mother's death). All this increased the young sisters' intimacy with her, their affection and protectiveness of her; 'we tried to prove ourselves equal companions for Stella and our lives were much quickened by the chivalrous devotion she aroused in us.'[25]

Virginia noticed that it was Vanessa alone of all the members of that household who could offer most to Stella, precisely because she asked nothing of her; Vanessa was already well practised in the womanly virtue of caring for others before oneself. Stella too, she surmised, saw in Vanessa a striking similarity to their mother and so derived some consolation in contemplating the continuity of her unique qualities.

Stella's efforts at reinstating everyday family life allowed Vanessa and Virginia to emerge from the morbid stasis that had threatened to engulf them. Indeed, in the summer of 1895, in the immediate aftermath of their mother's death, Virginia, suffering a breakdown of sorts, had been submerged temporarily in the swamp of family

hypocrisy, distorted emotion, subtle tyrannies and unnatural silence. Her collapse manifested itself in a racing pulse, over-excitation followed by extreme depression and an acute embarrassment on meeting people. Knowing as little as we do about this first episode of instability, it could be argued that it was nothing more than a particularly receptive young woman's understandable response to the extraordinary stresses of her mother's death and all that messily followed, concurring with the natural emotional disturbance and exaggerated self-consciousness which can accompany the onset of puberty.

Although the most feminine of women, Virginia all her life was to be troubled by her own fugitive sexual identity; 'Poor Billy [Virginia] isn't one thing or the other, not a man nor a woman, so what's he to do?'[26] she wrote plaintively to Vanessa when she was a 45-year-old woman. As a girl of only fourteen, having already endured the loss of her mother and the ensuing emotional turmoil, Virginia was faced by the inescapable evidence of her body – with menstruation as the flag – that the refuge of childhood was gone and her fate as a woman was marriage and motherhood.

There was no mistaking the message, particularly to the daughters of a Victorian, particularly to the daughters of Julia Stephen who believed so devoutly that girls must be changed into married women. In fact not to expedite such a change was to be a negligent mother, for only women who married and married well ensured any life for themselves, any security, any status or even place, in society. 'An unmarried woman has missed the best of life,' was not only Mrs Ramsay's (and Mrs Stephen's) personal conviction, but a wider social truth.

So Virginia's puberty threatened her with a future of limited choices and made the most private processes of an already modest and shy young woman open to public scrutiny. Growing breasts could not be camouflaged easily in clothes designed to enhance the voluptuous bosom and hips of women and menstruation was treated as a debilitating monthly curse. Both Vanessa and Virginia retired to bed at its onset for various lengths of time, Virginia for the first day of her period, Vanessa sometimes for more than a day. This invalidism interrupted social activities and disrupted work, thus enhancing the sense of biology's tyranny over women and their emotional and physiological frailty in the face of men's active lives and reliable constitutions. But above all, this cyclical withdrawal meant that the

menstruating girl was denied privacy. By being bedridden, if only for a day, it was advertised to servants, fathers, brothers and, in Vanessa's and Virginia's case, half-brothers too, the precise functions of her changing body; her inevitable emergence into sexual maturity. Virginia admitted in her forties that for ten years of her life she had made sanitary towels out of kapok rather than have to ask a shop-girl for them, and admit, 'I too am a woman.'[27]

A young woman's adolescence is a time of excitement and fear, in varying degree, as she attracts the increased attentions of men. In *The Years*, Virginia described an episode of male exhibitionism, commonplace enough, perhaps experienced by her as a child, but used in her novel to emphasise how such sexual aggression intimidates and restricts the freedom of girls, how it invades the thoughts, impels silences and deceit, and weights with guilt:

> The lamps stood at great distances apart, and there were pools of darkness between. She began to trot. Suddenly, as she passed the lamp-post, she saw the man again. He was leaning with his back against the lamp-post, and the light from the gas lamp flickered over his face. As she passed he sucked his lips in and out. He made a mewing noise. But he did not stretch his hand out at her; they were unbuttoning his clothes.[28]

For Vanessa and Virginia these prurient men were not only strangers in the street and acquaintances at social events, they were also within their intimate circle, living alongside them in the home. Closing the front door could not provide the necessary refuge. For these sisters not even their bedrooms were a sanctuary as both girls perhaps, and Virginia certainly, endured the night-time visits of half-brother George.

So the tragedy of their mother's death and the resultant emotional pressures of a mourning Victorian family, complicated by the turbulent presence and demands of half-brothers and a peculiarly self-centred and overwrought father, were combined with their own emergence into womanhood. These were the forces to which Virginia and Vanessa were subject and they took their individual toll. Vanessa, for the time being, closed her eyes and contained them, filling as best she could the role of eldest and most sensible Stephen. Virginia, on the other hand, her eyes wide open, perhaps could not accommodate them and expressed the conflict in collapse: 'I believe these

illnesses are in my case ... partly mystical. Something happens in my mind. It refuses to go on registering impressions. It shuts itself up.'[29] Certainly after Virginia's second and most serious breakdown in 1904, following her father's long illness and death, she laid blame unequivocally at the door of the family 'tangled and matted with emotion'.[30] This first time surely her diagnosis could hold as true.

Virginia in her collapses would see herself sometimes as being half at sea, 'amphibious still, in bed and out of it'.[31] But Vanessa was undoubtedly a goddess of dry land and her fidelity and clarity of vision was the beacon which led her younger sister to shore. 'Where should I have been if it hadn't been for you, when Hyde Park Gate was at its worst?'[32] was Virginia's astonished cry.

In this first collapse, the family's doctor Dr Seton thought Virginia's state serious enough to order a cessation of lessons and at least four hours of outdoor activity every day. Given the vagaries of the English climate, his prescription must have been a measure of her physical robustness at the very least. This breakdown (or possibly no more than an unhappy exaggeration of her usual susceptibility) was the first obvious indication to Vanessa that her younger sister might react more acutely to emotional pressure and crisis, that the particular sensibility, intelligence and imaginative brilliance that so delighted her family and friends would occasionally show its darker side.

Mood fluctuations, extreme nervousness and irritability, exaggerated self-consciousness, lack of interest in food, all these and worse to come were the symptoms for which Vanessa had to learn to be vigilant. Maternal from the moment in the nursery when she realised that there were younger, more vulnerable beings than herself, she was propelled into premature maturity. Considered always to be so sensible and sane, she was edged further into self-containment and dispassion. But the emotions were there, more securely constrained than her younger sister's, less readily acknowledged and expressed; Virginia recognised this hidden force with some awe, 'she has volcanoes underneath her sedate manner,'[33] she pointed out to their half-brother George.

Vanessa's natural imperturbability was heightened by Virginia's natural expressiveness, in the inevitable poise and counterpoise of any such close relationship; while Virginia was leaving the ground, Vanessa had to root herself even more firmly to earth. It was the maintenance of familial equilibrium at which their mother had excelled; deftly smoothing, anxiously anticipating, delicately compen-

sating. It was a balancing act which, through the intimacy of her relationship with Virginia, fell to Vanessa far too early in life. Before she had a chance to ask something special for herself, to speculate and indulge in youth's pardonable follies, she was forced to be sane, sensible and controlled.

> If her mother had lived, [Virginia wrote] it is easy to imagine how Vanessa questing about her, like some active dog, would have tried one experiment after another arguing, painting, making friends, disproving fallacies, much to her mother's amusement; she would have delighted in her daughter's spirit and adventures, mourned her lack of practical wisdom and laughed at her failures, and rejoiced in her sense. But that is one of the things, which though they must have happened, yet, incredible though it seems, never did happen, death making an end of all these exquisite preparations.[34]

So Stella, as the pale brave image of their mother, became central to their lives. She touched their hearts with her pathetic stoicism, hiding her tears, denying to her younger sisters her suffering, 'as though she did not imagine one could understand'.[35] But the months passed and Stella's etiolated beauty began to gain colour and life under the ministrations of her dogged suitor, John Waller (Jack) Hills. Vanessa and Virginia, so vulnerable themselves to the slightest intimation of hope in the future, of happiness regained, became enmeshed sympathetically in the progress of their courtship.

Jack Hills was an unremarkable young man who, in his persistent and so far unsuccessful wooing of Stella, had become a regular and favourite visitor of the young Stephen family. His practical good sense, his knowledge of bicycles, dogs and bug-hunting, his transparent honesty and candour commended him to Virginia, and particularly so to Vanessa, and seemed to compensate fully for his lack of more romantic qualities. Perhaps Stella grew to appreciate this too, for the girls noticed how he came to be a constant in her life. Certainly Jack Hills was the first person to put her needs and her happiness above all considerations and to offer her the devotion she had shown so selflessly to others.

Virginia recalled vividly the night of the final successful proposal that summer in 1896. In the evening, while Stella and Jack walked in the garden of their borrowed summer house, Hindhead House in Haslemere, the Stephen children, sent to bed by their father, could not

sleep and huddled together, as Virginia remembered, 'cold, melancholy and strangely uncomfortable ... we felt a little frightened, for it was no ordinary night and ominous things were happening.'[36] Eventually Stella emerged out of the dark and came to tell them shyly that she was to marry Jack. This happy decision, Virginia felt, Vanessa had played a part in effecting, for her sympathetic support of Stella and her own evident maturity and practicality had freed the over-conscientious Stella from a self-denying sense of responsibility to her step-father and his family. Without too many qualms, Stella could hand over the charge to Vanessa.

After the initial congratulations and delight, the engagement stirred up a variety of emotions in the family. Leslie Stephen's better nature was in conflict with his worst self and was more often than not the loser: he moaned and groaned; his loss was irreparable; his happiness was a matter of rapidly diminishing importance; his 'pocket had been picked'.[37] He was petulant, how much he disliked the name Jack: it sounded like the crack of a whip. This singularly intelligent and sensitive man, who recognised his own jealousy and selfishness in the matter, seemed complacent about these failings and quite oblivious to the tyrannies they exercised over Stella and his children. 'The last seven or eight months of the engagement have brought me a good many selfish pangs; but – well, I should be a brute if I really complained,'[38] he confided philosophically to *The Mausoleum Book*. And yet complain is what he did, in no uncertain terms and without stinting on self-pity.

Virginia observed Stella's brothers too doing a peculiar two-step, embracing her with kisses and then ensuring that the newly engaged couple should not be alone too often. George would dismiss Jack after dinner by insisting Stella should rest, or otherwise enforce the social proprieties aimed more at maintaining society's authority in the matter rather than protecting an unmarried woman's chastity. Virginia herself was equivocal. She did not relish change. 'Stella had united many things otherwise incompatible'[39] and the day-to-day normality of family life which had begun to return to 22 Hyde Park Gate under her regency was threatened by her marriage. Stella's patience and sympathy too had provided the necessary balm for Leslie Stephen's spirit, enough for him to begin to discover that his children at last were at an age when their companionship was rewarding.

The house still marked the boundaries of Virginia's life; she spent her day there reading, writing, working on her lessons. Anything that

affected it affected every aspect of her world, and Stella's allegiance to someone outside the family gave her some moments of unease. Virginia's unpublished 1897 diary showed her growing increasingly irritable as the wedding approached. On the eve of the ceremony she had resolved to make the best of things, 'Too much to do to be dismal, though the last evening was in danger of ending unhappily.'[40] Whatever her forebodings, however, as to the personal loss Stella's marriage might bring to her, Virginia could not help but be caught up in the general mood of ready emotion; the evidence of a renaissance through love. The young sisters saw that Jack had given Stella a hold on life that although fragile was transfiguring and 'miraculous to see'. 'It was beautiful; it was, once more, a flight of unfurled wings into the upper air'[41] was how Virginia expressed the intensity of feeling in herself, an adolescent girl.

Vanessa was less threatened by the marriage and most likely less ecstatic on the miraculous effects of love. She was, however, involved profoundly in Stella's happiness. For the months between their mother's death and Stella's marriage, she was her half-sister's closest companion. She painted with her, they cared for Virginia together, settled the unhappy Adrian into school and discussed her own coming out. Virginia believed that it was Vanessa's implicit encouragement and her evident capability which helped Stella decide to accept Jack Hills and trust in a future of her own. In her memoir of the time, Vanessa noted that Stella's self-sacrifice extended almost, but not quite, to refusing the man who had been in love with her for years; only 'much persuasion'[42] turned her from her self-denying course. Perhaps that persuasion was as effectively Vanessa's as Jack's.

But Vanessa, not only more closely concerned with Stella's point of view than Virginia, had also the inestimable advantage of an important life of her own away from the enclosed, emotionally demanding world of 22 Hyde Park Gate. From the end of April 1896 she had been attending Cope's School of Art in preparation for entrance to the Royal Academy Schools. Bicycling to South Kensington, long-skirted, large-hatted, Vanessa, like an escaped bird, flew through the streets, swooped round corners, navigating gusts of cross-wind which made her skirts flap and hat take off, to alight finally in the dusty quiet of the studio. This was her spiritual oasis. Here the only demands were aesthetic; all that need absorb her were the problems of line and space and colour, their very impersonality the greatest relief to her. And perhaps too her growing control over the medium was not only

satisfactory in its possibilities of creation, but reassuring in providing an arena in which she had power to direct and perfect, in a world of random suffering where otherwise she was powerless.

On 10 April 1897 Stella and Jack Hills were duly and ceremoniously married. Virginia in her diary was watchful, intensely curious and a little fearful of the transformation and implications of sexual love and marriage brought thus so intimately to her attention. Two days before the ceremony she noted that Jack was banished 'not to be allowed love till he is a married man'.[43] She felt the wedding day passed as if 'half a dream or nightmare'. She watched as Stella entered the church, 'walking in her sleep her eyes fixed straight in front of her – very white and beautiful',[44] appearing to her uneasy half-sister more like a sacrificial victim than a bride. Virginia was to echo this sentiment thirty years later when writing of Mrs Ramsay, the portrait of her mother in *To the Lighthouse*; she suggested how she wove a spell to make the young in her orbit want to marry, and then 'led her victims ... to the altar'.[45]

Her diary, written when she was fifteen, had no sense of joy or apprehension of Stella's happiness. Yet, her reminiscences of the engagement and marriage written in 1907 when Virginia was twenty-five, and then her memoir written more than thirty years later, conveyed a poignant and unforgettable sense of Stella's revivification through love, and her own and Vanessa's share in it, vicariously, covertly: ' "There's never been anything like it in the world," I said – or something like it – when she found me awake one night. And she laughed, tenderly, very gently, and kissed me and said, "oh lots of people are in love as we are. You and Nessa will be one day." '[46]

The naturally subjective account of her contemporary diary revealed a young girl, anxious, fearful, easily irritated, still under treatment and medication for the breakdown following her mother's death, questioning and apprehensive of the adult world. No doubt Vanessa, herself nearly eighteen at the time of Stella's marriage, felt some of this fascination and anxiety too as she watched a sister cross the divide into fully-fledged adulthood, her sexuality sanctioned publicly by Church and State. Certainly two days later both girls went to visit Kitty Maxse, a lively and sophisticated friend of the family, and let themselves go, 'screaming with laughter',[47] as perhaps an inevitable reaction to the mixed and powerful emotions of the previous weeks.

Stella's relationship with Jack Hills became a 'a standard of love' for the young Virginia and, one can imagine, for Vanessa too: 'My first

vision – so intense, so exciting, so rapturous was it that the word vision applies – my first vision then of love between man and woman.'[48] How shocking, therefore, how profound and far-reaching in their effect must have been the events which followed. Stella returned from her honeymoon pregnant and ominously ill.

Love, particularly sexual love, was seen by an already anxious Virginia as something dangerous, out of control, even life-threatening. When Vanessa and Virginia were children, 'mad' Jim Stephen had been besotted with Stella, and unpredictable and alarming in his expression of that passion. The young girls were exhorted by their mother to protect Stella from his attentions. Lust contaminated the streets, much as did the grotesque man exposing himself to Rose Pargiter in *The Years*, making it inadvisable for young girls to go out alone. Demands and desires, unacknowledged yet implicitly sexual, invaded their life at home too with their step-brothers. Now Jack's more orthodox and socially approved emotion had taken from them Stella, a perfectly healthy if not robust young woman, and brought her back impregnated and ailing with some terrible and mysterious disease which the doctors could neither diagnose nor cure.

This powerful idea of the nature and perils of sexual love was worked over by Virginia many times, often during – even causing – periods of great emotional crisis. In her first novel *The Voyage Out* her heroine Rachel Vinrace, who shared many characteristics with the youthful Virginia, finally evaded the problem by dying of a mysterious illness before this troublesome love between a man and a woman could be consummated. It was not too extravagant a surmise that to the young Virginia sex and death came to seem perilously intertwined.

Horror-struck and incapable of influential action, the sisters had to endure once more whatever fate was to deal them. Virginia's diary relating the events of those three months was pathetic and moving in its laconic constraint. It was a sweltering summer and Virginia herself was unwell and full of foreboding about the state of Stella's health. She resorted to sleeping with Vanessa for comfort, both girls living on their nerves, hope alternating with despair. Over all hung a sense of their own powerlessness, while others in positions of knowledge and influence procrastinated. They were left with the harrowing certainty that through incompetence Stella's life had been allowed to slip inexorably away.

Thursday 15 July [1897]: She came into me before breakfast in her

dressing gown to see how I was. She only stayed a moment; but then she was quite well. She left me, & I never saw her again. . . .

Saturday 17 July: I had not been out of bed yet; but Georgie lifted me up, wrapped in Stella's fur cape, she called out 'Goodbye' as I passed her door –

Monday 19 July: At 3 this morning Georgie and Nessa came to me, & told me that Stella was dead – That is all we have thought of since; & it is impossible to write of.[49]

Vanessa recalled in a later memoir but to equally telling effect, that 'after three months of what still seems to me a time of horrible suspense, muddle, mismanagement, hopeless fighting against the stupidity of those in power, she died at the age of 28.'[50] Stella was eventually diagnosed as having appendicitis which had developed fatally into peritonitis.

Both Vanessa and Virginia stated categorically that Stella's dying was a more catastrophic event in their young lives than even their mother's untimely death. In the long term, of course, the death of their mother was an irreparable loss; as Virginia saw it, 'a definite need, unbearably keen at moments, which was never to be satisfied'.[51] But the circumstances that surrounded Stella's death and the hopes that were riding on her renewed life and the healing power of love meant that to these surviving sisters this second death was doubly baleful in its effect. Vanessa recognised it as, 'the more appalling of the two tragedies which had wrecked our normally cheerful family life'.[52]

In an unpublished fragment of Virginia's the emotion was raw, the attempt to express and explain evocative, metaphorical:

Even if I were not fully conscious of what my mothers death meant, I had been for 2 years unconsciously absorbing it . . . the negative results – the hiding of society[?] of family, the glooms & morbid silences, the shut bedroom, the giving up of St Ives, the black clothes – all this had tuned my mind & made it apprehensive: made it I suppose unnaturally responsive to Stella's happiness & the promise it held for us and for her – when even more unbelievably, catastrophically – I remember saying to myself this impossible thing has happened; – as if it were unnatural, against the law, horrible, as a treachery, a betrayal, – the fact of death. The blow, the second blow of death, struck on me: tremulous, creased, sitting with my wings still stuck together in the broken crysalis.[53]

3

Us Two Against Them

'In that world of many men coming and going, we
formed our private nucleus.'
 Virginia Woolf, *Moments of Being*

WITH STELLA'S DEATH the second protective female influence was
removed from the family. Like many Victorian families the Stephen
family was hard on its women; having started off equally balanced,
five males, five females, poor Laura, then Julia herself and Stella had
all been lost to the family. Vanessa and Virginia were the last
remaining women, and at eighteen and fifteen barely women, in a
household of men. It could seem that love and marriage and service to
their menfolk had exhausted and finally destroyed the two most
important women in these young girls' lives.

With a terrible sense of dread Virginia watched Vanessa step into
that fatal office. There was a ghastly inevitability about her apparent
sacrifice. Indeed she had been bred for it. The irresistible weight of
Victorian society; of family tradition; of the peerless examples of
selfless womanhood provided by her mother and Stella; of her
father's and brothers' expectations: all propelled Vanessa uncom-
plaining, unquestioning, into place as head of the household and chief
provider of sympathy, succour and feminine wisdom. George and
Gerald had to be deferred to and mollified. Her father had to be
obeyed, humoured and supported. Her younger brothers were to be
organised and cared for. But of all these men in need, Jack Hills was
her immediate concern. His grief was terrible and dumbly demand-
ing; he came to the house most evenings for companionship and
consolation and it was to Vanessa increasingly that he turned.

The period from Stella's death until their father's death in 1904
marked 'the seven unhappy years'[1] which Virginia all her life shrank
from remembering. Vanessa was to wonder how they managed to
survive it: 'It seems almost too ghastly and unnatural now ever to have
existed . . . I hope no one will ever have to go through it again.'[2] They

were young women under seige from all quarters. The expectations and pressures of their family, and even the revered example of their dead mother, ran counter to a profound but unformed ulterior purpose in their lives, a different dream. Like Mrs Ramsay's daughters in *To the Lighthouse*, 'It was only in silence ... that her daughters ... could sport with infidel ideas which they had brewed for themselves of a life different from hers; in Paris, perhaps; a wider life; not always taking care of some man or other.'[3] But in the meantime Vanessa and Virginia could see no way to avoid their female destiny and, as the elder, the full weight of expectation fell on Vanessa.

And so in this household of needy, greedy men, Vanessa and Virginia formed a very close conspiracy. Virginia described it thus:

> We had an alliance that was so knit together that everything (with the exception of Jack perhaps) was seen from the same angle; and took its shape from our own vantage point. Very soon after Stella's death we saw life as a struggle to get some kind of standing place for ourselves We were always battling for that which was always being interfered with, muffled up, snatched away.[4]

Jack Hills was the exception and was the only subject on which the sisters could not wholeheartedly agree. As such, for a time, their divergence of views on their grief-stricken brother-in-law was the only flaw in that intimate bond. He was their first burden. Stella's death had devastated him in such a way that for a long time he was incapable of progressing beyond his grief. It was to be thirty-four years before he married again.

Vanessa and Virginia in their affection for Jack, in their naïvety and their own desolation offered him every emotional comfort they could, sitting with him, talking and, when words were inappropriate, sympathetically silent and suffering. Increasingly Jack turned to Vanessa rather than Virginia and she met his needs more faithfully, her affections at their most vulnerable. It was inevitable that in that household of confused miseries, irritation and suppression, of loss and lack of love, Vanessa and Jack should begin to feel that each could assuage their unhappiness in the other.

Virginia resented their growing intimacy partly because she was excluded necessarily from it, partly because she felt Jack took the wealth of sensitivity and feeling offered by Vanessa without appreciating the fineness of her character and the quality of her love. Most of

all perhaps, Virginia resented the growing bond because it was the one area in her own passionate relationship with her sister where she could not rely on Vanessa's complicity. They would walk together and discuss endlessly the unreasonable behaviour of other members of their family and plot how best to annex a little independence for themselves. But Virginia's protestations at Jack's demands and insensitivities produced a hurt withdrawal in Vanessa and 'an instant sense of treason'[5] in herself. Throughout her life she could not bear to be excluded in any way from Vanessa's life and became miserable and frightened on the few occasions when her matriarchal approval or affection was withdrawn.

The months of Jack's and Vanessa's increasing emotional involvement were a particularly confusing and unhappy time for Virginia. Her fears and resentments, however, were uncertain. Only when she was taken aside by George and actually asked to try and persuade Vanessa to see less of Jack (for this illicit love affair was embarrassing her half-brothers and providing the inquisitive aunts, especially Aunt Mary Fisher, with limitless scope for outrage) did Virginia realise how solidly she was on Vanessa's side in the matter. How she would always be on Vanessa's side; 'us two' against 'them'. Even their brother Thoby allied himself with convention and expected his sisters to obey George, serve Father, be kind and polite to Aunt Mary, despite her own deplorable interference; altogether to act their parts and know their place.

How isolated these young women were with no one to protect them from the full weight of family duty, with no one to encourage or validate their 'infidel ideas'. How lacking was even the most basic sympathetic understanding and consolation. A daughter's longing for lost maternal comfort was expressed poignantly by Virginia, at this time, when she wrote to their family friend Violet Dickinson about the emotions that a statue of Venus (probably de Milo) aroused in her: 'I weep tears of tenderness to think of that great heart of pity for Sparroy [a pet name for herself] locked up in stone – never to throw her arms around me – as she would, if only she could.'[6] The poignancy may have owed something to the sense that, even while she lived, a part of her own mother's heart was locked in stone, inaccessible to her daughters. It is likely that she, while not necessarily approving their incipient rebellion, would have sympathised and understood, chafing as she had done at times within the burdensome confines of her official domestic life. Julia Stephen had insisted too, as would her daughters

after her, on her own vocation – albeit nursing and therefore one of service – of work, nevertheless, that belonged to her alone, where she could operate unencumbered by social or familial duties.

Amongst the living, however, the embryonic painter in Vanessa and the writer in Virginia found little encouragement and no recognition of their ambitions. Virginia found her father, for all their intellectual affinity, a demoralising influence on her work and on her serious intent to be a writer. He was ambivalent about women and education. In theory he deplored their ill-educated state, yet instinctively felt that conspicuous intelligence and opinions ill became their sex – very much like Mr Ramsay in *To the Lighthouse*, Virginia's avowed portrait of her father, in whose company the young woman Minta Doyle purposefully appears stupid because she knows he finds her more attractive as a woman if he can also think her a fool.

Somehow Leslie Stephen had communicated to his perceptive daughter that a woman could not be truly womanly when the hard edge of her intellect was in any way explicit, let alone advertised to the world. To him, as to Mr Ramsay, a woman's greatest role was as supreme comforter and complement to her husband; as Virginia was to point out so memorably some twenty-five years later in *A Room of One's Own*: 'Women have served all these centuries as looking-glasses possessing the magic and delicious power of reflecting the figure of man at twice its natural size.'[7] No wonder men like her father, so dependent on that miraculous power, should be uneasy at the rearing of female discernment and intellectual autonomy.

In *Three Guineas*, written with anger and passion forty years later, Virginia inveighed against the limiting education of women of her generation and class and the consequently limited hopes and influence of their lives. Her examples reflected the pressures that weighed upon her and Vanessa, and against which they had to struggle:

It was with a view to marriage that her mind was taught. It was with a view to marriage that she tinkled on the piano, but was not allowed to join an orchestra; sketched innocent domestic scenes, but was not allowed to study from the nude; read this book, but was not allowed to read that, charmed and talked. It was with a view to marriage that her body was educated; a maid was provided for her; that the streets were shut to her; that the fields were shut to her; that solitude was denied her – all this was enforced upon her in order that she might preserve her body intact for her husband. In

short, the thought of marriage influenced what she said, what she thought, what she did. How could it be otherwise? Marriage was the only profession open to her.[8]

While her father lived and George had effective authority over the family, Virginia saw herself and Vanessa as secret revolutionaries, plotting their futures, planning small incursions into family life to win a little more privacy or freedom. Always, she would hide her writing if someone other than Vanessa entered the room. Vanessa was as secretive and wary with her art. Their thoughts and plans were subversive: their activities were as solitary and clandestine as if they were vices.

Vanessa at least could enjoy a form of apprenticeship, learning the rudiments of her art at Cope's School, amongst other young women, and later at the Academy Schools. But back at home in 22 Hyde Park Gate she spoke to no one except Virginia of her work and her progress. Even when she won a prize for her drawing she could not bring herself to tell the family. The news was related haltingly to Virginia – ' "They've given me the thing – I don't know why." " What thing?" "O they say I've won it – the book – the prize you know." '[9] – and Virginia, already established as the great communicator, was expected to take the news, properly embellished no doubt with detail and appropriate drama, to the family at large.

Similarly, when Vanessa passed into the Academy Schools along with only a few of her companions, the news again was related to her father by Virginia. Vanessa's inarticulacy, her silence about her art, the most important, most engrossing element in her life, was due partly, as Virginia claimed, to her sensitivity to her family's lack of interest, their lack of artistic tradition; 'Her views did not agree with those current around her, and she feared to give pain.'[10] But it was also an expression of her own lack of confidence in her skill with words in an area in which Virginia's dazzling facility from her earliest youth could be quite intimidating. She meant the family to know about the prize but she preferred the news to be communicated with her younger sister's silver tongue.

Vanessa was to find it difficult always to talk of the things that mattered most to her, the feelings that were most intense. Neither could she make easy conversation with strangers, and so became known for her reticence and silence. This made her entry into society a particular ordeal for her and a particular frustration for her half-

brother George, who offered to launch her on the world. She was so beautiful she should by rights enjoy a scintillating season, quite naturally crowned by an engagement to the scion of some noble family. But George had overestimated Vanessa's social charms and underestimated her strength of character.

George ordered from the brilliant dressmaker Mrs Young an evening dress for Vanessa, a confection of filmy white and black silk sparkling with sequins which fulfilled the conventions of mourning yet contrived to be exquisitely pretty and becoming. Dressed in this work of art (much loved by Vanessa despite the miseries with which it would always be associated), adorned with the fashionable jewels George had bought her, her hair pinned up, sculpted into graceful waves and folds, for a time at least, the eighteen-year-old Vanessa looked indeed ravishing. But on closer inspection, as George hustled her out to the waiting carriage, her expression may have seemed rather sullen, her full lips disinclined to smile, her eyes dreamy and vacant and her brow decidedly furrowed. George was not acute enough to realise what Virginia had always known: 'Underneath the necklaces and the enamel butterflies was one passionate desire – for paint and turpentine, for turpentine and paint.'[11] And belying the calm and reasonable beauty, volcanic emotions were held resolutely in check.

Vanessa, in retrospect, accepted that it was perfectly reasonable and even wise for George to want to rescue her, a young woman on the threshold of life, from the gloom of 22 Hyde Park Gate, where night after night the two sisters would sit on the sofa, their father in his favourite chair, all reading silently by the light of a lamp until bedtime. It would have been negligent indeed if Vanessa, and then Virginia in her turn, were not introduced to other appropriate young people and influential older ones. Society, the dances, the At Homes and weekend house parties existed for this purpose. George busied himself as chaperone and sponsor of his lovely, motherless half-sisters, soliciting invitations for the pair of them. Vanessa at first went docilely and with some anticipation. The first few dances she attended, in 1897, her eighteenth year, were enjoyable enough. She was neither oblivious of her beauty nor immune to the excitement of brilliantly lit drawing-rooms and their bespangled occupants, nor indeed to the interest and appreciation her own person must have aroused in others. But when the social round began again after Stella's death and the family's initial period of mourning, the dances and dinner parties increasingly became an ordeal for her.

George Duckworth's circle of friends was a dull one, largely political with a sprinkling of elderly grand hostesses. This formal, facile society proved a most bizarre contrast to Vanessa's shuttered life at home and even the refreshingly impersonal and workmanlike industry of Cope's School. 'One had been living in such a different emotional world. It was not easy to turn from the horrors of illness, death and long conversations about the dead and the past to the cheerful society of Booths and Pollocks,'[12] she recalled in her even-keeled way. But most inhibiting of all perhaps was Vanessa's own sense of social inadequacy, largely due to her inability to converse lightly and amusingly on a catholic range of subjects, a result largely of temperament, natural disinclination, social inexperience and a very sketchy education which had resulted in large tracts of wilderness and unexpected pitfalls in the land of general knowledge.

Virginia, and subsequently their adult friends, were to consider Vanessa's incomplete mastery of facts and phrases an endearing and idiosyncratic part of her character. Her mixed metaphors, such as, 'There's a dark horse in every cupboard,' undoubtedly had their charms, as does, 'It's a long worm that has no turning.' To such a shy and inexperienced young woman, however, when faced with the demands of formal social intercourse this lack of facility was dumbfounding. On one painful occasion she sat through the whole of one evening without saying a word to anyone. Such endurance excited Virginia's admiration, pity, and fear for herself of what lay ahead.

During an important and much dreaded weekend party at the Chamberlains' which George, using cajolery and downright emotional menaces, had insisted she attended with him, Vanessa's only moment of conversational ease came when she discovered she could talk to Neville Chamberlain, who was only ten years her senior and shared her interest in moths. There was more to interest Vanessa in the objects of the house than in the alarming and demanding inhabitants. She was delighted to see many of the best paintings from the annual Royal Academy Summer Exhibitions hanging on the walls of the stairwell gallery. She liked the exotic opulence of the place, the palms growing indoors and the orchid houses. Nevertheless, when Monday morning arrived at last and she could be released, not even George's damning praise (her dresses had been admired but her hair was a mess) could mar her relief.

Virginia stayed awake at night reading by candlelight waiting for her sister's return from dances and soirées. She listened with excite-

ment mixed with alarm to the stories Vanessa had to tell: dinners that lasted for hours and marooned her in a sea of silence with a strange young man on either side; dances where everybody seemed to know everybody else except oneself; continual embarrassments of dress, where hair threatened to become unpinned, skirts unhitched and undergarments slip unceremoniously to the floor. Only with their talisman of a Mrs Young dress, so well-made, so becoming and unfortunately almost too expensive for the Stephen sisters' meagre allowances, could that particular source of anxiety be allayed. 'If only I had Mrs Young at my back ... I could face them all,'[13] Vanessa once wrote to Virginia, having arrived at a grand house party minus her luggage.

The constraints of dress and decorum caused both Vanessa and Virginia much misery and an underlying uneasiness that would dog them all their days. It was peculiarly intense at this time when the sisters were groping towards womanhood, with no sympathetic older woman as guardian and guide and only George as arbiter of social behaviour, a man crushingly conventional in his own aspirations and insensitive to his protegées' fragile self-esteem. He would inspect them in their evening dresses with a critical and unsparing eye. Like fillies turned into the ring, they were subject to his searching, impersonal gaze and rarely felt they had properly pleased him.

Virginia in an ingenious and thrifty moment had thought it a good idea to have a dress made up in green furnishing fabric. When the time came to present herself and the dress to George, she knew immediately she had sinned not only against some aesthetic standard of his but, more crucially and imponderably, against the whole moral and social order that he existed to uphold; 'I stood there, conscious of these criticisms; and conscious too of fear, of shame and of despair – "Go and tear it up," he said at last.'[14] The unorthodoxy of Virginia's dress was taken personally as a mockery, a criticism of himself and the social code by which he lived. He sulked throughout dinner and Virginia, unnerved, never wore the offending dress again in George's company.

His cold criticism and displeasure were to contribute markedly to both sisters' sense of social failure. They felt merely spectators of the glittering game with its esoteric rules and inestimable rewards, while others, like George, seemed so well equipped to play. This strong and distressing sense of being outsiders was, perhaps, an active if unconscious motive for the later exclusivity of their own Bloomsbury

circle, which in later years developed in Vanessa into a kind of xenophobia, especially towards women whom other intimates at various times wished included. To preside over a small social group with yourself and your sister as the nucleus was to create the ultimate security, to nullify the ultimate fear of rejection and not-belonging.

But while they had yet to create a society of their own, Vanessa and Virginia, on the brink of adulthood, hated being social failures and longed, for a time at least, to be effortlessly successful at the centre of the party. In a memoir Vanessa remembered her happiness at waltzing sedately to the Blue Danube, 'knowing that I need not give a thought to my frock since it came from Mrs Young'.[15] With hindsight she agreed with George that there was a great deal of pleasure to be derived from society, that she was not naturally reclusive.

Virginia, even more so than Vanessa, yearned to belong. 'I went to *Two Dances* last week but I think Providence inscrutably decreed some other destiny for me ... I would give all my profound Greek to dance really well,'[16] she reported wistfully to her beloved friend Violet Dickinson. In her unpublished diary of 1903, she painted a picture of herself and Vanessa attending far fewer parties than their contemporaries and sitting through those they attended largely in silence with only each other to talk to.

It was at this time that Desmond MacCarthy caught sight of Vanessa at a dance and likened her to a Greek slave. One imagines he saw her beautiful and proud, yet humiliated; compliant, yet with a flare of defiance in her eyes. Those Greek-slave years for both sisters were merely an addition to the general sum of unhappiness. 'We always seem to be outsiders where everybody else is intimate,'[17] although Virginia realised this feeling, intense as it was, did not reflect entirely the facts. They were ill at ease, however, and tended to withdraw through shyness and a self-protectiveness which their experiences at home had inevitably enhanced. But ever curious and observant, Virginia watched and admired the young women who were adepts at the game: 'What does she talk about? I see her lips move – honey drops from between them apparently, but I know I shall never hear what she says – if I come by she is silent.'[18]

For Virginia herself had not always been so silent. When it was her turn to be presented in society, when George's determination to socialise Vanessa had had to concede finally to the greater force of her intractability, he turned his entrepreneurial eye to Virginia. Perhaps he could compensate for his failure with one sister by making a

spectacular success with the other. Virginia at first was game enough. She knew that Vanessa's weaknesses were her strengths: 'George had always complained of Vanessa's silence. I would prove that I could talk.'[19] However, Virginia's idea of talk (on one memorable occasion a fluent discourse on Plato's view of the value of expressing the emotions) left the company gasping and George's face congested with embarrassment. She was to learn painfully that a young unmarried girl of eighteen was not expected to utter anything more profound than charming responses to the polite conversational sallies of others and, occasionally, to offer an amusing and unprovocative comment of her own.

It seemed that in the society to which they were born, in the narrow segment confined to their sex, their beauty was wholly in order but their individuality decidedly was not. Vanessa's seriousness and silence was as unbecoming, as inappropriate and unfeminine, as Virginia's intellect and articulacy. Both sisters felt they could not evade the dismal verdict: 'The truth of it is, as we frequently tell each other, we are failures,' and, as Virginia wrote for them both, 'Really, we can't shine in society. I don't know how it's done. We aint popular – we sit in corners and look like mutes who are looking for a funeral.'[20]

And so in mutual failure, their conspiracy was further consolidated: commiserating with each other; reminding each other that there was another world where books and painting and philosophy were discussed; where young women were not so encumbered with appearance; where to have opinions and aspirations beyond marriage was not to be considered profane. Even if this world existed, however, Vanessa and Virginia had no access to it. Those 'seven unhappy years' were characterised by a terrible sense of being thwarted and constrained at every turn, their only hope a dream of their future, sustained by each for the other.

'The cruelty was that while we could see the future we were completely in the power of the past,'[21] and although their pasts would lay a claim always upon them, the immediate obstruction to that dreamed-of other life was their father, and to a lesser extent George with his dominion over them as practical head of the family. Leslie Stephen was a Victorian of the noblest and most uncompromising kind. He was untroubled by religious or philosophical doubt. Having cast his religious belief aside when a young man, he had not once looked back with nostalgia for its security, even on the deaths of two

much-loved wives. He could not conceive of a radically different way of life from the one he had known as a young man, or that his daughters might wish to experiment with the possibilities of a wider and looser way of living. And then the great difference in age between Leslie and his children widened further the emotional and philosophical gulf between them.

In 1901 when Queen Victoria died, Vanessa was twenty-two and Virginia only nineteen, both young women ready to join the new century, the new age. But they were leashed by a father of sixty-nine who, through loneliness, inflexibility and increasing deafness, seemed even older and out of reach. The old Queen, whose influence had extended over more than seven decades, was finally dead and the modern age was gleaming at last on the horizon. But at 22 Hyde Park Gate, Vanessa and Virginia felt they were forced to live submerged still in the 1860s, hung about with memories of the dead, weighed upon by their father's joyless presence and the excruciating conventionality of their half-brothers George and Gerald.

A typical day then for the Stephen family began with breakfast at 8.30 a.m. Adrian was the first to be seen off by his sisters, as he hurried, often late, to Westminster School. Thoby was already at Cambridge and out of their immediate care. Their father's breakfast was punctuated by his groaning and an exaggerated sense of his own pathos to which his children were well accustomed; if there were no letters 'then everyone has forgotten me,' if a bill he would roar and sigh and declare the family to be on the brink of ruin with only a small house in Wimbledon to keep them all from the poorhouse. George and Gerald would descend, immaculately dressed, George in frock coat and top hat for the Treasury and Gerald for business. Urbane and pleasant, George perhaps would engage Virginia in some gossip about the previous night's entertainment and Vanessa would disappear into the candlelit basement to talk to Sophy, the family's cook, about the day's meals. Then, with the younger men seen off to school and office and their father shut in his study at the top of the house, the sisters at last had the rest of the morning to themselves.

Vanessa, most days, cycled off to Cope's School and later, in 1901, to the Royal Academy Schools to immerse herself in the challenges of drawing from the life. Virginia would climb the stairs to her room, the old day nursery converted into a study one end and bedroom the other, to open her Greek books in preparation for her bi-weekly lesson. Her first tutor was Clara Pater, followed by Janet Case, who

was more rigorous and with whom she had a little of the sort of discursive intellectual discussion which gave her a taste of what her confined and limited education so sorely lacked. Writing to Thoby at Cambridge, she made her intellectual isolation poignantly clear: 'I don't get anybody to argue with me now, and feel the want. I have to delve from books, painfully and all alone, what you get every evening sitting over your fire and smoking your pipe with Strachey etc. No wonder my knowledge is but scant. There's nothing like talk as an educator I'm sure.'[22]

While Virginia felt so keenly the want of stimulating serious talk, Vanessa was only too relieved to be able to sit in silence in the studio and work totally absorbed in her composition. After the freedom of the morning, the pressure of society and family expectations would build up during the afternoon like a tropical-storm cloud, an inescapable daily endurance for those in its shadow. From four-thirty in the afternoon the air would become heavy; Vanessa and Virginia had to be home and ready to receive guests, mostly their father's, and elderly members of their own family for tea. Unwritten rules of conduct and demeanour were woven into this ceremony and Vanessa and Virginia, with their mother's incandescent example for ever in memory, had to contrive to steer their small, unpredictable party on a smooth and safe course, out of the shallows of conversational dearth and away from the lurking rocks of inappropriate comment. (For a guest to exclaim how well Leslie Stephen was looking was one such scupperer; never was sympathy to be diverted from him, and so his daughters had to soothe and dissemble to restore the equilibrium.)

They had to be vigilant too that their guests' feelings were not bruised. Virginia noticed that on Leslie Stephen's arrival at a gathering, his unfortunate hostess was likely to feel that a blight had descended on her carefully orchestrated gaieties. Not through any malignancy in the man but due rather to his naturally rapt silences, broken disconcertingly by uncompromising statements or sudden unselfconscious emissions of poetry, rib-shaking groans and chandelier-swaying sighs. As he grew older and deafer and more isolated from the company of others, his occasionally unflattering comments on people present and these self-pitying groans increased in volume, to everyone's dismay but his own. Alert and anxious, Vanessa and Virginia had to smooth and conceal; cakes were proffered, holidays enquired about, awkward moments glossed over with

flattery and cajolery. At last released from one duty, the sisters duly presented themselves for the next.

It was at night that the full oppressiveness of society fell on these reluctant, self-conscious young women. At seven-thirty, however cold and inhospitable the weather, Vanessa and Virginia had to undress to the waist and, standing in front of basins of water, scrub their necks and arms, the only parts of their bodies which their evening dresses would expose to view. Dressed appropriately, their fine straight hair manipulated into a passably tidy style, they presented themselves in the drawing-room for inspection.

During the Season, there were three or four parties a week to be attended and on those occasions after dinner, Vanessa and Virginia, with necks and arms clean, would put on the silken armour of their Mrs Young dresses and accompany George to some brilliantly-lit house where anticipation and fear contrived to speed the pulse, and attemps to dance and make acceptable small talk so often seemed to flounder. There was no room at all for the things that really interested them. Virginia found early on that to speak of ideas beyond the accepted subjects was to find one's flying feet suddenly stuck as if with glue and the conversation brought to an embarrassingly sticky end. The young Virginia had to content herself with observing, analysing and committing scenes to memory for future use.

Yet, the sisters' sense of being social failures would not have mattered so terribly if George had not made their social success some sort of metaphysical test of their fitness for life, of their moral calibre, even of the quality of their love for their dead mother and for Stella. This confused emotionalism with which George so readily managed to subdue his half-sisters did not mean he always had the upper hand. Both were in thrall to his authority, sanctified as it was by the shadow of their dead mother; it was his duty to do what she would have done and their duty to comply. Vanessa was quite capable of meeting his plans for her (and his) social advancement with straightforward opposition, much as in their childhood cricket matches she met the devious ball with her straight bat. But she was no match for George in strategic skills and downright trickery: invitations were accepted on her behalf and she was kept in ignorance until it was too late decently to demur; their relations and George's dowagers, taken into his confidence and informed of his grievances against Vanessa, predictably would inveigh against her ungrateful and unwomanly behaviour. Such mighty engines of war were rolled into place against

her and there was no chance that her opinion in the matter would be requested, let alone heard.

Virginia was more impressed and excited by the social world she was being asked to join: the romance of the intimate night illuminated brilliantly with lights – their own house was always so sombre and ill-lit – and the people who glittered in these circles. She was also more adaptable, more willing to please, altogether better equipped to cope with the demands of such society and suffered more acutely than Vanessa in her sense of social failure. But her dealings with George were less uncompromising than her sister's; she would co-operate with him so far but still take enormous pleasure in discomfiting him and showing her basic contempt for his facile values and intellectual second-ratedness. On the point of leaving one grand house, she realised with horror that somehow her drawers had come adrift from the general complement of underclothes and had collapsed to the floor. Scooping up the offending article in her skirts, she managed to hobble past her hostess and escape into the night, only to turn the incident to her account by flouncing into the drawing-room on her return to Hyde Park Gate and waving the drawers defiantly in George's face. She was flaunting her utter scorn for everything he held most dear; the suffusion of his face showed he recognised her pro-fanity.

There was a shady and disturbing area, however, in which her submission seemed total, as was her concomitant guilt and bitterness. The pressures on Vanessa and Virginia to present themselves for social acceptance or rejection, to conform to a feminine ideal towards which at the very least they were ambivalent, to submit to the authority of others at odds with their own tentatively emergent selves, did not always cease on their return home from a dance or an evening's entertainment. Virginia described in a memoir how on such a night perhaps, she would return home longing for bed and the oblivion of sleep. But the welcome relief from social pressures gave way to another more sinister claim. The creak of a floorboard, her bedroom door stealthily opened, George's whisper forbidding her the light, and then, in the shadowed dark, the weight of his body pressing upon her in her bed. The technicalities of what happened in the dark are not known, but it is clear that these episodes of 'George's malefactions' started sometime after their mother's death and continued, however occasionally, until their father died nearly nine years later. It is indisputable, however, that Virginia was haunted all her life by a sense

of oppression, powerlessness and guilt for which, she believed, this confused relationship with George was largely responsible. She ended her memoir with the startling claim that 'the old ladies of Kensington and Belgravia never knew that George Duckworth was not only father and mother, brother and sister to those poor Stephen girls; he was their lover also.'[23]

There was a nightmarish quality about the multifarious stresses and expectations which weighed in on Vanessa and Virginia at this time. The sense of being outsiders, out of step with the world and with no obvious way of entry into the sort of life for which they longed, clung to them like a veil: 'How strange it was to think that somewhere there was a world where people did not go to parties – where they perhaps discussed pictures – books – philosophy – but it was not our world.'[24] Vanessa, never one for hyperbole, confided to Virginia years later that she did not know how they ever survived those years of confusion and unhappiness, of emotional bullying and abuse. She wrote to Virginia nearly a decade later: 'I really think families are wicked institutions in spite of all your arguments in favour of them ... even in the most highly intelligent ones, like ours, many vices seem inevitable, at any rate in the commanding members of the family.'[25]

It was on the point of George's social aspirations that Leslie Stephen could have been of the utmost help to his daughters, for he did not care a fig for success of the kind that titillated George. But in his age, in his grief and self-pity, he had abdicated his emotional responsibility for his children. Half-reclining in the rocking-chair in his study, an island surrounded by open books, he still had the power to soothe Virginia by his very saneness and intellectually unsullied point of view. She still felt great flares of passion and gratitude towards him and passionate anger too at the blindness and egocentricity which could allow him to bully so shamefully his defenceless elder daughter over the weekly ordeal of the books.

On the death of Stella, Vanessa had accepted her place as the female head of the household. This meant taking on the accounts, just as her mother and half-sister had done before her. Leslie Stephen had an exaggerated and quite unjustified fear of penury and an abiding belief that he teetered on the verge of ruin. In fact, his current account rarely dropped below £3,000, a most adequate parachute and certainly more than enough to accommodate with ease the ebb and flow of domestic expenditure. But the system Vanessa inherited, which her father insisted she continue, consisted of account books where every penny

had to be entered in its appropriate column (not much could be fudged under the heading 'Sundries') and the sums had to tally exactly for each heading and for every quarter-year. To someone who had no natural aptitude for sums, who had never been taught properly any arithmetic, the time-consuming effort and agitation that the task produced was bad enough. But Vanessa had to present the results of these hours of numerical puzzling and juggling to her father every week and extract from him a cheque with which to pay the tradesmen.

Without fail this duty of Vanessa's was transformed into a ludicrous and unpleasant ordeal for both sisters. Leslie Stephen, on being presented with the laboriously completed accounts, would flush and shake and begin to bellow. His old fear of ruination stared him in the face; he railed at his hapless daughter that he was shooting Niagara to ruin (one of his favourite phrases) and upbraided her for a callous lack of feeling: 'And you stand there like a block of stone. Don't you pity me? Haven't you a word to say to me?',[26] Virginia recalled as an unexaggerated account of his 'brutal' treatment of her sister.

Faced with such an assault Vanessa retreated into impenetrable dumbness. In her wish to be reasonable in all things, she did not choose to blame her father in a memoir of that time, but coolly remarked, 'What an aggravating young woman I must have been! For my only way of dealing with the situation was silence. I simply waited until the cheque was signed, unable to think of anything to say, acutely unhappy and rather terrified.'[27] Vanessa's only real contact with her father after Stella's death was to be this Wednesday confrontation and her natural lack of sympathy towards him was turned into an obdurate antipathy which she was able neither to come to terms with nor to express.

Virginia, with her greater understanding and love of her father, could express in her writing her outrage and anger at his insensitive brutality – she did not equivocate – with which on these occasions he treated Vanessa. She was a spectator to his histrionic bullying and possibly, in that powerless position, suffered even more than the beloved sister she longed to save; 'Never have I felt such rage and such frustration. For not a word of my feeling could be expressed.' That terrible sense of impotence and unavailing fury was enhanced by the fact that her father could turn from his full-blooded belabouring of Vanessa to enquire of Virginia, with a note of pathetic supplication in his voice, 'And what are you doing this afternoon, Ginny?'[28]

Neither Vanessa nor Virginia could tell him of their anger at

such treatment; nor could they dismiss it even to themselves as unpleasant but inconsequential irrationality. Their relationship with him was far more formal and reverential than even the next generation's was to be with their fathers. They could not easily detach themselves from his behaviour or opinions, as successive generations might have done, by considering him so old and out of touch that such emotional excesses should be weathered and as far as possible ignored. These daughters were conditioned by society and had been encouraged by their mother to accept their father's absolute authority. Therefore they endured, unprotected, the domestic tyrant in him.

Vanessa, who always chose understatement, even silence, rather than melodramatic exaggeration, admitted this weekly ordeal aroused unhappiness and terror in her, an otherwise stalwart, self-possessed young woman of nearly twenty. Virginia's writing became incandescent with indignation at the memory of his verbal assaults, his 'barbarous violence'.[29] The effect these unprovoked and unavoidable explosions had on both sisters cannot be underestimated.

In Vanessa, her natural fair-mindedness and unloquacious character were crushed into inarticulacy and resignation. Always identifying more readily with her mother, she bowed her head and endured whatever excesses male authority would fling at her. Perhaps her inability to soothe Leslie Stephen, to handle him as skilfully as her mother had done, made her feel somehow lacking in womanly virtue, failing that ideal of femininity. No doubt the emotional tantrums and intimidation resorted to by Leslie Stephen were exacerbated by the sight of his obdurate daughter who stood so mute before him. Perhaps he interpreted her silent suffering as a reproach, much as her reflective, melancholic expression had been when she was a child. His behaviour continued to alienate the grown-up Vanessa until his death, which was for her an unmixed blessing, a deliverance at last into freedom.

Virginia, on the other hand, was plunged into an emotional maelstrom by her father's treatment of Vanessa, for she loved and admired both of them profoundly. She tried to analyse it, to understand it; how a civilised, highly intelligent and sensitive man could so abuse his power and authority. She had to conclude that he was unaware of the impact of his weekly browbeatings on his daughters, so lacking in subtlety or insight was his grasp of human character.

But Virginia was sickened to think that he only subjected women to

this terrorising, that if Thoby or George had presented the books she knew he would have been most reasonable and amenable. This, Virginia observed, was due to a number of factors, not least that throughout his life Leslie Stephen had been spoiled and pandered to by women. He was at heart a typical Victorian, believing woman was his servant. Just as servants might be allowed to see the dark side of their master's character, where the world saw only courtesy and reason, so Leslie Stephen, revered by his friends as the most mild-mannered and reasonable of men, practised no restraint before his womenfolk.

Virginia suggested too that the celebrated Cambridge education was so narrow, so concentrated on the intellect at the expense of the emotions and of temporal experience, that by the age of sixty-five whole areas of their father's human sensibility had shrivelled to dust. His apprehension of his own feelings and those of others was virtually non-existent and 'these violent displays of rage ... were sinister, blind, animal, savage. He did not realise what he did. No one could enlighten him. He suffered. We suffered. There was no possibility of communication. Vanessa stood silent. He shouted.'[30]

Even Thoby, handsome and heroic in stature, in character magnanimous, admired and adored by his sisters, even he sided with authority and the male point of view against Vanessa's and Virginia's tentative assertions of their own wishes. Of course it was perfectly reasonable of George to want them to accompany him to dances and dinners; of course Father's wishes and needs were to be attended to before their own; the various cousins and aunts (some of whom, Virginia swore, would have made paradise uninhabitable) had to be honoured and humoured and paid their due respect.

Thoby was to die tragically young and so our picture of him is hazy, incomplete and filtered through the rosy lenses of his friends and sisters. His few extant letters, written in a fluent hand, conjure the confidence and humorous urbanity of a young man who knew the world lay before him. Photographs of him corroborate all accounts of his physical splendour; his height, his breadth of shoulder, his classical good looks make it perfectly understandable that the majority of his male intimates at Cambridge were, if not actually in love with him, then certainly in affectionate awe. They nicknamed him 'the Goth' in recognition of his physique and the grand simplicity of his mind.

Thoby was an inheritor of the promise and privilege of a masculine

upper-middle-class world. Memorialised by Virginia in her novel *Jacob's Room*, like Jacob, 'He looked satisfied; indeed masterly;... the sound of the clock conveying to him (it may be) a sense of old buildings and time; and himself the inheritor.'[31] His sisters were not the inheritors. Yet Thoby unwittingly was to show them a way to the life for which they schemed, of which they dreamed.

Thoby, fifteen months younger than Vanessa, fifteen months older than Virginia, already was out in the world at Clifton College and then Trinity College, Cambridge, while his sisters remained at home and attended their father who was increasingly deaf, reclusive and obsessed with the state of his health. (Vanessa noticed wryly that once he became mortally ill, his health was no longer a source of anxiety to him.) Vanessa and Virginia were vestals preserving the flame of Victorian domestic life.

By the time Thoby had gone up to Cambridge it would appear that Virginia had appropriated the prime relationship with their heroic brother, a relationship that had been so important to Vanessa when they were children. Out of childhood, Virginia and Thoby had more in common, sharing the pleasures of Greek and engaging in 'stupendous arguments' on the merits and demerits of Shakespeare and the ancients. Virginia's letters to her brother were full of intellectual playfulness and arch deference (he is at times 'your Highness'). Nevertheless, their characteristic jokiness and exuberance could not disguise her intellectual curiosity and longing to engage in debate, argue opinions and share literary enthusiasms. Thoby took her seriously enough to join her in intellectual argument and respond to her occasional requests for books. But Virginia felt he must have been amused, certainly bemused, by this curious younger sister, intent on her mastery of Greek, voracious in her reading of the classics (she would consort only with 'minds of the very first order'),[32] and touching in her need to know and to communicate her attempts at knowing.

Vanessa wrote to Thoby too, but her letters, unlike Virginia's, were not saved. Her interests diverged increasingly from his as Thoby's education took him away from home and into the narrowly academic, and entirely non-visual world of public school and then Cambridge, the masculine shrine of the intellect. Painting and appreciation of art were not part of the average young man's education. She received birthday presents from him, paints and art books as directed by Virginia, and no doubt when he returned home he was grateful for her

administrative skills and admired, and could identify with, her dedication to her work and her physical robustness and mettle.

But the gulf between the males and the females of the Stephen family was wide and growing wider with the disproportion in experience and opportunity available to each sex. In that family of brothers only Adrian, the youngest, their mother's favourite, appeared not to assume so effortlessly the natural inheritance of his class's masculine supremacy. He was a silent fractured personality on whom the loss of his mother, at the age of eleven, no doubt had had a catastrophic effect. As a young adult he enjoyed elaborate practical jokes and in later life suffered suicidal depressions. Awareness of his own perturbed and multi-layered nature may well have drawn him to the new discipline of psychoanalysis, where in mid-life he embarked on the lengthy and rigorous training to become a doctor, and finally an analyst himself. But during the seven unhappy years, in a family shattered by their mother's then Stella's deaths, he was perhaps the most isolated and therefore the most unhappy of them all.

From Westminster School he followed Thoby to Cambridge. An immensely tall and gawky youth, he had never inspired the devotion and admiration which seemed to accompany his elder brother as irresistibly as his shadow. Adrian had neither Thoby's charm nor his arresting character, neither his beauty nor his bulk; he was merely a talented, intelligent, probably introspective young man who had had the misfortune to be born the last of an extraordinary family. And he had the greater misfortune to have been much loved, even spoiled, by a remarkable mother who was then prematurely obliterated from his life, to leave him utterly bereft, with only self-sufficient sisters, an awesome elder brother and a remote and unsympathetic father as family.

Inevitably, of all his siblings, Vanessa was the one with whom Adrian was most at ease. Her maternal qualities echoed their mother's, and her practical approach to life and lack of intellectual challenge made her more reassuring and comforting than the demanding Virginia. Virginia was to suffer some guilt that she could not feel the same passion and allegiance for him as she did for Thoby or Vanessa. Her attitude was often one of exasperation and sometimes hilarity at his ungainliness and lugubriousness. When they were all in their forties Virginia reported of Adrian's doctor's analysis, that 'he is a tragedy ... I am probably responsible. I should have paired with him, instead of hanging on to the elders. So he wilted, pale under a

stone of vivacious brothers & sisters.'[33] But she suffered also that familiar jealousy that Adrian had always preferred Vanessa, even, she felt, respected Vanessa but never respected her.

Virginia recognised that she had much in common temperamentally with Adrian; a disturbing sense that she was not like other people, an outsider's watchfulness, a certain uneasiness about her body's corporeity, a liability to the profoundest depression. But, on her own admission, Virginia was more fortunate in experiencing, on balance, many more periods of acute happiness and contentment than not, and in enjoying a vitality and inspiration which seemed to have passed Adrian by. Certainly she thought the idea apt that the labour of the *Dictionary of National Biography*, which had taken such a toll of Leslie Stephen as its editor during the gestation and infancy of the two youngest Stephens, had made her cleverer but less stable than she might have been, but had extracted the greatest price from Adrian – 'the D.N.B. crushed his life out before he was born.'[34]

Virginia's guilt about Adrian's isolation, however, was a matter for hindsight. During the years at 22 Hyde Park Gate, most of her and Vanessa's energies were expended on getting through each day: dispensing the minimum of social favours; catering to the needs of their brothers, half-brothers and father; avoiding as far as possible the duller or more malicious friends and relations and preparing for and recovering from the dreaded presentation of weekly books. But most important of all to Vanessa and Virginia was to claw back extra time for themselves, and conserve something of their energies for their own pursuits – the things that really mattered.

The sisters' belief in another world that one day they might inhabit, pared to the essentials of friendship and freedom from social constraint, of real talk on any subject, of a life of books and painting, was reaffirmed when they escaped the family on long walks or retired to their rooms with time to themselves. Virginia had a sense of herself and Vanessa being natural adventurers and revolutionaries. Unwilling to accept the hold of the past and its example, they were as yet uncertain of what alternative to construct and how. They caught glimpses of the life they wanted; on holiday in 1899 at Warboys Rectory in Huntingdonshire, the Stephen girls bicycled to Huntingdon and back on a hot summer's day and Virginia conveyed vividly their exhilaration at being beyond reach or influence of family, friends or society. Just the two of them, alone on a road that shimmered with heat under a limitless sky.

We forgot all our cares (and they were many – Nessa and I each had a large string bag full of melons which bumped against our knees at every movement) in gazing – absorbing – sinking into the Sky ... we have ceased to be dwellers on the earth. We are really made of clouds ... I want to read books about [the Fen country], and to write sonnets about it all day long. It is the only place for rest of mind and body, and for contentment and creamy potatoes and all the joys of life.[35]

The next year Vanessa embarked on her first visit to Paris. Having been despondent at the prospect of the trip, in the company of George, she was won over completely by the seductive reality. The paintings, the city, the food, all made her 'frantic with excitement'.[36] The pre-eminence given to art and artists in that city and the vitality of the studio and café life was to be a revelation to Vanessa and undoubtedly helped her to formulate something of the relaxed yet diligently hard-working communal atmosphere of the houses where she was to live and work. Virginia had spent virtually every day of her life with her sister and missed her thoroughly, was, she declared, 'as melancholy as Hamlet'[37] and retreated into her shell like a tortoise. There was some consolation in the thought, however, that although 'sisters are too expensive luxuries'[38] one was stuck with them for life; Vanessa could never relinquish the relationship, and Virginia need never fear it could be forfeited.

Meanwhile Vanessa and Virginia both took their chosen professions seriously and worked daily at their art. Vanessa graduated to the Royal Academy Schools in 1901. Here she was offered a formal training in drawing – from the antique and from life (in classes still sexually segregated) – anatomy, composition and perspective. She worked away at her projects and exercises with single-minded and dogged attention. Virginia was to find always that Vanessa had a 'passive ferocity',[39] in her ability to concentrate which could be alarming.

But Virginia was capable of working in a disciplined and highly productive way too. She had long ago begun training to be a writer and her extensive reading and untiring observation formed the base on which her art was built: 'It was the Elizabethan prose writers I loved first & most wildly, stirred by Hakluyt, which father lugged home [from the London Library] for me.'[40] She kept a journal in which she would write experimental descriptive pieces of places visited, devel-

oping theories and reporting a little of family life, a book which she likened to Vanessa's sketch-book.

In the same journal she describes a dance that she watched in her nightdress from her window, having just returned from a dance herself. Because she could observe unseen, freed from society's demands and unencumbered by anxieties of dress, she enjoyed watching the dance below far more than the one in which she had to participate. Two years earlier, in 1900, at her first May Ball at Thoby's college, she set herself apart and unapproachable, with two female cousins, on a platform of sorts from where she watched the dancing, 'without being disturbed'.[41] So much of Virginia's observation was to have the freshness, sense of the ridiculous and acerbity characteristic of an outsider's perspective and was to exhibit too the outsider's longing, however fleetingly, to belong. Only in that world of which they dreamed, and had yet to create, could the Stephen sisters ensure that it was they who were the initiates, they who practised the selection and exclusivity.

In the aftermath of Queen Victoria's death in 1901, when there was an upsurge in optimism, a recognition that the new century would herald a new age, Virginia expressed her ideal of freedom:

The only thing in this world is music – music and books and one or two pictures. I am going to found a colony where there shall be no marrying – unless you happen to fall in love with a symphony of Beethoven – no human element at all, except what comes through art – nothing but ideal peace and meditation.[42]

Vanessa was not to agree about the marrying and would have insisted on more than one or two pictures, but she would have been whole-hearted in her championing of art as the basis for life, free as it was of the emotional baggage that accompanied humanity, and full of possibilities for working friendships and for retreat from the sentimentality and social trivia that at times had made 22 Hyde Park Gate a nightmare of dissembling and constraint.

But, as they both realised, 'the most imminent obstacle and burden was of course Father.'[43]

4

Death and Freedom

'His life would have entirely ended mine. What would
have happened? No writing, no books – inconceiv-
able.'

Virginia Woolf, 28 November 1928, *Diary*, vol. III

THE PROTRACTED ILLNESS of Sir Leslie Stephen (as he became in
1902) and his death and the immediate aftermath was a period when
Virginia's and Vanessa's conspiracy was loosened as their experiences
and feelings diverged in a way that was most painful for Virginia. By
the time their father was incurably ill with cancer, Vanessa had
detached herself emotionally from him. After her mother's and
Stella's deaths she communicated as little as possible with him; she
saw nothing of the reasonable intellectual side that Virginia loved,
only his tantrums and hectoring outbursts which terrorised her, on
her own admission, into an obstinate and unforgiving silence. Virginia
noticed how this crushing of her sister's integrity, how the conflict
between what she was forced to do and what she longed to do (with-
draw to draw and paint, paint and draw) was responsible for a
decidedly chilly aspect in her character.

Vanessa was able to remove herself not only spiritually but
physically too from the demands and pathos of her father's condition.
By the spring of 1902 when Leslie Stephen's doctors first diagnosed
cancer of the intestine, Vanessa was happily established at the
Academy Schools whence she escaped most mornings. Here her
painstaking work, with the challenges set her by the practice of her
art, was blissfully free of the obscure emotionalism of her family life.
When Sir Leslie relinquished at last the authority of signing the
weekly cheque to her, Vanessa was freed of all painful contact, in fact
of any but the most perfunctory contact, with her father. His long-
expected death could represent for her only a great sigh of relief, an
exhalation of breath that had been held for too long. Her subsequent
exhilaration with life, and her haste in discarding the old life and

inventing a new, were to jar with Virginia's more equivocal, more intricate feelings about their father, about the responses of his other children to him, about his illness and his death.

Virginia was not in sole charge of the welfare and nursing of her terminally ill parent; there were servants and finally nurses to deal with the daily chores of the household and the sickroom. She was, however, the only member of the family to spend most of her day at home and certainly saw more of him than did the others. They shared the common ground of his library and appreciation of the same time-honoured authors, the same rigorous interrogatory approach to reading (one was to approach authors and their works 'laden with questions and suggestions ... They can do nothing for us if we herd ourselves under their authority and lie down like sheep in the shade of a hedge'),[1] the same acute but commonsensical intellect. Just as Virginia was more aware and consequently more repelled by her father's domestic tyrannies, so she was more sensitive and appreciative of the nobility and large-heartedness of the man; the essential qualities that made him in his friends' esteem and her own, 'so lovable'. The more ill he became, the more the emotional tyrant diminished and the admirably sane and incorruptible man of letters, the appreciative father came to the fore.

Virginia, alone of all her family, carried an ambivalent passion for Leslie Stephen. She carried the emotional responsibility too for she was the only one who understood and sympathised with this difficult, lonely old man. Yet perhaps like Cam in *To the Lighthouse*, who has much of the young Virginia, she felt in loving him she betrayed the filial compact:

[Her father] was so brave, he was so adventurous, Cam thought. But she remembered. There was the compact; to resist tyranny to the death. Their grievance weighed them down. They had been forced; they had been bidden. He had borne them down once more with his gloom and his authority ... Cam would never resist tyranny to the death, he [James, her younger brother] thought grimly, watching her face, sad sulky, yielding.[2]

She might have been speaking directly to Vanessa when she continued:

You're not exposed to it, to this pressure and division of feeling, this extraordinary temptation. Her father was feeling in his

pockets; in another second, he would have found his book. For no one attracted her more; his hands were beautiful to her and his feet, and his voice, and his words, and his haste, and his temper, and his oddity, and his passion, and his saying straight out before every one, we perish, each alone, and his remoteness. (He had opened his book.) But what remained intolerable, she thought, ... was that crass blindness and tyranny of his which had poisoned her child-hood and raised bitter storms.[3]

Virginia intended in this book 'to have father's character done complete',[4] her mother, their relationship and the relationship with their children, the particular magic of their summers at St Ives; all were part of the plan. And Leslie Stephen stood at the centre, drawn with anger, with pity and with love. She could never be set as resolutely against him as was Vanessa, and yet she could not deny or forgive his treatment of her sister, indeed of them all. Yet how was she to retain her precious conspiracy with Vanessa, the two of them against tyranny, against the world, and yet respond to the old tyrant himself, whom she loved with a particular poignancy during his last years? Virginia felt isolated from her siblings by this conflict of loyalties; perhaps, like Cam again, desperate to answer the irreconcil-able needs of both parties, to remain 'fierce and loyal to the compact, yet passing on to her father, unsuspected by James, a private token of the love she felt for him,'[5] and yet failing inevitably and suffering that diffuse guilt and misery which was to find catastrophic release in her first serious breakdown.

But the period from spring 1902 leading up to his death in February 1904 was lengthy and emotionally entangled. His daughters knew that his death was the prerequisite of the sort of freedom to live as they chose, of which they could only dream. Remembering his birthday more than twenty years later, Virginia was forthright; had he not died when he did but lived on to a greater age, 'His life would have entirely ended mine. What would have happened? No writing, no books – inconceivable.'[6]

The two years of steady decline in Sir Leslie's health meant 22 Hyde Park Gate became even gloomier. The two young women, enclosed by its creeper-hung walls, were even more restricted and hampered by the increasing attentions of female relations intent on cornering them and wringing from them a suitably doleful response to their own sentimental jeremiads. Perhaps Vanessa and Virginia had become

obstinately resistant on this point; this was the third invasion of family mourners, after all, and they were by then well practised and better armed.

His doctors announced various dates by which the disease should have vanquished him. Sir Leslie confounded them all. Virginia believed he held so tenaciously to life because at last his children were old enough to be his intellectual equals and of real interest to him. She noticed with irony and some bitterness that their mother, whose continued life would have saved her children so much misery, found it very easy to relinquish herself to a premature death.

In Virginia's subtle delineation of light and shade in the portrait of her parents in *To the Lighthouse*, she conveyed an apprehension that beneath the beauty, the unifying, harmonising creativity of Mrs Ramsay, there was a fatal submissiveness and lack of fight, on her own behalf and on the behalf of her children. Given this extraordinarily finely drawn, richly hued picture of their mother (Vanessa was overwhelmed with emotion when she first read it, 'It is almost painful to have her so raised from the dead'),[7] it is perhaps not fanciful to believe that Virginia, at least, laid some blame on Julia Stephen herself for submitting too easily to death, for abandoning her young children too soon to a hostile and incomprehensible world.

Virginia knew that the loving influence and presence of their mother during childhood was central to their happiness and sense of completeness, but that in their twenties Julia Stephen would have been a formidable impediment to her daughters' stand for freedom, for a life different from hers, less bound by duty, no longer defined by a husband, and dedicated to his care. The move to a less reputable area, the informal socialising, their commitment to their art rather than to husband-hunting, the casting off of unsympathetic relations, the social experimentation, the freedom to run their own lives and their resultant euphoria could not have been theirs had Julia Stephen survived to live out her natural span. She was an irresistible force in her subtle insights and astute practicality, as much as in the imperiousness which flared sometimes through her philanthropy and inspired ministrations. Where Leslie Stephen was that more straightforward of tyrants, demanding that his own needs be met first and foremost, Julia Stephen could be subtly tyrannical in the guise of knowing best what should be done about the needs of others.

Sir Leslie Stephen died at last on 22 February 1904. Being deprived by death of a good mother during childhood was quite simply, as

Virginia maintained, 'the greatest disaster that could happen.' But being released from all parental influence in one's early twenties could have its benefits. In Vanessa's and Virginia's case it meant that they were freed of the weighty impedimenta of Victorian parental will. It left them with limited but adequate capital and the freedom that entailed, as they stood poised on the brink of a new century with the promise of a new age before them. For the sisters at this critical time in their lives, orphanhood had its practical and spiritual advantages.

Vanessa lost no time in making the most of those practical advantages. She was full of plans for clearing up the family home, moving house, travelling, painting, negotiating for herself and Virginia the longed-for way of life. She was not, however, entirely untroubled by the past that she dusted so speedily from her heels. Soon after her father's death she dreamed of having committed a murder but, with her ability to evade distress and her resistance to examining and expressing her true feelings, promptly stopped dreaming – or rather stopped acknowledging what she dreamed.

Virginia was much more in thrall to the past, much less able and less willing to discard anything, to close a door and walk away. In the immediate aftermath of Sir Leslie Stephen's death she was full of regrets and remorse. She heard his voice again as she read his books and was left longing to talk with him once more: 'I think of all the things one might have said and done and never did.'[8] She dreamed of him, of telling him how much she cared, only to awake to self-reproach at not responding more to him while he lived. She tortured herself with the vision of a lonely, misunderstood old man, who realised too late the rewarding relationship he might have had with his children. She castigated herself for not making it clearer how much she cared, 'If I could only tell him once more—.'[9]

For the first time in her life she could not confide in Vanessa. Her anguish at the loss of her father and her sense of having failed him were not emotions shared by her sister. What feelings of regret Vanessa might have had that her own relationship with her father had so deteriorated during the last years were given little consideration; quite understandably she did not wish to be reminded by Virginia's present grief of the miseries of the past. In that household, Vanessa and Virginia had formed such a close alliance in their attempt to protect their small territory from the emotional encroachment of their menfolk, that this inevitable but temporary loosening of the pact may well have added to Virginia's sense of familial loss. It was in letters to

Violet Dickinson, the remarkable, wise and motherly woman who had befriended the whole Stephen family in those unhappy years following their mother's and Stella's deaths, that Virginia spilt a little of that dammed emotion: 'You cant think what a relief it is to have someone – that is you, because there isnt anyone else to talk to.'[10]

In her unpublished diary written as her father was dying, Virginia wrote a piece identifying closely with a woman who had drowned herself in the Serpentine in Hyde Park, leaving the message, "'No father, no mother, no work'". Virginia wrote that she could not get the words out of her head, the sense of yearning for the dead mother and father, the realisation how irredeemable and absolute was their loss to their child. Husbands can be replaced, more children can be born, but a mother and father once lost, 'the longest life can never bring again'.[11] It was painful for Virginia to come to terms with the realisation that no one and no thing would ever be able to take the place of that lost fundamental tie. A terrible sense of her father being cheated by death of a fulfilling relationship with his children, and she herself being left with so much that had to remain unsaid, undone, made Virginia unable to relinquish him. There were many times when she said she felt he was with her still.

A few days after their father's funeral, Vanessa and Virginia, their brothers and half-brothers, set off for a month's holiday to Manorbier, amongst the wild coastal scenery of Pembrokeshire. It was unexpectedly successful; the house was warm and comfortable, the scenery reminded them delightfully of their beloved St Ives and, as in Cornwall, the walks were challenging and rewarding. Everyone's spirits in general seemed high, sometimes so much so that Virginia at least suffered some pain at the incongruity of their gaieties after the grim months of illness and death, a feeling that in their mundane pleasures somehow they were denying the gravity of their loss, and thereby the centrality to their lives of the man. 'Oh dear, what a world it is!' she wrote to Violet Dickinson using her favourite world-weary phrase at the time, an expostulation about which Vanessa would tease her. 'I keep thinking I shall find father at home – and what I shall tell him – I wonder how we go on as we do, as merry as grigs all day long.'[12] There was a hint of Virginia's uneasiness as to the others' apparent lack of grief – their expression even of relief – and desperation too at how long she herself would be able to maintain her part in the family levity.

It seemed that she alone felt this and grieved thus. Given Thoby's

extreme reticence on emotional matters, given her lack of any real correspondence with Adrian, her younger brother, it seemed likely that when Virginia wrote about the lack of family sympathy with her grief – 'It is so hard to talk to even ones own brothers and sisters'[13] – it was her inability to talk to Vanessa, the most important person in her life, about something as profoundly affecting as their father's death, that was so inhibiting and galling.

Vanessa, all her life, was to shy away from confronting and giving vent to the disturbing emotions of grief, jealousy and, ultimately, of sexual love. She had a horror of raw emotion, quite possibly the result of a natural antipathy worked upon by the weekly displays of shameless emotionalism meted out by her father, the over-exposure to pious sentimentality of mourning aunts and cousins, and George Duckworth's own maudlin and tainted devotion. Where Virginia always regarded herself and others with penetrating curiosity, was fascinated by endless speculation about what she was, what had made her thus and how she was to proceed in a world peculiarly menacing to her; where she was willing fearlessly to open doors and lift veils, to acknowledge the meanest elements in her character, to face even her most terrifying experiences of madness, Vanessa wanted only to force the cupboard door shut – particularly if it bulged with dark unnameable shapes, unmanageable forces. Her recoil from even legitimate and necessary passion, in herself and others, might explain that certain aloofness and chilliness in her character which could so disconcert, and hurt, others. In later life, there were many incidents related of her struggle for calmness, rationality and passive acceptance in situations of loss, threat and fear. When the struggle overwhelmed her, she too was subject to harrowing emotional collapses.

Vanessa's silence on any threateningly emotional matter was of long-standing duration; in a letter to her friend, Margery Snowden, some ten months before her father's death, she contemplated not passing on to Virginia, not even to Thoby, the doctor's opinion on his chronic and deteriorating state. Evasion of the issue for as long as possible, and a determination to continue with daily life as if nothing had changed, was her instinctive response: 'I know all this must sound very hard & cold – but you will understand.'[14] It was most practical but it made no allowance for the natural but less clear-cut and convenient emotions which afflicted Virginia at least, if not other members of the youthful Stephen family.

Despite this, however, the break from their gloomy, memory-

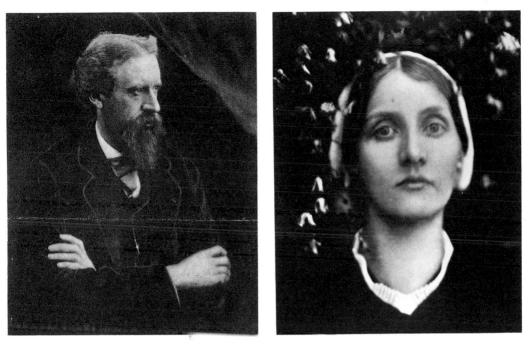

1 Leslie Stephen (photographed by Julia Margaret Cameron)
2 Julia Duckworth, later Stephen, 1867 (photographed by Julia Margaret Cameron)
3 Leslie Stephen, Adrian, Julia Stephen, Thoby, Stella Duckworth, Vanessa and Virginia

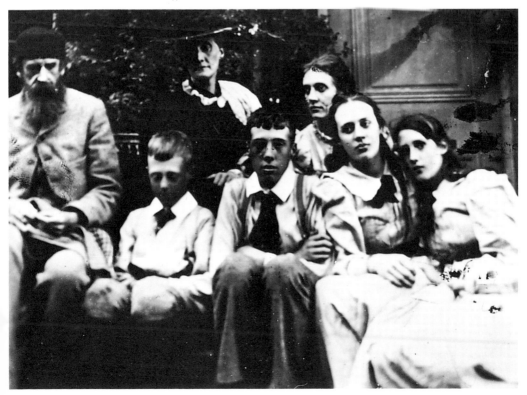

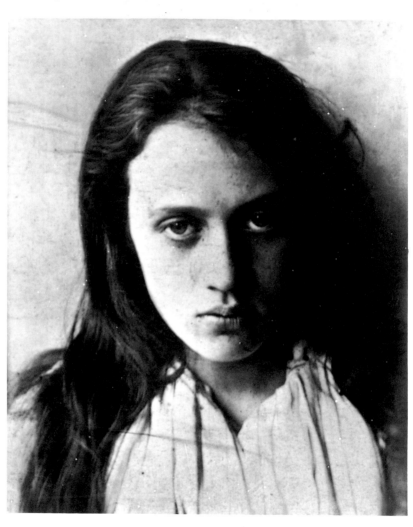

4 Vanessa

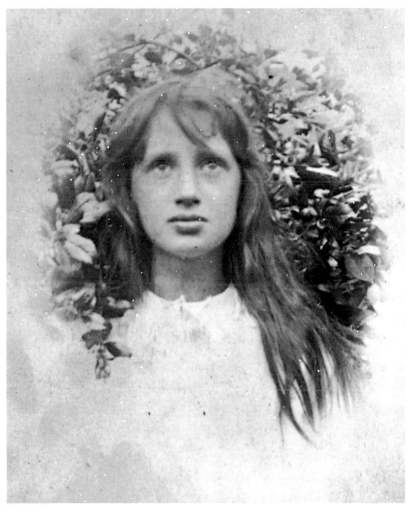

5 Virginia

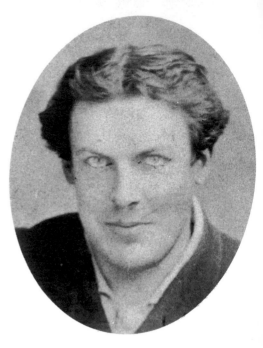

6 Laura Stephen

7 James Kenneth (J.K.) Stephen

8 George Duckworth and Julia Stephen

9 Stella Duckworth

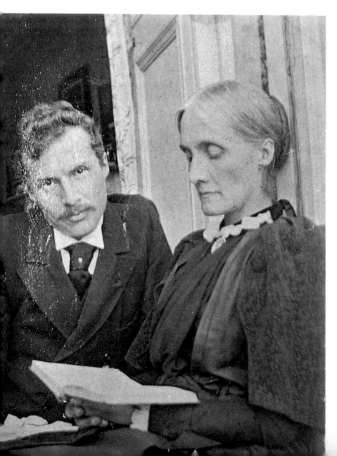
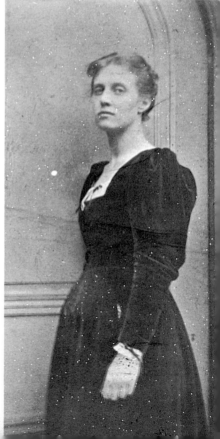

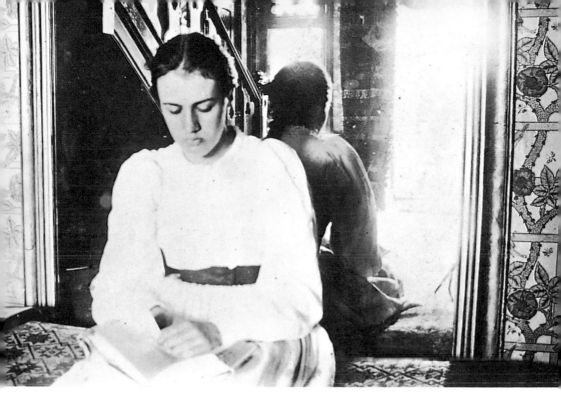

10 Vanessa at Talland House
11 Virginia and Leslie Stephen 1902

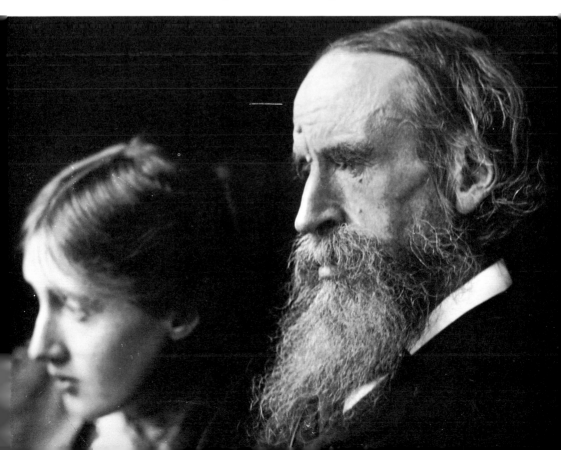

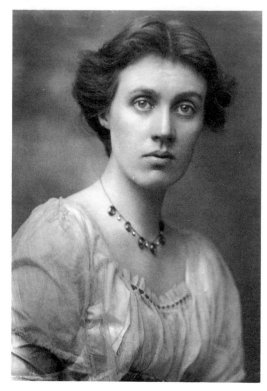

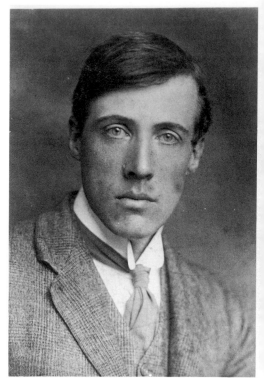

12 Vanessa 1907 13 Thoby 1906

14 Adrian 15 Virginia 1902

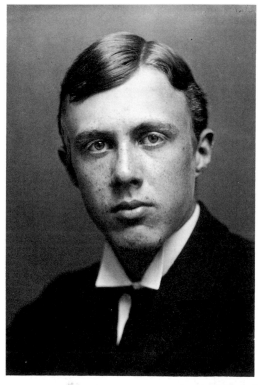

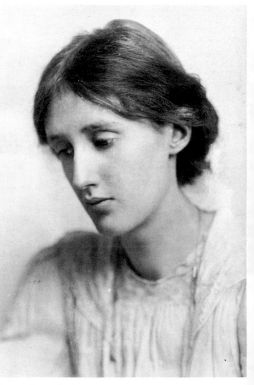

Studio portraits by George Beresford

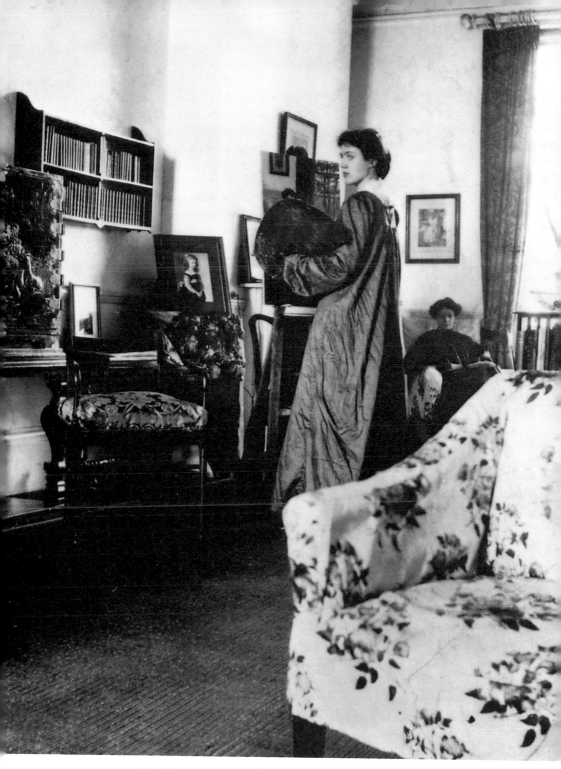

16 Vanessa painting Lady Robert Cecil 1905

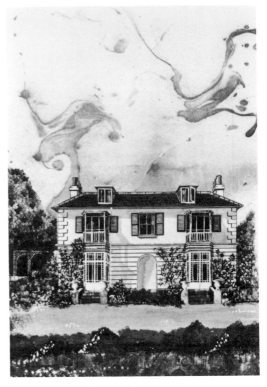

17 *22 Hyde Park Gate*　　　　18 *Talland House*

19 *46 Gordon Square*　　　　20 *Asham House* (Asheham)

Illustrations by Leonard McDermid

21 Clive Bell 1910

22 Leonard Woolf and Virginia 1912

23 Roger Fry

24 Duncan Grant 1913

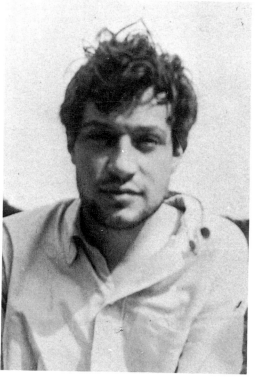

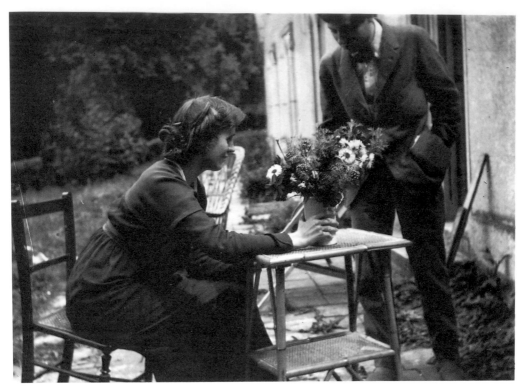

25 Vanessa and Duncan Grant at Asheham 1913-14

26 Clive Bell, Virginia and Julian Bell at Blean, near Canterbury, 1910

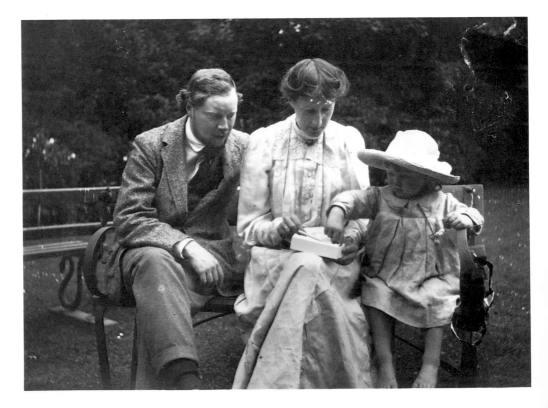

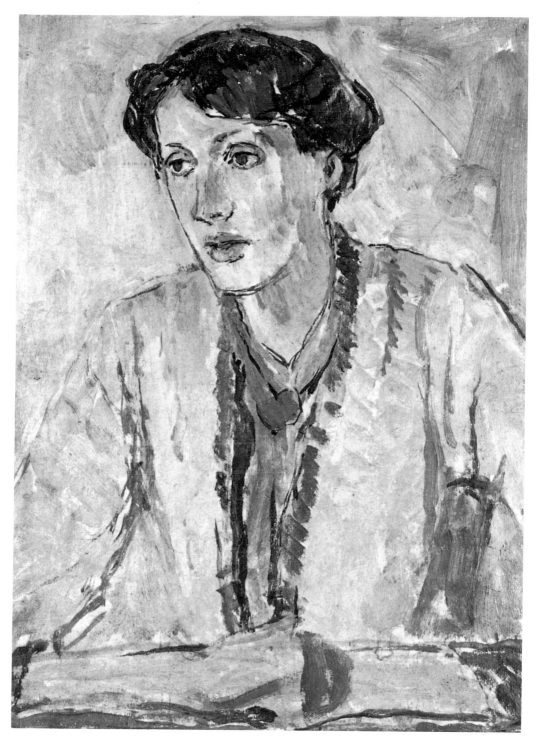

27 *Virginia Woolf* Vanessa Bell 1912 (Monk's House, Rodmell: The National Trust)

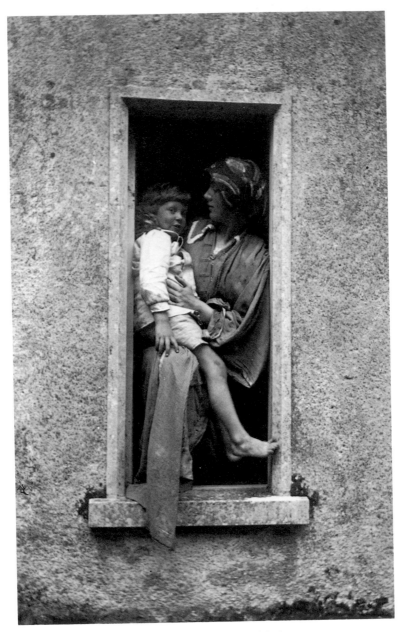

28 Vanessa and Julian Bell at Asheham 1912

ridden house, the exhilaration of the landscape at Manorbier and freedom from social constraints had a favourable effect on both sisters' creativity that spring of 1904. Vanessa painted a small portrait of Thoby, reading by the window, which Virginia felt was impressive and full of vitality. Virginia herself read and wrote copiously and reached a most important turning-point in her deliberations on the kind of life she should lead and the kind of literary work she would do. In remembering that time she wrote in a later diary: 'I [at seventeen] was for knowing all that was to be known, & for writing a book – a book – But what book? That vision came to me more clearly at Manorbier aged 21 [22], walking the down on the edge of the sea.'[15]

There must have been some reluctance to return to the dark, shuttered family house for, while in Wales, an Easter holiday to Italy was arranged and a few days after their return they were travelling again: Venice, France, then home via Paris. Gerald Duckworth, who accompanied them, was bored to death with Venice, and very cross, Virginia reported, but his young half-sisters and half-brothers, to whom, to begin with at least, the whole expedition was an adventure and feast for the senses, could hardly contain their excitement. Vanessa was ecstatic at the wealth of paintings to admire: 'They are simply gorgeous.'[16] She found the funereal gondolas mysterious and the sense of menace as they glided along at dead of night, nothing but thrilling.

Whatever excitement and sense of adventure Virginia might have set out with was quickly exhausted. She found the gondoliers shouting and laughing beneath her window unbearably irritating; her lack of the language was humiliating; the Italians themselves incorrigibly dishonest, a beastly nation of beggars and cripples; 'Thank God, I say, I was born an Englishwoman.'[17] And Venice was a cage that depressed her. She grew more susceptible to the underbelly of all human life as they moved on to Florence. She longed for England and everything English, while Vanessa continued to be rapt with the glories of the arts and intoxicated with the beauty all around her, the light, and her new-found, hard-won freedom.

Virginia's emotional alienation, even a sense of betrayal by her sister's apparent indifference to their father's death and the personal treasures it had robbed from them, grew more pronounced as their own responses to Italy diverged. Vanessa was exhilarated by magnificent Tintorettos and luxuriant gardens, 'walls covered with oranges and the roses are coming out all over the place',[18] with breathtaking

views beyond, all basking beneath vast, clear skies. Virginia, on the other hand, was beyond appreciating such splendour. She was obsessed and disgusted by her fellow tourists, by humanity generally; 'Germans are brutes: – and there is a strange race that haunts Hotels – gnome like women, who are like creatures that come out in the dark. An hotel is a sort of black cave.'[19]

Virginia was slipping fast into her own dark cave. By May she had entered a period of serious breakdown and insanity which was to threaten her life and prove a terrifying and tragic ordeal for her. Their journey home included a sojourn in Paris, where the civilised café life, introduced to them by Thoby's Cambridge friend Clive Bell, 'talking of Art, Sculpture and Music till 11.30 ... while we smoked half a dozen cigarettes a piece', was entirely to Vanessa's taste. Even Virginia, in her mentally fractured state, recognised the attractions of 'a real Bohemian party'.[20] It gave them their first glimpse, in their quest for a new way of living, of the sort of life and conversation and informal deportment which both sisters were to cultivate so successfully with their friends.

These diversions, even the urbane attractions of Clive Bell, eager to share his friends and haunts, were not enough to stave off Virginia's breakdown. Not even this vision, the promise of the sort of life for which the sisters had battled and dreamed and now had within reach, could save her from impending chaos. Her last extant letter on this journey, written to Violet Dickinson, who had joined the family at Florence, had something pathetic and desperate about it:

> Oh Lord, how cross I have been, how dull, how tempersome, – and am still. You had much to stand: I wish I could repay all the bad times with good times. There should be some system of repayment in this world ... Oh my Violet if you could only find me a great bit of solid work to do when I get back that will make me forget my own stupidity I should be so grateful. I *must* work.[21]

Meanwhile Vanessa was writing to Margery Snowden in delight at having brought some decorative old picture frames and drawing books of old paper, far superior to modern paper. From Paris she noted with oblique humour, 'Your old friend Bell is here & he knows a lot of the young artists & tells us of all the latest geniuses.'[22] The painful incongruence of the sisters' moods, so evident during their time in Italy, was levelled out on their return home when Vanessa's

euphoria gave way once more to her familiar yoke of responsibility and care.

Within two days of their return to 22 Hyde Park Gate, Virginia's state of mind had deteriorated from pronounced irritability and unhappiness into an unmistakable mental breakdown, more serious, more frightening and more lengthy than anything she had suffered before. This was Virginia's second breakdown but the first serious enough to need nurses and seclusion. It began in May 1904 and lasted in its acute stage for about three months with a further three months or so convalescence.

It was on Vanessa that the burden of Virginia's welfare and safety fell. It was an alarming responsibility for a young woman who was only twenty-five years old with no experience of mental illness and, faced with the disintegration of Virginia's personality, no reason to believe that she would ever recover. Yet again the sisters were locked together in desperate circumstances. But this time their relationship was less an equal conspiracy against the world and rather more an utter collapse and dependency (and anger) on Virginia's side, answered by an onerous responsibility (and no doubt, some resentment) on Vanessa's.

It is little wonder Virginia was to feel at times throughout her life that 'the great cat is playing with us once more,'[23] when sudden deaths, illness and collapse brought low her otherwise happy, productive years. It was a time of blankness and silence as far as their letter-writing and Virginia's diaries and memoirs were concerned. What she wrote subsequently can be pieced together to form an incomplete vision of that nightmare summer. Virginia's reasonable grief for her father became unreasonable and manic, she was plagued with strange voices urging her to do 'wild things';[24] birds sang in Greek and King Edward VII lurked in the bushes outside her window, using, Virginia reported, the foulest possible language. (As a girl in Hyde Park Gate she had lain in bed one night and heard a tramp shouting obscenities in the street below. No, no the grown-ups had told her the following morning, not what you thought at all, only two cats fighting. When even reality had been confused with denials and taboos, how difficult it must have been to believe the assurances of others that these voices and the overheard obscenities were delusions; 'Nessa says they were always only my imagination,'[25] she wrote after her restoration to health but still not entirely convinced.) She refused to eat, believing the voices that made her fear she was

going mad were a result of overeating, and at times became so violent that three nurses were necessary to restrain her. At one point she threw herself from a window but, as it was close enough to the ground, sustained no serious injury.

Perhaps the most difficult and wounding symptom of this particular breakdown was that Virginia turned against Vanessa, becoming at times openly hostile towards her. We cannot know what was suffered, what was said, but we have the evidence of Virginia's letter from Italy, of her simmering resentment of Vanessa's evident relief at the death of their father, her eager embracing of life and pleasure, none of which Virginia could share. Their close conspiracy, their unity, the 'private nucleus'[26] they formed which had proved life-giving and sanity-securing during the seven unhappy years from Stella's death in 1897 to their father's in 1904 was loosened. To Virginia it might seem that not only had she been deprived too soon of her father, but the essential protective mother figure in Vanessa appeared to be deserting her too. This understandable sense of loss, exclusion and even betrayal was the basis, perhaps, for her rejection of Vanessa during the months of her breakdown.

But on a more profound level too the competitiveness between Vanessa and Virginia ran like an underground current and the territories annexed by each sister had their borderlines redrawn and strengthened by such a dramatic reversal. 'The Goat's mad'[27] was to become a half-joking family refrain, but in her nickname there is the unmistakable meaning of 'scapegoat'. In assigning the madness to 'the Goat' there is a sense that Virginia's state exempted the rest of the family from madness – although in the future both Adrian and Vanessa were to endure a variety of nervous disorders, even breakdowns. Thus if 'the Goat's mad', then Vanessa was seen also, in as unequivocal a light, as monumentally sane.

The younger sister, who enchanted and amused not only her family but increasingly a wider range of friends and acquaintances, whose wit and beauty, sheer intelligence and originality could prove fascinating to men and women alike, was formidable competition. Vanessa related one of many incidents when her own charms were eclipsed by Virginia's:

Thoby has come in. He dined with Nelly [Lady Robert Cecil] & sat next her niece ... He seems to have talked to her the whole evening. She said 'I hear you have a beautiful sister.' He said 'I have two.'

She said 'But the one I mean is very clever?' He said 'They're both very clever.' She said, 'But this one is about my age.' Then he had to own that it was the youngest of his sisters. I knew it must be at the beginning – but I hoped it might be left doubtful.[28]

Her tone was amusing, self-deprecatory, she was relating the story to Virginia in order to cheer her during her convalescence, but how revealing it was that Vanessa knew from the first phrase, 'I hear you have a beautiful sister,' that the speaker meant Virginia. And it is one of many like incidences at this time. Even her own great friend Kitty Maxse joined the general acclamation, 'Kitty full of your loveliness! How lovely you were – more so than ever.'[29] Violet Dickinson, from her great height and wisdom, was moved to tell Vanessa how wonderful she thought Virginia, how original and interesting was her mind, that 'you always had something to say on any subject & your writing, so living ... She really thinks you are a genius.'[30] And then Madge, their childhood friend who had married their worthy cousin William Vaughan, with whom Virginia spent some of her convalescence, piled on the superlatives: 'Madge says you came as a boon and a blessing to them ... with your delightful mind – So finely trained & your curious penetrating personality – to say nothing of your affectionateness.'[31]

It is not surprising that Vanessa exclaimed to her sister, with humour and more than a little truth, 'I shall borrow your green eyes in my old age.'[32] For, as she reminded us in her memoir of Virginia's childhood, this ability to enchant others was a quality that had manifested itself from their earliest days together: 'I don't remember being jealous of the fact that her appearance and her talk had obviously the greatest success with the grown-ups. They laughed at her jokes but so did we all, and probably I was as much aware as anyone of her brilliance and loveliness to look at.'[33]

It would be quite understandable if Vanessa were to experience, somewhere bound in with her genuine love, distress and concern for Virginia during this breakdown, some feeling of respite in contemplating such a devastating flaw in her otherwise relentlessly gifted younger sister. We can only surmise Vanessa's feelings on the matter of 'the Goat's madness' for, unlike Virginia, she was steadfastly unconscious of her own deepest feelings and unwilling to confront the conflicts and passions in herself and others, let alone commit them to paper. (There are a few revealing volcanic rumblings in her letters, particularly to Roger Fry, and then the desperation and

misery of some of her later letters to Duncan Grant. She also made some candid asides in conversation with Virginia, which seemed to startle her sister and console her too in her competitiveness.) Vanessa appeared, on the whole, to be monumentally imperturbable in her instinctive commonsensical approach to the world. At one extreme this could seem, as Lytton Strachey once found, alarmingly powerful yet inarticulated, a 'dumb animality – like some creature *aux abois*',[34] and at the other, a literal-minded integrity, an insistence on rationality in all human transactions, even in matters of the heart. But as Virginia knew, Vanessa's placidity was as the earth's crust, not always containing the ferment of inchoate matter within. She had volcanoes under her skin.

Virginia, on the other hand, did give us reason to believe she sensed some sort of triumph in Vanessa, in those early days at least, on the occasions when Virginia herself was reduced to the role of victim. In her first novel, *The Voyage Out*, written and obsessively rewritten from 1907 to 1913, and intimately bound up with her own life as she emerged painfully into adulthood, Virginia encompassed the experiences and conflicts which most exercised her at the time, drawing her characters from the people closest to her. Helen Ambrose, accepted by both Virginia and Vanessa as a portrait in some salient respects of Vanessa – both were distinguished by their beauty and their largeness and simplicity, 'which made her stand out from the rest like a great stone woman'[35] – exuded a superiority over her unworldly niece Rachel Vinrace, the Virginia character, that has elements of jealousy, derision and a destructive desire to control.

These more sinister qualities were woven to some effect through a character that on the surface seemed self-possessed, maternal and wise. In one of his marvellous critical letters on the book, Clive Bell was to write to his sister-in-law that he found Helen Ambrose by far the best character, and about her 'I cannot trust myself to speak, but I suppose you will make Vanessa believe in herself.'[36]

During this most serious of breakdowns, Virginia did turn against Vanessa. She was the most important, most passionately loved person in Virginia's life, but perhaps in her derangement, in her madness, Virginia responded to the ambivalence in Vanessa's feelings; the undoubted maternal selflessness underlined, with a steely purpose, a necessary selfishness which desired a life for herself too, beyond their mother's example of exalted service to others. In these dire circumstances, Violet Dickinson came to the sisters' aid. In June she took

Virginia to live with her in her house at Welwyn in Hertfordshire and cared for her until she was well enough to return to Vanessa in early September.

Virginia's friendship with Miss Dickinson was to be the most passionate and important relationship outside her family during her youth. She was seventeen years older than Virginia and had been taken under the protective wing of Julia Stephen when her own mother had died. When Julia herself died Violet Dickinson subsequently had proved a stalwart and affectionate friend to Stella and the Stephen children and became a focus for Virginia's passion, her confidences, her fantasies of being a small child or a pet animal who required Violet's affectionate scolding and limitless comfort. She was a very tall, generous-hearted, exuberant character, a spinster of independent means, connected through lineage or friendship with most of the aristocratic families in the land. She was loved and admired, it seems, by all who knew her, including the critical Stephen family.

Her quality of character and affection must have been tested by those summer months in 1904 when she took the deranged Virginia into her care. She was at various times violent, suicidal, intractable, alarmingly beyond reason. No doubt it was the greatest relief to Vanessa to be able to rely on Violet's reassuring and maternal capabilities in such extremity. Virginia too, although beyond acknowledging it at the time, was filled with a touching gratitude once she had emerged from that particular nightmare. Her first letter to Violet once she began to recover from her ordeal, while staying in a house rented by Vanessa in Nottinghamshire, was pathetic in its contrast with her usual tone of teasing affection and unembarrassed vitality. The few lines expressed poignantly the shame and humiliation for her of the previous months: 'My Violet, Nessa said you wouldn't mind coming. I don't know how to write to you now, but if you didn't hate it too much I should like to see you.'[37] She felt that she had been in some way unclean, contaminatory; she was relieved that Violet's cats continued to proliferate despite her morbid presence, and that 'my germs haven't killed them all.'[38] Violet Dickinson did not fail her. She came, she reassured, and the precious relationship was back on course again.

While Virginia was struggling back to normality, Vanessa had been busy putting the most important part of her plan for their new life into action. She was determined that they leave behind the gloomy

family house with its inescapable weight of emotion and association. During Virginia's convalescence, Vanessa wrote to her every day and she was never far from her mind. One of the few advantages, but a seductive one, of illness was that once more Virginia inhabited the centre of her beloved sister's thoughts. 'Be careful of your health or you shall never leave me again,'[39] Vanessa wrote to her on her first trip abroad after her breakdown; given Virginia's possessiveness that was almost an encouragement to retire into invalidism.

By spring 1904 Vanessa had decided on a move to Bloomsbury; then inexpensive, unfashionable and as far as was reasonably possible from Kensington with its melancholy associations and proximity to the dreaded aunts. At first, Virginia had been in no hurry to move. Her first impressions, anyway, of her sister's choice of locality were unfavourable, 'Lord how dreary! It seems so far away, and so cold and gloomy.'[40] And she feared they would never find a house they liked as much as 22 Hyde Park Gate. She was still loath to cast herself off from the place where she had lived all her life: twenty-two years marked out from the rest by their significance and the intensity of experience.

But Vanessa was not to be deflected by timidity or sentiment. In little more than six months she had found 46 Gordon Square, overcome family resistance, sorted through the accumulated possessions of the Stephen and Duckworth families which had lain multiplying in the cupboards and corners of 22 Hyde Park Gate, organised the despatch of books, pictures and furniture, and settled the Stephen family into the bare, light-filled rooms of their new house.

The bareness and spareness of those lofty rooms seemed an external confirmation of the sisters' longed-for ideal of personal freedom; lives pared down to essentials, the clutter and emotionalism of 22 Hyde Park Gate gone for ever, friendship and work the only necessary furnishings of this their new life. The discarding of the excess baggage of the past was completed, at the last moment, by George Duckworth marrying and moving into his own residence and Gerald agreeing to live in bachelor rooms. For the first time the Stephens were alone, responsibility for the disposition of their lives entirely their own.

This radical and liberating move, motivated by Vanessa and carried through unfalteringly in her practical, clear-sighted way, was a triumphant example of the ruthlessness and rightness of her instinct. She was made fully aware of the 'strong pressure' from family and old friends not to move from the safety and 'suitability' of Kensington or

Mayfair to the distant and decidedly less respectable purlieus of Bloomsbury. Precisely this sort of pressure and interference helped propel Vanessa beyond convenient calling distance, and thereby brought the euphonious 'Bloomsbury' into universal language.

During the initial stages of Virginia's recovery it was considered by Virginia's doctor, Dr Savage, probably reinforced by Vanessa, to be better for Virginia if she remained distant from the stimulation of London and the turmoil of the move for a little longer. So at the end of October she went to stay with her Quaker aunt Caroline Emelia Stephen in Cambridge. While there she contributed some reminiscences of her father to F. W. Maitland who was writing his biography.

Vanessa wrote daily, exhorting her to live sensibly, encouraging her to endure life with the aunt she called Nun, and offering always the requisite mothering, 'My own baby – how I long to know how you are. You must be well cossetted for a year.'[41] Virginia grew increasingly bored and restive, 'the quacking Quaker' was irritating her intensely with her trivial talk and her fussing old-womanish nature. 'The only place I can be quiet and free is in my home, with Nessa: she understands my moods and lets me alone in them,'[42] she complained to Violet. But Vanessa, engrossed in the novel delights of decorating and furnishing their new house entirely to their liking (pale walls, sparse furniture, light everywhere with dashes of vibrant colour from the family's collection of Indian shawls thrown over a table or chair), was reluctant to plead Virginia's case too forcefully with Dr Savage.

The excitement of beginning her new life at the age of twenty-five, the life of which both sisters had plotted and dreamed since they were girls, could not be subdued in Vanessa for long. Remote in distance and spirit from the constraints of their old life, Vanessa, and Virginia too – though belatedly and more tentatively – felt elation at striking out on their own. 'Life was exciting, terrible and amusing and we had to explore it, thankful that one could do so freely,'[43] Vanessa was to write in a memoir years later, keen to underline just how unusual and precious such freedom was to young women then. Virginia, also in retrospect, explained something of the personal significance of the move: 'The gulf which we crossed between Kensington & Bloomsbury was the gulf between respectable mum[m]ified humbug & life crude & impertinent perhaps, but living.'[44]

Thoby had his own quarters at 46 Gordon Square and his friends began to come to visit Vanessa in her white rooms, Clive Bell among

them, enquiring about Virginia. But as yet, putting the house straight and trying to keep Virginia happy in her convalescent exile absorbed most of Vanessa's thoughts and energies during the autumn of 1904.

Vanessa's genius for decoration, her capacity for creating around herself, in whatever place she happened to be, the exact space and colour and form which she found most harmonious to her nature and conducive to work, was given its first free rein in this spacious, airy, even chilly, house. This channelling of a large measure of her creative energy into everyday life was to culminate, more than a decade later, in her masterpiece of Charleston farmhouse. But here at Gordon Square she was exploring her decorative abilities for the first time. We have her assurances that, to her painterly spirit, 22 Hyde Park Gate was visually bereft, spiritually oppressive, at times, almost physically stifling with its closed-in darkened rooms. The windows were hung with creepers on the outside and heavy curtains within, the paint-work was black, the overcrowded rooms stuffed with light-absorbing furnishings; there was no view, no horizons, only the layer upon layer of family associations, many of them unhappy, all of them retrogressive.

Vanessa felt strongly that in a family of writers she, as an artist, was an outsider. They did not see as she saw and what they saw had quite different significances for them from those she recognised. In desperation she had attempted a small reform at 22 Hyde Park Gate, which involved banishing a few of the ugliest and most sentimental of the multitude of family photographs which stood in serried ranks, virtually invisible, it would seem, hidden as they were by flower arrangements and curtains and general Victorian paraphernalia in the darkest corner of a dark room. But because of the human associations they embodied, the writers in the household noticed immediately, Vanessa asserts half in jest, accused her of sacrilege and demanded their reinstatement.

Her much bolder dismantling of an enormous and grimy chandelier, that had hung 'from time immemorial' in the centre of the sitting-room and effectively blocked what light there was, produced a much more dramatic change – as far as she was concerned – 'Light flooded the room and we felt horrible exposed in our guilt. But no one noticed – you see the chandelier had only been a mass of colour and reflected lights and semi-transparencies – it had no particular human associations.'[45] It was a revelation to her that such a release of light and colour, the very basis of her way of appreciating the world, barely

impinged on the literary sensibilities and traditions of the family she lived amongst.

At Gordon Square, Vanessa was in charge. She was the oldest, Thoby was absent much of the time, Adrian was still at Cambridge and Virginia was convalescing in the homes of friends and family. To begin with the interior was very spare and the great draughty rooms, heated only by coal fires, very cold. Walls, windows and floors were largely bare, as Vanessa had yet to gain the confidence to begin imprinting the very fabric of the house, the walls, the shutters and doors, with her own decorative vision of patterns and figures applied freely with brush and paint. She contented herself with enjoying the novelty of so much uncluttered space and unobscured light. For the time being the Indian shawls as well as some newly bought green and white chintz, and the natural beauty of the family's extensive collection of calf-bound books, provided pattern and colour enough.

Having sold all the surplus family furniture at Harrods, Vanessa was left with a few of the best bits to which she added a new desk and sofa to make Virginia's sitting-room welcoming, and a red carpet and table for their shared white dining-room. The bareness and clarity of the rooms seemed to throw into much greater prominence the few paintings and pieces of furniture she had retained. Five of the best photographic portraits of their mother by Julia Margaret Cameron, which she hung in the hall, astonished her rather by how beautiful and striking they looked as a set. It was cold. She was alone for much of the time until Virginia returned to resume life there, yet Vanessa recognised the renaissance that this move represented for her: 'It was exhilarating to have left the house in which had been so much gloom and depression, to have come to these white walls, large windows opening onto trees and lawns, to have one's own rooms, be master of one's own time.'[46]

Virginia too in the autumn of 1904, the year of such fundamental change in their lives, expressed to Violet Dickinson her sense of rebirth as she emerged chastened and renewed from the suffering of the summer.

> If there were a God, I should bless him for having delivered me safe and sound from the miseries of the last six months! ... What an exquisite joy every minute of my life is to me now ... I do think I may emerge less selfish and cocksure than I went in and with greater understanding of the troubles of others![47]

5
Marriage and Betrayal

'We [Virginia] have been your humble Beasts since we
first left our Isles, which is before we can remember,
and during that time we have wooed you and sung
many songs of winter and summer and autumn in the
hope that thus enchanted you would condescend one
day to marry us. But as we no longer expect this
honour we entreat that you keep us still for your
lovers.'

Virginia to Vanessa on the eve of Vanessa's
wedding day, 6 February 1907, *Letters*, vol. VI

BOTH VANESSA AND VIRGINIA married perilously late. For a young
Edwardian woman to reach the end of her twenties without having
captured a husband was seen to be flirting dangerously with spinster-
hood, and the limited, statusless life that implied. As it was, it took the
tragically early death of their brother Thoby to precipitate Vanessa
into marriage at the age of twenty-eight, with Virginia following suit
with great hesitation five years later at the old-maidish age of thirty.

Their old household at Hyde Park Gate had been rancid with
emotion and sexual barter. Vanessa and Virginia were the beautiful
virgin 'slaves', as Desmond MacCarthy recognised so pertinently,
expected by their menfolk and the interfering aunts to attract as
husbands men of highest status. Vanessa's hasty removal of the family
to Bloomsbury was in part a flight from the cloud of marital specu-
lation and intrigue that had hung so heavily over the two young
women when they had lived in Kensington, within a household of
men, weighty with the memory of a mother who made female boun-
teousness and selflessness an art form, and surrounded by a phalanx of
meddling female relations.

In the two years' respite following their father's death in 1904, and
before Thoby's death, the Stephen family lived together free from the
social expectations of others, free too from outside romantic attach-

ments. Virginia's fantasy was that they could continue to live like this for ever. Thoby made an imposing masculine head of the family, but it was Vanessa, of course, as the mother and she, Virginia, as the pampered and brilliant child, who formed the centre of this familial utopia. Adrian filled the place in her scheme, perhaps, of the family pet, large, lugubrious, of little real significance.

Vanessa did not indulge so readily in such fancies, but she was particularly happy in their new house in Bloomsbury, with the exhilarating freedom to work and entertain when and how she chose. So occupied was she with the pleasures of this autonomous life, so unaware always of the inner workings of her psyche, of her own unconscious desires, so unawakened sexually, that even in her mid-twenties this sensuous beauty was unconcerned with love. At last she had been able to put away her pearls, hang up her Mrs Young dresses and roll up her sleeves and work.

Virginia's recoil from erotic passion was more explicit than Vanessa's. Perhaps temperamentally she would never have been eager to abandon herself to the physicality of sexual passion, although she was astonishingly candid and unsentimental about the base essentials of humanity; someone, as Leonard Woolf was to recognise, who knew that 'dung is merely dung, death death & semen semen'.[1] In her writing and her relationships with Leonard and with certain women, particularly Vanessa, she was no stranger to amorousness and sensuality. Given her natural antipathy to lust, however, given her early experiences with a mad cousin, with predatory half-brothers, given too the haunting implications of her mother's fatal exhaustion and Stella's post-nuptial death, no wonder sexual desire was to assume a menacing quality, even an association with dying.

Thoby's Cambridge friends, who started to call regularly at the house, provided a minimum of romantic distraction, for most of them were homosexual and, to the Stephen girls' initial relief, largely immune to their physical charms and arrogantly impervious to the accepted view that all young men and women should marry.

As long as she could live with Vanessa, Virginia saw no reason at all for marriage. Certainly marriage to any one of this motley, shabby crew of Thoby's friends, to whom social etiquette was an unnecessary encumbrance, would have seemed strangely inappropriate: 'Secretly I felt that marriage was a very low down affair, but that if one practised it, one practised it – it is a serious confession I know – with young men who had been in the Eton Eleven and dressed for dinner.'[2] But in

order to counteract her feminine fate and evade matrimony, Virginia needed Vanessa's wholehearted conspiracy in the matter, and this she was not altogether certain of obtaining.

At Gordon Square they continued to share a lively social life. There were dances and dining out at least once or twice a week, activities which, to judge from Virginia's unpublished diary of the time, seemed amusing enough to them both. No doubt the absence of George's social pressure, hypocrisy and covert disapproval made a difference. But Vanessa's and Virginia's own greater maturity and the fact they had choice in the matter released them from duty into enjoyment. The significant expansion of their social and intellectual life, however, began with the establishment of Thursday Evenings in the spring of 1905. Virginia believed this was the germ from which sprang the phenomenon of friendship that came to be called 'Bloomsbury'. It began so indifferently, however, that it may well have appeared more as a contraction than an expansion.

Thoby's friends from Cambridge were invited to drop in inform-ally after dinner every Thursday evening. Cocoa and biscuits were on the house. Vanessa and Virginia had met most of these young men when they visited Thoby at Trinity during May Week in the year before their father died, and already had seen quite a bit of Clive Bell since moving to Gordon Square. They had been regaled with Thoby's generous – perhaps over-generous – appraisal of his friends' brilliance, eccentricities and general pre-eminence amongst the intellectual elite of their generation. Woolf, the austere Jew whose trembling hands betrayed his passionate nature, sent to subdue the natives in Ceylon; Bell, the Shelleyan blood; exotic Strachey, physically asthenic and prodigiously cultured; and Sydney-Turner, the avatar of pure intel-lect. The last three would come separately or together to Gordon Square along with other friends and occasional family, and these much heralded young men would sit, often in silence, until something worth their attention would surface in the conversation. Such a lack of basic social graces was first a shock and then a liberation for Vanessa and Virginia, who were themselves schooled so painfully in the niceties of drawing-room etiquette.

Virginia has left us a marvellously deft sketch of an archetypal first meeting when the rebellious, yet nevertheless Kensington-educated, Stephen sisters came up against the Cambridge-educated, Moore-inspired, intellectual élite. After dinner late one spring evening in 1905, three young men filed wordlessly into 46 Gordon Square and

folded themselves, catlike, into chairs and sofas to await proceedings. Vanessa's and Virginia's excitement and anticipation survived the first revelation of how undistinguished, even disreputable, these young lions looked. (Old family friends Kitty Maxse and Henry James were never to get over their disapproval on this point.)

Their second disillusionment was more difficult to ignore. These friends of Thoby's, renowned for their brilliant talk, hardly talked, although Clive Bell was always an exception both sartorially and conversationally; one of Virginia's disparaging nicknames for him, Parakeet, conveyed this flamboyance and natural volubility. Polite conversational sallies from the Stephen sisters procured an unadorned variation on the, 'No, I haven't seen that/been there.'³ Silence hung, not heavily as it might have done at Hyde Park Gate, Virginia assured us, but rather provocatively and charged with expectancy. Virginia sensed that the standards of what was worth saying had risen to exacting heights.

Then perhaps Vanessa used the word 'beauty' in mentioning an exhibition of paintings and the cats lost their languor, ears were pricked, whiskers bristled and the 'meaning' of beauty was pounced upon and tossed into the air. Virginia characterised herself during these early Thursday Evenings as being spellbound by the process of dialectic in their discussions of the great abstracts of Truth, Beauty, Goodness et al. She would follow each intricacy of the construction and then introduce her own carefully honed contribution. To have it accepted in the building of the dialectical edifice was the greatest pleasure to her. It was the discussion itself far more than any outcome that was important. It was what she and Vanessa had to say rather than how they looked or behaved that mattered, providing a refreshing shift in emphasis. She saw these evenings as the nearest she and Vanessa could get to the delights of undergraduate life.

Vanessa acknowledged that the presence of 'acute intelligence' gave these evenings a particular keenness, even though that intelligence often was unexpressed. She pointed out however, with her devastating matter-of-factness, that most of the time the Cambridge intellects were so uncertain themselves on what they meant by Truth, Beauty, Goodness et cetera that the opinions of two young women, less constrained in their thinking processes and with quite different points of view, were welcome and refreshing.

Vanessa and Virginia rapidly became the focus of these gatherings, their genii and personalities at the heart of this group of talented

friends. The one, at this time, implicitly wary of men yet startlingly clever, and prone to silences as disconcerting as Lytton Strachey's could be; the other magisterial and remote as a Victorian matriarch yet essentially sympathetic, with a surprising and bawdy sense of humour and a basic understanding of men and their values. Virginia was to protest that she found the company of women far more interesting. During a meeting a few years later of these male friends, she wrote to her absent sister, 'They sat round mostly silent, and I wished for any woman – and you would have been a miracle.'[4] Vanessa preferred always the company of men.

The sisters, having suffered the sense of exclusion and social failure in the elaborate game of London Society, withdrew gradually – but for Virginia never completely – and set up their own more exclusive and interesting version. They turned their backs on the patronage, etiquette and suitable alliances with which conventional society was built and made their own rules and chose their players; embracing honesty, friendship and unsuitable alliances. They ended up practising an exclusivity far more ruthless and stringent than anything they had endured as girls.

There is disagreement on when the group came to be known as 'Bloomsbury', and because it was not a commune but rather a tendency, a mutual philosophy of work and life, it is not entirely clear who exactly were its constituents. Probably by about 1911, the term began to be used to describe the group of friends which began to collect at the fireside at 46 Gordon Square during 1904–6, pared down from a much larger and more fluid collection of the Stephen family and old friends.

The core of that famously intimate circle whose influence ranged over art, literature and economics, originally consisted of Vanessa, Virginia, Thoby (until his death) and Adrian Stephen; Lytton Strachey, biographer; Leonard Woolf, political writer and socialist activist; Clive Bell, art critic; Maynard Keynes, economist; Desmond MacCarthy, literary journalist and editor, and Molly MacCarthy; Saxon Sydney-Turner, sphinx-like civil servant; Roger Fry, art critic and painter; and the artist Duncan Grant. The novelist E. M. Forster philosophically belonged there too.

'Bloomsbury' functioned much as a large family would with its distinctive mannerisms and language, its sense of natural superiority and self-containment, tolerance of squabbles amongst its members, yet fierce loyalties and impenetrable solidarity when facing criticism

from outside. Vanessa accepted naturally her role as repository of maternal warmth and wisdom, for she had the prime example set by her mother of how to bind a disparate family with an unfaltering devotion to herself.

It provided these two orphaned young women with the security of a largely sympathetic nucleus of support which allowed them to venture into the world with their most personal offerings. The evolution of this proxy family gave both Vanessa and Virginia the freedom to experiment in their work and in their personal lives, ignoring the strictures of more conventional society. If they had continued as two parentless young women with conventional elder brother and half-brothers, struggling alone towards their vision of a freer, more honest existence, they might have felt isolated, disheartened and, eventually, given way. All the pressure would have been on them to succumb to a way of life more appropriate to women of their class and breeding.

Virginia, who with Vanessa was the other pole of attraction and influence, offered something quite different and much less comforting to this group of friends. As a young woman in company she exhibited, most disconcertingly for some, the extremes of her character. She could be silent and aloof, offering a hand but not a glimmer of a welcoming smile on introduction to a new acquaintance; but then again she could be mesmerisingly witty and fantastic in her speech. She would appear cool and forbiddingly critical at one instant and then alight with the most genuine affection and generosity the next.

Her intelligence, sensitivity and imaginative virtuosity made Virginia Stephen uniquely fascinating but, in those early days, difficult company. Everything about her was concentrated and intense: her feelings for her family, her possessiveness of Vanessa, her suspicion and envy of what Cambridge had given her brothers and male contemporaries, her curiosity about other people's lives, her acute intellectual percipience and her voluptuous savouring of the sensations and amusements of everyday life. All was felt keenly, lived intensely. But in those early euphoric months of freedom at Gordon Square her energies were centred on her life with Vanessa, her work and her determination that this life should continue unchanged.

This determination, however, demanded the collaboration of her sister. As the two central women in such a group of intellectual young men they may well have felt liberated from the forced preoccupations of dress, comportment and courtship; but Vanessa, at least, knew that there were desires and possibilities, as yet unknown, which

in the end would lead them all to marriage. Virginia watched in a great looking-glass as her sister stretched her arms languorously over her head, excited by her own beauty and seductiveness, and realised with a chill that Vanessa could not be trusted to keep this sisterly compact. As Vanessa pronounced – much as Mrs Ramsay or perhaps their mother might have done – that it was inevitable that they would all marry, Virginia 'could feel a horrible necessity impending over us; a fate would descend and snatch us apart just as we had achieved freedom and happiness.'[5] The catalogue of deaths in the sisters' pasts was enough to make them expect and fear further loss. Virginia feared, more than anything, the loss of her adored Vanessa; her only sister and substitute mother. She was the focus of a fierce almost erotically possessive love, Virginia's sheet-anchor to life. 'If you died, my life would be worthless,'[6] she wrote to Vanessa when she was in her late twenties and the intensity of that dependence never really left her.

The first major threat to the sisters' solidarity was to come from the heart of the group which had been one of the factors in their social liberation. From the beginning, Clive Bell had been a frequent visitor to Gordon Square. In many ways he was an anomaly in that group of friends. Thoby had described him to Vanessa and Virginia before they had got to know him as 'a sort of mixture between Shelley and a sporting country squire';[7] Leonard Woolf had been arrested by his first sight of him at Trinity College, walking through Great Court in full hunting-rig complete with a hunting-horn and in the company of his whipper-in, plus whip.

Unlike Leonard Woolf, Saxon Sydney-Turner and Lytton Strachey, who not only considered themselves intellectuals but were grateful to have their superiority even amongst other intellectuals sanctified by membership of the Apostles, Clive Bell was as at home in the hunting field as he was late at night in smoky college rooms, batting a philosophical conundrum in front of the fire, or gazing enraptured at a Cézanne in some Paris studio. He was not an Apostle, did not belong to that secret Cambridge élite, and although he had a genuine passion for literature and a witty and discriminating mind, this robust and worldly element in his character, his artistic interests too, set him slightly apart from the 'intellectuals'. It meant that there was an element of disdain at times in Woolf's and Strachey's attitude towards him – a certain snobbery from which Virginia herself could not be entirely absolved. In a biographical exercise addressing Clive's

early life she, with some irony and no doubt an essential accuracy, illuminated his intellectual pretensions as a youth: 'He quoted Shakespeare in a shrill triumphant voice, when there was no occasion for it, and scorned the young lady who asked him for the name of the author.'[8]

Thoby got on famously with Clive; but then he also appreciated the profane pleasures of the field as much as the Holy Communion of intellects. By contrast, it was the masculine certainties of college life, crowned by membership of the Apostles, which were to prove the most sublime experience of Leonard Woolf's and Lytton Strachey's lives. They and other members of that Apostolic élite would never quite recapture the exhilarating sense of exclusive superiority, of intellectual supremacy and affectionate community. The nearest thing, perhaps, was the coterie that formed around the magnetic Stephen sisters.

Clive Bell was not to suffer the *Weltschmerz* on leaving Cambridge which seemed to afflict those of his more self-consciously intellectual contemporaries. His temperament was much more optimistic and his best years were always yet to come. He was to have an extensive influence on both Vanessa's and Virginia's lives. Avid for experience, unequivocally heterosexual, confident, enthusiastic; Clive Bell was a young man thoroughly at home with his instincts and as such he was a peculiarly attractive contrast to the shy, diffident and difficult males of the Stephen family.

In a group of largely silent, self-consciously cerebral young men, he was robust, with an exuberant appetite for the gentlemanly pursuits of both the countryside and the bed. And he could talk. With great charm, humour and felicity he would energise the most torpid conversations. But at times his more austere friends accused him of exasperating fatuity. Most tellingly of all, in a group of largely homosexual young men, 'buggers' as Virginia was to call them unequivocally, a bugger Clive emphatically was not. Having been introduced to women and sex at a young age, he brought his breezy heterosexuality into the homoerotic insularity of early Bloomsbury and laid it at the feet of Thoby's beautiful sisters. He was smitten by them both: Vanessa, who had her brother's classical beauty enhanced by an enigmatic femininity and unexpected wit; and Virginia, a more delicate beauty animated by an originality which left others rooted, prosaically, to the ground: 'Vanessa, & her sister, the two people I love best in the world.'[9]

So the sisters' freedom from marital intrigue was not to last long. In the summer of 1905, after barely six months of life at Gordon Square, Clive Bell proposed to Vanessa. She had no trouble in declining. She explained to her old painting friend Margery Snowden that she had no idea his friendship had taken this particular turn; and she found the whole shift in emphasis rather intrusive, for now she was forced to think about marriage, even if it was only to reiterate her opposition to it. Certainly, her explanation would have reassured Virginia; 'I am conceited enough to believe that my family wants me – & as far as I am concerned I get all the fun & none of the bother of married life as it is.'[10] To Clive himself she explained in retrospect that his first proposal came as such a surprise to her because she 'had always taken it for granted that you thought me rather stupid & quite illiterate & were only polite to me because of the rest of the family.'[11] The rest of the family, against whose attractions she measured herself so unfavourably, were brother Thoby and, particularly, the incomparable Virginia.

During the following year Clive renewed his proposal more than once. Vanessa was increasingly adamant in her dismissal of his suit. However, his fortunes and Thoby's were to become tragically linked. At the beginning of September 1906, Vanessa and Virginia left England in the company of Violet Dickinson on their way to Greece. There they met Thoby and Adrian and continued on to tour the sights. By the beginning of October Vanessa was ill but she still expressed her antipathy to marriage, suggesting in a letter to Clive that they should not see each other for a time. There was a sense of her being harried and troubled by his persistence. After nearly two months away, Vanessa and Virginia returned to Gordon Square with Vanessa still unwell and promptly sent to bed. Thoby had already returned home ill and they found him bedridden with some mysterious disease which did not respond to treatment.

Even in this house of illness and mounting gloom, Vanessa felt adamant enough that she did not wish to marry Clive Bell. In her straightforward way she was brutally specific: 'Dear Mr. Bell ... It seems to me that in every way it would be best if you were to go away – I thought for a year.'[12] That was written on 8 November 1906. Thoby's health declined, misdiagnosed and wrongly treated. The sisters' sense of powerlessness in the face of medical ignorance and bungling was a nightmarish repeat of the desperate confusion and mismanagement during the weeks when Stella's life had seeped away.

Too late, the doctors realised Thoby had typhoid. Twelve days after Vanessa had written that dismissive letter to Clive, Thoby died. Two days after his death, Vanessa accepted Clive Bell's proposal of marriage.

Virginia was struck forcibly and unexpectedly with a double loss. Thoby, the heroic brother both sisters had fought over, was dead at twenty-six. And then within two days, the anchor of her life, the person she loved most in all the world, had given her allegiance to an interloper. Virginia could not accept the brutal reality all at once and in her letters to her old mentor and mother-figure, Violet Dickinson, herself ill at home, she kept up a bizarre fiction of Thoby's continued recovery and restoration to health. These remarkable letters covered the month after Thoby's death and are poignant with bogus medical reports and wishful details such as, 'Thoby is going strong – at least the dr. is satisfied and the nurses are pleased: he begins to curse a good deal, and points out the virtues of a mutton chop,'[13] written well over three weeks after his tragic end. Virginia only stopped the fantasy when Violet found out the truth from a report in the newspaper. She excused her actions by saying she wanted to protect her friend from the news until she was better. But it was Virginia who needed to protect herself from the awful truth – until she could pretend no more.

Vanessa also was in a state of shock. Drowning, she had put out a hand. Her decision to marry was clearly made under duress, as the result of an extraordinary and tragic situation. It was a decision quite contrary to her previous reasoning and perhaps against her unwrought instinct too. There is a sense that in embracing Clive she was attempting to evade the agony of grieving yet another death in this her most intimate family; that she was attempting too a spontaneous substitution for her lost brother. This was partially borne out, in a letter to Madge Vaughan, by the bizarre juxtaposition of philosophic acceptance of Thoby's death with her own happiness:

I do feel that Thoby's life was not wasted. He was so splendidly happy, in these last two years especially, with everything ahead of him full of the best possibilities and able to see constantly all the people he most cared for, that sorrow does seem selfish and out of place, more than with most people. But I as yet can hardly understand anything but the fact that I am happier than I ever thought people could be, and it goes on getting better daily.[14]

Nevertheless, by this strange transmuting of death and grief into life and celebration, Vanessa managed to evade her profoundest feelings and, for a time, was made most happy.

By substituting the dead, god-like Thoby with the living and all too human Clive, Vanessa's engagement and marriage was at first, artistically and sexually, a most liberating time. Vanessa's physical blossoming from pale convalescence to full pre-marital beauty was almost miraculous to behold, and Virginia, loving her, could not but be caught up in excitement and wonder: 'She had a gauze streamer, red as blood flying over her shoulder, a purple scarf, a shooting cap, tweed skirt and great brown boots. Then her hair swept across her forehead, and she was tawny and jubilant and lusty as a young God.'[15] But then marriage and sex too had this unnerving power to change people; and certainly Vanessa, with the experienced and sensual Clive as her lover, did appear to Virginia to grow palpably more beautiful, more confident, more remote.

Sexual desire and fulfilment were to come relatively late to Vanessa but they came as a revelation and a means of expressing her affectionate, voluptuous nature that she took to with gusto. She explained, years later in a letter to her son Julian, that she, and most other girls too she surmised, felt initially only the vaguest sexual yearnings suggesting, 'they don't suffer from unsatisfied lusts till much later.'[16] And it was this awakening to the intense pleasures – and eventual anguish – of erotic love that the ever curious Virginia watched in her sister. It was one of her anxieties that through sexual intimacy a completeness in one's nature was somehow broached, something elemental lost for ever. Vanessa's transformation was both gratifying and dismaying.

Despite Vanessa's evident happiness, Virginia believed nobody could ever be good enough for her sister and nothing could make her regard the forthcoming separation of herself from Vanessa with anything other than suspicion and pain. Her letters to Violet Dickinson, her main confidante at the time, showed admirable restraint and a desire to make the very best of things for Vanessa's sake. But the strain of being reasonable and generous sometimes told, and understandable anger and fear broke through:

I shall want all my sweetness to gild Nessa's happiness. It does seem strange and intolerable sometimes. When I think of father and Thoby and then see that funny little creature twitching his pink skin and jerking out his little spasms of laughter I wonder what odd

freak there is in Nessa's eyesight. But I dont say this, and I wont say it, except to you.[17]

Just as with their father's death, Virginia was left mourning – alone once again, it seemed – the catastrophic loss of a brother such as Thoby, while Vanessa was caught up in the whirl and ecstasy of her new life. Virginia was left as the custodian of the family's grief and she alone shouldered the responsibility of remembering, recording, and eventually memorialising the beloved dead in her greatest fiction. For her, even more than for Vanessa, the freedom of their early Blooms-bury associations had been exhilarating in its intellectual austerity and apparent lack of sentimentality. Although Virginia was to discover only later that what had seemed to her at the time a refreshing lack of interest in love was confined merely to its heterosexual expression; the loves of 'the buggers' was for most of them as preoccupying as conventional marriage-broking ever had been at 22 Hyde Park Gate

With Vanessa's marriage to Clive, the early simplicity and reserve of 'Old Bloomsbury', as it came to be called by its members, was over and the more gregarious and social Bloomsbury gradually came into being. In retrospect Virginia was to recognise that this change was inevitable and liberating in itself. But at the time she viewed Vanessa's marriage and the transformation of the sisterly relationship and their way of life, so hard won, with powerfully mixed feelings.

Considering the extraordinary intimacy of the compact between the sisters, the 'us against them'; considering that Vanessa by marrying was not only loosening – perhaps even severing – their bond from nursery days, but also was inviting a stranger, and a male, into the most private recesses of her life where previously Virginia alone had dwelt; considering that a significant part of this new contract between Vanessa and 'this funny little man' was a sexual intimacy with her sister which Virginia could never share: considering all this, Virginia's restraint was heroic and Vanessa's conciliation supreme.

An extraordinary letter, written by Virginia to Vanessa on the eve of her marriage, revealed just how sexually possessive and directly rejected she felt – and yet how generous and affectionate she could be in defeat. She wrote using a plurality of pet animal names for herself:

We the undersigned three Apes and a Wombat wish to make known to you our great grief and joy at the news that you intend to

marry. We hear that you have found a new Red Ape of a kind not known before who is better than all other apes because he can both talk and marry you; from which we are debarred . . .

We have been your humble Beasts since we first left our Isles, which is before we can remember, and during that time we have wooed you and sung many songs of winter and summer and autumn in the hope that thus enchanted you would condescend one day to marry us. But as we no longer expect this honour we entreat that you keep us still for your lovers, should you have need of such, and in that capacity we promise to abide well content always adoring you now as before.[18]

Not only did Virginia fear losing a sister, however; she feared too that her own virginity and autonomy thus were made vulnerable. Friends and family started talking about her marrying. Vanessa's succumbing to her female destiny had made it almost inevitable that Virginia would have to follow suit. The two sisters united might have stood out against family, society and their female destiny; Virginia, on her own, felt the vulnerability of the outsider and the force of others' expectations: 'The world is full of kindness and stupidity, I wish everyone didn't tell me to marry. Is it crude human nature breaking out? I call it disgusting.'[19]

But Virginia recognised happiness to be, for their family at least, a fragile, fleeting thing and she did not wish to detract from Vanessa's in any way. Vanessa evaded the full tragic impact of Thoby's death by turning so rapidly to embrace his friend and the uncomplicated vitality he offered. She seemed surprised by the intensity of happiness that had come her way. She felt in some profound sense unworthy of it: 'Have any other engaged couple ever seen each other in the way we have I wonder? . . . I get morbid sometimes & think I must be boring him or that it is all too wonderful to be true & some awful catastrophe must happen but after all I suppose it *is* true – Isn't it? What does your philosophic mind think, Billy,'[20] she wrote to her sister. Surely the ghost of Stella's short-lived married bliss shadowed both sisters' memories; 'I think that is why she is so completely happy; it is a kind of economy, because it mayn't last,'[21] Virginia confided to Violet Dickinson.

Vanessa married Clive Bell at St Pancras Registry Office on 7 February 1907. Thoby had been dead for just two and a half months. For that first year or so Vanessa was so transformed with a carefree

happiness that as Virginia exclaimed, 'God made her for marriage; and she basks there like an old seal on a rock.'²²

The inevitable separation, however, of the sisters was a wrench for them both. Despite her happiness, Vanessa too was reluctant to relinquish her old intimacy with her sister who had accompanied her this far. While waiting for the train to take her on her honeymoon, having parted from her less than an hour earlier, she wrote a short amused letter to Virginia, charting her and Clive's dilatory progress to Paddington Station. Still on honeymoon, she wrote at the end of March on the eve of Virginia's removal to a new house shared with Adrian at 29 Fitzroy Square: 'I wonder what I shall feel like, living alone with Clive in Gordon Square which yet will be quite different from Gordon Square. The old woman who woke up & said "Is it I?" won't have had nearly such odd sensations as I shall have.'²³ By the summer she was writing, only partly in jest, that Virginia would have to live with her again. She day-dreamed that the sisters once more would share a country house.

As Vanessa endured the long summer holidays, isolated within the claustrophobic mundanity of her family-in-law's house in Wiltshire where Clive naturally became more of a Bell, she found herself longing for the infinitely more amusing and talented Stephen family: for Virginia in fact. Letters were the only consolation and Virginia's were so quick with affection and flattery, so full of amusement and gossip, conveyed in prose of effortless brilliance that no one could attempt to match. To Vanessa, mired, as she felt, in Wiltshire banality or male bloodlust on a shooting weekend in Scotland, Virginia's coruscating letters seemed to come from quite another world, one of art and intellect and social rebellion.

It was not that life with Clive was dull. Rather, it was that the demands made on Vanessa's time and energy as a wife, and soon as a mother too, encroached on her precious opportunities for painting. She was forced to spend time doing things she would never choose to do had she still been living the carefree, independent existence with Virginia at Gordon Square. Yet life with Clive released Vanessa's naturally erotic nature. He gave her a confidence in her own sensuality and physical beauty that Virginia would never find in herself.

This burgeoning of the instinctual side of her nature was to make Vanessa queen, among Bloomsbury, of the sexual and procreative. This was a domain in which no one challenged her authority, in which she could excel but where Virginia could not as yet venture. In this

way Vanessa sidestepped, with triumph, those early painful comparisons with her brilliant younger sister. As a wife, lover and mother, she could be loved, worshipped even, for quite different qualities from those in which Virginia had been pre-eminent always.

Clive also, most importantly, was almost as interested in painting as was Vanessa. His particular talent lay in criticism and exposition but his informed enthusiasm and fine judgment provided Vanessa with the second great revelation of her early married life. At last she could share intimately with someone else her obsession with art. He filled for a time her hunger for artistic fellowship and intimacy, a need which would lead her into the two other important sexual relationships in her life.

Vanessa's and Clive's first child Julian was born on 4 February 1908, a year almost to the day after their marriage. Julian's arrival marked a detachment in her relationship with Clive, initially more of his making. Vanessa was to find the claims of this new vulnerable human being debilitating, yet utterly irresistible. To Clive, however, who could not bear the noise, the disorder, the deflection of attention, this infant son, on a mundane level, was entirely resistible. He refused to hold the baby; frailty and unreason unnerved him. He no longer slept with Vanessa; once woken by Julian he was too disturbed to get to sleep again.

Vanessa felt increasingly marooned by marriage and motherhood, while life and art – particularly her sister's life and art – went on without her. Virginia had much more sympathy for Vanessa's predicament, greater imagination as to how mother love fettered, frustrated and helplessly enthralled. Nevertheless, she too resented this bawling scrap of humanity which displaced her claims as Vanessa's only child, distracted Vanessa's attention, exhausted her emotional reserves and snatched time and love from Virginia's own hungry childlike self.

With Vanessa's two self-centred lovers thus disaffected, Clive's longtime fascination with Virginia was provided with the soil in which to grow. Virginia's motives for embarking on an extraordinary and painful flirtation with her brother-in-law, with at times what appeared to be the connivance of Vanessa, were a more subtle and complicated matter. And Vanessa's feelings were dissembled, obscured even to herself.

Uppermost in Virginia's mind at this time was the loss of her sister, first to marriage and then, further, to motherhood: 'Nessa comes

tomorrow – what one calls Nessa: but it means husband and baby, and of sister there is less than there used to be.'[24] But along with the sense of being forcibly separated from her, after nearly three decades of sisterly intimacy, was a tantalising image of the once prosaic, unchallenging elder sister – 'the Saint' of their nursery – become a saint no longer, but rather a seductive, mysteriously fulfilled, and fruitful woman. From this time, Virginia characterised Vanessa as goddess: life-giving, elemental and difficult to placate.

> To be with her is to sit in autumn sunlight; but then there is Clive!
> ... We are all so much dry or green wood, thrown on her flame;
> and it dont much matter to that portent what it feeds on: it
> 'transmutes'.[25]

There was a new-found profligacy too about Vanessa – 'she overflows in all ways'[26] – which attracted Virginia. But she was repelled too. The image of her sister pulling the heads off flowers 'like a wasteful child',[27] which she described to Violet Dickinson in a letter, occurred again in an early version of Virginia's first novel *The Voyage Out*, when a branchful of apple blossom was destroyed wantonly by the heroine's mother, the destructiveness of the act thrown into relief as 'the whole burden of autumn fruit vanished in a moment.'[28] There was something alarming about Vanessa appearing suddenly to have so much richness in her nature and her life that recklessly she could so disregard, even destroy, the fragile promise in others.

There was no doubt that Vanessa's marriage and motherhood altered fundamentally the balance of the relationship between the sisters. Virginia was to remember always the date of her sister's marriage, but was vague about her own; on 12 August 1918, she wrote in her diary, '(I believe this is near about the anniversary of our wedding day, 6 years ago).' She was two days late. For it was Virginia who felt the outsider: unwanted, left behind, disregarded. This was the feeling which had driven her in the nursery to break into the close relationship between Vanessa and Thoby, and seek to enchant this coveted brother with the weapons of wit and charm which his more responsible elder sister could never conjure. This old fear of being the outsider was to cause Virginia to repeat that plunder of Vanessa's necessarily exclusive relationship with Clive, and was to bring lasting pain to both sisters. To Clive she explained her double loss: 'Nessa has all that I should like to have, and you ... have her.'[29]

The memory of that lost intimacy was used by Virginia in her lighthearted and revealing autobiography of Elizabeth Barrett Browning's spaniel Flush, the animal which, her biographer Quentin Bell pointed out, Virginia identified with closely. The intense relationship between mistress and pet was a mirror in part of that pre-marital conspiracy between herself and Vanessa. To Flush's impotent horror, Elizabeth Barrett was falling in love with the hated interloper Robert Browning:

> What was horrible to Flush, as they talked, was his loneliness. Once he had felt that he and Miss Barrett were together, in a firelit cave. Now the cave was no longer firelit; it was dark and damp; Miss Barrett was outside He whined. They did not hear him. At last he lay in tense and silent agony.[30]

The sentiments expressed bore a striking resemblance to the extraordinary letter Virginia wrote to her sister, on the eve of her marriage to Clive, when characterising herself as a plurality of beasts, she lamented that she was debarred from marrying Vanessa herself by being of a different species. Flush watches his mistress transformed with love for this human male, and then suffers the ultimate isolation: 'Flush, poor Flush could feel nothing of what she felt. He could know nothing of what she knew. Never had such wastes of dismal distance separated them.'[31]

Knowing nothing of what Vanessa knew, the virginal Virginia's fear was that, as a woman, crossing the sexual divide would transform her and inexplicitly diminish her integrity and selfhood. Only on her honeymoon was this to be assuaged when she discovered, with some relief, that in every salient respect she remained still the Virginia she had always been.

Her letters to Vanessa from the time of her marriage in 1907 to Virginia's own marriage in 1912 were amongst the most passionate, admiring and needy of affection of any that she wrote. Vanessa acknowledged this: 'I read your letters over & decided with Clive that when they are published without their answers people will certainly think that we had a most amorous intercourse. They read more like love-letters than anything else – certainly I have never received any from Clive that you could compare with them.' And then she added a further line, significant for the admission of her need, 'I like love-letters – the more passion you put in the better ... I am greedy for compliments and passion.'[32]

After the first year or so of happiness with Clive, the realities of being a mother and a wife of an amiable but self-centred man, who intended to continue his bachelor existence with as little compromise and disruption as possible, pressed in on Vanessa, depriving her of painting time, of freedom, and of Virginia. For it seems, from her letters to Virginia during the period from Julian's birth to the beginning of her love affair with Roger Fry, that Vanessa's emotional needs were answered more reliably by her sister than by her husband.

Undoubtedly she still loved and wanted Clive, particularly as he detached himself further from their early intimacy, and her old fear of losing those she loved reasserted itself (two years into the marriage Clive had taken up again with his mistress, Mrs Raven-Hill). Vanessa's letters to him when he was absent were flirtatious, humble and self-effacingly affectionate. She was a 'poor little dolphin', referring to herself protectively in the third person, and uncertain as to his feelings in return; 'Do you miss her at all? but you won't tell me.'[33]

On the other hand, there was no doubting the strength and constancy of Virginia's feelings for Vanessa. There were periods certainly when the sisters wrote to each other daily, and in fact this tradition may have been upheld throughout the transition term of their separation, before Virginia married. Virginia's relationship with Vanessa was lifelong in duration: profound, intense and naturally exclusive in character. Clive Bell was the interloper, never considered by Virginia to be good enough for the Stephens, let alone for the Stephen whom she loved most in all the world and over whom she felt she had prior claim. This sense of Stephen superiority operated in Vanessa too. For her, on those protracted holidays in Wiltshire when Clive distressingly became more like his family, he seemed somehow alien, inferior to her own family whose best qualities of intellect, discriminatory wit and beauty were embodied in Virginia.

Clive, no doubt, felt some resentment of this particularly close sisterly relationship. If Adrian should be exasperated that his sisters wrote to each other daily, what might Clive have felt, given his young wife's morose silences at his parents' table, her reluctant support of him on shooting parties, seeing her transported by the arrival of a letter – or best of all Virginia herself – into a conspiratorial jokiness and intimacy no outsider could penetrate.

During these early years of motherhood and at times lengthy separations from London, Vanessa's letters were poignant with longing for the unreserved ease, enjoyment and affection that was

brought her by contact with Virginia. From Scotland, Vanessa wrote to her sister a characteristically wistful letter:

> There is an atmosphere of undiluted male here. How you would hate it! if only you were here we should now light a fire and sit over it talking the whole morning, with our skirts up to our trousers. You would say 'Now what shall we talk about?' & I if I were tactful would say 'Our past' & then we should begin & discuss all our marvellous past & George's delinquencies etc. & so come to our present & then to your future & whether & whom you would marry. & then at last to the one great subject. 'Now what do you really think of your brains Billy?' I should say with such genuine interest that you'd have to tell me & we should probably reach the most exalted spheres. Why aren't you here?[34]

It is against this emotional background that the romance between Virginia and Clive, Clive and Vanessa, Vanessa and Virginia – for it was in many respects a three-cornered love affair – needs to be placed. Of these three interleaved relationships the one which caused the greatest grief by far, to everyone concerned, was the flirtation between Virginia and her brother-in-law Clive. It began, understandably enough, with the birth of Julian and the irresistible engrossment of Vanessa in motherhood. The alliance between sister and brother-in-law was first forged in the spring of 1908, when Julian was just over two months old and he and Vanessa and Clive joined Virginia for the last week of her holiday in St Ives in Cornwall. There the baby's cries and Vanessa's preoccupations sent Clive and Virginia off on walks together, Virginia feeling 'a deserter',[35] to discuss ideas and literature in general, their futures, and her own writing in particular.

In Cornwall, the paradise of her youth, Virginia was in her element. Like her father she enjoyed long strenuous walks along cliff top and across country and no doubt Clive, accompanying her, discovered for the first time the unique delights of his sister-in-law's company. She was undoubtedly beautiful. Indeed for Clive female beauty was to be always especially affecting, but perhaps Virginia's beauty was invested with an added seductiveness by its close resemblance to his own wife's classic features. Virginia was also the cleverest and most entertaining woman Clive had ever met. Indeed she was cleverer and more entertaining than almost anyone he knew. That Lytton Strachey

should ask of him, one wet afternoon in the waste of the countryside, 'Love apart, whom would you most like to see coming up the drive?' then answer for them both, 'Virginia, of course,'[36] rang with absolute truth.

Clive's attraction to Virginia was perfectly understandable. That he should pursue it, however, given the intimacy and importance of the sisters' relationship, given too his greater sexual sophistication and Virginia's inexperience with men, was more culpable. Undoubtedly Clive was a sensual, susceptible and virile young man who had the intelligence and discrimination to celebrate creative genius in others, and to feel therefore all the more intensely the lack of it in himself. Neither Virginia nor Vanessa were content ever to do nothing. Their work mattered more to them than anything. To Clive, so readily distracted by the alternative pleasures of life, this dedication, this genius in the sisters, although temporarily suffocated in his wife by marriage and maternity, was enviable and infinitely attractive. 'Like all men who do nothing I am always extremely busy doing it,' he wrote to Virginia in the early part of their liaison, and added poignantly his sense of futility at this state of affairs; 'The things that are really worth having, – haven't I missed them somehow? ... I have missed something; amongst others, – a light to lighten the darkness.'[37] Appreciation of women was to become as much a vocation for him as was appreciation of art. The pursuit of love was to be for Clive, perhaps, a way of keeping at bay that darkness of the soul.

The extraordinary closeness of the sisters and, with Vanessa's retreat into motherhood, the increasing polarity and complementariness of their natures, made it inevitable that in loving one there was an irresistible fascination in the other. Leonard Woolf was to experience this, but sublimated the emotion within his second novel, *The Wise Virgins*. Clive was of a less controlled, less scrupulous, more amorous disposition. His fascination with Virginia was expressed as an erotic and intellectual flirtation that lasted, in its intense form, until Vanessa herself deflected her amatory interests on to Roger Fry in the summer of 1911 and Virginia succumbed to Leonard's courtship in the following year. But for Clive, no woman was able ever to efface the passion of his youth for these two remarkable women.

The very intimacy of this relationship aroused not only fascination but envy and resentment too in the hearts of the men they married. Certainly each sister, with fundamental Stephen hauteur, felt that the

other's spouse was in no way good enough and this natural superiority was recognised and accepted by both men. The Stephens were accepted as being intellectually and socially of a higher status than either the Bells or the Woolfs.

Leonard Woolf was the hard-working intellectual second son of a large, professional, Jewish family, impoverished by their father's early death and reduced to living in Putney. We know, from the unmistakable anger inspiriting *The Wise Virgins*, that the fact that families of natural privilege and position, like the Stephens, considered Jews and *arrivistes* inferior caused Leonard exasperation and pain. Perhaps Clive too suffered pique at such discrimination. His family had made their fortune from coal and, in common with most county families, their tastes were robustly philistine (animals and hunting animals dominated their conversation). A small part of the motive for his flirtation with Virginia might have been his need to charm the most important and most vocal source of Stephen disapproval. There may have been also a desire to moderate the passionate intimacy that bound these two sisters and made any newcomer, however welcomed, always something of an outsider. How better to weaken their solidarity than to woo both and set up a sexual rivalry, albeit covert, one sister against the other?

And set out to woo Virginia, Clive did. His charm for her, however, was not as compelling as hers for him; Clive had the disadvantage in this affair of a lively and demanding sexual nature while Virginia's responsiveness was more cerebral and romantic. Leonard, in his novel, caught the frustration inherent in such a passional imbalance when he made the Clive character storm against the sexual quiescence of the sister who was modelled on Virginia; 'She's a woman and a virgin ... Didn't you hear her say: "One wants so much." Wants? They don't know, they simply don't know what desire is. What they want is to be desired – that's all.'[38] There was also the sense that a comfortable privileged background made for pallid, dispassionate lives. Leonard's race and temperament made him full of passionate desires, revolutionary plans, compared with which the Stephen sisters seemed complacently self-sufficient and self-reflecting.

Virginia's part in this inward-looking triangle owed much more to her profound and passionate feelings for Vanessa than to any great emotional involvement with Clive. Catastrophic domestic tragedies and the minatory incursions by the men in their family into their

fragile and defenceless state had bound them in a mutually protective conspiracy. The sense of never being loved enough, especially by a mother who had then prematurely abandoned them, united the sisters in an emotional symbiosis, that to Virginia particularly was central to her life. This exclusive intimacy continued well into adulthood, and in some ways existed until Virginia died.

It was only to be expected, therefore, that she found the spectacle of her own Vanessa being taken up by, taken in by, the unworthy upstart Bell distressing in the extreme. It was particularly unsettling that Vanessa had agreed to marry Clive in the devastating aftermath of their brother Thoby's death. Once more death and sexual desire were intimately connected, both predators on her happiness. The one took Thoby from her for ever, the other claimed Vanessa in what at first appeared to be almost as irrevocable a loss. 'I did not see Nessa alone, but I realise that that is all over, and I shall never see her alone any more'[39] expressed poignantly her acute sense of bereavement.

During the early stages of Vanessa's courtship and marriage, Virginia's letters were full of wonder and adoration for her sister as she appeared to burgeon, through love, into an extraordinary beauty and creative power. But it was love for Clive, the discovery of sexual pleasure, the promise of a new life which had worked this transformation on Vanessa; they were all areas from which Virginia was essentially excluded. 'You dwell in the Temple,' she wrote to Clive, 'and I am a worshipper without.'[40] She felt too that she had lost her power to influence and affect Vanessa's life, having been for so long the most important element in it.

Virginia responded to her loneliness, fright and sense of abandonment by wooing her sister through Clive, joining him in a partly fantastic adoration of Vanessa which characterised her as a pagan fertility goddess. Virginia's letters to him at this time were full of voluptuous exhortations intended for her: 'Kiss her, most passionately, in all my private places – neck – and arm, and eye, and eyeball, and tell her – what new thing is there to tell her? how fond I am of her husband?'[41] They were emotional and amatory appeals to Vanessa which shared something perhaps of the over-emotionalism and inappropriateness of George's demanding behaviour to Virginia herself, in the claustrophobic years between her parents' deaths. Also, it became clear that this neediness in Virginia erotically enmeshed Clive to a degree that was not wished for or indeed understood by her. Her only instinctive need had been to make a place for herself

anew in Vanessa's life. Clive appeared to be the means by which she could re-establish that intimacy. But he was also a means of advancing the other great passion in her life, her writing.

Virginia was working intensively on what was to become *The Voyage Out*, and was quite single-minded in channelling Clive's romantic interest in her into invaluable criticism and encouragement of her efforts; a stimulus that, at the time, she desired more than any love affair. A letter she wrote to Clive on returning to London from her holiday in Cornwall with him, Vanessa and Julian, revealed clearly her puzzlement and evasive flirtatiousness in the face of Clive's teeming sentiments, her constant and intense preoccupation with Vanessa – and her overriding involvement in her own creative development.

Why do you torment me with half uttered and ambiguous sentences? my presence is 'vivid and strange and bewildering'. I read your letter again and again, and wonder whether you have found me out, or, more likely, determined there is nothing but an incomprehensible and quite negligible femininity to find out. I was certainly of opinion though we did not kiss – (I was willing and offered once – but let that be) – I think we 'achieved the heights' as you put it. But did you realise how profoundly I was moved, and at the same time, restricted, by the sight of your daily life. Ah – such beauty – grandeur – and freedom – as of panthers treading in their wilds – I never saw in any other pair. When Nessa is bumbling about the world, and making each thorn blossom, what room is there for me? Seriously nature has done so much more for her than for me. I shrank to my narrowest limits, and you found me more than usually complex, and contained ... There are various matters I should like to talk to you about; for, with my loose pen I am always afraid of inflicting gashes on your ears. I have been reading Lamb and Landor – and set beside them a page of my own prose. Lord! what vapid stuff! If you could have seen my misery as I was at this exercise you might have believed in my modesty. I see all you say of my looseness – great gaps are in all my sentences, stitched across with conjunctions – and verbosity – and emphasis ... Now I must face my novel. I think you will laugh at the natural trend of this letter.[42]

In fact this novel, written and rewritten with enormous commitment and intensity of feeling during the years between the sisters'

marriages, carried even greater autobiographical impact than that traditionally associated with first novels. One of its most interesting themes is the exploration of the relationship between the heroine Rachel Vinrace, faltering on the brink of life, her aunt Helen Ambrose (based largely on Vanessa), and the young man Terence Hewet (based loosely on Clive), who was to fall in love with Rachel and be drawn irresistibly to Helen, guardian and mentor – and substitute mother – in the motherless Rachel's life.

The most startling and erotic passage in the book described an almost dream-like confrontation between Helen and Rachel. Rachel and Hewet were walking together, both increasingly aware of a rare and fragile sense of happiness uniting their most unalike temperaments, when suddenly Helen makes her presence felt:

A hand dropped abrupt as iron on Rachel's shoulder; it might have been a bolt from heaven. She fell beneath it, and the grass whipped across her eyes and filled her mouth and ears. Through the waving stems she saw a figure, large and shapeless against the sky. Helen was upon her. Rolled this way and that, now seeing only forests of green, and now the high blue heaven; she was speechless and almost without sense. At last she lay still, all the grasses shaken round her and before her by her panting. Over her loomed two great heads, the heads of a man and woman, of Terence and Helen.

Both were flushed, both laughing, and their lips were moving; they came together and kissed in the air above her. Broken fragments of speech came down to her on the ground. She thought she heard them speak of love and then of marriage. Raising herself and sitting up, she too realized Helen's soft body, the strong and hospitable arms, and happiness swelling and breaking in one vast wave.[43]

Helen's jealousy and possessive love for the younger woman was expressed in this menacing and implicitly sexual scene. Her aggression towards Rachel, however, was transmuted, by means of a symbolic kiss between herself and Terence Hewet, into an ecstatic union of the two women, with Helen suddenly transformed into the forgiving, all encompassing mother.

The conflicts in this triangular relationship mirrored elements of the conflict in real life. The jealousy of the one woman, the submissiveness of the other; the lack of confidence in both even though

Helen seemed so omniscient and rich in experience ('What can I tell you? ... After all, though I scold Rachel, I'm not much wiser myself');[44] the marginality of the male: all was resolved here with a kiss. By the end of the novel, however, Rachel was unable to consummate her relationship, to voyage into adulthood, perhaps because her guide, in Helen, was not disinterested and in her own way fallible and incomplete.

The love affair between Rachel and Terence Hewet, in remaining chaste, thus was declared the perfect union, 'which had been impossible while they lived'. Virginia had Terence Hewet exult over Rachel's dead body: 'No two people have ever been so happy as we have been. No one has ever loved as we have loved,'[45] – echoing the sentiments of Julia Stephen for her first husband Herbert Duckworth, sentiments that had contributed poignancy and mystery to Virginia's and Vanessa's childhood vision of their mother. They were emotionally charged words, which were to linger in Virginia's memory and be used again to tragic effect in the final line of her last loving letter to Leonard, written contemplating her own death.

Vanessa's marriage to Clive had forced Virginia to separate psychically from her sister and therefore allowed her to be objective enough to transmute personal, subjective experience into a novelist's detached perspective. Through writing about the people she loved, Virginia sought to understand them, control them and secure them for ever, with a durability that seemed to be tragically lacking in life.

Although Virginia's first interest in her love affair with Clive may well have been to re-establish an emotional intimacy with Vanessa and to share with a receptive and intuitive critic the intellectual intimacy of her attempts at writing fiction, there must have been some excitement too for Virginia in being the focus of so much erotic feeling from the first unequivocally heterosexual man with whom she had had any close contact, as an adult and an equal. She admitted herself that the initial relief of escaping her family's and society's conventions of sexual behaviour, through the company of the buggers of Bloomsbury, had turned to irritation and boredom at the lack of any sexual interest between herself and these young men. To a young woman unsure of her sexuality, unsure of her feminine attractions, and afraid of the carnal male, Clive's gallantry could have been a necessary yet unthreatening initiation into the mystery of sexual love. His passion was domesticated by the fact that he was Vanessa's husband and therefore to Virginia not a serious contender for her hand or her virginity.

Virginia's innocence and naïvety about sexual passion and sexual jealousy, her self-centredness, were to make her unaware of the full destructive impact of such an intrusion on the most private and vulnerable part of Vanessa's life. Within a sisterly compact of trust and intimacy, any sexual or emotional involvement with that sister's husband is the most fundamental betrayal. Vanessa at the time, however, expressed nothing of her outrage and hurt. Her letters to Clive when they were apart were pleading, flirtatious and self-effacing; her letters to Virginia flattering and self-denigrating. She could well have put an immediate and conclusive stop to the whole thing by confronting Virginia, but instead absorbed the suffering as she had learned to do, and would continue to do, so effectively and self-destructively all her life.

Vanessa's part in this triangular love affair was curious and confused. After her marriage, and particularly since the birth of Julian, Vanessa's letters to her younger sister were peculiarly touching in expressing her need for Virginia's affection, reassurance, and above all for the unique stimulation of her company.

> I had a charming long letter from you this morning with flattering hints of rose-gardens & daylight round corners and I dont know what all. I purr all down my back when I get such gems of imagery thrown at my feet & reflect how envied I shall be of the world some day when it learns on what terms I was with that great genius.[46]

This she wrote at a time when Virginia's and Clive's flirtation was already established, a time of painful and contradictory emotions, the time Vanessa recalled ten years later in a discussion about jealousy when she suggested that intensity of emotion was in direct relation to one's evaluation of the person who aroused the jealousy: '[Vanessa] produced Virginia of whom she had been more jealous than anyone at a time when she admired her more than any woman she knew.'[47]

This was the tragedy of the situation; Vanessa and Clive were both enchanted by Virginia, both delighted in her intellectual and physical charms; both were hugely entertained and exasperated by her. In a reciprocal bind, Virginia and Clive shared a passionate reverence for Vanessa, undoubtedly enhanced by Virginia's seductive mythopoeic gifts; an intimacy vicariously reaffirmed perhaps through her new intimacy with that beloved sister's husband. Thus Vanessa found herself agreeing with her husband on the beauty and brilliance of this

rival for his romantic attention. Worse, she found herself longing for Virginia's company and diminished without her: 'Clive & I walked the garden last night & sang your praises till even you might have blushed ... there's no doubt you are a wonderful little animal an ape of the first degree ... Oh dear, I feel so old and dull in comparison.'[48]

During the period when this love affair between Virginia and Clive was at its height – and Clive's agitated letters bear witness to it being effectively a love affair, perhaps made all the more tantalising on his side by the fact that it was not consummated – Vanessa was at her most demoralised. She was having to conform to the demands of being the beautiful wife of a man with no regular occupation who spent weeks, indeed months, passing the time in pursuits which were thoroughly uncongenial to her and demanded periodic exile in philistine company, and separation from Virginia and London and London friends.

The birth of Julian had compounded this sense of her life not being her own to dispose of as she wished, of expectations which she felt inadequate to fulfil. Vanessa's pronounced maternal instinct, on her own admission, was not unleashed fully until the birth of her second child, Quentin. Until that time, the emotional and practical revolution in her life effected by motherhood was disturbing, frustrating and not entirely welcome. 'You can imagine that I play the part of the proud mother even less well than I did that of the engaged young lady,' she wrote from her parents-in-law's house in Wiltshire to Virginia in London, 'revelling in your genius'[49] as Vanessa imagined wistfully.

At this point in her life, Virginia embodied everything for which her benighted sister longed and, much like an extra-marital lover, she brought gaiety and interest to the mundane realities of Vanessa's domestically restricted life. Vanessa's engagement and the early days of marriage had brought her star into the ascendant, while Virginia could only watch from a distance the transformation of her sister into goddess: admiring, enraptured, excluded. So, when maternity temporarily leaded her feet, Vanessa too was excluded from Virginia's life of enviable creative and social freedom. She was left longing for time to herself to paint, while her younger sister's writing developed apace with regular reviewing for *The Times Literary Supplement* and solid and often exhilarating progress with her first novel. During this fallow time, Vanessa's need of the intellectual stimulation and amorous devotion offered by Virginia, combined with a sense of her own inferiority in the face of the boundless admiration she then felt for her

younger sister, may well have explained her surprising acceptance, even complicity, in the affair between her husband and her sister. To Clive she wrote:

> The Goat [Virginia] & I had a long talk – of a most intimate & interesting character – about which I shall tell you some day ... we have ranged over all subjects, our feelings for each other – you – her art – Art altogether – Lytton – Hilton Young – all very rarefied & exquisite. I enjoyed it thoroughly – & in fact I think its very odd that you dont go to tea with the Goat every day. I should if I were you.[50]

Then too, Vanessa's fascination and admiration for Virginia and comparative diminishing of her own abilities would be reinforced by Clive; she wrote to Virginia having seen her off to Bayreuth in the company of Adrian and Saxon Sydney-Turner: 'It was very melancholy leaving you on Wednesday night at least I felt it to be so, but perhaps you didnt ... we talked of you, but then we so often do – we did last night too – that I'm sure you cant be curious to know what we said. I will only say that the word "genius" did actually occur in our conversation more than once.'[51]

In this way, in the realm of the intellect where her insecurities were greatest, Vanessa seemed to need to nurture the relationship between her husband and her sister. In needing Virginia at this time so vitally to fertilise her own life, and in wanting to retain Clive's love and interest, yet uncertain of her own powers, perhaps she enlisted the attractions of the one to hold the other. But this invasion where no sister had a right to trespass hurt both Vanessa and Virginia deeply and left a lasting wound.

Decades later, Vanessa, in that discussion of jealousy related in Duncan Grant's diary, was to remember the peculiar force of the emotion at this particular time when her brilliant younger sister was the most admirable woman she knew. After all, had she not learnt in childhood the pain, the impossibility, of competing with her? But Virginia suffered too. Nearly twenty years later she recalled in a letter to a friend, that 'my affair with Clive and Nessa ... turned more of a knife in me than anything else had ever done.'[52] And self-aware as always she recognised the fact that her affair had been a triangular relationship and had more to do with love for Vanessa than with passion for Clive. The knife's wound was the damage done to the precious sisterly compact; the loss of Vanessa's trust and her sub-

sequent self-protective retreat. Years later and without knowing the reason at the time, Vanessa's daughter Angelica recognised 'a wariness on the part of Vanessa and on Virginia's side a desperate plea for forgiveness',[53] which in retrospect she realised dated from this period of emotional confusion and intimate betrayal.

And yet in suffering the sisters kept their own counsel. True to that characteristic of lapidary reasonableness that Vanessa was making her own, concealing even to herself her powerful and undifferentiated emotion, she expressed not one word of pain or outrage at this sister's flouting of a fundamental taboo. Only under pseudonomous guise in a letter-writing game indulged in during a few months of this fraught period, involving all three of them, plus a few of their closest friends, could she reveal to Virginia a fleeting sight of her hurt and sense of exclusion:

> Dearest Eleanor [Virginia] ... I never get at you at first hand now; it is always through James [Clive] that I have to find out how you are behaving & his accounts cannot be taken too literally. You seemed to have seen a great deal of him lately ... it is late at night & James [Clive] has deserted me. He said he was going to see Roger [Hilton Young?] & might look in on you on the way. So I shall perhaps hear of you from him – as usual.[54]

Vanessa's silent endurance was made more steadfast perhaps by the Bloomsbury code of reasonableness which extended into human relationships outlawing, in theory at least, the primitive and irrational passions of sexual jealousy, possessiveness and rage. Only obliquely could she retaliate by suggesting – as she did at this time – that Virginia had 'Sapphist tendencies'[55] and thereby attempt to reassert perhaps a little of her own sexual supremacy. More understandably perhaps, Virginia too refused to confront the serious emotions involved. Lytton Strachey, with his waspish perspicacity, had recognised on a visit to the Bells in early 1909 that Clive was in love with Virginia. Emboldened by his and his friends' use of assumed names during the few weeks this epistolary game survived, he raised the delicate subject in a letter to Virginia. She admitted it was not a happy state of affairs, and agreed that it was likely to be 'a little uncomfortable' for Vanessa, adding revealingly 'though I really won't admit it'.[56]

Vanessa's marriage and motherhood had broken that primary con-

spiracy of the sisters against the world and had excluded Virginia in a most fundamental way. No doubt it was an emotional re-enactment of those nursery tussles when she could not bear to be left out, determined to invade the close alliance between Vanessa and Thoby and make it stretch to include her too. Now the bonds were more complicated. Marriage made a prior claim on Vanessa, it physically separated the sisters, it cast Virginia out to exist as 'only an erratic external force, capable of shocks, but without any lodging in your lives'.[57]

Her capacity for shocks, however, was as great as ever. In the summer of 1910 a further serious collapse in her mental health was added to the continuing agitation caused by her flirtation with Clive. The responsibility for Virginia's welfare was thrown once more on to Vanessa's shoulders. This demand from Virginia for maternal solicitude could not have come at a worse time for Vanessa, who was awaiting the birth of her second child. Vanessa sacrificed her own peace of mind by leaving Clive behind with Virginia in the Moat House, a country house at Blean in Kent, which they had rented for most of June, in an attempt to treat through rest her incipient breakdown. Marooned in London for the summer awaiting her confinement, her letters to Clive during the separation showed her dependent and bereft: 'Dolphin [Vanessa's nickname] does want you back very badly. She feels very odd & forlorn having to arrange everything for her self Still I see that the Goat [Virginia] must be considered.'[58]

She was grounded in Gordon Square in London during July and August while Virginia was reluctantly incarcerated in the fastness of Miss Thomas's nursing home in Twickenham. Vanessa wrote daily to her unhappy sister who appeared to be on the verge of revolt or flight. These letters were eloquent of her concern and exasperation, of her natural assumption of a maternal responsibility and its concomitant guilt. 'I don't make undue fuss about you ... really I feel that I have made only too little fuss during the last three years,'[59] she wrote to her in remorse.

And then again, an uncharacteristic outburst of feeling for her husband left Vanessa vaguely uneasy and apologetic:

Oh dear how nice it will be to have you back ... I am quite cheerful but I do feel curiously lop-sided without you, & things crop up that I want to say to you every minute. I have been meditating on marriage, how odd it is, it seems to give me something that these

123

other people & I before I married had no conception of. It is you who give it to me I suppose not marriage. Your nature gives it to me. It is like being always thirsty & always have some delicious clear water to drink. You do make me astonishingly and continuously happy. *Be quiet Dolphin.*[60]

This tripartite love affair continued uneasily and intermittently from 1908, when Julian was born, until it tailed off in intensity as Vanessa found herself falling in love with Roger Fry, and Virginia married at last in 1912. It was a discomfiting, stimulating and, in different ways, dismaying period for them all. Love-letters were written, most notably between the sisters; Vanessa, marvelling at the amorous nature of Virginia's and encouraging her to be even more effusive in her expression of affection, for Clive, she declared, had never written her anything so passionate. Thoughts of Virginia and the pleasure of her letters – amongst the best she wrote – fertilised the temporary wasteland of Vanessa's creative life. Writing from the Bells' house in Wiltshire: 'I wont go on [complaining] only the contrast between this and your beauty, wit & intellect is great.'[61]

Always unselfconsciously spontaneous and affectionate when writing to Vanessa, Virginia's letters were particularly exuberant during this period between the marriages of the two sisters. They were rich with verbal sketches of friends and passing strangers, full of glancing asides on life and art and her passion for Vanessa; all conveyed with her characteristic singularity of vision and limpidity of prose. Virginia, writing to her sister from Bayreuth in the summer of 1909, was intimate and conversational:

These are the humours, sweet honeybee; writing seems to me a queer thing. It does make a difference. I should never talk to you like this. For one thing, I dont know what mood you are in, and then – that the subtleties are infinite. The truth is, I am always trying to get behind words: and they flop down upon me suddenly And then you are much simpler than I am. I thought about that at the opera last night. How do you manage to see only one thing at a time? Without any of those reflections that distract me so much, and make people call me bad names. I suppose you are, as Lytton once said, the most complete human being of us all ... God! how happy to be with you! and then these letters will seem absurd. Do you want me too?[62]

Her letters to Clive, on the other hand, were archly, uneasily flirtatious and self-consciously literary, except when discussing her own writing which mattered too much for her to obscure with pretence. His to her were poeticised, febrile and carefully constructed to impress – except when he was responding to requests for advice on her writing, when he was a naturally inspiring critic. 'To-day I saw a full, rich, ear of barley spared somehow by the reaper standing alone in the middle of its stubble, and so I thought of you; Vanessa will complain that I never say things of that sort to her.'[63]

And then in a later letter in which he declared 'Vanessa & her sister, the two people I love best in the world', his emotional agitation showed in his fractured handwriting, discomposing even his literary pretensions:

> I was too shy to kiss you on Wednesday afternoon though I wanted to more than I care to say even in a letter. It's really odd my shyness with you; to be sure you gave me a chance of making a habit of kissing you but that I found was not at all what I wanted. Perhaps I'm shy because you're so exciting in which case it's clearly for the best ... God forgive me; Virginia forgive me; what a letter; never heed it; try to feel half the affection for me that I feel for you.[64]

It was quite evident to Vanessa that the best thing would be for her sister to marry. Virginia was unhappy when Vanessa's full attention was deflected by the demands of her own relationships and, just as in the nursery when jealousy of Vanessa's and Thoby's comradeship made her capable of conjuring black moods of despair in her elder sister, so she exerted her disruptive fascination again in her determination to be restored to the centre of Vanessa's life. An unhappy Virginia was a dangerous Virginia and her sister realised in 1909 that 'in spite of all drawbacks she had better marry. Still I dont know what she would do with children.'[65]

Vanessa, however, was going to have to wait a few more years for that deliverance. Away from the confusion of mixed motives and the anguish of love, that other great central force in their lives was increasingly insistent. It was work which really mattered; as Virginia expressed it, despite 'the ebb & flow of the tide of life ... the central fact remains stable, which is the fact of my own pleasure in the art.'[66]

6

Work is the Real Thing

'I cannot remember a time when Virginia did not
mean to be a writer and I a painter.'
Vanessa Bell, *Recollections of Virginia's Childhood*

VANESSA AND VIRGINIA grew up in a family where it was under-
stood implicitly that idleness was as much a sin as was intellectual
dishonesty. The Stephens belonged to the upper-middle classes. They
were members of the intelligentsia who, although modestly well-off,
with some inherited money, nevertheless needed to work and to earn
a living.

Unlike George and Gerald Duckworth, whose work was to take
them away to government and publishing offices, Leslie Stephen's
work was largely conducted in the heart of the family. Work and
domesticity were combined childhood influences, and always there
was a proper respect for the relentlessness of work. A lasting memory
for Virginia, as she sat at her studies in her own room, was the sound
of the occasional thud on the floor above her, when her father
working in his study would cast some large book open on to the floor
beside him, and then another, until he became an island isolated in a
sea of printed words.

During their earliest years, Vanessa and Virginia had formidable
examples of Victorian industriousness held daily before them in the
lives of both their parents. Their mother was ceaseless in her activities
on behalf of others. Not only was she responsible for the administrat-
ive, emotional, and sometime educational demands of her large
multifarious family, but she was orderly and diligent to a fault in the
disposition of her duties beyond the confines of 22 Hyde Park Gate.
Whether in London or during the summer at St Ives, she involved
herself practically with the destitute and sick, the needy and dying.
She travelled on dusty and cold omnibuses, she walked encumbered
with a basket of clothes or provisions. Her nursing, whether of
members of her closest family or amongst villagers at St Ives and the

poorest in a London slum, she considered as vocational work. She had warned Leslie Stephen before she married him that there would be times when she would have to leave him and the children in order to pursue it. Her slender publication *Notes from Sick Rooms*, full of good sense and a fine sensibility, was a testament to her professionalism.

Then, at the tail end of each busy day, Vanessa and Virginia would watch their mother sitting, tired but resolute, at her desk answering numerous and various letters. Clearing out Talland House at St Ives after she had died, Virginia came across a daily quota of letters put neatly inside her desk ready to be answered. Apart from letters from the family and household bills, there was a letter from an unemployed nurse, from a woman whose daughter had been betrayed requesting help, and a life history, many pages long, from a girl who had quarrelled with her parents and had to unburden her soul to Mrs Stephen. And then there were the begging letters, full of stories of hardship and heartbreak.

Their mother's example was one of self-discipline, self-sacrifice and unfaltering effort; it would seem that the phrase 'I cannot' was not part of her vocabulary and was discouraged in her children's. She did insist, nevertheless, on that small bastion of independence, represented by her vocation for nursing, which she protected from the ravenous demands of her husband and the more easily resisted needs of her children. It meant there were periods of the day and occasional longer absences of a week or more when she was away from the dominion of her husband and society, entirely her own mistress, unattainable, answerable to no one, of vital importance to her patient, and creative in her abilities to soothe and to mitigate the sufferings of others.

Their father, too, was a prodigious worker in the tradition of the Victorian self-made man, bringing his heroic energies and pragmatic vision to bear on the world of literary journalism, philosophy and biography. In 1864, at the age of thirty-two, he left Cambridge and the life of a don and a cleric (for which he felt his agnosticism unsuited him) and embarked on his literary career. He started modestly but industriously by writing every week for many years two articles, often of essay length, for the *Saturday Review*, at the same time providing regular contributions to other weekly and monthly papers on a wide range of subjects from literary criticism to the antics of Westminster for an American readership. From 1871 to 1882, when

he shouldered the heavy burden of organising, initiating and editing the *Dictionary of National Biography*, Leslie Stephen was editor of the *Cornhill Magazine* and still churning out a remarkable volume of literary journalism for that publication and others.

He published also the books that he hoped would further his reputation as a philosopher. The ambitious *History of English Thought in the Eighteenth Century* in two volumes was probably more highly regarded by his critics then and since than the book for which he felt most affection, *Science of Ethics*, published in the year Virginia was born. An illustration of his extraordinary literary output was provided by the example of a literary biography of Johnson, requested as the inaugural volume of a new series of English Men of Letters. The book was commissioned on 7 August 1877 and was delivered by Leslie Stephen six months later practically to the day, having been written while maintaining still his other editorial and journalistic commitments.

This relentless productivity and professionalism was manifest even more admirably in his driving to completion the massive undertaking of the *Dictionary of National Biography*. For the early volumes the administrative and editorial responsibility fell entirely to him, along with his own commitment as chief contributor which ran in the final count to over a thousand pages of entries. In what would appear a punishing schedule of a volume to be published every quarter, Leslie Stephen never allowed the great machinery of such an enterprise to falter. Remarkably that publishing schedule was met. But the toll that such extensive, painstaking and pressured work exacted on his health and the peace of mind of his family was great.

He was an anxious, over-sensitive man and he became increasingly harried by the drudgery and all-consuming nature of his task, a workload that left little time or energy for his own original work. Like Mr Ramsay in *To the Lighthouse*, he feared quite probably that on the A-Z of intellectual endeavour his achievement was stuck on 'Q' and he would have to leave it to younger and better men to strive for 'R' and the rarefied regions beyond.

Inevitably, it was to prove too much for him and a breakdown in his health compelled him to relinquish the editorship of the *Diction-ary* in 1891, but with the best part of the project completed and already greeted with acclaim. His family felt the release from such a literary treadmill; Virginia believed herself to have been cramped and cabined in the womb – and Adrian to have been annihilated almost –

by the great work that so dominated her father's life, and therefore her mother's too. But the family born to him in his declining years suffered also from his own sense of being ultimately a failure, 'a jack of all trades'[1] and master of none.

However, this remarkable man was never just a book-bound intellect. As a young man he had been a noted mountaineer and had scaled many of the Alpine ridges, including Mont Blanc. He was an oarsman, a runner and a walker of great stamina and wiry strength. His daughters too shared his capacity for physical toughness and endurance. Although by the time his children knew him his youth and his mountaineering feats were well behind him, they were aware of the rugged adventurer that was their father as a young man. The house was littered with mementoes and trophies of those days and his own memories, which spanned so many decades before they were born, would be shared sometimes in piquant and pithy anecdotes, as of the time he walked from Cambridge to London just for dinner – a matter of fifty miles and twelve hours of unflagging effort. Even in middle age, still he went on 'tramps' with family and friends and thought nothing of spending all day striding briskly on his grasshopper legs over rough, open land, or tirelessly following the steep ascents and declivities of his beloved North Cornish coastline.

With examples such as these, Vanessa and Virginia from their earliest days recognised that their own vocations demanded practice and hard work. They encouraged each other with their industry. They would sit together in their small sitting-room at Hyde Park Gate, Vanessa sketching, Virginia writing or reading aloud. On holiday at St Ives, Vanessa practised her water-colouring and diligently filled in numerous little squares with crosshatching, having read John Ruskin's *The Elements of Drawing*.

Virginia's first extant diary was started at the beginning of 1897, when she was nearly fifteen, and was intended as a record of the year rather than a more calculated practice ground for her art. Begun eighteen months after her mother's death, unbeknownst then to Virginia, this little notebook was to cover a most intensely emotional and catastrophic year in her life in which Stella was courted, married and died. Not surprisingly, there were times when writing it up was too burdensome or, during the last muddled days of Stella's illness, quite overwhelmed in importance by the desperateness of the situation. She did not abandon it, however, and wrote up the last days later in spare yet emotionally charged detail.

Vanessa and Adrian had started diaries at the same time but they did not seem to have persevered for long. Virginia's became a record for both sisters; she often used the pronoun 'we' and always meant herself and Vanessa. Her sister's approval of 'the "great work" '2 kept her going to the end of the year, when she could sign off with sadness, some relief and pride, and understandable faintness of heart at what the following years might bring:

> Here is a volume of fairly acute life (the first really *lived* year of my life) ended locked & put away. And another & another & another yet to come. Oh diary they are very long, & I turn cowardly ... when I look at them ... Nessa preaches that our destinies lie in ourselves ... here is life given us each alike, & we must do our best with it.3

Virginia's next two diaries, written during the summer months of 1899 and probably 1903 respectively, were much more concerned with writing exercises; descriptive pieces on visits to Stonehenge, watching a dance from the window at Hyde Park Gate, a soirée at the Royal Academy. They were at times witty, always well observed, often self-consciously straining for effect and nearly always included the beloved elder sister as the silent partner in that 'we': 'We have wrenched ourselves free of London. Nessa & I.'4

Just as Vanessa had her sketch-books in which she practised various aspects of her drawing, so Virginia, comparing herself, saw these two volumes serving her in a similar way, 'as an artist fills his pages with scraps & fragments, studies of drapery – legs, arms & noses – all useful to him no doubt, but of no meaning to anyone else – so I take up my pen & place here whatever shapes I happen to have in my head.'5

But the old competitiveness between them had its less constructive sides too. Vanessa had pointed out how their early choice of different professions had minimised one significant potential rivalry, but when comparisons between the sisters became too close, even in such apparently disparate areas as their work, each was capable of a sometimes subtle, in this case absurd, retaliation in an attempt at redressing the balance between them. When someone had remarked that Vanessa had a harder time practising her art because she had to stand all day at her easel, Virginia promptly ordered a tall desk to be made for herself at which she could stand to write. Virginia was not going to have her sister's effort, nor indeed her sister's art, held up as

being superior to her own. Work and play in the Stephen household always had been a serious, strenuous, ascetic business.

From early on, certainly from after the death of their father, both intended to practise their arts in a professional manner; if not propelled by absolute necessity, nevertheless, they wished to do work that would earn them money, 'our old ambition'.[6] So determined on this was Virginia that even a lecture from their Quaker aunt Caroline Stephen (who twiddled her thumbs all day, her irreverent niece reported, while exhorting her to realise the 'beauty of hard work'),[7] denigrating 'journalism' and the selling of her soul for gold, left Virginia undismayed. She told her cousin, Madge Vaughan, and no doubt Vanessa too, that she would readily sell her soul for gold as long as there was enough of it.

Virginia was first off the mark in realising this ambition. Given an introduction by Violet Dickinson to a Mrs Littleton of the clerical journal the *Guardian* in November 1904, she submitted her first trial piece, written at Manorbier in an attempt, she recalled, to try and disprove what had become increasingly evident – that she had begun her descent into that summer's terrible breakdown. She was proud of the article, yet anxious, prickly and self-protective in this her first exposure of herself and her writing to professional estimation. 'I don't think my chances are good. I dont in the least want Mrs L's candid criticism; I want her cheque! I know all about my merits and failings better than she can from the sight of one article,'[8] she wrote agitatedly to Violet.

In fact that piece was not accepted for publication, but her abilities had impressed enough for her to be asked for an article of 15,000 words on any subject and be promised some reviewing work. By the end of 1904 Virginia Stephen had seen her first review and article (on Haworth Parsonage) published in the *Guardian*. On 10 January 1905 she noted in her unpublished diary the happy fact of finding her first earnings in that morning's post '£2.7.6 for *Guardian* articles which gave me great pleasure.'[9]

Virginia was to make a point at this time of mentioning in letters to her friends that she was a journalist, and that summer enjoyed describing herself for the purposes of getting a library reading ticket as a ' "journalist who wants to read history" and so I do feel a professional lady'.[10] She was no longer a young woman reading and writing in solitude and obscurity, she had made her first move into the professional world. Indeed more than a decade later, when *Orlando* was

published in 1928, Virginia noted with justifiable pride that she had made £1,800 in six months, 'the salary almost of a cabinet minister'.[11] Vanessa's reputation was to grow in the twenties, equalling Virginia's, but she was never to make anything like as much money.

More work followed then. A memoir of her father for F. W. Maitland who was writing the authorised biography of Sir Leslie Stephen, more articles and reviews for the *Guardian* and also the *National Review* and the *Academy*. In the spring of 1905 she began her most lengthy and productive relationship with *The Times Literary Supplement*, reviewing regularly and extensively under the encouragement of the editor, Bruce Richmond. Recognition of Virginia's brilliance was no longer confined to the intimate circle of family and friends. There the word 'genius' had already been used, by Violet Dickinson and Madge Vaughan. This was an appellation Virginia did not rebut, although the isolation of her largely self-taught education meant she had little with which to compare herself. ' " Genius" is not a word to be used rashly,' she wrote to her cousin Madge. 'It gives me enormous pleasure, and something more than pleasure, that you should find anything of that kind in me. I am no judge; and honestly dont know from hour to hour whether my gifts are first – second or tenth rate.'[12]

Now with publication of her fluent, percipient and elegant journalism, the world was beginning to judge her. And Vanessa once again had her younger sister's intellectual precocity brought home to her in comparisons that could only be unfavourable. When Vanessa met the writer and politician Herbert Paul, soon after Virginia's articles had begun appearing in *The Times Literary Supplement*, she was somewhat bemused by his conversation until she realised that he had mistaken her for her sister: 'So I pulled myself together & realised what he meant & explained at length that I was I & you were you & that I didn't indulge in literature. It was evidently a great blow to him & he had nothing more to say to me.'[13]

Vanessa had already become interested in portraiture during her time at the Royal Academy Schools and had painted various members of her family and those friends she could persuade to sit. She, like Virginia, had every intention of putting her art on a professional basis. Her commitment to it from childhood, the central importance it played in her life, meant painting could never be a ladylike and amateur occupation for her idle hours. But moving her art from the private into the public arena was more difficult for her. Virginia had

extensive literary connections through family and friends. She had the advantage of being the daughter of a man of letters whose reputation was held in the highest affection and esteem. There were a number of journals willing to give her a chance, and in fact her half-brother Gerald Duckworth's firm of publishers was to publish her first novel. The footpaths to literary celebrity had been trod before her.

For Vanessa, however, the trail had to be newly beaten. She had always been aware that to be a painter in a literary household like the Stephens' was an aberration. Her vocation and its preoccupations were tolerated, sometimes with amusement, yet it placed her outside the sympathies and traditions, the philosophical mainspring of the family. It was this isolation that was to make Clive Bell and his artist friends, their talk, ideas and enthusiasms, so refreshing and revelationary to Vanessa. It was this need for congenial artistic interaction which was to determine her founding of the Friday Club, in the autumn of 1905, to provide a gathering point for artists, and some select guests, to attend talks, join freely in discussions and exhibit paintings. There may also have been an element of the artistic sister claiming an equality for her art alongside the largely literary Thursday Evenings.

But, in the meantime, Virginia's success in finding a public for her work and in claiming her first earned money most probably precipitated Vanessa's ambitions too. At the beginning of 1905 she went to stay at Lord and Lady Robert Cecil's house in Sussex in order to paint Lady Robert's portrait. Nelly Cecil was a beautiful, intelligent and cultured woman with literary ability and connections. She was introduced to the Stephen sisters by Violet Dickinson and was to become more Virginia's friend than Vanessa's, but harboured a warm affection for them both and chose to give Vanessa her first professional commission, following it up with a request the following year that Vanessa paint her husband's portrait too.

Lady Cecil's profound deafness may well have made the sittings less of an ordeal for Vanessa, by making her own silence and lack of conversational skills less pronounced. It must have been slightly disconcerting, however, for Vanessa to be told by her, as she struggled to solve the problems of composition, of recording a likeness and not overtaxing her illustrious sitter, that Virginia ought to be painted but, 'there was no one alive now with *poetry* enough to do it!'[14] (The exclamation mark is Vanessa's in her report to her sister awaiting her return.) There were to be many times when Virginia, or her

reputation, appeared to have arrived before Vanessa's more measured progress, enchanting all with her wit and beauty and leaving Vanessa with the role of beautiful but duller, more sensible sister.

Her painting progressed well, yet Vanessa felt all her social and intellectual inadequacies thrown into relief by this sophisticated and well-informed household. She sent Virginia her familiar cry from the heart, 'I wish I weren't such an ignoramus. I've come to the conclusion that staying away is a very severe test for one's general intelligence & its appalling to find how little I've got.'[15] The sisters' lack of formal education was a greater burden in those early years to Vanessa than to Virginia.

Virginia had an innate fascination for ideas and their expression that led her naturally to books. She had the intellectual apparatus to seek out knowledge for herself from the printed word and to study, albeit alone with neither the direction of a fine teacher nor the stimulus of her peers. She had the desire and ability to build for herself an education, in many ways superior to a more orthodox, institutional one – as she was to maintain with justifiable pride.

Vanessa's natural predisposition lay with sensation and the visual world. Self-motivated book-learning never attracted her and so general knowledge, inculcated in most children by rudimentary schooling yet neglected in her own childhood, remained for her a largely featureless desert, punctuated with pitfalls into which social conversation at any moment might spring her. She was known for perusing newspapers only for the pictures, and preferring the *Daily Mirror* largely for this reason. There was a story, possibly apocryphal, of her finding herself at a dinner party seated next to Asquith, prime minister at the time. Perhaps finding his face familiar but unable to identify him immediately, Vanessa turned towards this elderly gentleman and politely enquired whether he was interested in politics.

Her idiosyncratic mixing of metaphors and occasional abstractedness were sources of great amusement to her family and closest friends, but Vanessa's awareness of her tentative grasp of the facts about the outside world undermined her confidence in her ability to cope in society, and led her to undervalue her own gifts of character and intellect. It made her unnecessarily self-denigrating and was to propel her into creating a close and closed society around her. This was to become much like a mother-centred family, with Vanessa herself as the matriarch at the centre, reverenced and beyond criticism.

The portrait of Lady Robert Cecil pleased Vanessa enough for her to decide to exhibit it. Not until the New Gallery's show opened in April 1905 did she know if it had been selected or not. Virginia was dispatched after breakfast to reconnoitre and dashed back in high spirits. It was included and quite well hung. Even so Virginia noted how reluctant her sister was to go and see for herself. It brought her the satisfactory recognition, however, of a new commission by a stranger, Mrs Seaton, 'to paint one or both of her children'.[16] And thus Vanessa too had breached the public world with her art. 'So now one niece at anyrate is launched,'[17] Virginia wrote with sisterly pride to Violet Dickinson.

Virginia was aware always of how much easier it was in purely practical terms for a woman to be a writer than a painter. In her typescript for the speech she delivered in January 1931 to the National Society for Women's Service, she pointed out how cheap her materials were, just pen and paper; how unobtrusively, even clandestinely, a young woman writer could practise her art; how little family life was disrupted. The painter, on the other hand, and she must have been thinking of Vanessa as she wrote, needed easels and paint and canvases, 'models, studios, north lights'.[18] Vanessa's painting could be sabotaged so easily by a day of grim London fog while Virginia, paper and pen to hand, need only pull the lamp closer. It was, Virginia maintained, merely the cheapness of writing materials which had made it easier through the ages for women to become writers than painters – or composers or any other profession which required finance or collaboration from men – and she admired the tenacity that Vanessa required just to be able to paint.

Along with their professionalism and their need for – yet timorousness towards – a public ran an equally strong commitment in both sisters to the belief that each had to press through existing traditions to find a point of view of their own. It was a difficult and lengthy business and they supported and encouraged each other all their lives. As girls they had had their ritual of 'autumn plans'[19] when, in the dying days of summer, they would walk together in the evening, discussing the year ahead. The new year began for them in autumn with their return from the sea or countryside to London and metropolitan life. The most important part of their speculations and excitement centred round their work, their gifts and their individual futures as painter and writer. A soft gusty day at the end of summer some years later could remind Virginia vividly of those walks and

plans and the thrill in anticipating the work ahead. Did she, the uneasy thought presented itself, give as much encouragement as she received? 'Did you ever feel neglected?'[20] she wrote to Vanessa with a spasm of remorse.

When back in London their apprenticeships were served largely independently, with Virginia being the more solitary. Her unpublished diary chronicling the first half of their first year at Gordon Square showed her regular daily routine; 'Read, wrote, cursed & walked – all as usual',[21] with only their sheepdog Gurth for company. Vanessa spent most days drawing at Alexandra House, lunching with young women painter friends as well as old family friends like Kitty Maxse.

But gradually Virginia's working life expanded. By the autumn of 1905, she had accepted a post teaching working girls at Morley College, first History and then English Composition; work that she approached with characteristic thoroughness and wit. Although she had few illusions as to how useful Morley College or her lectures were to such educationally and socially impoverished students, she continued her work there for nearly three years. Shy, uneasy under the gaze of others, ill-educated according to her own lights, it said much for Virginia's basic confidence in what she had to offer and her desire to communicate and experience a more varied exposure to life that she could continue, with enthusiasm, with these sometimes ill-attended classes. Her robustness was tested when she ploughed on through a talk on English Composition in front of Miss Sheepshanks, her principal, who thought it to be the most useless subject on the curriculum, so much so that Virginia was aware throughout the lecture of her employer's restiveness; Miss Sheepshanks 'almost stamped with impatience'[22] at the content, Virginia recalled with remarkable absence of chagrin.

Socially the sisters' lives had expanded too. Most of that year they had been getting to know the motley crew of Thoby's Cambridge friends with the establishment of Thursday Evenings. These friends were responsible for a liberation of the Stephen sisters which had inevitable consequences for their work. The security of a small nucleus of friends within the much larger and less sympathetic world encouraged boldness and originality. Within the group there was a feeling that every member had some contribution to make to the world of literature, philosophy, art. And indeed a surprising number of these friends were to do just that. But it was also a remarkable and

exciting period in which to be young. The new century appeared to hold an enhanced promise. To some of these Cambridge friends, particularly, a cultural and social revolution truly seemed possible and the building of a new society imperative.

This new world had to be free of the stultifying codes and proscriptions of the Victorians, had to be based instead on rational and civilised principles, put to the acid test of the philosopher G. E. Moore's *Principia Ethica*. What the real meanings were behind the words 'truth' and 'good' and how rational principles should govern all actions. The excitement at the possibility of fundamental change, which enthused the minds of the educated and largely male youth during these early years of the century, was described vividly by Leonard Woolf in his autobiography. 'This period of our early manhood, perhaps the most impressionable years of one's life, was an age of revolution ... we were in the van of the builders of a new society which would be free, rational, civilised, pursuing truth and beauty. It was all tremendously exhilarating.... And no doubt ... we were naive.'[23]

Virginia and Vanessa were more interested at this time in reforming their domestic environment, to create for themselves space and time in order to work, in congenial surroundings with congenial friends who accepted them as they were. This ambition was triumphantly realised by 46 Gordon Square and Thursday Evenings. However, the feeling that Leonard Woolf and his contemporaries found so exhilarating, that the wider social, cultural and political world was on the brink of reform – even revolution – inevitably animated the exchanges and attitudes that the Stephen sisters were party to, and made the breaking of new ground in their art not only possible but necessary.

One of the last taboos for the reticent young women brought up in a Victorian household was the taboo of talking about sex. Virginia wrote, in a paper to be delivered to the Memoir Club in about 1922, of their youthful initiation into sexual candour in casual conversation.

It was a spring evening. Vanessa and I were sitting in the drawing-room [at Gordon Square]. At any moment Clive might come in and he and I would begin to argue – amicably, impersonally at first; soon we should be hurling abuse at each other and pacing up and down the room. Vanessa sat silent and did something mysterious with her needle or her scissors. I talked egotistically, excitedly, about my own affairs no doubt. Suddenly the door opened and the

long and sinister figure of Mr Lytton Strachey stood on the threshold. He pointed a finger at a stain on Vanessa's white dress. 'Semen?' he said.

Can one really say it? I thought and we all burst out laughing. With that one word all barriers of reticence and reserve went down. A flood of the sacred fluid seemed to overwhelm us. Sex permeated our conversation. The word bugger was never far from our lips. We discussed copulation with the same excitement and openness that we had discussed the nature of good. It is strange to think how reticent, how reserved we had been for so long.[24]

The wider intellectual world which Cambridge masculinity brought to the Stephen sisters was met with their reciprocal and equally influential contribution of basic female common sense and a far greater emotional maturity and independence of spirit. Vanessa and Virginia had felt and suffered profoundly. They had experienced more of the exigencies of life and death than any of the young men who congregated at their Bloomsbury fireside. Even Thoby, who had been subjected to the same family losses, had not experienced them in the same intense and baleful way. His age, his sex, his detachment – both emotionally and physically for he could always escape to school, then university – had served to insulate him from the full force of loss, from the devastated hopes and the deadly expectations of others.

In a perceptive memoir of Virginia, Duncan Grant was at pains to point out how refreshing, even shocking, was the effect of the young women's 'boldness and scepticism' on the arid intellectuality and self-regarding seriousness of these Apostolic young men. They brought too an iconoclastic sense of humour; neither young woman was remotely likely to be converted to the theism that centred on Moore (Virginia did not get round to reading *Principia Ethica* until three years later); neither was to revere, as its members did, the élitist, exclusive and secret society, the Apostles, with its selection of 'embryos' to be honoured with the Society's gift of Life. When Virginia was not envying the intellectual camaraderie, impulse and influence such an education provided, she was suspicious and critical of the emotional impoverishment of the Cambridge mind. 'How I hate intellect! There were several brilliant young men [at a dinner party in Chelsea] whose lights had been kindled at Cambridge and burnt all of them in precisely the same way.'[25]

But more important even than this feminine independence of spirit

was the fact that the sisters opened the door for these young men on the hitherto unexplored world of the arts. Lytton Strachey and Clive Bell might have displayed a few examples of modern painting on the walls of their college rooms, a peculiarity that had given cause for comment in artistically benighted Cambridge. But Vanessa and Virginia were not mere spectators in the field. In their certainty and dedication to their chosen vocations, and in their vision of the world, both had been artists since childhood. At the time that Thursday Evenings came into being, they were putting their art into practice and earning some reputation and a little money, while these highly educated young men were barely working at anything (apart, of course, from Leonard Woolf who was Ceylon-bound and working harder than anyone else). These young men were uncertain still as to what they were to do with their lives and were nostalgic already for Cambridge, days that threatened, for some of them at least, to have been the happiest of their lives.

The two young women at the heart of this group of friends had long been certain of their destinies and, although by 1907 Vanessa's single-mindedness had been slightly deflected by marriage and motherhood, Virginia's energies were increasingly concentrated on her art. In her determined desire to produce her first major work of fiction, she turned to her sister's husband Clive Bell, who was to be Virginia's first and most encouraging critic. Although in the role of brother-in-law he was resented and envied, his relationship with her sister poached upon and coveted, when it came to the really important area of Virginia's work she was single-minded, business-like and bold.

Unlike his more austerely intellectual contemporaries, Clive Bell's sensibilities were alive to every sort of stimulus. His unerring instinct, combined with an enquiring, discriminatory mind, made him a good and natural critic, an engaging and constructive commentator; whatever his faults and inadequacies as a husband, however much an interloper in Virginia's conspiracy with Vanessa, his qualities as a critic of her early writing were invaluable.

At the very beginning of the sisters' friendship with him, it had been Clive who introduced them to the joys of Parisian café life. In fact it was Vanessa who responded so positively to this exhilarating atmosphere where painting could be discussed, practised and criticised every hour of the day and night within a fluid community of impassioned, dedicated and uninhibited young artists. Virginia was never to be as enamoured with the bohemian way of life, but the

artistic freedoms, the lack of reverence for convention, the fact that art was considered seriously and talked about as if it was important, were illuminating to them both.

Vanessa particularly responded to this freedom. All her youth, she had endured the sense of alienation that being a painter in an overbearing literary and masculine family evoked. Clive Bell was rare and refreshing in being not only interested in literature and ideas, but in art too, in its past masters and future aims. He was a stimulating companion for her and appeared to be *au courant* with the new art then emerging from the studios of Paris, his iconoclastic attitudes corresponding with Vanessa's own; Christianity was an amusing aberration, the establishment painter G. F. Watts was terribly old hat. During their early married life, Clive encouraged and collaborated with Vanessa in her experimentation in avant-garde interior decoration. Their marital home was bare of carpets and, for the time, would have been considered virtually unfurnished with just the minimum of essential pieces, a bed, a table, a chair, all of finest quality. For a while this purist approach to decoration persisted, with Clive hiding the yellow and blue matchboxes from sight because they were not in harmony with the colour scheme of the rest of the room. Clive could appreciate Vanessa's fundamental seriousness and absolute dedication to her art. It was with philosophical regret that he acknowledged he would never bring to his own work that essential gravity and centrality that characterised the Stephen sisters' approach to their vocations.

Virginia had spent years thinking about the book she was to write. She continued with her conscious preparation for it by practising descriptive pieces, reading extensively, exploring new ideas in the privacy of her room or on long walks through London, and over the moors and fields when on holiday in the country. Thus gradually she approached her first major work with the stealth and patience of a hunter on the trail of a rare and elusive beast. A great deal of solitary thought, intuitive excursions and an ability to adventure into the unknown brought Virginia at last to within netting distance of her quarry: 'I shall re-form the novel and capture multitudes of things at present fugitive, enclose the whole and shape infinite strange shapes. I take a good look at woods in the sunset, and fix men who are breaking stones with an intense gaze meant to sever them from the past and the future – all these excitements last out my walk.'[26] That was written in the summer of 1908, when she was twenty-six and had enjoyed three years of their new social arrangements in Bloomsbury. Years which

had proved so liberating and yet reassuringly enduring, and continued after Vanessa's marriage when Thursday Evenings were established again at both sisters' houses, 46 Gordon Square and 29 Fitzroy Square.

In the autumn of 1908 she sent Clive Bell a hundred pages of her first novel, 'Melymbrosia' (to be renamed *The Voyage Out*), feeling it had failed and asking for his verdict. Virginia was aware of how much the work preoccupied her and how exasperating such creative absorption might seem to others. Yet she was unrepentant over what she recognised as 'my egoism that wont let me or anyone else think of better things'. Clive's was the only opinion she sought or valued at the time and his encouragement was vital to her, for he believed in her unique vision and her ability to capture, in language of extraordinary limpidity, the fugitive essence of situations and sensation.

Virginia's opinion of her own genius was a fragile thing. She could believe at the age of twenty-five, with all her great work still to come, that she had it in her to become, 'a writer of such English as shall one day burn the pages',[27] but such tentative confidence could be dashed by a dream in which her father's intellectual authority negated all her creative effort: 'I dreamt last night that I was showing father the manuscript of my novel; and he snorted, and dropped it onto a table, and I was very melancholy, and read it this morning, and thought it had,'[28] she admitted to Clive.

Against this ever-present reminder of the aridity of the masculine Cambridge intellect, in whose face her own creative impulse seemed so heretically to fly, Clive's endorsement of her efforts cannot be over-valued. Even amongst her male contemporaries from Cambridge – her brothers and Saxon Sydney-Turner she names particularly – there was a sense perhaps of amused disparagement of her more imaginative, free-wheeling states of mind – 'Saxon, Adrian and the rest accept my lowest estimate of myself, and think it handsome.'[29] But as Clive explained in a letter to Virginia, when the 'manly talk' of Adrian and the others excluded if not diminished her, he wished to say, ' "that's what you and I think about it; but Virginia has a view of the world which makes what she says about it worth a great deal more than all we shall ever think." '[30] Yet he could not break ranks publicly with his own sex, and Virginia accepted that he and Adrian would continue to exchange knowing glances at further Virginian excesses. Covertly he would give her, however, the invaluable encouragement, and at times acute criticism for which she was so eager as she evolved, with intense

creative energy and halting reservations, a way of realising her own literary voice.

No doubt the growing attraction Clive felt for Virginia's person added an incandescence and further point to his literary criticism. His excitement in her novel, as parts of its creation were shared with him, however, was genuine and inspiriting.

> There are a hundred things that I long to talk or ask about ... your power (to which I think I have always done justice) of lifting the veil & showing inanimate things in the mystery & beauty of their reality appears once or twice to equal – to excel rather – well never mind – it is all very exciting and delightful.[31]

Teased by Virginia for extending his vanity into his letter writing with rough drafts and diligent stalking of the polished phrase, these letters to her have a spontaneity and effortless felicity which at times rivalled even her own.

Similarly, Virginia's letters to Clive during the labour and birth of this first novel lost all the archness and flirtatiousness which made her early letters to him self-consciously contrived and heavy-footed. When she was discussing her work and responding to his criticisms she was unveiled, disarmed – and quite disarming; '[I] long for some assurance that all my words are'nt vapour. They accumulate behind me in such masses – dreadful if they are nothing but muddy water.' And she ended with what was to be a leitmotif of their working relationship at this time, 'Ah, how you encourage me.'[32]

Years after Virginia's death, Clive Bell was to claim that his early recognition of her genius was the achievement of which he was proudest. 'You were the first person who ever thought I'd write well,'[33] she had written to him after she had offered to the world, with much suffering, this first novel – and the world had begun to take notice. This creative intimacy, lasting from 1908 to 1911, which the newly married Clive Bell shared with his extraordinary young sister-in-law, was as intense and as exclusive as any sexual affair. They walked in fields where Vanessa could only watch from the gate, admiring, exasperated, entertained but ultimately excluded. She could respond emotionally to Virginia's work and because so much of it was autobiographical, and so vividly and evocatively so, this was a fertile area for much valuable comment. But Virginia's struggle with the technicalities of her art, with her attempt to enclose the fluid,

impressionistic whole, effecting 'the feel of running water'[34] within an architecture diaphanous yet resilient, poised and three dimensional, only Clive at this time could appreciate.

Vanessa remained on the outside of this creative alliance, kept firmly in her place with the subtle tyranny of Virginia's characterisation of her as some elemental goddess of transcendent beauty and power. This superhuman sacred Mother stalked Vanessa through her sister's letters, her diaries and fiction. Formidable, critical, difficult to please but worshipped for her beauty and authority, desired for her power over life, her fruitfulness; she was dramatised as instinctive, elemental, prepotent. 'It is a game of mine to find figures for her,'[35] Virginia admitted, but the images she hung about her sister were so memorable, and expressed to Vanessa herself and the world at large in such radiant language, that they threatened to create a mythopoeic cloak that obscured and restricted the woman they purported to describe.

The portrait Virginia painted of her carried such force because it was founded on the observations of a particularly perceptive young woman, a consummate artist, who was fascinated, at times almost morbidly so, by the character of her elder sister, the subject of 'my own proper science: the theory of Vanessa'.[36] This could prove so exasperating to that sister because the undeniable truth at the heart of the representation was coloured up and distorted at the expense of other less picturesque or convenient truths. This mythologising by Virginia prompted Vanessa's indignant protest:

> Virginia since early youth has made it her business to create a character for me according to her own wishes & has now so succeeded in imposing it upon the world that these preposterous stories are supposed to be certainly true because so characteristic.[37]

Just as it suited Virginia's purposes both artistically and emotionally to enhance the mother-goddess aspects in Vanessa's character, so it suited her to denigrate the intellectual, for that had been, and would be always, her own unalienable territory. In one letter to Violet Dickinson, Virginia celebrated the particular sensual energy and lustre about Vanessa's beauty which love had inspired; her sister was, 'tawny and jubilant and lusty as a young God'. And then, in the same breath, implying, with a patronising tone, that when it came to intelligence Vanessa was no competition at all: 'Old Nessa is no

genius, though she has all the human gifts; and genius is an accident.'[38] Once again the closeness of their relationship, the competitiveness within it, were such that in order to maintain their solidarity each sister had to be confined to her own specific territory, marked out by them as children; art versus literature, common sense versus sensibility, instinct versus intellectuality. Vanessa recognised where the boundaries of her territory lay, and commented with a mixture of exasperation and humour, 'It is always rather a joke that she [Virginia] advises everyone to write – me, Adrian, everyone who wouldn't excel her!'[39]

Clive, however, was allowed to venture into the field of the intellect because Virginia cared much less passionately for him than for Vanessa and he was proportionately less of a threat. Nevertheless he had to be put in his place too, as having much character and style, fine judgment and a gift for the felicitous phrase, but a man of genius? No. So Vanessa was excluded intellectually and imagined by her sister to be vexed, as indeed she had every right to be, by Virginia's demanding preoccupation with her work and irresistible conspiracy with Vanessa's husband.

As Virginia turned increasingly to Clive for creative encouragement there was an inevitable lack of sympathy between Vanessa and Virginia over the evolving novel. Virginia employed Vanessa's critical faculties only as far as finding her alternative names for her characters. Perhaps Vanessa was reserved in discussions of a more literary character, certainly Virginia felt unsure as to the kind of literary offering which would give her sister most pleasure: 'I wish, some day, you would write down what you need in a letter; some facts I know; but as for the padding, the reflections and affections, I never know your taste.'[40] To which Vanessa replied, in keeping with her affectional role in the relationship, 'You ask what kinds of letters I like. What can I say but one thing? of course what I really like is flattery & affection.'[41]

It was flattery and affection, and entertainment too, that she became desperate for when she faced the reality of motherhood with the birth of her first child, Julian, in February 1908. Vanessa's maternal instincts have become legendary; both sisters referred to them with awe, her second son Quentin recognised that they were 'so highly developed as to be a menace both to herself and to her offspring'[42] and yet, on Vanessa's own admission, it was not until Quentin's birth that they were released in full flood. For joy at the advent of her first baby was accompanied by an equal measure of frustration and dismay.

Virginia was jealous, and rather horrified by the irresistible demands of this thief of her beloved sister's affections and time: 'A child is the very devil – calling out, as I believe, all the worst and least explicable passions of the parents – and the Aunts. When we talk of marriage, friendship or prose, we are suddenly held up by Nessa who has heard a cry.'[43] More often than not she and Clive chose to escape such domestic distractions in order to pursue their own interests, these being, at this time, almost exclusively to do with Virginia's novel and the nature of their own relationship. 'Clive and I went for some long walks; but I felt that we were deserters, but then I was quite useless, as a nurse, and Clive will not even hold it,'[44] she reported to Violet Dickinson.

At about this time Virginia began a fragmentary biography of Vanessa, their mother and Stella, produced ostensibly for Vanessa's newborn son Julian. It was written in fact for Vanessa and was a small masterpiece of subtle insights and observation, conveyed in crystalline prose of extraordinary beauty. She wanted to reaffirm her intimacy with the sister she feared she had lost to motherhood and marriage, and obliquely to ask forgiveness. It provoked in Vanessa a not entirely welcome rush of memories and feeling; 'I felt plunged into the midst of all that awful underworld of emotional scenes ... It seems to me almost too ghastly and unnatural now ever to have existed.'[45] But her admiration for Virginia's genius in springing fully to life characters which had been so intimately close to them was all the praise her younger sister needed: 'You will have to keep me supplied with works of yours whenever I am here [at Seend, her parents-in-law's house in Wiltshire], for contact with your wits lifts me out of this dead level of commonplaceness & I sniff the air like an old war horse & snort with delight.'[46] Virginia's talents had achieved all she had hoped. Vanessa had needed her too, she had accepted this offer of love and asked for more. That was all the spur Virginia needed to continue the exploration of their childhood and the sisterly relationship that each found so fascinating.

But Vanessa was still excluded from the important world of work and ideas. Her independence, hard won from under the authority of father and brothers, seemed to be fenced in again with the new demands of husband, babies, domesticity: her freedom to paint temporarily languished by the crib. 'I suppose you are happy at work again on Mel. ['Melymbrosia': *The Voyage Out*.] I envy you. What wouldn't I give for a steady uninterrupted two months' work. Here

[she was in Cornwall for a holiday] I do vague sketches out of the window and of Julian ... Shall you embark on motherhood?'⁴⁷ She wrote as if motherhood was a ship on which she was becalmed offshore while the two people she loved best flourished on the mainland, refusing to cross to her side.

Vanessa's letters at this time were uncharacteristically wistful and dependent. The familiar balance in the sisters' relationship was reversed; now it was Vanessa who hungered for love and attention, who recalled the pleasures of their intimate talks by the fireside with skirts hitched up, when the favourite subjects of their past and Virginia's genius were discussed with relish. She longed for affection from her sister, for 'pettings'. After Julian's birth not very much was offered by Clive. She was demoralised, doubting her attractiveness, doubting even her ability to create good art, and all in the glare of the self-evident brilliance and unencumbered freedom of her incomparable younger sister.

From the nadir of her last devastating breakdown, when Vanessa's qualities of redoubtable common sense and maternal solicitude cast her in heroic mould, Virginia's star had been in ascent, leaving her elder sister once more feeling inferior and earthbound – incapable even of engaging her own husband's interest in the face of such sisterly competition: 'I feel painfully incompetent to write letters & becoming more & more so as I see the growing strength of the exquisite literary critical atmosphere distilled by you & Clive with your wits alert to pounce upon convoluted sentences & want of rhythm.'⁴⁸

Vanessa's melancholy sense of stagnation and inferiority, of her art suffering 'under the heel of moo-cows'⁴⁹ while Virginia's was progressing apace, with the solid, admired achievement of a first and lengthy novel her main preoccupation, was not to be eased until the birth of her second child and the beginning, in 1910, of her momentous relationship with the painter, art critic, connoisseur and creative enthusiast, Roger Fry.

This same year saw the controversial opening of an exhibition organised by Roger Fry of the shockingly uncouth paintings of Van Gogh, Gauguin, Cézanne, Matisse, Picasso, in what came to be considered the first Post-Impressionist exhibition. To the critics and public at large, used to art that was largely realistic, narrative, sentimental, these canvases were a moral and artistic outrage.

To Vanessa, however, the vulgar exuberance of colour, the aban-

donment of realistic draughtsmanship and of sentimental baggage, the very lack of politeness and pretence were all an authorisation of her own artistic freedom; the directness of communication, a confirmation of her and Virginia's attempts at more honest, less constrained social relationships. It was her own painting and her ideas about art which were liberated directly by the almost epiphanic force of this massed show. But also, on her own admission, the revolutionary excitement radiated out through every area of her life: 'That autumn of 1910 is to me a time when everything seemed springing to new life – a time when all was a sizzle of excitement, new relationships, new ideas, different and intense emotions all seemed crowding into one's life.'[50]

The seismic effect was experienced by Virginia too and the first Post-Impressionist exhibition was recognised implicitly by her as the first public explosion in the necessary demolition of the Victorian and Edwardian conventions in human relationships, the outgrown traditions in art. 'On or about December, 1910, human character changed,'[51] she asserted some fourteen years later in an essay on the challenges facing the modern novelist. The year 1910 was one of political upheaval in an era of change and strife; two elections were called by Asquith's Liberal coalition government; Edward VII was succeeded by George V; the agitation for women's suffrage was increasing and Virginia that year offered her services addressing letters and doing other administrative tasks for the cause. But there is little doubt that, when she declared human character had changed, she was thinking of the liberating effect this exhibition had on them all as artists and writers, and on their professional and personal lives too. Vanessa claimed it was for her a revelation that at last she could be herself: 'One might say things one had always felt instead of trying to say things that other people told one to feel.'[52]

The championing of such mutinous art by one of the most distinguished of art critics was bound to provoke a spluttering attack from his fellow critics and the atlantes of the artistic establishment. But Roger Fry remained unshaken by the broadsides directed against him and dismissed 'this outbreak of militant Philistinism'[53] with a certain sense of superiority. The establishment might have attacked him abusively as either charlatan or madman, but the young English painters gathered around him. The excitement was intense. He had shown them the way to take English art from a stagnant backwater into the mainstream of international modern art. And amongst those young artists, the most precious to him was Vanessa Bell.

Simplicity, directness and honesty were what mattered most in art and in life, and as this liberated Vanessa in her painting, so it freed her in her personal relationships too. Her subsequent love affair with Roger Fry the following spring, and the unselfconscious and un-inhibited expression of feeling for him was perhaps as much a spiritual as it was a practical result of their involvement in this cultural revolution. She was beginning to be bold in her experimentation. New ideas of how to represent things gripped her imagination. But she wanted to find her own distinctive voice, much as Virginia did, her approach being, 'not Picasso or anyone but Vanessa'.[54]

It was refreshing and exciting too to be a painter in the cultural vanguard, while the writers, her brilliant sister in particular, were left behind. 'The writers,' Vanessa wrote, 'were pricking up their ears and raising their voices lest too much attention ... be given to painting.'[55] Under the influence of this new inspiration, even the common-placeness of her family-in-law, even the aggressive philistinism of her surroundings at their house in Wiltshire, offered some artistic potential: 'I am beginning to see how even here one could paint, turning all these hideous fir trees into geometrical blocks of purple & green & yellow,'[56] she wrote to Roger Fry.

Watching her sister becoming swept up in the controversy and exhil-aration that eddied around Roger, Virginia recognised that the same principles, which these Post-Impressionist paintings embodied to such startling effect, could be applied as relevantly to her own writing. 'Literature was suffering from a plethora of old clothes. Cézanne and Picasso had shown the way; writers should fling representation to the winds and follow suit,'[57] she wrote in her biography of Fry, when discussing the ideas that concerned him, Vanessa, herself and the rest of their friends in the fertile aftermath of that first exhibition. For Virginia, the old guard in literature were, amongst others, Mr Wells, Mr Bennett and Mr Galsworthy. The restrictive ill-fitting and out-moded old clothes these men of letters had slung around the shoulders of the new generation of writers was a materialism, a morality that distorted the true nature of fiction. 'They have laid an enormous stress upon the fabric of things,'[58] Virginia asserted. The layering of detail and description may have communicated something wondrously life-like, just as a particularly skilled painter could produce on canvas a bowl of cherries at which birds would peck, but the true reality of the character or experience somehow eluded such material represen-tation.

As Vanessa moved further away from a mimetic representation in her painting, so Virginia was confirmed in the course of her experimentation with fiction: 'My own particular search – not after morality or beauty or reality – no; but after literature itself.'[59] She too had to explore the traditional form of the novel before she could abandon the methods of the past without regret. This Virginia did, rather surprisingly, with her second novel *Night and Day*, published in 1919 and an apparently retrogressive step towards conventionality that she explained in the painters' terms she must have heard many times from her sister's lips: 'It taught me a great deal, or so I hoped, like a minute Academy drawing: what to leave out by putting it all in.'[60]

The painterly qualities in Virginia Woolf's work provide enough speculation and example for a study in themselves. Everywhere there is evidence of how fertile for Virginia were the painters' preoccupations and explorations at this time. Sentences, she realised, were like brush-strokes, they had a rhythm and a shape that were distinctive to the artist who made them. Her acute visual sense suffused her writing, giving the sense on countless occasions that she was creating a picture, painting with the pared-down boldness and simplicity of a Post-Impressionist.

In *The Waves*, the episodic progress of the sun through the day was brushed in with just the sureness of touch and colour that was so exhilarating in a Matisse for instance.

> The sun fell in sharp wedges inside the room. Whatever the light touched became dowered with a fanatical existence. A plate was like a white lake. A knife looked like a dagger of ice. Suddenly tumblers revealed themselves upheld by streaks of light. Table and chairs rose to the surface as if they had been sunk underwater and rose, filmed with red, orange, purple like the bloom on the skin of ripe fruit. The veins on the glaze of the china, the grain of the wood, the fibres of the matting became more and more finely engraved. Everything was without shadow. A jar was so green that the eye seemed sucked up through a funnel by its intensity and stuck to it like a limpet. Then shapes took on mass and edge. Here was the boss of a chair; here the bulk of a cupboard. And as the light increased, flocks of shadow were driven before it and conglomerated and hung in many-pleated folds in the background.[61]

This was the book that was inspired originally by a description

Vanessa wrote to her sister, in May 1927, of the capturing of a giant moth in her house at Cassis in the South of France.

I sit with moths flying madly in circles round me & the lamp. You cannot imagine what it is like. One night some creature tapped so loudly on the pane that Duncan said 'Who is that?' 'only a bat' said Roger, 'or a bird', but it wasn't man or bird, but a huge moth – half a foot literally across. We had a terrible time with it. My maternal instinct which you deplore so much, wouldnt let me leave it. [Her children were keen bug hunters.] We let it in, kept it, gave it a whole bottle of ether bought from the chemist, all in vain, took it to the chemist who dosed it with chloroform for a day – also in vain. Finally it did die rather the worse for wear, & I set it, & now, here is another! a better specimen ... I know how one would have blamed one's elders for not capturing such things at all costs so I suppose I must go through it all again. Then I remembered – didn't Fabre try experiments with the same creature [an Emperor moth she thought] & attract all the males in the neighbourhood by shutting up one female in a room? – just what we have now done. So probably soon the house will be full of them.[62]

Virginia had replied: 'Your story of the Moth so fascinates me that I am going to write a story about it ['The Moths', which was to become *The Waves*, published in 1931]. I could think of nothing else but you and the moths for hours after reading your letter. Isn't it odd? – perhaps you stimulate the literary sense in me as you say I do your painting sense.'[63]

Eventually, on reading the completed novel, Vanessa recognised it as a work of art that moved her, not only through its personal associations with their brother Thoby's death, but through her sister's artistic genius in removing the relationships of the characters from the personal and sentimental to the universal; by attaining a perfect balanced whole. She was intrigued by the similarities between what had been achieved in *The Waves* and what she herself was struggling to achieve in one of her paintings, now lost:

Will it seem to you absurd and conceited or will you understand at all what I mean if I tell you that I've been working hard lately at an absurd great picture I've been painting on and off the last 2 years – and if only I could do what I want to – but I can't – it seems to me it

would have some sort of analogous meaning to what you've done. How can one explain, but to me painting a floor covered with toys and keeping them all in relation to each other and the figures and the space of the floor and the light on it means something of the same sort that you seem to mean.[64]

Both sisters recognised this mutual encouragement and inspiration in each other's work. Vanessa greeted Virginia's novels with a genuine awe and admiration, but she was exasperated too at how her sister seemed to plunder their lives for the sake of her art. Helen Ambrose in *The Voyage Out* was recognised by their intimate friends as being largely, and not altogether sympathetically, based on Vanessa. In Katharine Hilbery, the central character in *Night and Day*, Virginia set out deliberately to explore and celebrate the character of her elder sister, a subject of abiding fascination for her. That sister on reading the novel dedicated to her was uneasy at this brilliant raid on real life: 'Novel writing seems a queer business, at least this kind. If its art it seems to me art of quite a different sort from making a picture.'[65]

Beneath the surface encouragement, and a deeper layer of pride in each other's achievements, there was a strain of particular competitiveness as to which sister's art was 'superior' as art. All her life, both implicitly and explicitly, Virginia had maintained that painting was an inferior business compared to literature. This was due, partly perhaps, to her family's predisposition towards writers, but more to the confused rivalries and passion which Vanessa inspired in her.

Virginia's comments on the qualities of the opposing arts were addressed largely to Vanessa and, although nearly always teasing, had a serious message for her. 'Your art is far more of a joke than mine,'[66] she wrote having spent a morning at the Manchester Art Gallery looking at the Pre-Raphaelites. Virginia worked from the premise that painters knew nothing and cared less about the outside world. Her opinions were based solely on her experience and characterisation of Vanessa. 'There they [Vanessa and Duncan] sit,' she wrote years later to Julian who was in China as Europe was poised on the brink of war, 'looking at pinks and yellows, and when Europe blazes all they do is screw up their eyes and complain of a temporary glare in the foreground.' Her own art, she pointed out, was more engaged: 'Unfortunately politics get between one and fiction.'[67] She was in the middle of revising *The Years*, the fictional counterpart to *Three Guineas*, both

books informed with her feminism and pacifism. Vanessa wrote to her son from Charleston, a few months later, unwittingly confirming her sister's characterisation of her retirement: 'Its only too easy for one to relapse into forgetfulness of public life ... [I] can only too quickly get into a world of complete unreality.'[68]

Not only were writers more involved in the things that mattered, their tool, language – Virginia believed – was a more expressive and impressive medium than was mere paint. To her younger nephew, Quentin Bell, she wrote, half in jest, that writing as well as he did, he could not seriously consider becoming a painter:

> Surely you must see the infinite superiority of the language to the paint? Think how many things are impossible to paint: giving pain to the Keynes', making fun of one's aunts, telling libidinous stories, making mischief – these are only a few of the advantages; against which a painter has nothing to show: for all his merits are also a writer's.[69]

Regretting that painting would never be as subtle in its expressiveness as literature, Virginia could lose her sympathy with the artists who did see further layers of significance and meaning in works of art. Having been exposed to the Second Post-Impressionist Exhibition in 1912; having endured the endless enthusiasm and growing confidence of the artists, particularly, perhaps, of Vanessa who was entering one of her most creative periods: Virginia fulminated against all artists – but essentially against Vanessa's preoccupations – declaring, 'Artists are an abominable race. The furious excitement of these people all the winter over their pieces of canvas coloured green and blue, is odious.'[70]

Vanessa, naturally less vocal but more judgmental than her younger sister, countered this general deprecation of her art by wondering herself occasionally whether Virginia's novels qualified as works of art at all. *The Voyage Out*, Virginia's much agonised over first novel, was credited by Vanessa with being extraordinarily brilliant at times, but, she wondered, was it art? She compared it unfavourably to Jane Austen's work which 'put one into a different world, one that's the same really that one is in when one looks at a Cézanne,' while her response to Virginia's writing was, necessarily, much more personal and therefore, by her criteria, disqualified it from being a work of art. 'Reading V's book', she explained to Roger Fry, 'is much more like

being with an extraordinarily witty and acute person in life and watching all these things and people with her ... I know all the people nearly and how she has come at so much of it which makes it very difficult to be fair.'[71] Vanessa was to modify her opinion in reply to Roger's more effusive verdict, but she maintained still that Virginia had not produced something she would call art. She did agree, however, that her sister was an artist and, grudgingly, although she said she would not choose to call it that, 'I suppose it's true that she has genius.'[72]

Vanessa was to embrace certain of Virginia's subsequent novels with much more enthusiasm, and ignoring the overwhelming auto-biographical elements, in *To the Lighthouse* for instance, she was to allow them the status of works of art. She did maintain, however, a prejudice about writers which was complementary to Virginia's dismissal of artists: 'After all it seems to me hardly any literature is [art] & plenty of writers survive who arent at all artists.'[73]

To Virginia's eye, painters might practise an inferior and easier art but their lives were enviably collaborative and sensually satisfying: 'They are very large in effect, these painters; very little self-conscious.' She was thinking of Vanessa and Duncan at Charleston when she wrote, 'they have smooth broad spaces in their minds where I am all prickles & promontories.'[74] She believed her art was much more demanding and dangerous and the difficulties brought her near to a despair that was peculiar to writers. 'Sometimes it seems to me that I shall never write out all the books I have in my head, because of the strain,' she wrote in 1921, convalescing near the end of writing her experimental *Jacob's Room*: 'The devilish thing about writing is that it calls upon every nerve to hold itself taut. That is exactly what I cannot do – Now if it were painting or scribbling music or making patchwork quilts or mud pies, it wouldn't matter.'[75]

Despite this deep-seated rivalry, the true affection and admiration each sister bore for the other and her art in the end triumphed. Commenting on Vanessa's own show in the spring of 1927, Virginia gave her the highest praise, using the language of her own art: 'You are now mistress of the phrase. All your pictures are built up of flying phrases ... I dare say your problem will be to buttress up this lyricism with solidity.' Virginia was thinking of her own work on *To the Lighthouse*, in which she had just struggled with the same problem of bringing structure to her lyricism. But here she allowed that Vanessa had achieved success in her creative struggle equal to her own: 'I think

we are now at the same point: both mistresses of our medium as never before.'[76]

Perhaps *To the Lighthouse* was the work of Virginia's which in its entirety was most like a painting, and in which she explored most directly the painterly eye and instinct. She was exercised by the structure of the whole novel, with how to connect the past and present by constructing the section 'Time Passes' as the central core – just as her fictional artist Lily Briscoe struggles with the relationship in her painting between the masses of the wall, the hedge and the tree. Lily realises in triumph that the tree has to be moved to the middle of her painting and thus, by completing her vision, vindicates her vocation as an artist. Virginia similarly had seen how her novel's fluidity and the impressionism of her images had to be contained and synthesised by just such a rigorous design. Like Lily, managing to capture and communicate her unique vision not only freed Virginia from the haunting of her mother and the past, but vindicated her vocation as a novelist in the face of patriarchal disparagement – 'Women can't paint, women can't write ...'[77] – and like Lily's painting, completed with the last brush-stroke in the book, the structure was shown to be what makes the work truthful and whole.

Vanessa contributed her own simplicity of design to the book with an evocative dust-jacket depicting a lighthouse, plumb centre, thrusting out of the waves and spurting light. Virginia was delighted with this artistic collaboration: 'I thought it lovely ... Your style is unique; because so truthful; and therefore it upsets one completely.'[78]

In her diary, contemplating the writing of *To the Lighthouse*, Virginia had mapped out her design:

'When I begin it I shall enrich it in all sorts of ways; thicken it; give it branches & roots which I do not perceive now. It might contain all characters boiled down; & childhood; & then this impersonal thing, which I'm dared to do by my friends, the flight of time & the consequent break of unity in my design. That passage (I conceive the book in 3 parts: 1. at the drawing room window; 2. seven years passed; 3. the voyage:) interests me very much.'[79]

It could be seen as her literary equivalent of the Post-Impressionism which had seemed so liberating to Vanessa and their artist friends, where a steeliness of design had always to be apparent.

To Roger Fry, high priest of Post-Impressionism proclaiming the

sacred versicle, *Vision and Design*, Virginia protested that the lighthouse itself meant nothing, it was less a symbol and much more a necessary feature of the design of her work, as the positioning of the tree was to Lily Briscoe's: 'One has to have a central line down the middle of the book to hold the design together,'[80] Virginia explained valiantly. This perceptive, subtle, limpid, many-layered thing, in which she suspected she had conveyed her vision, had become her masterpiece. Virginia assessed her success, again in painter's terms: 'I ... got down to my depths & made shapes square up.'[81]

The influence by association of the Post-Impressionists' stylistic freedoms, the inspiration for 'The Moths'/*The Waves*, the painterly structure of *To the Lighthouse* (and the painter protagonist), all came to Virginia through Vanessa. And of course there were the number of times her character was used as the inspiration for Virginia's fictional women. But Vanessa was also her audience; it was for her that she wrote and her approval which mattered most: 'I always feel I'm writing more for you than for anybody.'[82] Leonard offered measured and rational criticism of Virginia's work, much valued and accepted with a surprisingly detached equanimity, but it was Vanessa's praise which was the real prize, awaited with much the same intensity and trepidation which attended her offering of the 'Hyde Park Gate News' to her mother for appraisal when she was a girl.

In a letter written to Vanessa two years before her death, Virginia explained that it was their creative solidarity which made her comments so valuable: 'I was all of a heap that you liked my story [The Searchlight] – the only person in the world whose opinion can heap me ... The terror of both families [Bells and Woolfs] is their complete absence of any creativeness – hollow shells; and so one can't get in touch.'[83] But undoubtedly, too, Virginia needed Vanessa's approval like she needed a mother's approval, as a reconfirmation of her loveableness and worth.

She awaited most keenly Vanessa's verdict on *To the Lighthouse*, the book that explored in such unforgettable images the ecstatic and tragic association of their childhood and the central relationship of their parents. Virginia was nervous: Was it too subjective? Had she encroached on her sister's territory? 'God! how you'll laugh at the painting bits in the Lighthouse.'[84] Having exposed so much of the old hurt, having confronted so many ghosts, she feared ridicule, she feared the charge of sentimentality. But Virginia was so eager for Vanessa's opinion that she wrote a week after two copies of the book

had been despatched to her sister in the South of France, begging a letter, with a most witty verbal sketch of the two painters, Vanessa and Duncan Grant, unable to find time or inclination to read her book with the requisite critical application, attempting an expedient prevarication. But behind the humour was her desperate need for praise from the one person in whom was vested the greatest authority. Virginia admitted to this magisterial sister – what possibly was more profoundly what she had feared always about her mother – 'I can never believe that you approve of me in any way, strange though it may seem.'[85]

She need not have worried for Vanessa already had written: 'I am excited and thrilled and taken into another world as one only is by a great work of art.' She was overwhelmed, she said, by being faced once again by her mother; Virginia's re-creation of her in all her subtlety and glory was an extraordinary artistic accomplishment. Vanessa added a particularly sweet accolade from a painter struggling to realise her own vision: 'You see as far as portrait painting goes you seem to me to be a supreme artist.'[86]

Virginia herself was never to be so genuinely astonished and moved by her sister's paintings. Although deeply responsive to the natural world, she was never entirely at home with art and art criticism. She found the silence of paintings difficult, the little they revealed about the artist frustrating. In the 'strange painter's world ... mortality does not enter, and psychology is held at bay, and there are no words,' she wrote in the catalogue introduction to Vanessa's *Exhibition of Recent Paintings* at the Cooling Gallery in 1930. Unlike the self-revealing novelist she maintained, 'Mrs Bell says nothing. Mrs Bell is silent as the grave. Her pictures do not betray her. Their reticence is inviolable.'[87] To a Post-Impressionist, this impersonality would be seen as proper, but there is a sense, in the words Virginia uses, that she is unsympathetic to a certain chilliness that results. Perhaps Virginia was uneasily reminded too of how reticent and impenetrable Vanessa could be in life as well as in her art.

Her comments to her sister, however, on her paintings were genuinely admiring and encouraging, always critically astute, but often reflexive: her pictures inspired her with ideas for stories; where there was silence, Virginia longed to provide the words. Vanessa's experimentation with a pared down, non-narrative form in her painting – leading during 1914 and 1915 to some purely abstract works in paint and collage – helped illuminate for Virginia her own parallel

search for a style that captured what was significant and essential, by cutting away the mundane sentimentality and materialism which characterised much of the fiction of the previous generation.

Praise for Vanessa's work from others caused Virginia that familiar spasm of sisterly comparison: 'Several people have told me that your picture of the enormous women was a revelation to them. Thank God, I say, that she doesn't write.'[88] In part humorous, in part an affectionate flattery, but underlain by a heartfelt sentiment expressed on a number of occasions, that to endure such intimate competition in this the most momentous activity of her life (to be prevented from writing, she declared, was to be cast into the pit of Hell) would be unbearable.

The picture of the enormous women, *A Conversation*, was painted by Vanessa in 1913 and then modified in 1916. It was a large painting dominated by the figures of three monumental women, leaning in towards each other, rapt in conversation. One can imagine why this image created by her sister appealed so distinctly to Virginia. It was not so silent nor devoid of psychological interest. The amplitude of the figures, their female intimacy and fertility reinforced by the brilliantly coloured flowers in the circular flower-bed through the open window by which they talk give a palpable sense of the women's solidarity, the closed circle of their backs a conspiracy against the outside world. It stimulated Virginia's admiration and imagination. 'I think you are a most remarkable painter,' she wrote to her sister after seeing the painting again in her 1928 exhibition. 'You are into the bargain, a satirist, a conveyer of impressions about human life: a short story writer of great wit and able to bring off a situation in a way that rouses my envy. I wonder if I could write the Three Women in prose.'[89] Five months later Virginia read two papers at the women's colleges at Cambridge on 'Women and Fiction', which she was to expand into *A Room of One's Own*, published the following year.

Another painting from that decade, *The Tub*, painted in 1918, conveyed more vividly than words the remoteness and silence, as well as the emotional charge, that struck Virginia as being at the heart of Vanessa's work. The naked woman stands looking down, lost in her own thoughts, isolated compositionally from the bath-tub which, upended and empty, dominates the centre of the painting. Pared visually to a minimum, shorn of any narrative baggage, the picture is full of stifled emotion; loneliness and unfulfilled longings. Circular shapes were the distinctive mark of Vanessa's decorative work,

expressing fullness and fertility. But here her circle of the empty tub gives a powerful sense of disappointment and barrenness.

It was painted during the last year of the war, a time of great hardship and isolation for Vanessa, running a large household without enough provisions and in primitive conditions. Her relationship with Duncan Grant and his lover at the time, David Garnett, known as Bunny to his friends, was strained. They were living there together, Vanessa keeping house, looking after her children and painting, Duncan and Bunny working on the land. Passions and jealousies raged between the men, with both seeking solace from Vanessa. She loved Duncan and was at last pregnant by him, but any further sexual intimacy was to be denied her. He was obsessed with Bunny, as he would be with other men, and she looked after him and was solely responsible for her children; there was nobody restoring energy and love to her. Although analogous with Vanessa's situation at the time, the poignancy of the painting's imagery did not fit easily with Virginia's lifelong view of her sister as someone who was self-sufficient and fulfilled.

Vanessa's portraits of Virginia were among her most delicately executed works. She worried about doing her sister's beauty justice and tended to seek more for a realism and charm than when painting people for whom she did not care so deeply. The 1912 portrait, presently hanging at Monk's House, the Woolfs' house in Sussex, shows a vivid young woman with a fine-boned luminosity. She leans forward in response, her lips slightly parted as if about to speak. There is a watchful eagerness about the pose which contrasts with her other two portraits painted that year, probably both at Asheham.

These two show Virginia absorbed, reflective, silent. In one she reclines in a deck-chair, in the other she leans back in an armchair, her head tilted to look down at her knitting. Both portraits show Virginia's face as virtually without features, yet the outline and posture of the figures convey an unmistakable presence, which at the same time recedes to become part of the pattern and colour of the whole. The lack of definite representation allows also a freer response, for instance the sea-green colours of her dress and the shapes of the second portrait suggest some shy sea creature, enclosed within the wings of the armchair, curved like waves about her. The facelessness in Vanessa's portraits of Virginia could be in part her instinctive response to her sister's uneasiness in inhabiting a physical body, her longing at times to lose individuality and merge consciousnesses: a

longing to become part of the whole pattern hidden behind the unnecessary detail of existence, which could only ever separate and exclude.

Then in a much later portrait (1934) Vanessa returned to realistic detail, placing a delicate, long-limbed Virginia in a room full of books, flowers and Grant and Bell decorations on walls, floors and chair. She painted her sister's face slightly turned away, her expression rather wary, her hands and feet fragile and expressive. Each looked to the other as material for her art. Both were reluctant sitters, but both were serious enough about their work, and each other's work, to see the necessity of this exposure.

Both women were not solely painter and writer, each solitary in studio and study. Both were to be involved in businesses which brought their art into the retail trade as designer/decorator and publisher, allowing the sisters their long artistic collaboration in The Hogarth Press. On 25 January 1915, Virginia's thirty-third birthday, she and Leonard Woolf had determined to take the lease on Hogarth House in Richmond, and to buy a printing-press.

Their plans for the press were deferred by Virginia's mental collapse during that spring and summer, but it was delivered at last in the spring of 1917. This was to mark the beginning of The Hogarth Press, a hobby that Leonard had suggested to Virginia as a way of keeping her from too much introspection and unremitting absorption in her writing, which became, by 1924, a literary publishing house of increasing success and reputation. It was to publish all Virginia's books (eventually acquiring the rights for *The Voyage Out* and *Night and Day* from Duckworth) and other important works such as T. S. Eliot's *The Waste Land*, and Freud's Collected Works. The Press was not only an outlet for Virginia's own writing, but was an expression, in the early days particularly, of her skills as a talent-spotter, editor, printer, binder and at times general parcel packer. Most significantly too, it was to be an important showcase for an aspect of Vanessa's decorative skills. Every Virginia Woolf title that The Hogarth Press published bore a distinctive dust-jacket designed by Vanessa, a visual symbol of the sisters' artistic collaboration.

The trainee printers, Leonard and Virginia Woolf, however, started in 1917 very modestly with an 150-copy printing of a thirty-two page pamphlet, *Two Stories*: 'The Mark on the Wall' written by Virginia and 'Three Jews' by Leonard. Every process they did themselves and by hand, even sewing the pages together in the dining-room of

Hogarth House. From the start, the look of their publications mattered to them and this first pamphlet was illustrated with woodcuts by Dora Carrington, the painter who lived with Lytton Strachey.

Vanessa was interested in the possibilities for the artists in this enterprise of her sister's and suggested that the Press should publish a booklet of woodcuts produced by herself, Duncan Grant and Roger Fry. Her determination to have final artistic control, however, met Leonard's insistence that he, not the artists, would have the final say. Vanessa was as uncompromising as Leonard and so withdrew the plan, 'knowing what his taste in those ways is',[90] as she explained rather loftily to Roger.

This was not to be the only friction between the sisters over the activities of The Hogarth Press. Two years later, in 1919, Virginia's lyrical story *Kew Gardens* was published with two woodcuts of Vanessa's used as a frontispiece and endpaper. Vanessa often found her imagination stimulated by Virginia's writing and on reading this story had felt moved to do a drawing. She never saw it as her business to illustrate the text; the writing and the image were to stand separately, yet connected by the ideas and impressions each conjured up. As far as the collaborative artist, and slightly rivalrous sister, was concerned, the printing of her woodcuts in *Kew Gardens* was over-inked, shoddy and second-rate. She said something to that effect to Virginia, even the positioning of the woodcut for the frontispiece was wrong; altogether, Vanessa inferred, the Press itself hardly deserved to be dignified with the name.

Virginia reported back how this swingeing criticism had undermined her; how she had gone to a professional printer for the reprints. From them even worse mistakes emerged, with covers printed so crooked and mismatched that Virginia had had to pare them down by hand with a knife. How she had suffered under her sister's contempt, 'My soul shrivelling like a – I cannot remember the image exactly, but its something one does by rubbing a piece of sealing wax and then everything curls up – as if in agony.'[91] To restore her self-esteem, Virginia claimed, she bought a peculiar little house in Lewes on the spur of the moment, in an act of defiance, perhaps, towards her sister; in an attempt to demonstrate independence of her opinion, and general insouciance to the world. Virginia was to regret this rash purchase almost immediately. She and Leonard had to give up Asheham House and had already been looking for an alternative house. They saw notice of the auction of Monk's House in Rodmell,

on their unenthusiastic way to view Virginia's folly, and spontaneously decided to get rid of the one and buy the other.

Like all their rows, this one blew over; Virginia's apologetic, conciliatory gestures warming her elder sister's judicious disapproval. From then on Vanessa designed every dust-jacket for Virginia's books, a policy Virginia was faithful to even when the jacket for *Jacob's Room* was ridiculed by some of the bookshop buyers and generally condemned. This and all her other designs were to be distinctively Vanessa Bell: boldly Post-Impressionist, full of flowers and circles and images of plenitude; sensuous rather than numinous, they bore not much obvious relation to the contents of the book and sometimes not even to the title. Vanessa admitted to John Lehmann who was running the Press when, in 1937, she was working on the design for *Three Guineas*: 'I've not read a word of the book – I only had the vaguest description of it and what she wants me to do from Virginia – but that has always been the case with the jackets I have done for her.'[92]

This freedom and independence was characteristic too of the designs Vanessa drew for the 1927 illustrated edition of *Kew Gardens*, where the delicacy of Virginia's prose was dominated by the sweeping lines and circles of Vanessa's drawings, suggesting vigorous, organic growth with the generative power to take over the page. After the initial problems with the Press printing Vanessa's work satisfactorily, this collaboration between the sisters was a happy and productive one. It confirmed also the complete intimacy and yet independence of their working relationship. As each Virginia Woolf book was published, be it masterpiece of experimental fiction, or collection of essays, polemical non-fiction, or *jeu d'esprit*, it arrived at bookshop and in the mail of friends encased in the distinctive signature of a Vanessa Bell dust-jacket. The book, often the result of years of unremitting labour, anguish and exhilaration, and proffered to her public in trepidation, was protected and promoted by a cover which appeared to be the happy result of an afternoon's work in a summer studio with birds singing. Just as, when they were young women going out into society, wearing an evening dress by Mrs Young gave them confidence and protection, so, each time Virginia had to face the world with her tender artistic vision she was, as it were, clothed with a jacket of Vanessa's, in complicity and reassurance.

Although she was to be enthusiastic and encouraging of her painting and her art, to Virginia always, it was Vanessa herself who was the

ultimate work of art. Her beauty and character, her abilities and sensuous charms were celebrated in spontaneous and fulsome outbursts in Virginia's letters. In her more reflective diaries such contemplation could be the cause of periodic collapses into self-doubt and misery. Indeed Virginia's obsession with Vanessa was as much to do with her need of these particular qualities of solidity, maternity and sublimity that her elder sister embodied as it was to do with a profound sisterly competitiveness and envy: 'One of the concealed worms of my life has been a sisters jealousy – *of* a sister, I mean.'[93] She admitted that in order to intensify these feelings of inadequacy she enhanced her vision of Vanessa, savouring her favourite images of her as pagan goddess, archetypal woman, the breath of life, 'a bowl of golden water which brims but never overflows.'[94]

Using more naturalistic hues Virginia explored in her fiction the enigmatic fascination of this sister whose formidable exterior hid sensitivities and frailties seldom revealed. In *Night and Day* she placed Vanessa at the centre: 'You've got to be immensely mysterious and romantic, which of course you are; yes, but its the combination that's so enthralling; to crack through the paving stone and be enveloped in the mist.'[95] In this book she explained she had set out to examine the importance of the things which are not said in relationships and the effect suppression had on the emotions. Virginia recognised that Vanessa, from her earliest days, had been restrained in her expression of feeling, a natural reticence petrified by the tragedies in her youth and by the brutal emotional demands of her father and half-brother George. Thus the paving stones had been hammered firmly in place over feelings, unacknowledged and so intense that at times she was overwhelmed by terrible emotional collapse.

Precious as Vanessa was to Virginia, both personally and creatively, the qualities she celebrated in her sister belonged to the instinctive, domestic areas of life and were always in Virginia's imaginative control. A character in a novel is at the mercy of her creator. This beloved sister would only have to approximate to the image of exacting mother or fecund goddess for Virginia to derive her own emotional solace from contemplation of such similitude. But when Vanessa stepped away from this eidolon, however subtle and flattering and sometimes startlingly truthful it might be, and appeared autonomously outside the domain mapped out for her, Virginia felt her power diminish, her own terrain less securely hers, and she grew uneasy. Then the relationship began to reveal its raw edges.

After the first of the London Artists' Association's exhibitions in
1926, when Vanessa's reputation as a painter of note began its ascent,
Virginia reminded her that she was stepping outside her agreed
territory and that artistic genius and international celebrity belonged,
by treaty, to her alone; 'I am amazed, a little alarmed (for as you have
the children, the fame by rights belongs to me) by your combination
of pure artistic vision and brilliance of imagination.' In the same letter
she continued, amusingly and disarmingly, to reveal the old sore:

[I] kept on saying that your genius as a painter, though rather
greater than I like, does still shed a ray on mine. I mean, people will
say, What a gifted couple! Well: it would have been nicer had they
said: Virginia had all the gifts; dear old Nessa was a domestic
character – Alas, alas, they'll never say that now.'[96]

From their early childhood, when Virginia had used her consider
able physical charms and verbal wit to amuse and enchant the adults
and nursery alike, that may well have been a view that was generally
held and sometimes, no doubt, expressed. Virginia had the genius and
Vanessa the womanly virtues of beauty, practicality and common
sense. It was not only Virginia who recognised the subterranean
rivalry between them. For a time at least at the end of the twenties and
the beginning of the thirties, Vanessa's celebrity as a painter equalled
Virginia's as a writer. After Virginia in 1928 had delivered her lectures
on 'Women and Fiction' in Cambridge to a rapturous reception,
buoyed on the commercial success of her latest novel *Orlando*, that
most brilliant and cunning of intellects, Maynard Keynes, came up to
Vanessa and, to her understandable irritation, slyly said, 'well, there
can be no doubt who is the famous sister now.'[97]
The fame did by rights belong to Virginia, but, as she herself
recognised, her continual efforts to communicate, the creative energy
she channelled so unreservedly into her work, was partly the result of
her not having children, not having that natural badge of potency and
worth which Vanessa so effortlessly wore. Yet Vanessa's maternity
had detracted from her primary need to communicate her vision
through paint, and Virginia could sympathise with the sacrifices her
sister had made: imagining her, as her last child Angelica left home to
go to school, 'going back, perhaps rather sadly to the life she would
have liked best of all, to be a painter on her own. So we have made out
our lives, she & I, propelled into them by some queer force.'[98]

7

Husbands and Sisters

'My own gifts & shares seemed so moderate in comparison [with Vanessa and her children]; my own fault too – a little more self control on my part, & we might have had a boy of 12, a girl of 10; this always makes me wretched in the small hours.'

Virginia Woolf, 5 September 1926, *Diary*, vol. III

VIRGINIA WAS VEHEMENT in her rejection of the idea of marriage for herself when, once Vanessa had married, friends and older family began to intimate that this too was her natural destiny. But circumstances had changed since those two euphoric years at Gordon Square when all four Stephens had planned to live together for ever. Thoby was dead. Almost without pause for mourning, Vanessa was married. Life for Virginia living with Adrian at 29 Fitzroy Square was increasingly unsatisfactory for they were an explosively ill-matched couple. Grease spots on their dining-room wall bore witness to the number of mealtimes when each in exasperation would fling butter pats at the other. The lack of sympathetic understanding between them heightened Virginia's sense of emotional isolation.

It was still the case that, until marriage, a woman was expected to live under the protection of a male member of her family: only upon marriage did she attain status and social freedom. In the dream of Virginia's youth, she and Vanessa united could have defied the convention that demanded all young women should marry; but Vanessa had reneged on the sisterly compact and the weight of family and social expectation was not easily opposed.

Marriage for Virginia, therefore, became less abhorrent as it appeared increasingly as an escape, from solitariness and a spinster's circumscribed life. She had before her too the example of her sister's early married bliss, a transformation that had exhilarated Virginia, yet filled her with the outsider's envy and a particular alarm. What was the nature of sexual union that it brought about such a change in a

woman's very nature? There was a tentative excitement at the novelty of the experience for, as an idea, marriage was another adventure, a further voyage of discovery. The interesting thing, however, was just whom the sisters considered as a suitable husband for Virginia.

From about 1909 until her eventual engagement in 1912, there were a number of suitors of varying interest, seriousness and suitability. Hilton Young, a personable family friend and contemporary of Thoby's at Cambridge, was an interested but unsuccessful runner; the sphinx-like member of their inner circle, Saxon Sydney-Turner, was for a time an enigmatic outsider in this marital speculation; an intrigued but timid Walter Lamb intermittently hove into view, eventually and vainly to declare his interest in the summer of 1911. But of most interest, to begin with, for both sisters was the magnetic Lytton Strachey.

Of all these tentative suitors, Lytton was the most unlikely and the most timorous. Born in 1880, the second youngest of ten surviving children, he had grown up in a large family with the same social background as the Stephens. Upper-middle-class intelligentsia rather than landed aristocracy, the Stracheys had to work for their living. But family life in the vast, grim house at 69 Lancaster Gate was more chaotic and exuberant than for the Stephen sisters cloistered in sepulchral 22 Hyde Park Gate, on the other side of the park. Only when Lytton and Thoby went to Trinity College, Cambridge did the Strachey young meet the Stephens.

Lytton Strachey was the most literary of Thoby's Cambridge friends, the most obviously original and bizarre. Pallidly asthenic, his drooping physique was further devitalised by a fragile constitution and a sturdy hypochondria. Burdened with an implacable self-disgust, in seeking beauty Lytton Strachey deplored his own ugliness, fearing that he was as physically unattractive to others as he was to himself. Longing to love, he could not accept that he too was lovable. In those early post-Cambridge days he was pre-eminent amongst those young men who congregated regularly at the new Stephen family house in Gordon Square, initially drawn by their admiration for Thoby but becoming consolidated emotionally and intellectually, as a group, around the complementary foci of his two sisters.

Virginia was predisposed to admire Lytton by her brother's extravagant descriptions of this prodigy. 'He was exotic, extreme in every way – Thoby described him – so long so thin that his thigh was no thicker than Thoby's arm. Once he burst into Thoby's rooms, cried

out, "Do you hear the music of the spheres?" and fell in a faint.' He was pronounced the essence of culture and the possessor of such wit and learning that even the dons would come to listen to him: '"Whatever they give you, Strachey," Dr Jackson had said when Strachey was in for some examination, "it won't be good enough."'[1] Dr Jackson was proved to be right for Lytton Strachey left Cambridge disappointed, with neither a fellowship nor even a first to mark his celebrated passage through academe.

It was his cat-like intelligence, in part so like her own, which attracted Virginia, yet made her wary. The fascination of his talk, the sympathy of his perceptions made him uniquely exhilarating company. 'If he were to walk in at this moment we should talk about books & feelings & life & the rest of it as freely as we ever did,' she reminisced ten years or so later, 'with the sense, on both sides I think, of having hoarded for this precise moment a great deal peculiarly fit for the other.'[2] This intellectual reciprocity was most seductive to the young Virginia, painfully aware of her own lack of formal education; enjoying the unfamiliar satisfaction of exercising her intellectual skills amongst her peers; winning herself approbation from the rigorous male intellects trained by the educational establishments she had been denied; and struggling with her first novel, her personal voyage out.

However congenial Lytton Strachey was to Virginia, he possessed one quality which would have seemed to have made him glaringly unsuitable as a husband to a young woman who had assured a later suitor that she did want to have children 'and love in the normal way'.[3] Lytton Strachey was an unequivocal homosexual, 'the arch-bugger of Bloomsbury',[4] as Quentin Bell succinctly put it. After Thoby's death and Vanessa's marriage he was quite open with Vanessa and Virginia about his life, and discussion of his loves and the loves of the other Bloomsbury buggers provided much speculative amusement during those early years of independence. It gave the sisters, Vanessa particularly, an invigorating sense of freedom and dashing impropriety.

That both sisters, however, should see him not only as a possible but as a desirable husband for Virginia was remarkable and revealing. It is easier to understand why Virginia should discount the matter of Lytton's homosexuality. Her own experience of sexuality was limited and confusing. As a girl, she had been threatened and disgusted by male lust. For the rest, she admitted she knew more theoretically from books than from life itself.

I knew there were buggers in Plato's Greece; I suspected – it was not a question one could just ask Thoby – that there were buggers in Dr Butler's Trinity, Cambridge; but it never occurred to me that there were buggers even now in the Stephens' sitting-room at Gordon Square.[5]

In her young womanhood, Virginia seemed almost as unfamiliar with the reality of heterosexuality. Vanessa's transformation during the first year of married life into a sexually fulfilled woman was transfigured by Virginia into something impersonal, almost mythical. In her favourite imagery of her sister at this time she divested Vanessa of her humanness and cast her as a goddess of elemental power. In her flirtation with Clive too, she seemed barely aware of the sexual feelings involved; it was her intellect and sentiments which were titillated, her need for attention and adoration that was gratified. When it came to the theory of her own marital expectations, Virginia said she wanted children, that she wanted a man 'to make me vehement',[6] but she did not seem quite to connect either of these desires with sexual passion.

Lytton Strachey appealed to Virginia intellectually, as an extension of her education, and sympathetically, as an inveterate outsider like herself. Both were thin-skinned and needy of love, yet uneasy with their corporeity. There was too a similarity of temperament: both could share that plunge of despair, that overwhelming suspicion of their worthlessness – and express it in strikingly echoic language. 'You don't know what it is to be twenty-five, dejected, uncouth, unsuccessful – you don't know how humble and wretched and lonely I sometimes feel Oh God, these are wretched things to be writing,'[7] was Lytton's cry to Duncan Grant; Virginia's to Vanessa: 'I could not write, and all the devils came out – hairy black ones. To be 29 and unmarried – to be a failure – childless – insane too, no writer.'[8]

There was also a welcome ease for Virginia in the company of men who were for the most part uninterested sexually in women. Initially, at least, this was a great relief to her after the tortuous rituals, the humiliations and tedium of the social etiquette to which she had been introduced briefly and unsuccessfully by her half-brother George. The possibility of escape from this that Lytton offered, her natural affinity with him, together with her own sexual diffidence, made Virginia's choice of a confirmed homosexual as a possible husband less remarkable.

Vanessa's championing of Lytton Strachey as a husband for her sister, however, carried an entirely different import. It expressed something, perhaps, of the polarisation that resulted from their intimacy and rivalry. If Virginia claimed intellectuality, then sexuality belonged to Vanessa. Unlike her younger sister, Vanessa was no longer naïve about the important part sexual love played in adult lives and how central it was in marriage. In fact for her the discovery of sexuality had been particularly joyful and creative. By championing Lytton as a partner she knew precisely what this liaison would deny her sister, yet over a period of more than two years she nurtured hopes, at times even expectations, of such a union.

During the time when her husband was still in love with her sister and their flirtation continued to disconcert her, Vanessa wrote to Virginia pointing out that her often expressed preference for the company of women, her 'sapphism' as Vanessa chose to call it in this letter, made Virginia and Lytton, with his 'sodomism',[9] peculiarly well suited. It was written in jest but perhaps, given the circumstances, there was a more serious attempt at undermining Virginia's threat to Vanessa's heterosexual supremacy.

Initially, Vanessa was realistic about the practical consequences of Lytton's homosexuality. 'I should like Lytton as a brother in law better than any one I know but the only way I can perceive of bringing that to pass would be if he were to fall in love with Adrian,'[10] she wrote to Virginia in the summer of 1908. But less than a fortnight earlier, she had written to her sister, 'Did Lytton propose to you this afternoon? ... I would rather you married him than anyone else'[11] and encouraged her in such a plan up to and, remarkably, more than eighteen months beyond the advent of the proposal and its subsequent hasty retraction.

In February 1909, in an impetuous moment, seeking escape from the inertia of his own creative and emotional life at the time, Lytton Strachey did propose to Virginia Stephen. Almost immediately he realised his mistake and recoiled from her acceptance, 'in terror lest she should kiss me'.[12] Virginia seemed to intuit his apprehension and released him next day from his commitment by saying she did not love him anyway. Lytton believed, however, that despite this denial Virginia did love him, and she herself in retrospect, fifteen years later, confided to her diary, 'Oh I was right to be in love with him 12 or 15 years ago. It is an exquisite symphony his nature when all the violins get playing as they did the other night; so deep, so fantastic.'[13]

After the fiasco of the proposal, there is no evidence – and it is most unlikely – that Lytton still nurtured that particular romance, yet surprisingly Virginia and Vanessa continued to do so. The fact that Virginia did not find Lytton physically attractive did not seem to make her demur, so his homosexuality, his lack of sexual feeling for her, did not appear to be a barrier, as far as she was concerned, to the idea of their marriage.

Vanessa too seemed to be undeterred by the abortive engagement. She wrote to Clive, nine months later, expressing most matter of factly that she fully expected Virginia to have married Lytton in less than two years 'or at any rate be practically engaged to him'.[14] And then as late as the following autumn of 1910, the sisters, holidaying together at Studland in Dorset, were discussing the endlessly fascinating topic of Virginia's future and her marital plans when the possibility of Lytton as a husband must have been mooted yet again. Reality, however, had at last been faced, for Vanessa relayed to Clive 'the main line of our talk was that an alliance with [Lytton] was impossible & that marriage with somebody was quite possible.'[15]

Virginia at least seemed to come to terms philosophically, but not without regret, with this basic incompatibility between them which made marriage impossible. She expressed it, in an astute analogy, in *The Voyage Out* written during this period, where the *ingénue* heroine attempts to dance with St John Hirst, the character based quite closely on Lytton Strachey:

> Rachel, without being expert, danced well, because of a good ear for rhythm, but Hirst had no taste for music, and a few dancing lessons at Cambridge had only put him into possession of the anatomy of a waltz, without imparting any of its spirit. A single turn proved to them that their methods were incompatible; instead of fitting into each other their bones seemed to jut out in angles making smooth turning an impossibility, and cutting, moreover, into the circular progress of the other dancers.[16]

Yet even as late as the spring of 1912, Virginia had not dismissed entirely a vestigial thought of marriage to 'the Strache', for she explained to Molly MacCarthy, 'No, I shan't float into a bloodless alliance with Lytton – though he is in some ways perfect as a friend, only he's a female friend.'[17]

It was Virginia's status as the most fascinating woman Vanessa

knew, as well as her familial history as sister, intimate and, from babyhood, the prodigy and favourite of father and friends, which gave such force to Virginia's capacity to disturb Vanessa's equanimity – this time by invading her most intimate life with Clive. And so, the marriage of this infuriating yet fascinating younger sister became a way of releasing Vanessa from some of the burden of responsibility for her, and of earthing her profligate charms. It seemed that marriage, even to an incorrigible homosexual, would do; it could be argued, particularly to an incorrigible homosexual, for then Vanessa's supremacy as the sexual sister would be assured.

Before Virginia was secured by marriage, however, Vanessa embarked on another important relationship which in the long run was to enrich immeasurably her own life and those of her children and friends – and of Virginia too. Its immediate effect was to revive Vanessa's sense of her vocation as a painter and of her own personal potency and beauty. Within it, she was allowed to be dependent, for the first and only time since her mother's death, on another being more powerful and with as great a capacity for maternal love as herself. This person who had such a profound effect on her life was the painter and critic Roger Fry.

Their love affair began in the spring of 1911 when Vanessa went to Turkey with Clive, Roger and Harry Norton, a Cambridge mathematician with whom she had had a mild and therapeutic flirtation. Roger was always at his best when called on to exercise his prodigious powers of sympathy, enthusiasm and ingenuity. When Vanessa suffered an unexpected miscarriage in a remote area of Turkey, he virtually saved her life (certainly so, Virginia believed), and managed all the administrative arrangements to bring her and the party home. This emergency caused Virginia to fly from England to her sister's side in trepidation. She was terrified that the tragedy of five years previously, when Vanessa was taken seriously ill abroad and Thoby, on his return, actually died, was about to be re-enacted. Three times the sisters had suffered the sudden catastrophic deaths of the closest members of their family and the threat of such depredation in the midst of the most innocent circumstances was to haunt both Vanessa and Virginia for the rest of their lives.

Vanessa's gradual falling in love with Roger Fry altered the balance once again in the central relationship between the sisters. Most obviously it unravelled further the emotional skein of the Bell marriage. Already Clive had resumed his sexual relations with Mrs Raven-Hill,

a voluptuous married woman who had initiated him in his youth into the pleasures of sex and had continued their dalliance up to his marriage. Two years later he had taken up with her again and continued to see her until 1914; interestingly Virginia noted, '[Mrs Raven-Hill] coincided with his attachment to me then'.[18] This fact of sexual infidelity appeared barely to ruffle Vanessa's surface composure, although it may well have been a factor in her eventual emotional retreat from the marriage. She had met Mrs Raven-Hill in her early married life and had been rather excited and a little shocked at her candid advice on contraception and other sophisticated sexual etiquette. Later, Vanessa writing to Clive would call her 'your whore' and request that any gossip be relayed. She never owned to feeling the hurt and jealousy which Virginia's intrusion in her life with Clive caused her, even though this was an affair that was never sexually consummated. Virginia was far more formidable competition than any other woman could ever be.

But now, with the natural contrariness of human emotion Clive, sensing Vanessa's disengagement, focused his romantic feelings less exclusively on Virginia and more securely on his wife. He grew irritable and jealous and Vanessa, recognising this, wrote ruefully to Roger, 'If this had happened 3 years ago when Clive was thinking only of Virginia it might all have been easy! though I dont know its wonderful how you did divert him to me again.'[19]

Virginia too recognised the shift in Vanessa's marriage into something less passionate, less exclusive, more readily recognisable as friendship, and therefore less threatening to her own position in her sister's life. Both were restored more nearly to the easy intimacy of their old pre-marital compact, with Virginia's letters confiding, conspiratorial, and confident of the constancy and impregnability of the love they shared: 'At lunch I compared you with a South American forest with panthers sleeping beneath the trees. I also gave a passionate vision of our love – yours for me, I mean.'[20]

Vanessa, however, had periods of great anxiety and panic as she faced the inevitable extrication of herself from her marriage. Even at the height of her passionate adultery with Roger, she wished above all to keep Clive complaisant. An incident on that fated trip to Turkey seemed to her then to be in some way a sinister portent, symbolic of some greater loss. On a visit with Roger to a villager's house in Broussa, Vanessa removed her rings to wash her hands in the well. Somehow the ring Clive had given to her on their engagement fell into

the water and could not be retrieved. Over twenty years later Vanessa remembered, 'I was more distressed than I could quite understand. It seemed to me as if something obscure but terrible had happened.'[21] But however afraid she may have been of change and loss, however reluctant to relinquish her hold on her marriage and Clive, Roger Fry brought Vanessa the luxury and liberation of being loved consummately for herself.

With Roger, she felt beautiful, interesting, infinitely desirable, cocooned in the security of a love that was unconditional and sustaining: 'It can only do you good sometime to have someone around who admires every movement of yr. body & mind – you aren't vain about yourself and you always are too critical of yr. work if anything so think my praise can only help you ... I can never tell you quite how beautiful & splendid you are.'[22] Roger gave Vanessa the rare opportunity to be weak and ill and afraid. For over two years she suffered from an undiagnosed nervous disorder, the full symptoms of which she confided only to him. He allowed her to be most truly herself; as he described it to her:

Not making any huge effort just living very intensely & naturally & how perfectly reasonable you are (except when one meddles with your pictures) and yet how your being so reasonable is never dull or monotonous or too much expected and is in fact much more exciting to me than if you were all whims and caprices like the professionally seductive.[23]

Vanessa allowed Roger during this time to love her with all the passion and devotion of which his rich nature was capable. 'I can tell of your beauty ...' he wrote to her in his angular artistic hand, 'I could tell of it till even you might be bored – I think it all over and over again, every bit of it from your eyes to your little finger nail and the queer silkiness of the palm of your hand and your throat that swells like a great wave when you throw back your head for me to kiss it and the little waves of hair that ripple round your ears, and your torso that's hewn in such great planes and yet is so polished, your "squareness" beneath the armpits, and the movement of your head when you look round in delight at being so beautiful.'[24] During their love affair, he was to find this amatory narcissism in Vanessa provocative and touching.

She also freed him to be himself. 'Virginia is here & so far we have

been very peaceful,' she wrote to him at the beginning of their affair in the summer of 1911. 'Keynes is staying on which helps to that end. He's very nice & easy & bawdy. It was a question the other night how freely one could talk before you! I am supposed to have educated you to hear free talk – I said one could say *anything* to you & I thought my education of you was very successful.'[25] Vanessa dispelled his loneliness and, thirteen years his junior, drew him into greater intimacy with the younger generation that congregated at her and Virginia's hearths in Bloomsbury.

But even in this relationship where she shared 'some much more complete sympathy than I had ever had with anyone',[26] Vanessa for a moment was afraid that Virginia could enter here and work her enchantment. Afraid that, in jealousy and pique, this sister would take for herself again something important and precious that belonged to her alone; that she would change the relationship for ever as she had done in Vanessa's relationship with Thoby and then with Clive. 'You know I dont really mind your going to see Virginia if you like!'[27] Vanessa wrote to Roger unconvincingly. She had already warned him about Virginia's propensity to indiscretion and wanted to keep secret from her sister her love affair with him; 'She's really too dangerous,'[28] Vanessa wrote, ostensibly referring to her sister's exuberant tongue, but acknowledging too perhaps the broader threat to any important relationship Vanessa herself might have with a man. She need not have feared; Roger's passions were deeply committed and remained so, heartbrokenly, long after Vanessa's had cooled. He did not fail, however, to find Virginia's company a delight, her beauty affecting and her artistry sublime. He considered her quite simply to be a genius.

Virginia, loving him yet awed by him too, the most endearingly entertaining and admirable of men, was aware of this unbreachable loyalty to Vanessa and felt diminished by what she believed was an inevitable comparison. Even years later she felt unable still to equal Vanessa's place in his esteem. Apologising for a 'silly, vain, egotistical letter', she suggested that probably Roger did not understand quite how intoxicating words were to her, what a verbal showman she could become and, then, eclipsed by the shadow of Vanessa, she faltered before Roger's imagined reproach: 'Perhaps I ought to be a nicer woman: perhaps I am still inhibited by some strange quality in you – some queer light cast on you by number 46 [where Vanessa lived] ... I merely throw this out, in case you have my passion for taking feelings to the window and looking at them.'[29]

Again this was at the heart of the debate, the rivalry between the sisters: the love of men versus the love of women. Vanessa had assumed much of the character and qualities of their mother; to Virginia she was charged with something of the psychic power of that apotheosis of womanhood. Vanessa, like their mother, preferred the company of men. To Roger she explained: 'I was impressed with the ease with which I can, by remembering your advice, get onto intimate terms with a man at once. It would take me years with a woman.'[30] Vanessa was not at ease with women, did not value them – or herself – and was prepared to sacrifice both herself and other women, as her mother had, for the well-being of the men she sustained.

Virginia, on the other hand, loved her own sex, found them sympathetic, their natures richly heterogeneous and rooted in a reality that owed little to the aggressive egotism, the pre-eminence of form over substance, the degradation of feeling, that characterised so much of the male world. If Virginia felt she should have been 'a nicer woman', it was by the lights of the masculine perspective accepted so unquestioningly by her sister and her mother.

To practise her art with honesty and force she had to have a voice, but that individual expression was in direct opposition to the polite training of her youth, the inextricable example of her mother: to be responsive rather than initiatory, never to assert but rather to influence, and ultimately to submit. To be truly feminine she had to maintain the equilibrium at all costs; she had to join the caryatids supporting the masculine entablature of society and the state. To raise her head, to stand outside, to be an artist with a voice appeared to Virginia to be a defiance that brought her identity as a woman into question. She was sheepish in her apology to Roger; her exhilaration with words and ideas made her show off: 'I plume and preen and can't sit still on my perch'[31] – this showing-off, the assurance, so disapproved of in Victorian children – particularly so in girls – and in young women seen as pathologically unsound.

This necessity to deny the old concepts of womanliness, the selfless angel in the house, in order to retain one's essential nature and ability to create was explored by Virginia with delicacy and passion in *To the Lighthouse*. There, the artist Lily Briscoe struggled against the seductive credal authority of Mrs Ramsay, a maternal figure of archetypal force: 'They all must marry, there could be no disputing this: an unmarried woman has missed the best of life.'[32]

She struggled too against the demands made on her by men, by

society, purely because she was a woman; expectations which inter-
fered with her autonomy, her own sense of mission and purpose.

She hated playing at painting. [Virginia writes of Lily struggling to
convey her vision.] A brush, the one dependable thing in a world
of strife, ruin, chaos – that one should not play with, knowingly
even: she detested it. But he made her. You shan't touch your
canvas, he seemed to say, bearing down on her, till you've given
me what I want of you. Here he was, close upon her again, greedy,
distraught. Well, thought Lily in despair, letting her right hand fall
at her side, it would be simpler then to have it over. Surely she
could imitate from recollection the glow, the rhapsody, the self-
surrender she had seen on so many women's faces (on Mrs
Ramsay's, for instance) when on some occasion like this they
blazed up – she could remember the look on Mrs Ramsay's face –
into a rapture of sympathy, of delight in the reward they had,
which, though the reason of it escaped her, evidently conferred on
them the most supreme bliss of which human nature was capable.
Here he was, stopped by her side. She would give him what she
could.[33]

But Lily failed. She failed to live up to the exacting standards of
how women should behave to men, memorably embodied in the
image of Mrs Ramsay, who even though exhausted, still gathered her
creative energies for the sterile male to feed from: 'His immense self-
pity, his demand for sympathy poured and spread itself in pools at
her feet, and all she did, miserable sinner that she was, was to draw
her skirts a little closer round her ankles, lest she should get wet. In
complete silence she stood there, grasping her paint brush.' And
she was doubly guilty, damned for being a woman: damned for not
being woman enough: 'A woman, she had provoked this horror; a
woman, she should have known how to deal with it. It was
immensely to her discredit sexually to stand there dumb.'[34]
 Aware always of this conflict, the virginal Virginia contemplating
the fecundity of her sister – a Mrs Ramsay in the making – found her
own integrity faltering in her need to live up to the world's, their
mother's, test of her womanliness. A part of her knew she had to
marry in order to confirm her sex. 'Am I to have no proposal then?'
Virginia had written to her sister in the summer of 1908 when con-
templating a proposal from Hilton Young. 'If I had had the chance,

and determined against it, I could settle to virginity with greater composure than I can, when my womanhood is at question.'[35]

Marriage, however, held all sorts of primitive terrors for Virginia. Surely it would be an assault on her everyday freedom to be herself, to do as she wished? She need only to look at her mother, at Vanessa even, to see that. It seemed somehow to narrow horizons, to close doors. 'I didn't mean to make you think I was against marriage,' she wrote to her friend Molly MacCarthy just before she accepted Leonard Woolf's proposal, 'though the extreme safeness and sobriety of young couples does appal me.'[36] It seemed that to fulfil her mother's and society's idea of her destiny as a woman involved an inevitable violation of the self, a loss, a dilution of intensity she was loath to accept.

But safety was not something that Leonard Woolf at first seemed to offer. With his courtship during the early part of 1912, Virginia experienced at first hand the nature of the concupiscent heterosexual male – but as the expression of an equal not, as in her childhood, as an abuse of fraternal power. For her, Leonard's desire had its unsympathetic, even repellent, aspects but at last she knew what marriage to Lytton would have meant: 'a bloodless alliance'[37] to someone who offered all the reassuring familiarity and lack of emotional excitement of an attachment to an, albeit brilliant, spinster friend. Instead she was faced with Leonard, this alien, undomesticated, wild man who, as Thoby's myth had it, trembled all over with the violence of his feelings.

For seven years he had been living the muscular life of a colonial administrator and eventual successful provincial governor in Ceylon. Solitary, rigorous, uncompromising, an enforcer of laws, an unsquea-mish executant of punishments; power over men's lives had lain in his hands. Leonard returned to England purified of some of his self-admitted Apostolic arrogance and preciosity. Although he was never to lose an almost religious veneration for the Society and its creed, it was tempered by his unmitigated exposure to the brutality, the banality of life as lived by the vast majority of people outside the symmetry of Cambridge.

Vanessa approved of this modification of Leonard's character. 'He is of course very clever & from living in the wilds seems to me to have got a more interesting point of view than most of the "set" who seldom produce anything very new or original,'[38] she wrote to Clive, whose jealousy of Leonard's intimacy with Virginia was to be

reciprocated with sometimes uneasy consequences. Of all the 'set', Leonard was easily the most undilutedly male, and the intensity of his wooing agitated and threatened Virginia, causing her at one time to confide to Vanessa that she thought she would never marry anyone. Given all this, it could be seen as a sign of Virginia's great courage and adventurousness that she did finally throw her sexual reservations to the wind and agree to marry, not an epicene young man but this revenant from the jungle who, with some ill-judged exaggeration perhaps, had listed his faults for her: 'I am selfish, jealous, cruel, lustful, a liar & probably worse still.'[39] Nevertheless, just as Vanessa attempted with the men in her life, Virginia contrived to find something of their fair Greek god of a brother Thoby in the uncompromisingly saturnine, Old Testament austerity of Leonard's face.

Perhaps in trying to make him like the beloved lost brother, Virginia sought to find something familiar and fraternal in this thoroughly unfamiliar man. Leonard, with some bravado perhaps, had warned that he was 'lustful'; he could not know what confused images that word conjured from her past. The sexual aspect of the relationship was the cause of the most serious reservations Virginia had about accepting Leonard as her husband. She wrote to him an extraordinarily honest exposition of her feelings; drawn as she was to the companionship he offered, overwhelmed as she might be by his caring for her, nevertheless: 'I feel angry sometimes at the strength of your desire As I told you brutally the other day, I feel no physical attraction in you. There are moments – when you kissed me the other day was one – when I feel no more than a rock.'[40]

As Virginia struggled with the ambivalence of her feelings, the foreignness of Leonard (his Jewishness was very much on her mind), her recoil from the intensity of his need for her, her incomprehension and anxiety over sex, Vanessa was snatching what odd days she could with her lover Roger Fry and writing the sort of libidinous letters to him she had protested always she was too inarticulate and self-conscious to write to Clive.

Oh Roger, it was delicious to-day in spite of sordid surroundings, like a little water when one was very thirsty. In fact I think perhaps the sordid surroundings are like the Matisse – I mean one has to fall back on the really important things. I have always had a taste for love-making in the midst of quite ordinary things – it

turns them into something else. Not that it wouldn't be divine to do it in Asia Minor too.[41]

Beautiful, elegant and feminine as assuredly she was, Virginia had never felt at ease in her body. Buying clothes, which she did as infrequently as possible, loomed as an unpleasant and humiliating procedure. She hated being stared at. Sitting for the sculptor Stephen Tomlin in 1931 became such an ordeal that she fled from the torture long before the bust of herself was completed (it was, however, a vivid representation and considered by her contemporaries to be a fine likeness). Throughout her life she showed little interest in food, although she could write about it sublimely. Periodically, as a symptom of her breakdowns, she would punish her body in an anorectic denial of its most basic needs. Virginia had a lifelong fear, too, of looking-glasses which she suggested might have been rooted in that early sexual experience with her half-brother Gerald in the hall of their holiday house at St Ives: in a mirror there she remembered seeing a grotesque animal face reflected back at her. Perhaps her distrust of her body and its responses may have dated from the same incestuous incident when, as a little girl, she had been shamed and bewildered by the contradictory emotions that assailed her.

Part of that shame sprang from the realisation that the essential carnality of her female body attracted male interest and desire, often entirely unsolicited, and sometimes gross, frightening and constraining in its effect on women's lives. '"So that's why I can't walk alone!"', Rachel in *The Voyage Out* exclaimed to her aunt who had explained that the women in Piccadilly were prostitutes:

> By this new light she saw her life for the first time a creeping hedged-in thing, driven cautiously between high walls, here turned aside, there plunged in darkness, made dull and crippled for ever – her life that was the only chance she had – a thousand words and actions became plain to her.
> 'Because men are brutes! I hate men!'[42]

Women, it seemed, were responsible not only for their own bodies, their own sexuality, but were held responsible for men's too. In her memoir of life at Hyde Park Gate after their mother's death, Virginia described the obscure threat that hung over the sisters, that if their half-brothers were not happy at home, if Vanessa and she refused to

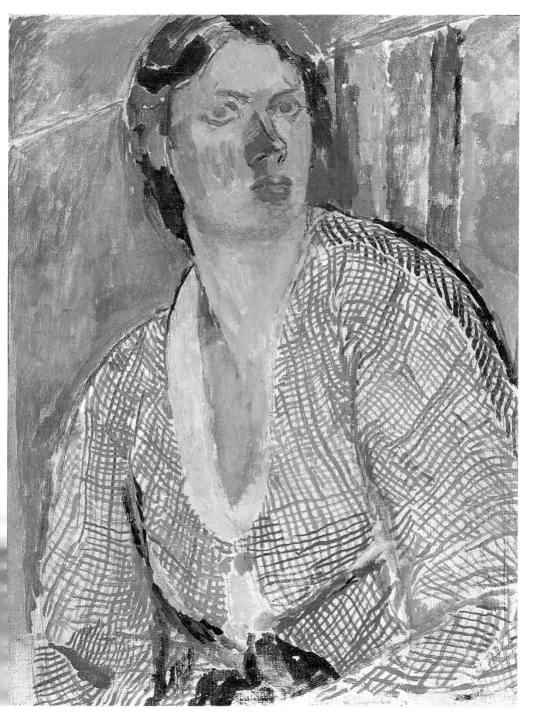

29 *Self-portrait* c.1915 (Yale Center for British Art, Paul Mellon Fund)

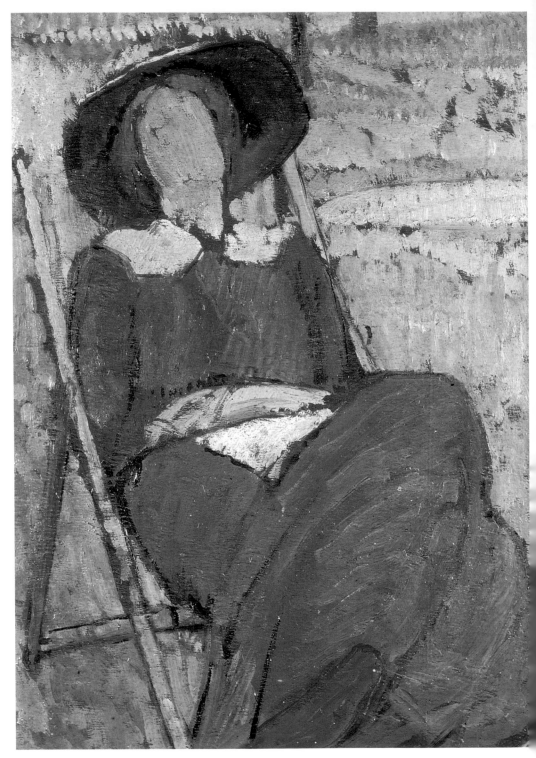

30 *Virginia Woolf* c.1912 (Ivor Braka Ltd, London)

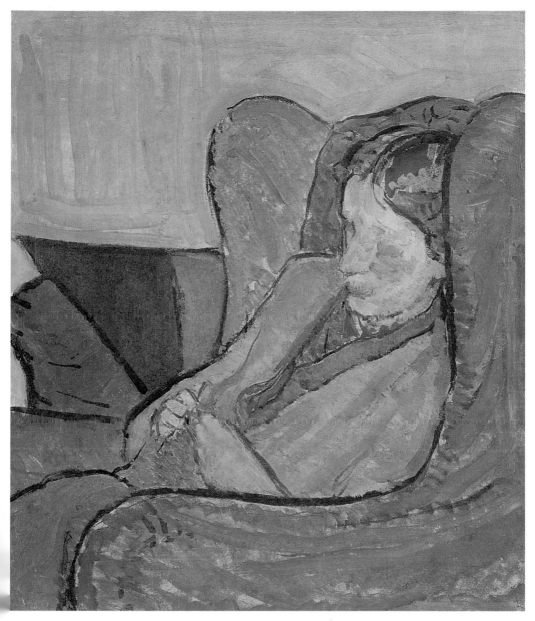

31 *Virginia Woolf at Asheham* 1912 (National Portrait Gallery, London)

32 *Omega Paper Flowers against the Omega Fabric 'Maud'* 1915
(Sandra Lummis, London)

33 *A Conversation* 1913-16 (Courtauld Institute Galleries, London, Fry Collection)

34 *Portrait of David Garnett* c.1916 (courtesy of Anthony d'Offay Gallery, London)

35　*Interior with Duncan Grant* 1934 (Williamson Art Gallery and Museum, Birkenhead)

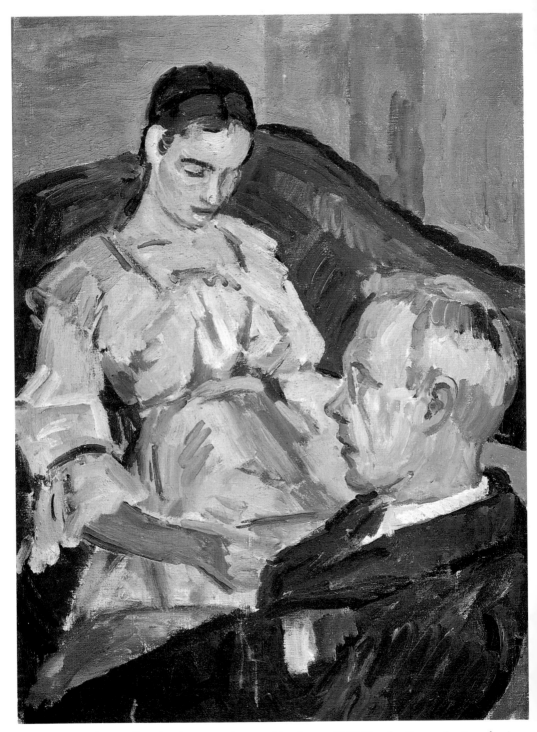

36 *Angelica Bell and Adrian Stephen at Charleston* 1935 (Sandra Lummis, London)

go out with them and entertain their friends, then these chaste young men 'would be forced into the arms of whores'.[43] Again in *The Voyage Out*, Virginia wrote a peculiarly emotional account of her young heroine's initiation into the nature of men's desire and women's responsibility for that desire. Provoked by nothing more than her beauty and the fact of her sex, the married and sophisticated Richard Dalloway suddenly pulled Rachel to him and kissed her passionately. Its effect on Rachel was much as if she had suffered an assault. And yet, as the victim, she was nevertheless accused of inciting the man to act thus: '"You tempt me," he said. The tone of his voice was terrifying.'[44]

That night Rachel had a nightmare described by Virginia with a particular force that in a first, highly autobiographical novel was quite possibly carrying a personal freight of emotion:

> She dreamt that she was walking down a long tunnel, which grew so narrow by degrees that she could touch the damp bricks on either side. At length the tunnel opened and became a vault; she found herself trapped in it, bricks meeting her wherever she turned, alone with a little deformed man who squatted on the floor gibbering, with long nails. His face was pitted and like the face of an animal. The wall behind him oozed with damp, which collected into drops and slid down. Still and cold as death she lay, not daring to move
>
> She felt herself pursued, so that she got up and actually locked the door. A voice moaned for her; eyes desired her. All night long barbarian men harassed the ship; they came scuffling down the passages, and stopped to snuffle at her door. She could not sleep again.[45]

Written during the years when Virginia herself was struggling to emerge into full adulthood, it is interesting to see that Rachel only managed to contain her shock and the pain of her powerful emotions by suppressing all feelings, 'a chill of body and mind crept over her.' In very much the same way Virginia described her chilliness in the face of Leonard's desire, perhaps a self-protective withdrawal learnt when she was that defenceless girl at 22 Hyde Park Gate, hearing with dread the creak of her bedroom door.

Apart from the obvious sexual symbolism of the passage she passed through with walls oozing drops of moisture, leading to a vault from

which there was no escape, the images she used in this dream to convey the grossness of male lust, the fear of the female against whom this was directed, were images documented in Virginia's fragments of autobiography. Certainly, she and Vanessa, the only girls in a family of men, felt cloistered at the family house in Hyde Park Gate by expectations and conventions, by the very bricks and mortar which kept them from participating fully in the life outside those walls. Virginia, particularly, was trapped there, writing and studying at home. Being less refractory than Vanessa, she became the main focus for George's confused emotionalism, 'an unfortunate minnow'[46] as she saw it, trapped in the same tank as a turbulent whale. More devastatingly, it was Virginia alone who was at the mercy of his night-time visits to her room, incursions from which there was no escape, either physically or cathartically through being able to tell another adult or confront George himself.

The deformed, gibbering man, with the face of an animal, was close to her descriptions in a memoir of this suffocatingly emotional half-brother; with his pointed faun-like ears, his dark brown eyes, suggestive of the obstinacy, greed and stupidity of a pig, Virginia claimed, his face like 'a pug dog's'[47] ludicrously wreathed in soft wrinkles, expressing every emotion with a different arrangement of skin. Perhaps there was a similarity to the animal face in the mirror at Talland House, one of her earliest memories which she explained was an imperfectly recalled incident, possibly a dream, but nevertheless significant to her and associated always with the image of her own body, inextricably combined with feelings of guilt and fear and shame.

But faced with male desire, the only reaction of Virginia's first heroine, perhaps true of Virginia's own reaction too, was to benumb her emotions and stifle her body's responses; 'still and cold as death she lay'. In Virginia's own memoirs she stressed that her capacity for spontaneous joy and the most intense ecstasies of feeling was unimpaired as long as these pleasures were 'disconnected with my own body'.[48]

This was the legacy of her past which Virginia was exploring in her novel and in her life in the years that led up to her marriage. Perhaps it was this legacy which made her flirtation with Clive a necessary restorative, her first reassuring erotic experience with a man who was unthreatening, who was further domesticated and made safe by being loved by the sister Virginia loved more than anyone else in the world. It was the legacy also which most probably

was responsible for her reluctance to marry Leonard, undomesticated, unsafe, unknown.

Leonard first asked Virginia to marry him in January 1912. She had just moved into her new rooms at 38 Brunswick Square, a house which she shared with Adrian, Duncan Grant and Maynard Keynes, and, since Christmas 1911, with Leonard too. She had turned him down and grew increasingly burdened and anxious about the continuing question of her marriage. By the end of January she was close to a breakdown. Virginia explained to Leonard that she had taken to her bed with 'a touch of my usual disease, in the head you know'.[49] Her flippancy hid a more frightening reality.

For two weeks at the end of February she disappeared into Jean Thomas's nursing home, denied visitors, letters, contact with the outside world. Leonard continued to hope. But there was pressure on him too for his leave was running out and he would have to decide, before the end of that spring, whether he was going to continue with his colonial career without Virginia or give up his career and trust that she would eventually consent to be his wife.

The early spring was spent by Virginia at Asheham, at this time newly rented by Vanessa and herself. Here she convalesced while select visitors came to stay, Leonard amongst them. Gradually she returned to health and confidence. Gradually she came to understand how much this alien male and she had in common, how much she liked his company. She described his intellectual attraction for her in her novel *Night and Day*, when the character based on herself is thinking about Ralph Denham, based on Leonard: '"The wonderful thing about you is that you're ready for anything; you're not in the least conventional, like most clever men."

'And she conjured up a scene of herself on a camel's back, in the desert, while Ralph commanded a whole tribe of natives.

'"That is what you can do.... You always make people do what you want."

'A glow spread over her spirit, and her eyes filled with brightness. Nevertheless ... she was very far from saying, even in the privacy of her own mind, "I am in love with you."'[50]

Meanwhile Leonard had gambled on his love and had submitted his resignation. Virginia was still full of doubts. In late May she wrote to her oldest friend and mentor, Violet Dickinson, mentioning her work on *The Voyage Out* but afraid, 'you'll tell me I'm a failure as a writer, as well as a failure as a woman'.[51] A week later, Virginia had found the

courage to cross from girlhood to womanhood and join her sister and her mother on the far side. But in succumbing to marriage, she would have to make it on her terms, not theirs. On 29 May 1912, Virginia Stephen agreed to marry Leonard Woolf.

She broke the news of her engagement to Violet Dickinson, misspelling Leonard's name and defensively listing his disadvantages first: 'I've got a confession to make. I'm going to marry Leonard Wolf. He's a penniless Jew. I'm more happy than anyone ever said was possible – but I insist upon your liking him too.'[52]

Virginia waited until Vanessa's return from Italy to tell her in person. Although she had been expecting it and had even been encouraging it, once confronted by the sight of them both together, with Virginia affianced to another, Vanessa was disconcerted and upset. On returning home she wrote a letter congratulating them and expressing what she had been unable to say to their faces; although 'it was somehow so bewildering & upsetting when I did actually see you & Leonard together,' she wrote, 'I do now feel quite happy about you.'[53]

Vanessa on many levels was most happy and relieved that matters had turned out thus. She had realised some years before that Virginia married had many practical advantages. It would relieve her of much of the responsibility for her everyday welfare, it would ease the burden of her continual concern about Virginia's state of mind. Some of that hunger for love that had accompanied the sisters' relationship since babyhood would be visited less intensely upon Vanessa, as would her disconcerting, and at times destructive, impulse to share the most intimate relationships in Vanessa's life. Vanessa approved too of Leonard, despite the casual anti-semitism of her class and her snobbery about his family. Leonard shared too with her a matter-of-factness and a stoic determination which invested their relationship with a great deal of mutual respect. There was some exasperation on Vanessa's side when her adamantine opinions met his immutable will. Only on the sensitive subject of her children did Leonard's respect falter; he thoroughly disapproved of her aversion to disciplining them.

There was, however, the darker, deeper stain; the fear Vanessa suffered always of the loss of someone loved. This was an area of emotional experience Vanessa was never able to contemplate with equanimity, a fear she could never face and express as unflinchingly as did Virginia. She found it hard to relinquish her centrality, her control,

in the lives of her lovers and children – and with Virginia herself. Her emotional supremacy in Virginia's life was one of the corner-stones on which Vanessa's identity had been fashioned; mythologised by Virginia in rhapsodic images which seduced and yet burdened her elder sister. One enduring version of their relationship cast the inchoate, childlike – often pet-like – Virginia dependent on the mother-goddess, Vanessa, for light, for love, for life itself. With Virginia's marriage there was to be an inevitable shift in emphasis in the sisters' relationship, not as radical as it was when Vanessa married but nevertheless a threat to the foundation of a structure that had stood for twenty-nine years. There exist none of the direct expressions of alarm that Virginia communicated as she faced the loss of Vanessa; nevertheless Virginia was more aware perhaps of these unexpressed forces in her elder sister than was Vanessa herself.

In Virginia's intricate portrait of the relationship between Helen Ambrose and Rachel Vinrace in *The Voyage Out*, there were hints of Helen's need to control the younger less experienced woman, and her depression and jealousy as this niece, exercising her independence and attempting to enter the adult world by falling in love, slipped a little further from her influence. Helen, tending to the pessimistic in temperament, had a sense of dread: 'great things were happening – terrible things, because they were so great. Her sense of safety was shaken, as if beneath twigs and dead leaves she had seen the movement of a snake.'[54] The snake was fate, uncontrollable, unpredictable, usually malign. But it alluded to sexual desire too, the power that allied women to men and in doing so changed the intensity and allegiance in women's relationships with each other. So it was to be in Vanessa's relationship with Virginia.

Virginia's marriage was not, however, to herald a clear break in the affair with Clive. His initial response to her forming an alliance with another male was undisguisedly territorial: 'I know I'm not unworthily jealous, I know I'm not cold. But I'm dreadfully puzzled You know, whatever happens, I shall always cheat myself in to believing that I appreciate and love you better than your husband does.'[55]

A more detached love, resentment, and unexpected bitterness would continue to overflow periodically from him. A loyal affection, exasperated rivalry and mild contempt for his cocksureness and frivolity would sting her into occasional riposte. Some six years after her marriage, having dined out with Vanessa, Clive and Mary Hutchin-

son, the woman who was to endure in his life for longer than any other mistress, Virginia was made aware again of the edginess in their relationship. 'Clive has never forgiven me – for what? His personal remarks always seem to be founded on some reserve of grievance, which he has decided not to state openly,' and yet which Virginia felt sprung from his bitterness at her curtailing their previous relationship, thus leaving him, perhaps, permanently and unsatisfyingly attached to her and the possibility of what might have been; 'now all is second best,'[56] he had said accusingly.

During the marriage ceremony between Virginia and Leonard on 10 August 1912, with close family and friends gathered in the Registry Office, Vanessa interrupted proceedings to ask the Registrar if she could change her second son's name from Quentin to Christopher (a change that was never made). It was a peculiar little incident which cannot be dismissed entirely as being due to Vanessa's vagueness. It had something to do too perhaps with reclaiming her share of the emotional spotlight, stating her continued ascendancy in her sister's life. Then again, writing to Virginia on her honeymoon, Vanessa voiced undramatically the fear that marriage heralded sisterly neglect and dilution of love: 'I have given up all belief I ever had in your affection,'[57] exactly the fear that Virginia, so much more volubly and dramatically, had expressed in her attempts after Vanessa's marriage to reclaim her previous place in her sister's life.

But it was in the area of sexuality that Vanessa seemed determined to maintain her superiority over her younger sister. Just as Virginia was to categorise the equation that existed between them : 'You have the children, the fame by rights belongs to me;'[58] Vanessa's riposte could well have been: you have the intellectual, the physical and instinctual belong to me. The letters she wrote to Leonard on his honeymoon were strikingly unlike the matter-of-fact, kindly letters she wrote him during less sexually significant occasions. Self-consciously ribald, these were letters written to Leonard with the knowledge that Virginia would see them too.

You too sound very happy! I long to hear more details but I suppose I must wait for them till I see you. Billy [Virginia] may well be an apt pupil considering that he's been so much used as a brood ape. Ask him if he really feels more attracted by the male than by the female figure. Does he like manly strength & hardness? also do tell me how *you* find *him* compared to all the others you have had?[59]

This was a letter written about a much loved sister whose sexual inexperience, whose fears and insecurities, Vanessa knew intimately. It was after all the youthful Vanessa who, despite a deep reticence on such matters then, was driven to mention the taboo subject of George's abuse of Virginia to the doctor treating her for her breakdown in 1904. Virginia's history would have made Vanessa sympathetically sensitive to the whole subject of her sexual initiation. That she was not, in these letters, and in her subsequent advice to the couple when they sought reassurance, was disparaging of Virginia in the extreme.

To Virginia on honeymoon she wrote: 'Are you really a promising pupil? I believe I'm very bad at it. Perhaps Leonard would like to give me a few lessons. But of course *some* people dont need to be so skilful. At least thats my theory,'[60] a passage with a number of oblique messages. Was Virginia any good at sex? Vanessa recognised that she herself was not temperamentally equipped to play the courtesan (unlike Mrs Raven-Hill perhaps), but then she stated her theory that she was above all that, '*some* people dont need to be so skilful;' art is not necessary where nature suffices. The reference to Leonard giving her lessons in sex was on one level just a joke and flattering to Leonard, but it had echoes too of Virginia's longing to be an intimate part of her sister's marriage and an acknowledgment also, perhaps, of the attraction Leonard felt for Vanessa, an attraction he explored in his, at times bitterly revealing, autobiographical novel, *The Wise Virgins*, which he started to write on his honeymoon.

The honeymoon seemed to have been a success. They went to Somerset for a few days and then on to France, Spain and Italy. Virginia's letters home, although none to Vanessa survive, were exuberant and consistent in their picture of the pleasure in forging an affectionate, intellectually vigorous relationship. 'We've talked incessantly for 7 weeks, and become chronically nomadic and monogamic,'[61] she wrote to Molly MacCarthy. To Katherine Cox, a younger friend, she confided her relief that losing her virginity had not changed her fundamentally:

Why do you think people make such a fuss about marriage and copulation? Why do some of our friends change upon losing chastity? Possibly my great age makes it less of a catastrophe, but certainly I find the climax immensely exaggerated. Except for a sustained good humour (Leonard shan't see this) due to the fact

that every twinge of anger is at once visited upon my husband I might be still Miss S.[62]

There might have been some sense for Virginia that she was missing an elemental experience, but she seemed philosophical enough. Perhaps it was Leonard, however, who was concerned that things were not as he had expected. Four months after their marriage they sought counsel from the cynosure of all things sexual, Vanessa herself. She then relayed the gist of the conversation to Clive:

The Woolves ... seemed very happy, but are evidently both a little exercised in their minds on the subject of the Goat's coldness. I think that I perhaps annoyed her but may have consoled him by saying that I thought she never had understood or sympathized with sexual passion in men. Apparently she still gets no pleasure at all from the act, which I think is curious. They were very anxious to know when I first had an orgasm. I couldnt remember. Do you? but no doubt I sympathised with such things if I didnt have them from the time I was 2.[63]

This passage encapsulated one of the most important areas of the sisters' rivalry. It expressed also a pervasive attitude towards Virginia and sexuality, one which she did little to counter, and on which the whole supposition of her sexual frigidity was based. Most obviously, Vanessa admitted that she 'annoyed' Virginia but 'consoled' Leonard by placing the blame for the unsatisfactoriness of their love-making squarely at Virginia's feet; had she not always been cold? was what Vanessa virtually was saying, implying that this was a peculiarity of hers and was unlikely to change. On being asked about her own experiences she answered with an airy glee that she was quite the opposite for she had had so many orgasms, she could not really remember ever not having them. There was no consoling of Virginia, no mention of the fact that sometimes these things take time, that sexual pleasure might not arrive instantaneously with the loss of her virginity, that (could it be suggested?) Leonard might have a few things to learn too. But Vanessa was not the person to suggest it. The lesson she had learned at her mother's knee was to uphold the male, to protect him from apprehension of his own frailty, and sacrifice the woman, if need be, to this ideal. The lesson Vanessa had learnt from her childhood rivalry with Virginia was that there had to be some areas of life where she could undisputedly reign.

Any discussion of these early months of Leonard's and Virginia's married life may well be presumptuous and would certainly be speculative. It is important, however, because so much of received opinion about Virginia's character, even her art, rests on certain assumptions of her sexual, or asexual, nature. These were assumptions the sisters themselves accepted, even enhanced in their own mythology and thus polarised further their experiences in this most personal area of their lives.

The dowry of early experiences which Vanessa brought to her marriage had been well documented by her own word and by contemporaries. Leonard was much more reticent about his emotional and sexual life. There is little reason to doubt that this clever, ascetic, arrogant young man, when he came to leave Cambridge and set off for his Civil Service posting in Ceylon, had had little experience of women as friends and none of them as lovers. He was an Apostle and the Apostolic creed of his generation, while not actively encouraging homosexuality, certainly denigrated love of women. His letters to Lytton Strachey, a fellow Apostle and his closest friend at the time, revealed a passionate nature sublimated, almost completely, in ferociously hard work: 'I work, God how I work. I have reduced it to a method & exalted it to a mania.'[64]

When he was twenty-seven Leonard wrote from Ceylon to Lytton admitting he was in love with a young woman there, but that it was 'pretty degrading' to be in love with someone who was very young and very foolish: 'Sometimes I think really I am in love with silly intrigue & controlling a situation, & sometimes merely with two big cow eyes which could never understand anything which one said & look as if they understand everything that has ever been, is or will be. God, the futility & mania of existence sickens me.'[65] He appeared to have found human beings in general pretty appalling and female beings marginally more so: 'Most women naked when alive are extraordinarily ugly but dead they are repulsive.'[66] He reported to Lytton having just been shown a woman kicked to death by the man who lived with her, for not having his dinner ready on time. The desire to copulate he rated as 'degraded',[67] one of his favourite words at the time; riding his horse full tilt was a preferable pleasure he believed and, perhaps, he had yet to experience the other.

So Leonard had returned to England in 1911 at the age of thirty-one, a great success as a tough but fair-minded governor of foreign peoples, but less of a success socially and lacking certainly the sexual

experience and the flair of a dedicated philogynist such as Clive. He had returned with gratitude to the bosom of Bloomsbury, his spiritual family, but found Clive's centrality there galling. His temperament and his acute awareness of his Jewishness meant that Leonard was to feel always an inveterate outsider.

At the heart of Bloomsbury stood the two Stephen sisters, the beautiful young women he had carried as a fantasy of the highest order of civilised womanhood during his long years of exile. It had been Vanessa to whom he had been attracted at first and Clive had stolen her in his absence. Her brilliant, virginal, younger sister, however, remained and Leonard had returned with the express desire to marry her, knowing very little of her except that she was the sister of his friend Thoby. Thoby's death had shocked him profoundly, filling him with remorse that they had not elected him an Apostle and encouraging the sanctification of this naturally heroic figure. For Thoby's Cambridge friends, his sisters were endowed with the further glamour of their physical likeness to the god.

So Leonard, with intensity and fixity, had wooed Virginia. She, evasive and equivocal to the last, had eventually capitulated. Two intellectually sophisticated and sexually inexperienced people, at thirty-one and thirty no longer young and thoroughly accustomed to the celibate life, embarked on a honeymoon that consisted of six weeks of sometimes gruelling travel, often in intense heat and discomfort, through France, Italy and Spain. It proved fertile ground for extensive reading, talking, even writing. It could not, however, provide the ideal circumstances for the exploration of a more intimate compatibility, for a couple already rather anxious about the sexual element in their relationship.

Virginia had warned Leonard that she did not find him physically attractive and Leonard had given her a piece to read, probably written during his courtship or in the early days of his marriage, which revealed how in awe he was of her. Characterising her as Aspasia, he likened her to distant hills, 'against a cold blue sky; there is snow upon them which no sun has ever melted & no man has ever trod.' He showed himself to be intoxicated by the fearlessness of her mind, by her humour and imagination, and yet tantalised and daunted by a grandeur in her 'the most Olympian of the Olympians', the quality he sensed of her being beyond the reach of the more mundane human emotions. She, reading it and overcome perhaps by the chilliness of his vision of her, could only reply, 'I don't think you have made me

soft or lovable enough.'[68]

There existed a particular intellectual sympathy and excitement between them, and Virginia's letters and diaries, and even Leonard's emotionally reticent autobiography, bear witness to an enduringly loyal and loving relationship despite catastrophic illness, fame and all the extraordinary stresses to which they were subjected. Sex has been chalked up against them as their one grand failure, with Virginia's frigidity held to be the root and sole cause. Given the evidence, it would seem convenient yet unfair; convenient to Leonard's male pride (he was 'consoled' by Vanessa's diagnosis that Virginia had always been inadequate in this way); and convenient to Vanessa too perhaps (whose territory would remain undisputed by the sister who appeared supreme in virtually every other domain).

But Virginia had been annoyed by Vanessa's view of her and Leonard's problem; perhaps because at heart she knew she was not sexually frigid. Her love for Vanessa had a distinct erotic element which both acknowledged, with both offering and asking for pettings – kissings and stroking of hair, of the inner arms, of earlobes and neck. She may well have recoiled from the aggressive impersonal-conquering manifestation of male desire, and Vanessa's explanation that Virginia had never understood or sympathised with this characteristic in men was probably true. However, this did not mean that she was devoid of sexual feeling for men or that she did not have the potential, given the appropriate man, given the appropriate circumstances, to be sexually responsive, even if she was unlikely ever to be in thrall to her own libido.

The composer Ethel Smyth, an irrepressible admirer of Virginia, was extraordinarily candid about her own sexuality and, perhaps as a consequence, was the recipient of some of Virginia's frankest confidences. In 1930 she admitted to Ethel that despite perhaps intellectual reservations about him, there had been occasions when she had felt sexually drawn to a man whose description most nearly approximates Clive: 'When 2 or 3 times in all, I felt physically for a man, then he was so obtuse, gallant, fox-hunting and dull that I – diverse as I am – could only wheel round and gallop the other way.'[69]

Perhaps it explained why Clive, at times, seemed so bitter and wont to taunt her for what he saw as a lack of sexual fulfilment in her life, for she had denied him the chance of intimacy she had given another man. When they were both in their mid-forties, they lunched together and Clive was particularly exuberant about the delights of hetero-

sexual love (a favourite theme), which joys he accused Virginia of never having known, of being unable to know. This she denied but to little avail. By then the characterisation of her as cold had stuck and perhaps was convenient to Clive's pride too: in turning him down, 'the undaunted lover, the Don Juan of Bloomsbury',[70] all those years ago, Virginia must surely have been a frigid woman whom no man could woo successfully. These accusations rankled so much with Virginia that she reported to Vanessa, and then two days later to Roger Fry: 'Love is the only God, he says, and art and fame an illusion.' She ended in exasperation at the assumptions made by others of her passionless existence: 'I'm sure I live more gallons to the minute walking once round the square than all the stockbrokers in London caught in the act of copulation.'[71]

There is no doubt, nevertheless, that something was wrong between Leonard and Virginia, but not so wrong that she was forced by that to abandon the idea of having children. Just home from their honeymoon, Virginia described their new rooms in Clifford's Inn to the motherly Violet Dickinson: 'there's a little patch of green for my brats to play in.'[72] As late as April 1913, eight months after their marriage, Virginia was still hoping for children and, from Asheham, wrote to Violet Dickinson again, this time with a hint of defensiveness perhaps, aware that Vanessa had conceived almost immediately: 'We aren't going to have a baby but we want to have one, and 6 months in the country or so is said to be necessary first.'[73]

However, it was not to be. For a variety of reasons, Leonard decided as early as the January following their marriage that it would be unwise. During that first month of 1913 the sisters were discussing the whole subject of Virginia and children and Vanessa thought it a perfectly feasible idea. She relayed by letter Jean Thomas's favourable verdict; Jean ran the nursing home which Virginia had visited twice and had seen her at her worst. Sir George Savage, the mental specialist who had known Virginia all her life and was personally extremely fond of her, was also sanguine. It would do her the world of good. But Leonard had made up his mind otherwise, much to Vanessa's puzzlement: 'I wonder why Leonard has gradually come to think childbearing so dangerous,'[74] she wrote to Virginia having just reported Miss Thomas's optimistic opinion.

Leonard had yet to face the horror of the full-blown attack of insanity which gripped Virginia from the summer of 1913 until the end of the year, and then returned to torment them both just before

publication of *The Voyage Out* in the spring of 1915, only to leave her at last for a lengthy respite at the end of that year. When well, and throughout her life Virginia was largely well, she was robust, energetic and able always to work extremely hard, both at her own writing and at the mundane and physically demanding jobs involved in running a small printing press and publishing house. It may have been, however, that even then Leonard was more aware than Vanessa, and those other advisers, of a certain conflict of interests, of what he might have deemed an irrational desire, in Virginia's wishing to have children. Or it may have been that he was wary that Virginia's condition was genetic and could recur in the next generation, although he himself admitted in his autobiography that he had no idea at all of the seriousness of her breakdowns until the terrible summer of 1913.

It may possibly have been as much to do with Leonard himself not wanting children. He was an organised, orderly man, to an almost obsessive degree. During the early years of his and Virginia's marriage they had very little money and money played an important part in all of his practical considerations. Only in the mid to late 1920s (when Virginia was well over forty) with the extraordinarily successful publishing of *Mrs Dalloway*, *To the Lighthouse* and *Orlando* were the Woolfs freed of everyday monetary constraints. He had witnessed at close quarters Vanessa's two rampageous sons, left to grow up as untrammelled by discipline or convention as possible and, as a result, rather trying at times to visitors, occasionally even to their long-suffering mother. He admitted to a generally pessimistic view of human nature and a profound, almost mystical love and respect for animals, the young of which he found more sympathetically appealing than most human beings.

Perhaps the decision not to have children was as great a relief for Leonard as it was an abiding grief for Virginia. Certainly it was a decision which was taken by Leonard, ratified by medical opinion (he dismissed Sir George Savage's contradictory opinion as being more that of a man of the world than of a specialist doctor and found himself two other specialists who agreed with him) and then persuaded Virginia it was for the best. She wrote to a friend, years later when she was forty-five, 'I'm always angry with myself for not having forced Leonard to take the risk in spite of doctors.'[75]

The process of this decision was only important in that it explains in part Virginia's distrust and bitterness towards the power and arro-

gance she saw as endemic in the medical profession. Perhaps too it explains in part her violent anger against Leonard during her breakdown in the spring and summer of 1915. Perhaps even her animosity towards her sister sprang from this sense of powerlessness and betrayal, for Vanessa had always taken the side of the doctors and had helped to enforce, with some reluctance, their treatments of her breakdowns with confinement, intellectual and emotional deprivation and subjugation through drugs and overfeeding. The fact that this decision, so important to her, was made for her without her compliance contributed also to the inveteracy of her regret.

Virginia's portraits of the two doctors Holmes and Sir William Bradshaw in *Mrs Dalloway* burn with the veracity and anger of personal experience. She admitted: 'It was a subject that I had kept cooling in my mind until I felt that I could touch it without bursting into flame all over. You can't think what a raging furnace it is still to me – madness and doctors and being forced.'[76] And the following was the cooled-down version of that rage:

> Worshipping proportion, Sir William not only prospered himself but made England prosper, secluded her lunatics, forbade childbirth, penalized despair, made it impossible for the unfit to propagate their views until they, too, shared his sense of proportion ... this is madness, this sense; his sense of proportion.[77]

And there were times when Vanessa, whom she loved more than anyone in the world, and Leonard, who came a close second, appeared to her to side, so cruelly, with them against her, abandoning her to the crazy inhumanity of these regimes where she was forced to surrender absolute power over her person to doctors whom she had every reason to see as untrustworthy, dangerously ignorant and swollen with self-importance. In her history, doctors were harbingers of death; their bungling and misdiagnosis had cost Stella and then Thoby their lives. She had watched the doctor walk away with his hands clasped behind his back on the morning her mother died.

So childbirth was forbidden her, sexual relations with Leonard soon abandoned; she was a failure as a woman. 'A little more self-control on my part, & we might have had a boy of 12, a girl of 10: this always makes me wretched in the early hours,'[78] she was to write in her diary fourteen years later. Her failure was all the more poignant as it was pointed up by direct comparison with the very success of

Vanessa. During these months of Virginia's early married life, Vanessa had her husband (since sexual jealousy had rather gratifyingly re-focused Clive's interest on his wife); she had her sons then five and almost three years old; she had her lover Roger Fry, professing himself enchanted by every movement of her mind and body; and she had her art – with Roger, then Duncan Grant, as sympathetic painting companions.

Then there was the excitement of the opening of the Omega Workshops in the summer of 1913. This was Roger's experiment in providing decorative work for artists, including Vanessa and Duncan, with a showcase of their pottery, furniture and textiles. As Virginia awaited the publication of her first novel, not only Vanessa's life but even her work seemed to be much the more filled with possibilities. Vanessa too, as a painter, had always the opportunity of collaboration and a working companionship, which Virginia, as a writer in a solitary profession, could never share.

As 1913 progressed, Virginia became increasingly disturbed as she deteriorated into a catastrophic mental breakdown culminating in the suicide attempt that almost claimed her life. This breakdown appeared to vindicate Leonard's decision on the question of children and to seal for ever her childlessness. It may well have marked the bitter end of their incipient sexual relationship, a relationship which, many years later Virginia was to give Vita Sackville-West to understand, 'was a terrible failure'.[79] She had tried to be like her mother, like Vanessa, but, correcting her proofs of her first novel, adjusting still to marriage, she grew increasingly anxious, depressed, guilty about everything: about food, her body, its disgusting physicality, guilty about burdening Leonard, desperate at not being allowed to work: haunted always by her failure.

8

Sons and Lovers

'[Vanessa's] really is an almost ideal family based as it
is on adultery and mutual forbearance with Clive the
deceived husband and me the abandoned lover. It
really is rather a triumph of reasonableness over the
conventions.'

Roger Fry, 15 August 1926[1]

AS VIRGINIA FEARED she was no wife, no mother, no writer,
Vanessa was emerging from the frustrations and dependencies of early
motherhood and was settling majestically into her role as mother,
lover and artist, creating an atmosphere of largesse and ease wherever
she went. She revelled in the company of her two young sons and was
ready to have another baby, as she told Roger at the end of that
summer of 1913. Her emotional life seemed expansive too. She was
living still in intermittent conjugality with Clive and it was with Clive
she wished to conceive this third child. She was loved deeply by Roger
Fry who became increasingly desperate, during this year, as he
realised – before Vanessa did – that he was being displaced gradually
by another. She was falling in love with the painter Duncan Grant.

The nature of Vanessa's feelings was slow to surface and was even
more obscured to Duncan. On the fringes of Bloomsbury since its
earliest days, he had been an eccentric and much desired figure, the
eye of many emotional storms. When he had first met the two sisters
and their brother Adrian, just after Vanessa's marriage, he had been
most impressed by Virginia, his romantic interest was caught by
Adrian, and he was least affected by Vanessa. Slightly younger than
the rest, he was a cousin of Lytton Strachey and had been at various
times the lover of Lytton, of Maynard Keynes and, at the time
Vanessa fell in love with him, he was engaged in a lengthy, if some-
what desultory, affair with Adrian.

Vanessa, however, discerned only gradually that she preferred
Duncan's company to Roger's and yet still seemed unable to free

herself from her need for either Roger or Clive. It was 1913, perhaps the pivotal year when all three men seemed to have equal and complementary roles to play in her life. Clive, her husband, the father of her children and the prospective father of the third child she hoped to conceive, was a constant presence in her life from whom she still sought reassurance and affection. 'Peak darling are you fond of Dolphin and will you be glad to get to her? for she is getting *very* badly in want of you. It is such ages since we co-habited,'[2] she wrote to him after the Christmas holidays when her collapse through exhaustion, after helping Roger mount the Second Post-Impressionist Exhibition, had left her bedridden in London while Clive had taken their children to his parents' house in Wiltshire.

It was Duncan and Adrian who turned up on Christmas day to amuse the invalid but, of course, it was Roger who nursed her. His capacity for unselfish love and prodigious practical energy were most welcomed by Vanessa when she was ailing or exhausted and grateful for the maternal solicitude he offered. But this abundance of feeling was burdensome when she was restored to health and could reclaim her position as the primary dispenser of care. Virginia accused her of being a jealous woman, always wanting to give and never to take, 'afraid of the givers'.[3] Vanessa attempted to retain the power and control in this way, a sinister characteristic, as Virginia recognised, of the fierce maternal instinct in both her sister and her mother, like that of Mrs Ramsay in *To the Lighthouse* who suspected 'that all this desire of hers to give, to help, was vanity'.[4]

In the midst of extricating herself from the passionate stage of their affair, she wrote to Roger: 'I wondered how I could ever have thought I was less dependent on you. The fact is I believe you make me feel so sure of you that I feel quite independent when you're there & dont know how groggy I get alone.'[5] His love had been always more dependable and passionate than Clive's and he was deeply hurt, and for a time embittered, by Vanessa's ending their affair. For it was on Duncan, increasingly, that Vanessa focused her longings for sexual love, validated by a baby, for an artistic companion and a co-conspirator in her escape from the polite world.

In her single-minded and instinctive way she recognised that their compatible views and their shared love of painting were the bonds which would draw him to her initially, in place of the sexual attraction of his other relationships. She allied herself with Duncan therefore and emphasised the differences between the painters and the rest. She

pointed out to him that his influence was considered to be to blame for her becoming increasingly rebarbative in manner, unconcerned with appearance, face and clothes smudged with paint, her hair a mess.

In fact, during the early summer of 1914, as Europe lumbered towards world war, both sisters seemed oblivious of the conflagration to come. Virginia was still recovering from her personal nightmare of the worst breakdown she had endured. Most of the summer for her was spent at Asheham in Sussex. And Vanessa was distracted by the excitement of her personal and artistic life. In a later memoir, she explained something of the mood of the time which contributed to her, and others', lack of prescience:

> How could we be interested in such matters when first getting to know well the great artists of the immediate past and those following them, when beauty was springing up under one's feet so vividly that violent abuse was hurled at it and genius generally considered to be insanity, when the writers were pricking up their ears and raising their voices lest too much attention should be given to painting ... a great new freedom seemed about to come and perhaps would have come, if it had not been for motives and ambitions of which we knew nothing.[6]

Vanessa sought this solidarity with the artists, with Duncan, so that she could conduct her daily life in a way that suited her own nature and wishes. No longer need she labour unsuccessfully to attain Clive's ideal of the fashionable, well-groomed wife at the head of a civilised household. As Adrian separated himself gradually from Duncan during 1914, Vanessa's consoling presence drew Duncan into an increasing intimacy with her. But she learnt too, very early on, that in order to keep Duncan happy and by her side she not only needed to create a congenial environment for painting, but had to tolerate and encourage, sometimes even court, the men on whom Duncan's sexual interests were focused.

Thus early in 1915, the fourth man, David (Bunny) Garnett entered Vanessa's life and, quite against her natural instincts, had to be attracted, embraced and considered by her in her determination to keep Duncan happy. She admitted to Roger just a few months later, 'I really only see him [Bunny] because of Duncan.'[7] And to Bunny she would write, 'What a nice letter you wrote me & how lucky I am to be

able to think now that you'll soon be here & Duncan wont soon be going. You don't know what a relief it is to me.'[8]

That spring, Vanessa went to stay in Eleanor House, a cottage near West Wittering on the Sussex coast. Duncan had just begun farming there, with Bunny Garnett as a visitor most weekends, in an attempt to evade conscription. Vanessa stayed for most of the summer and it was during this emotionally charged time that Duncan's passion for Bunny was at its height and Vanessa's for Duncan was at last acknowledged. During this hot summer of confused emotions, Duncan admitted that he could love Vanessa; news which for a time made her ecstatic, but all the more distraught when his passions were deflected elsewhere.

On one level, this unexpected turn in events could be seen as the tragedy of Vanessa's life. That a beautiful, sexual, much loved woman, in her mid-thirties and at the height of her personal and creative powers, should fall passionately and irrevocably in love with an unequivocal homosexual, would make it difficult enough to reconcile her emotional interests with his. But the discrepancies between them were even more marked. He was a rare spirit, elusive, unburdened by responsibility – truly Dionysian in character. Throughout his life his sexuality was expressed without disguise or shame with a variety of male lovers. The gods had showered an embarrassment of gifts upon him at his birth: personal beauty, remarkable talent as a painter and an irresistible charm and individuality of manner. But they did not make him an ideal partner for a feeling, faithful woman. It is said that once, in front of Virginia, Vanessa broke down and wept at the hopelessness of her situation. But, otherwise, she was largely silent and suffered all her life with him from the emotional imbalance in their relationship, from her dependence on him, from her fear of losing him.

It was a relationship, however, which despite such intrinsic difficulties was responsible for occasions of tremendous happiness and creativity for both. Lasting all the rest of her life, it gave Vanessa intense pleasure and the creative spur of someone to paint alongside, someone with whom she felt a rare personal and artistic sympathy. It gave her too a most beautiful and talented daughter. This companionship and collaboration both Roger Fry and Virginia, working alone at their art, envied.

The relationship with Duncan focused too her prodigious motherly and domestic talents; at Charleston and at La Bergère in the South of

France, she was making a home not only for her children but also for Duncan, a place that was centred around him and painting, whose loveliness would insinuate into his soul and bind him to her. She was wooing him with all the charms of place, with the comfort of her undemanding presence at the heart, as a counter-attraction to the sexual attractions of his young men. In this she was largely successful. Duncan always came home in the end. Her love for him and her love of working with him were an inspiration to much of the decoration that made these houses so individual and seductive.

The toll on Vanessa personally, however, was significant, the frustration of desires Duncan could not fulfil stunting and dispiriting. In an extraordinary parallel, both sisters in their thirties settled for ultimately sexless unions with the men they loved. But whereas Virginia made a virtue of her state, writing from a sense of an unbreached integrity, all her energies harnessed to her work, uncompromised, uncompromising, Vanessa was an unreplenished stream, giving unstintingly to children, husband, ex-lover and particularly to Duncan. She put into devastating practice her mother's training in self-sacrifice for the sake of the more worthy male, and thereby made a stone of her own heart. 'There seemed to be so many slips between my lips and the cup I want to drink from – & its not a very certain cup at that is it? ... You won't believe how starved I feel without you to talk to – I'm already getting petrified within,'[9] she wrote from London in the spring of 1916 to Duncan in Suffolk. Longing for letters and afraid, for her hold on Duncan seemed so tenuous, Vanessa diminished herself in loving a man who could never find her as desirable as he did other young men: 'I believe you're so taken up with that beautiful yellow Buck bunny who bites & is so fierce that you have no thoughts to spare for humbler rodents.'[10]

In the end, even her painting, the most important source of energy in her life, the one area where her identity was not dependent on her relationship with others, was infected with the leitmotif of their relationship: her exaltation of Duncan and diminishing of herself. A revealing conversation during the Christmas gathering at Charleston in 1917 was recorded by Duncan in his diary.

We had a conversation at Christmas when Clive & Maynard were here as to whether we would any of us give our life for a cause. Clive said nothing would make him give his life for anything ... Maynard said it was curious to him this feeling & he believed it was

the *common* instinct of mankind to be willing to die for what they considered the good of the race & that he certainly strongly possessed it. I said I thought I did & that if I could be *promised* the world would be a better place if I did I should be willing. Nessa said she could not understand this feeling but that she could much more understand the desire to give one's life for someone else's in a purely reasonable way, if one thought it more valuable for instance. Maynard said she could not give her life for Quentin's. N [Vanessa] said she thought she could & we agreed it was reasonable on account of the different undiscovered possibilities in his development etc. Clive said he would be damned if he wouldn't push Matisse off a raft if there was the remotest chance of saving his [own] life thereby. Nessa said she would only give her life to save an artist in whom she believed but who evidently had not had yet opportunities of full development.[11]

And in a sense this was precisely what she did.

Vanessa had to continue to accommodate Bunny Garnett until 1919 when the intense phase of his relationship with Duncan was over. Although Duncan's passion was for Bunny, he did love Vanessa and relied on her for the physical and emotional comforts in his life. In an entry in his diary in February 1918, when the emotional strain in the household was intense, Duncan expressed something of his use of Vanessa as a comforter in Bunny's absence, and his inability to contemplate her as a sexual equal: 'I copulated on Saturday with her with great satisfaction to myself physically. It is a convenient way the females of letting off one's spunk and comfortable. Also the pleasure it gives is reassuring. You don't get this dumb misunderstanding body of a person who isn't a bugger. That's one for you Bunny!'[12] This continued intermittently, for some time in 1915 to the spring of 1918 when Vanessa's third baby was conceived. But Duncan was unable to sustain the sexual intimacy and reciprocity that she so desired.

The situation demeaned her, diminishing further her estimation of herself as a woman. Sex created its own problems for them both. Duncan was alarmed to discover the ferment of emotion and need that seethed beneath Vanessa's cool and tranquil surface. In sensing how much she wanted from him, he shrank from giving even what he had to give, confronted 'by a bewildering suffering expectation of it (hardly conscious) by her'.[13] Whereas Vanessa could not rid herself of

the knowledge that Duncan was not in love with her and perhaps even his sexual contact with her, occasional and confined to the early part of their relationship as it was, was prompted largely by pity.

This realisation was brought home to both in a discussion at Charleston in early 1918 when Clive, Roger and Duncan started talking about love. They were soon in the sensitive territory of whether one should 'go to bed with' someone who was not in love with you. Clive said he would find it too humiliating and at this point, Duncan, who recorded the gist of the conversation in his diary, became aware of Vanessa's retreat from the discussion. He knew she had taken it personally and was submerged in her own depressing thoughts and went to console her later; 'the same remark of Clive's ... had made her bitterly feel what she had lost in my not being in love with her.'[14]

Vanessa had wished to have another baby before she had fallen in love with Duncan. But it was when she was living with him and Bunny that she determined that it should be Duncan's child. Duncan was a genius, she thought, and any child of his would be exceptional too. Part of her hope in the matter was that a baby might be another bond between them in an otherwise unorthodox and precarious relationship. When she finally conceived in 1918, despite being already the mother of two boys, Vanessa wanted this baby to be male too. She herself preferred boys, but there was also the important consideration that she knew Duncan would be more emotionally involved in the progress of a son than of a daughter.

On the birth of their daughter on Christmas Day 1918, Duncan wrote a letter which revealed all the confusion of emotion and dishonesty with which Angelica's birth was shrouded. It was intended that Clive should be officially considered her father. Although Virginia was told the truth, she was told to keep it – for a time at least – even from Leonard. Duncan's note to Clive read:

Nessa's daughter was born on Christmas Day about 2 a.m. ... I am occasionally allowed to see Nessa as you are not here & the nurse is very strict ... [Vanessa] has not let your parents know, because she did not know where they thought you were. Will you see to that? ... Virginia of course is delighted it is a girl & so I think is Vanessa [now (crossed out)] really.[15]

Angelica's femininity was to be a particular delight for Virginia,

calling forth all her generosity and imaginative ingenuity. Her name, too, Angelica, was first suggested by Virginia. But perhaps there was a moment's jealousy too as this new female entered the centre of Vanessa's embrace. Virginia was so fearful always of being excluded by her sister's intimacy with another, that even here she suggested, albeit lightheartedly, that she would manoeuvre for herself a shared parentage of the baby, suggesting in a vaguely incestuous way that she was born of them both: 'She is going to think me something more than an Aunt – not quite a father perhaps, but with a hand (to put it delicately) in her birth.'[16] That spasm passed and the childless Virginia could genuinely enjoy Angelica's childhood. When her niece was nearly ten, she admitted to Vanessa, 'Angelica has become essential to me. An awful kind of spurious maternal feeling has taken possession of me.'[17]

Given the obscured situation, given that Vanessa had always assumed absolute authority over the household and sole responsibility for her children, given too the elusive character of the father, it is not surprising that there was no equivalent paternal passion forthcoming from Duncan. He only ever did what he wanted and always went his own way, sometimes necessarily in the opposite direction from the one which Vanessa longed for him to travel. Her letters to him during his pursuit elsewhere of various erotic interests were veined through with a stifled anguish, and a fearful self-effacement. For such an adamantly inexpressive woman her misery extended many times deeper than the fractured edge she reluctantly revealed.

Duncan even kept his romantic distance and independence from her in intimate circles. Their daughter recalled never seeing them touch or embrace, except when tragedy struck. And Duncan had requested that Virginia should not add his name , even in script, beside Vanessa's in her printed dedication in her novel *Night and Day*:

> to Vanessa Bell
> but, looking for a phrase,
> I found none to stand beside your name

According to a later lover of Duncan's, some time in 1918, the year of their daughter's birth, Duncan told Vanessa he could no longer have a sexual relationship with her.

This was the tragic fugue of Vanessa's adult life. The young woman who emerged from the obfuscation and constraint of her youth was

transformed palpably, so Virginia assured us, with freedom and sexual love into a glowing icon of creativity. From her late thirties and for the rest of her life she was to deny herself the source and expression of that power. When all hope of a sexual relationship with Duncan had to be abandoned, Vanessa sensed her own petrification; her observance 'it seems better not to feel more than one can help'[18] was the only way she had of accommodating a relationship which, even as she approached fifty with the compensations of her work, of family life, companionship and fame, left her emotionally bereft, 'when one is in love & cant have what one wants'.[19]

In that early sisterly rivalry, sexuality had been the territory that had belonged to Vanessa. One of the most wounding suggestions Virginia could have made was that her carnal elder sister was no longer living a sexual life. When she wrote to Vanessa almost a decade later, having visited her and Duncan at their Cassis house in the South of France, 'you and Duncan always seem to me, though some appearances are against it, marmoreally chaste,'[20] Virginia obviously hit her mark. What she had said was essentially true and elicited a confession from Vanessa: 'It is terrible to be thought chaste and dowdy when one would so like to be neither.'[21]

Bunny's place in Duncan's life was to be filled by other young men. None, however, was to be so involved in the intimacy of Vanessa's life at Charleston. On one hand this was a relief to her for in her dreams she wanted Duncan to herself. On the other hand, however, the reality meant that Duncan's pursuit of his relationships periodically took him away from her and made her suffer, at times, unbearable longing for his company and a terrible uneasiness over the true nature of the current relationship; the next love affair might be the one to take him from her for ever. This letter, written when she was forty-four and Duncan was thirty-eight, was not unusual in its tone of forced banter failing to disguise the deep insecurity, fear of loss and maternal impulse to care for and control, that Duncan's elusive and essentially self-centred nature always and inevitably would frustrate.

You are at this moment no doubt sitting in the arms of Tommy – at least feeling quite happy, I hope. also I hope not staying up too late, but no doubt relieved to think that *you can* stay up as late as you like or all night without my being a bit the wiser. But please my Bear write and tell me what you do. for at this distance it wont matter & I feel very remote from you and want very much to know

how the affairs of your heart progress. You seemed to me rather distrait and impenetrable. Are you keeping a great deal back from me. I cannot help wondering.[22]

There were nevertheless many periods of contented happiness 'for Vanessa. Centred on the increasing charms of Charleston, surrounded by her children, she was the compelling focus of family and a few selected friends. Her company was sought still by her husband and ex-lover but, above all, her greatest happiness was to be found in painting peacefully with Duncan, whose aesthetic sympathy and the generosity of his nature never failed to enchant her.

These moments of self-containment, when the canvases stood before them and Duncan was safe by her side, were noted with wonder and some envy by Virginia: 'I never saw two people humming with heat and happiness like sunflowers on a hot day more than those two.'[23] But the 'left-handed marriage',[24] as Virginia called it, of Vanessa and Duncan made for distorted emotions and great insecurities in Vanessa's life. In becoming increasingly a mother-like figure to Duncan (he joked about his slip of the pen in addressing her by mistake as Dearest Mother[25] in a letter), she grew increasingly lover-like in her passion for Julian, her elder son.

Temperamentally at odds with the world, more demanding of mothering than either his brother or sister, energetic, talented, undirected, he would have been naturally a focus of Vanessa's fierce maternal love, this instinct that Virginia mistrusted, and by which Vanessa herself seemed sometimes to be unwillingly enthralled. The affinity she felt for this hulking handsome son, named Julian Thoby after the brother both sisters had loved and lost, and likened often by Vanessa to that heroic figure, was impassioned by the very imbalance of her relationship with Duncan. Julian recognised the possessiveness of her love. He knew that she dreaded him marrying and knew too that no woman would ever come close to displacing her as the central woman in his life. His perceptive younger sister recognised the amatory quality of the relationship, watching the expression on her mother's face as she looked up at Julian leaning over the back of her chair at Charleston.

Virginia, loving all Vanessa's children, had been always obliquely jealous of Julian. She insisted it was she, not he, who was emotionally Vanessa's first-born, and it was his birth which had compounded her sense of being ousted from her place at the centre of Vanessa's life. All

through his life she was the much loved, riskily entertaining, and critical aunt. Virginia found herself admiring him in his manhood, 'a vast fat powerful sweet tempered engaging young man',[26] but resenting Vanessa's likening of such a Bell to Thoby, the icon of Stephen manhood.

She was strangely ambivalent about Julian's ambitions to be a writer; surely he would make a better lawyer, she told his doting mother. Virginia was in awe of Vanessa's fierce prejudices, never fiercer than when defending her young. But Virginia knew too that Julian fed a hunger in his mother that bound them both in a passionate conspiracy, 'the lover as well as the son';[27] their relationship charged with some of the unexpressed emotion which so alarmed Duncan and which, in his instinct for self-preservation, made him retreat. 'I think that if I showed any [passion for Vanessa] it would be met by such an avalanche that I should be crushed.'[28]

The emotional aridity of her relationship with Duncan left Vanessa fearful, exposed, at times even humiliated, when her intimate place in his life was disregarded by his family and sometimes flouted by his lovers. When Vanessa, with the eight-year-old Angelica and her nurse Grace, had dashed to Cassis in the South of France in January 1927 to be by Duncan's side when rumour had it that he was ill with typhoid, she discovered Duncan recuperating in the company of three elderly and adoring women, his mother, his Aunt Daisy and his mother's female companion. Vanessa sensing their possessiveness and her lack of rights, unable to see very much at all of Duncan, spent most of the day and all her evenings alone with Angelica and Grace. Duncan only moved into Vanessa's villa when his mother and aunt departed a month later.

There was a fundamental difference between the sisters' unions. The lack of certainty about the future, and the emotional strains involved in loving Duncan during the periods he was in love with someone else, sometimes left Vanessa exhausted and distracted, and during the worst times barely able even to work. In her struggle to maintain her reasonableness and calm, Vanessa retreated from emotion and contrived not to feel. But this involved an inevitable suppression that threatened to petrify all her responses, inhibiting her expressions of affection and joy as well as those of pain. She recalled years later to Julian how upset he had been as a young boy when nobody had remembered his birthday, not even his mother.

For Virginia, the consummate security in Leonard's allegiance to

her and her reliance on his protective love meant little of her creative energy was wasted. It flowed outwards into her writing, where she could direct it with such intensity that she was able to push through experiments in the actual form of her fiction. It flowed into her letters and diaries which were charged with life. It flowed into her work, alongside Leonard, as a printer and innovative publisher. And then there were her friendships, where she was open always to new relationships. Energy flowed too into her feminism, one expression of her interest in and concern for the way human beings behaved towards each other. Her collapses into insanity could be seen as energy out of hand, misdirected. Much as she longed to be able to continue work and maintain her closest relationships, the treatment then prescribed for her was a closing down of all her usual outlets of expression, a seclusion and forced rest. At times all work, visitors, even letters were forbidden, in what for Virginia was the cruellest of regimens. But somehow the equilibrium was restored and her prodigious creative energy once more was on course. 'Much more important (to me) than anything else was my recovery of the pen; & thus the hidden stream was given exit, & I felt reborn.'[29]

Vanessa's letters to Duncan and Virginia's to Leonard illuminate so clearly the different effects on the sisters of these two unorthodox relationships. Vanessa, at fifty, writing to Duncan who was alone with George Bergen, at Charleston, pursuing their love affair in the house created by Vanessa to bind Duncan to her:

> I think now the only thing I really mind at the moment is the complete uncertainty – not knowing in the least how long you will be away nor what can happen afterwards I feel all future life with you must be put aside at the moment for I cant think of it with any definiteness ... it seems now as if everything has been blotted out in vagueness. But I dont usually feel very much – I dont want to & I can generally switch off onto something else.... Duncan dear, I dont want you to come back, as far as I'm concerned until you come back altogether. If you neednt for other reasons please dont. I think it would be more upsetting.[30]

The self-effacement, barely acknowledged misery and fear of losing him were all characteristic of her letters at such times; the asking of nothing for herself and the smothering of feeling, the legacy of her unrequited passion.

Virginia, on the other hand, at forty-six and happy in the know-
ledge that she had always been loved by Leonard and always would
be, could express her own exuberance and affection without con-
straint or embarrassment. She could repose on the security that life
with Leonard represented. The baby/animal talk that she got the
austere rationalistic Leonard to indulge in too expressed some infant-
ile element in their love but just as surely was a sign of the comfort,
the ease and intimacy of their relationship.

> Dearest Mongoose, darling Mongoose, [she wrote from France
> where she had gone for a short holiday with Vita Sackville-West]
> Lord, I do hope you'll be careful motoring to-night, – and that you
> eat and sleep and dont give away all your affection to the poos [their
> spaniel Pinker's puppies]. Poor Mandrill [Virginia] does adore your
> every hair of your little body and hereby puts in a claim for an hour
> of antelope kissing the moment she gets back.... This is a horrid
> dull scrappy scratchy letter but all letters of real affection are dull.
> Do you think we are extremely intimate? I do; because, why should
> I, a born dandy as I am, write so carelessly.[31]

From their letters to each other and their diaries, there could be
little doubt that Virginia and Leonard shared a mutually dependent,
loving, even amatory relationship. From Virginia's point of view, how-
ever, Leonard's love provided her with much of the maternal care she
had sought throughout her life, the responsibility for which he had
taken from Vanessa. He loved her unconditionally, enduring through
the worst periods of insanity, surviving her vitriol against him in the
terrible breakdown of 1913; he looked after her, watched over her,
prescribed and proscribed, sometimes admonished, even bullied, but
remained rock-like in his dependability and strength of feeling.

In their middle age, the sisters had an interesting conversation
about why they had married their respective husbands. Vanessa
admitted to marrying Clive for the entertainment, social ease and
escape from Stephen gloom that he offered, while Virginia, who
owned she had little difficulty in being social, married Leonard for his
dependability, unselfishness, and the decisiveness of his nature. She
could never make up her own mind, she said to Vanessa and had to
have someone to do it for her, 'which L. no doubt does',[32] Vanessa,
who had confronted Leonard's inflexibility herself, reported drily to
Julian in China.

Where Leonard provided the daily love that conserved and sustained Virginia in an extraordinarily active and productive life, excitement and romantic passion was vested for her in her relationships with her own sex, primarily with her beloved sister. In a sense, both Vanessa and Virginia suffered from an unrequited passion, Vanessa's for Duncan and Virginia's for Vanessa. 'With you I am deeply passionately unrequitedly in love,' she wrote, not uncharacteristically, to Vanessa when they were both approaching fifty, and then added the postscript, 'and thank goodness your beauty is ruined, for my incestuous feeling may then be cooled – yet it has survived half a century of indifference.'[33]

There was certainly an element of hyperbole and a playful fantasy in her professions of adulation for her sister but Virginia's passion for Vanessa was constant and consistently documented from her earliest nursery days. It was the foundation on which was based the lifelong fascination Virginia felt for women, their sensibilities and the circumstances of their lives. This fundamental difference between them gave rise to gentle mockery.

> You will never succumb to the charms of any of your sex – What an arid garden the world must be for you! what avenues of stone pavements and iron railings! greatly though I respect the male mind ... I cannot see that they have a glowworm's worth of charm about them – The scenery of the world takes no lustre from their presence. They add of course immensely to its dignity and safety: but when it comes to a little excitement – !(I see that you will attribute all this to your own charms in which I daresay you're not far wrong).[34]

The fact that Duncan could not return Vanessa's love in either intensity or in kind meant she suppressed and distorted the feelings she had expressed so naturally in her early years with Clive, in her love affair with Roger. Instead, her emotions, barely expressed, were concentrated on Duncan and her children where they lay oppressively at times. After she fell in love with Duncan, even though his sexual life continued largely independent of her, Vanessa allowed no other man to enter her life, to fulfil either the erotic side of her nature or to provide her with an enduring, undivided love such as Roger had offered, such as Virginia enjoyed.

Virginia, however, from the base of Leonard's love and with the

enduring knowledge that she was bound for ever by passion to Vanessa, did not close herself off from the possibilities of other romantic relationships. From Vanessa, who could not be as demonstrably affectionate as Virginia longed for her to be, who never kissed her spontaneously and retreated from expressing in words her undoubted love for her, Virginia fell in love with another redoubtable woman.

Mrs Harold Nicolson, Vita Sackville-West, had an aristocratic largess which for a time was to prove irresistible to Virginia; her extravagant passions were barely constrained by reasonableness, convention or control. She and Virginia first met at dinner with Clive at the end of 1922. She was beautiful, exotic, a poet and author, a known sapphist, and Virginia was a little alarmed. '[She] makes me feel virgin, shy, & schoolgirlish,'[35] she wrote in her diary the following day. Virginia was forty and Vita was ten years younger. It was not until the end of 1925, however, that their friendship became a love affair which transformed gradually during the next four years into a warm friendship that was to last until the end of Virginia's life.

Virginia's 'sapphism', as she herself called it, needs to be set in the context of her feelings for her mother and for Vanessa. Since childhood, she had sought maternal figures who would love and protect her, women whom she could look up to and rely on. Both Vanessa and Virginia were deprived of sufficient motherly love through their own mother's over-extended life and her early death. But whereas Vanessa was propelled into premature adulthood and responsibility, Virginia, as the younger, could retreat into her dependence on this sister who so naturally assumed the maternal role. Vanessa was so central to her life, so closely implicated in her survival, that Virginia never managed to separate fully from her. It is against this emotional background – the hunger for the absent mother, the vesting of all her passionate feelings in Vanessa, the longing to become one again with the beloved – that Virginia's relationships with other women must be placed.

There was Violet Dickinson, the wise, older woman, the mentor of her girlhood, who encouraged her to seek independence through her work, and maturity through marriage and childbirth. Now there was Vita, a woman of passion and action who threatened to scoop Virginia up and carry her away in the protection of her large embrace. Both were tall, physically impressive women; Violet at six foot towered over Virginia. Vanessa too was tall and statuesque in figure, and Ethel

Smyth, the composer who was to come crashing into Virginia's life when she was nearly fifty, was physically indomitable. This largeness of character and physique offered the greatest capacity for that most necessary protective love.

Virginia felt she was attracted to Vita because she was cast in a similar mould to Vanessa, albeit one more worldly and more glamorous. She was attracted by her maturity, her easy control of all the practicalities of life, her capacity for maternal love for Virginia, her beauty, and above all, perhaps, by her breeding. For Vita, the only child of Baron Sackville and brought up at Knole, one of the great houses of England, embodied for Virginia the centuries of English history that had made her so heedlessly privileged and hung her round with the romance of the past. In the excitement of this exotic friendship, Virginia never lost sight of her central passion for Vanessa. She rather dreaded going to Charleston for Christmas having just spent her first night alone with Vita and affected still by the glamour of that and her surroundings. It was difficult to reconcile the different styles of both women. Virginia knew too that her elder sister was practised at bypassing the romance and seeing straight to the point, or lack of point, of things. So easily could she make her feel diminished, even a little silly. Virginia liked to boast, however, to Vanessa. And she attempted, successfully, to make her jealous.

'Vita is now arriving to spend 2 nights alone with me – L. is going back. I say no more; as you are bored by Vita, bored by love, bored by me, and everything to do with me, except Quentin and Angelica; but such has long been my fate and it is better to meet it open eyed,' she wrote to Vanessa, adding what could be seen purely as a provocative bit of description: 'Still, the June nights are long and warm; the roses flowering; and the garden full of lust and bees, mingling in the asparagus beds. I must go in and tidy up.'[36]

This was not wasted on Vanessa who did not feel equal to any comparison with the new love in her sister's life and answered this sally: 'Give my humble respects to Vita, who treats me as an Arab Steed looking from the corner of its eye on some long-eared mule – But then you do your best to stir up jealousy between us, so what can one expect?'[37]

Virginia fell less passionately in love than did Vita, but lingered longer in the romantic hinterland. Vita was hot-blooded, a conquistador in love, and when she realised that she could not expect Virginia to reciprocate fully her own physical passion she moved on to other

loves, though never relinquishing her affectionate loyalty to Virginia. Due to Vita's sensitivity to Virginia's 'inviolability',[38] the sexual side of their affair was barely expressed and of no great consequence to Virginia. It was the titillation of her imagination, the romance of being so courted and desired, which held the greatest attraction. But Virginia was capable of a certain erotic boldness too. When Vita threatened to drive over to Rodmell in the dead of night, throw gravel at Virginia's window and stay with her until 5 a.m., before stealing home again, Virginia sent her a telegram stating simply, 'Come then.'[39] (She didn't.)

Virginia knew Leonard found this affair of the heart 'rather a bore', but of course in the eyes of the world her love for a woman never could be as serious as would be her love for another man. In fact, Leonard suffered more jealousy retrospectively over Virginia's affair with Clive, a relationship which was sexually unconsummated and which belonged securely – on her part at least – to the period before their marriage. He ended up liking Vita, respecting her and publishing her, to the financial advantage of The Hogarth Press.

Vanessa tended to be suspicious of any new arrival in their intimate group of friends and intransigent in her opposition to the inclusion of any new woman. Only the necessity of maintaining her relationship with Duncan, at any cost, allowed some rather unlikely men to slip through, or rather over the top of, her fine-gauge net. But Vita was a woman, she was an aristocrat with the kind of unselfconscious style and authority engendered by centuries of dominance over men, houses and great tracts of land. She was a writer and she was an emotional enthusiasm of Virginia's. There was no chance that she could become an intimate of Bloomsbury.

Although Vanessa came to appreciate Vita's largeness of character, her simplicity of feeling, still her own insecurities and prejudices made a true friendship between herself and Vita impossible. For Virginia had been unfaithful to Vanessa with her pen. Vita was now a rival for those virtuoso love-letters that had flattered and entertained Vanessa for nearly forty years; 'Don't expend all your energies in letter writing on her,' she was moved to remind Virginia, 'I consider I have first claim'[40] (in what sounded an echo of Virginia's often expressed prior claim on Vanessa's maternal love).

Perhaps Vanessa was jealous of more than the letters, for Vita too strode into Virginia's fiction with flamboyant success. Vanessa was a model for central roles in three novels, *The Voyage Out*, *Night and*

Day and *To the Lighthouse*. Then, in 1928, inspired by Vita's exotic history and invigorated by her love affair, Virginia unloosed her creative energies to celebrate Vita's life and character in the writing of *Orlando*, her joyful fantasy biography of Vita, spanning three and a half centuries and casting her first as a boy and then transformed into a woman. This book became a best-seller. But on a personal level *Orlando* was a confident, public statement of Virginia's love and fascination with Vita, to whom it was dedicated and with photographs of whom, as Orlando's male and female personae, it was illustrated.

Those people Virginia loved were explored and recreated in her novels; at times she felt that really what she wrote was autobiography masquerading as fiction. Vita fully appreciated this gift. She was overwhelmed by the 'robe stitched with jewels'[41] which had been hung about her shoulders. She wept at having Knole, her ancestral home, returned to her in fiction when in bitter fact her inheritance had been denied her because she was a woman

Having her place temporarily usurped, there is little wonder that Vanessa took pleasure in reporting to her sister this unfavourable view of Virginia's lover, sighted seven years later with her new lover in tow: 'I hadn't seen Vita for ages – she had simply become Orlando the wrong way round – I mean turned into a man with a thick moustache & very masterful & surely altogether much bigger – How have you done it? Perhaps its partly by contrast with her absurd little lover.'[42]

Accepting with equanimity the fact and detail of male homosexuality, Vanessa professed some amazement at female homosexual love. Virginia reported a fragment of conversation with Vanessa in a letter to Vita: 'I told Nessa the story of our passion in a chemists shop the other day. But do you really like going to bed with women she said – taking her change. "And how d'you do it?" and so she bought her pills to take abroad, talking as loud as a parrot.'[43]

And yet, two years later, it was Vita whom Vanessa charged with the task of telling Virginia just how much her loving daily attention had helped her, actually had secured her to life and sanity, after Julian's death. It was a measure too of Vanessa's reluctance to express emotion that she chose to pass the message via Vita, who was not an intimate of hers, rather than tell Virginia herself. The two women, however, in the aftermath of Virginia's death, were to share again a fleeting intimacy of friendship and sympathetic feeling.

Ultimately, Virginia lost neither her head nor her heart to Vita but the relationship with her was particularly enriching to her personally

and artistically. It was exciting and flattering to have this young dashing woman in love with her and so generous and protective towards her. But when separated from Vita for four months, even during the beginning of their affair in early 1926, she missed her mainly for the pleasures she brought to her life 'the glow & the flattery & the festival. I miss her, I suppose, not very intimately.'[44] When Vanessa was away, however, Virginia's need of her was profound and elemental; she suffered always 'a kind of drought caused by the lack of Nessa',[45] and was never really sure that she could exist without her.

Vanessa's presence brought a fundamental sustenance to Virginia's life, was an aegis for her vulnerable self. After her sister arrived back in England in the summer of 1928, having spent some time in her house in the South of France, Virginia expressed what was for her a familiar feeling of renewal and safety: 'Mercifully, Nessa is back. My earth is watered again. I go back to words of one syllable; feel come over me the feathery change: rather true that: as if my physical body put on some soft, comfortable skin.' And then again Virginia characterised the inequality she sensed in the relationship between them: 'She is a necessity to me – as I am not to her. I run to her as the wallaby runs to the old kangaroo.'[46]

Vita's love affair with Virginia brought fun and glamour into her life, brought her great confidence too, as shown by a small but telling incident that she related in her diary in the summer of 1926 when her feeling for 'darling Mrs. Nicolson' was at its height. It had to do with a new dress and hat.

Virginia liked to be unaware of her own appearance. She was intensely uncomfortable with the whole subject of clothes and hated to be peered at, pointed at, or ridiculed for what she wore or how she looked. 'This is the last day of June,' she wrote in 1926, '& finds me in black despair because Clive laughed at my new hat.'[47] This was no exaggeration of her state of mind. She had placed the offending hat on her head and was wearing it without thought or concern. She was with Vita; it was a warm night and they were laughing and at their ease. Vita too had been somewhat startled by the hat – 'a sort of top-hat made of straw, with two orange feathers like Mercury's wings' – but she recognised it as 'curiously becoming',[48] adding that it pleased Virginia because there could be absolutely no doubt as to which was the front and which the back. They had decided to go to Clive's and on the way happened upon Duncan and Vanessa, 'in her quiet black

hat' as it seemed in retrospect. They were all sitting around in cosy propinquity when Clive, 'bawled ... what an astonishing hat you're wearing!' Virginia tried to change the subject but her evasions were countered, her dress was then discussed and, caught in what appeared to be unrelenting ridicule, she 'never felt more humiliated They pulled me down between them like a hare.'[49]

Remarkably, defiantly even, Virginia went out to lunch with Maynard Keynes the next day and wore the same dress and the very same hat and, bumping into Clive and his friend Mary Hutchinson, faced their scrutiny once again. This time the hat was not mentioned. Virginia stood her ground and the cloud of despair passed. Vita had brought a sang-froid, an expansive enjoyment to Virginia's life. She whisked her off for a week alone to France in the late summer of 1928 where, although Virginia missed Leonard, she was shown how easy and how much fun travel could be when undertaken by someone as confident, practical and experienced in such things as Vita.

Thus with escapades like this Virginia fertilised her life and her work. She may have felt that her abiding passion for Vanessa was an unrequited one but she did not draw the shutters on other possibilities, on new friendships, as Vanessa did in her exclusive and, at times, desperate love for Duncan. But then for Virginia there was always Leonard. Her sister and her women friends provided the excitement and passion in her life and Leonard provided the background stability, the perfect devoted mothering for which she had clamoured always. He gave her what her own mother had been unable to give and what Vanessa had intermittently offered; a quotidian loving care with Virginia's needs and welfare at the centre of his concern. He exercised a fairness and firmness she respected, regulating her life as he was so well equipped, temperamentally, to do. In return he received loyalty, gratitude, love and the stimulation of a uniquely fascinating, courageous woman with a boundless capacity for amusement and pleasure in the every day. He gave her the safety line and the base from which she could voyage out, in her art and her life: she gave him a life more varied and far richer than anything he would have enjoyed without her. It meant Virginia could write this in her diary as she approached fifty: 'I daresay few women are happier – not that I am consistently anything; but feel that I have had a good draught of human life & find much champagne in it. It has not been dull – my marriage; not at all.'[50]

Vanessa in middle age, disillusioned by marriage and firm in her

opposition to it, had no such emotional anchorage. With Virginia there were times when Vanessa could admit her unhappiness and sense of failure, but Virginia's fiction of her elder sister as preternaturally capable, creative and secure was a seductive one and encouraged Vanessa to be silent and to endure. Their deep-rooted and widely branched rivalry made weakness a danger. Yet the times when Vanessa showed Virginia her frail human face blurred the distinctions of their lives and brought the sisters closer: '[My melancholy] was much diminished by hearing Nessa say she was often melancholy & often envied me – a statement I thought incredible.'[51]

The feelings that might have found expression in a marriage or reciprocal love affair were vested in Vanessa's painting, the creation of the fabric and atmosphere of Charleston, and in her children. There the ferocity and prejudice of her maternal passion 'of the tigress kind' left Virginia exasperated and overawed:

> It is obviously immeasurable and unscrupulous. You would fry us all to cinders to give Angelica a days pleasure, without knowing it. You are a mere tool of passion ... in fact what you feel about marriage I feel about motherhood, except that of the two relations motherhood seems to be the more destructive and limiting.[52]

There was an element of competitiveness, perhaps, in her analysis, but Virginia was right about the limitation of Vanessa's life; of her basic desire to do nothing but paint, the practicalities of domesticity and motherhood were some inhibition. But the more profound limitation and contraction of her life, and even her art, was not due to the presence in her life of children but rather to her acceptance of the denial of self, instilled by their mother's model of womanhood.

Like Julia, Vanessa had sacrificed her own emotional needs for the man she loved. She had chosen someone who could not return her passion, who did not want the burden of feeling and unspoken need that this engendered. Perhaps she had chosen the one man who could never be seduced away from her by Virginia. Duncan offered Vanessa love and companionship and a painting collaboration of a rare kind. But he wanted from her only the unquestioning, comforting, maternal love which left him free to pursue his own passions elsewhere. This meant inevitably that there was some sacrifice; her happiness shadowed by the fear of loss, her emotions filtered, suppressed and constrained. Vanessa's letters to Duncan, and his to her, reveal,

sometimes with rawness, the anguish of unrequited love. She had given up so much. And her hunger could distort her maternal feeling into a devouring passion that relied too heavily and demanded too much – all the more potent, given that it was largely unexpressed. This perhaps was the destructiveness in the heart of Vanessa's maternity that made Virginia uneasy.

For Vanessa had given up something central to her identity. The sister who, as a young woman, had left the intellectual to Virginia and had taken, so triumphantly, the sexual and the physical as her own domain, now in relinquishing her sexuality had become static and frozen in some fundamental part of herself, unwillingly trapped in her self-protective recoil from demonstrative feeling. 'Unluckily for myself, I'm probably a very inexpressive person. I wish I weren't,'[53] she had once confided to Roger Fry.

Yet, Virginia – so reluctant to marry, marrying Leonard partly because saying goodbye to him was marginally more difficult than accepting him – by rejecting her mother's example of womanhood rejected too the concept of self-sacrifice and service. She gave and received from her marriage precisely what she needed and ended up with a living, sustaining thing. On their return from Cassis in 1925, Virginia remembered the emotions of the holiday: 'L & I were too too happy, as they say; if it were now to die.... Nobody shall say of me that I have not known perfect happiness, but few could put their finger on the moment or say what made it.'[54]

And then, too, there was the love and familiarity so obvious in this intimate interchange Virginia recorded in her diary; 'Do you ever think me beautiful now?' she asked Leonard when she was fifty-seven. 'The most beautiful of women,'[55] was his simple reply.

But Vanessa too had been offered a similar devotion by Roger Fry and had abandoned him eventually for the boyish and eccentric charm of Duncan Grant. She knew the relationship struck others who loved her as odd and unsatisfactory. Both Clive and Virginia were aware of her periodic despair and her basic solitariness as she took sole responsibility for so much to do with the happiness and welfare of others. In a kind of apologia she explained to Julian the charms of her one-time lover, whom she had been forced to accept more as a son.

[Duncan] is so incredibly full of charm, his genius as an artist seems to overflow so into his life & character & he is so amusing too & odd & unaccountable that lots of people I think dont see clearly

215

what to me is really his most adorable quality, his honesty, disinterestedness absolute sincerity & simplicity of character which made me depend upon him always in difficult moments. You can imagine that our relationship hasnt always been easy, but owing to him – this is true, I dont say it out of modesty – it has always come through to something better. Roger felt this I know. But sometimes I think even people like Virginia who should know him well, dont see it.[56]

Vanessa's compromises and forbearance and Duncan's magnanimity, their mutual love and respect, their interdependency and intimacy through work, all meant their relationship, left-handed as it may have been, survived for over forty-five years. Contrary to Vanessa's avowal, however, it was her sacrifices not his which made this so, for Duncan was free as air and never compromised. He always lived truly for himself, unencumbered by responsibility and external constraints, retaining an almost preternatural youthfulness into his nineties.

Vanessa, on the other hand, suppressed, submitted, and aged before her time. As with Virginia, she considered Duncan had genius; like Virginia too he was an enchanter of others. In committing her life to him, Vanessa placed herself once more in the familiar subordinate position. In promoting devotedly Duncan's genius for his art and for life itself, Vanessa necessarily diminished her own.

9
Art versus Life

'Yes, I was rather depressed when you saw me – What
it comes to is this: you say, "I do think you lead a dull
respectable absurd life – lots of money, no children,
everything so settled: and conventional. Look at me
now – only sixpence a year – lovers – Paris – life – love
– art – excitement – God! I must be off." This leaves
me in tears.'

Virginia Woolf to Vanessa Bell, 20 February 1922,
Letters, vol. II

THE SIMPLE EQUATION that Vanessa had chosen life at the expense
of her art and Virginia had chosen art at the expense of life, al-
though in their bleaker moments feared to be true by the sisters
themselves, was only one construction in the intimate interlacing of
their lives. For each the example of the other was present always.
Their various successes and the esteem in which each was held
publicly and privately accentuated the similarities and differences
between them. The essential conspiracy of these two sisters, the
feeling of being united against the world, that had helped them in their
youth to survive tragedies and tyranny, exerted its toll in envy, a sense
of inferiority and, in certain areas of their lives, a retreat from sisterly
competition.

Despite Vanessa's deepest disappointments, to Virginia she seemed
to have managed somehow to have it all ways: life, love, motherhood,
painting. Nowhere was this triumph of Vanessa's human and artistic
qualities more evident than at Charleston. This house, in its evolving,
ubiquitous decorations, its informality and atmosphere of creative
industry, of an orderliness, a mannerliness and freedom, created by
Vanessa herself, was a living work of art – some might claim her
masterpiece. Friends queued to be invited, drawn not by the material
comforts, for they were few, to begin with at least, but by the
restorative ease, the stimulation of the company, and by the peace and

beauty of Charleston itself, set at the foot of a massive spur of the South Downs.

This rambling farmhouse was to become home for Vanessa Bell and Duncan Grant for the rest of their lives. Although they had studios in Bloomsbury and for a time a house in the South of France, the constant presence of Charleston provided a sense of continuity, security and timelessness. At various times it housed Vanessa, Clive Bell, their sons Julian and Quentin, David (Bunny) Garnett, Maynard Keynes (who wrote *The Economic Consequences of the Peace* in a first-floor bedroom) and Vanessa's and Duncan's daughter, Angelica. Regular visitors were too numerous to mention, but included all the members of 'Old Bloomsbury': Lytton Strachey, Roger Fry, Molly and Desmond MacCarthy, Saxon Sydney-Turner, Morgan Forster; and then too a younger generation of friends, amongst whom were John and Rosamond Lehmann, Frances Marshall and Raymond Mortimer.

It was Virginia who first discovered Charleston farmhouse and thought immediately of Vanessa. The year was 1916, in the middle of the First World War, and Virginia and Leonard Woolf were staying at Asheham, the small Regency country house some four miles away which the two sisters had leased at the beginning of 1912. Virginia wanted to lure Vanessa back to Sussex from the remote and primitive farm at Wissett in Suffolk where she had gone with her children to be with Duncan Grant. There he and Bunny Garnett, both conscientious objectors, had begun to farm in a haphazard and amateurish way in the hope that their cases would be considered more favourably when they came before the Tribunal. In fact, it was to take Maynard Keynes's sense of theatre and unashamed flaunting of status to obtain, and then only at appeal, their exemption from active service. It is also possible that Keynes's official bag, stamped with the Royal Cypher, and talk of work of national importance awaiting him at the Treasury played a prominent part in their submission.

There at Wissett, Vanessa's sure domestic touch, her apprehension of the basic necessities of life, her ingenuity in surrounding herself with sympathetic colours and patterns, all transformed an unprepossessing building into something more homely, in its singular fashion and, above all, congenial to work, for herself and Duncan and the few others who were drawn into her circle there. Despite the fermenting emotional difficulties of this unorthodox *ménage à trois*, Vanessa discovered a contentment and delight in being able to shrug

off the unnecessary demands of civilisation: little communication with the outside world, no socialising, few constraints on dress or behaviour. She wrote to Roger Fry, 'I feel such a savage here; as if I could never go to a tea-party again. In fact I believe I am getting quite unfitted for town life.'[1]

Virginia visited her at Wissett and was amazed and admiring anew at how her sister seemed to manage to keep so many difficult and disparate elements in such apparent control. Once again her speculations as to the true nature of Vanessa and her hold on life inspired her; 'I'm very much interested in your life, which I think of writing another novel about. Its fatal staying with you – you start so many new ideas.'[2]

This was her second novel, *Night and Day*, in which Virginia's eternal fascination with her sister was explored through the heroine, Katharine Hilbery: 'Decision and composure stamped her, a combination of qualities that produced a very marked character.'[3] With some resignation, Vanessa had accepted that she was the model for this young woman who, powerful, emotionally passive and largely silent, nevertheless controls every other character in the story.

> She was inclined to be silent; she shrank from expressing herself even in talk, let alone in writing. As this disposition was highly convenient in a family much given to the manufacture of phrases, and seemed to argue a corresponding capacity for action, she was, from her childhood even, put in charge of household affairs. She had the reputation, which nothing in her manner contradicted, of being the most practical of people. Ordering meals, directing servants, paying bills, and so contriving that every clock ticked more or less accurately in time, and a number of vases were always full of fresh flowers was supposed to be a natural endowment of hers, and, indeed, [her mother] often observed that it was poetry the wrong side out.[4]

Virginia, who was missing Vanessa – always more than Vanessa missed her, she suspected – knew when she came across Charleston that this was the house to bring her sister back to her side. She wrote enticingly in May 1916: 'It is about a mile from Firle, on that little path which leads under the Downs. It has a charming garden with a pond, and fruit trees, and vegetables, all now rather run wild, but you could make it lovely. The house is very nice with large rooms, and one room with big windows for a studio.'[5]

Vanessa was at first reluctant. Eventually she visited it in August, staying on her own at Asheham and bicycling over to where Charleston farmhouse slumbered. The countryside and the colour and contour of the chalk landscape exerted its fascination once more, but she was unimpressed at first by the house. A few days later, however, drawn back by some lingering memory perhaps, Vanessa travelled down to Sussex again and, securing a promise of farm work for Duncan and Bunny, decided to rent Charleston. Virginia's intuition was to be vindicated over the next half century: 'I'm sure, if you get Charleston, you'll end by buying it for ever. If you live there, you could make it absolutely divine.'[6]

It was far from divine during the grim years of the war. Remote and primitive, water had to be pumped and heated on wood-burning stoves. There was no electricity, little fuel, rationed food. It could be so bitterly cold in winter that ice had to be broken some mornings before one could wash. In a letter, however, written to Roger Fry soon after she moved in, Vanessa described the physical beauties of the house and its surrounds, which made her endure these domestic privations:

> It's absolutely perfect I think ... most lovely, very solid & simple, with flat walls in that lovely mixture of brick & flint that they use about here – & perfectly flat windows in the walls & wonderful tiled roofs. The pond is most beautiful with a willow at one side & a stone – or flint – wall edging it all round the garden part Then there's a small orchard and the walled garden.[7]

In these primitive conditions, Vanessa's domestic responsibilities were immense. First of all, she had her two young sons to look after and educate; then there were Duncan and Bunny, two young men, one of whom she loved, who were themselves involved in a tempest-uous relationship while working long, hard hours on the land; and there were her sometimes restive servants to conciliate. She attempted also to provide domestic comfort and ease when her exacting and sybaritic husband and various other visitors made the pilgrimage out to Charleston. All fell squarely on Vanessa.

To Virginia, still obliged to live a quiet and monitored life after the ravages of her breakdown the previous summer, Vanessa seemed to take everything in her stride, heedless of what lesser mortals might consider domestic catastrophes. She appeared effortlessly to encom-

pass, in the broad sweep of her powers, the daily minutiae of her domestic and affectional life, along with the uncompromising demands of her art. Sitting in the studio at Charleston, when Vanessa had been living there a year, Virginia had talked to her sister while she copied a Giotto and had pondered on the peculiar pragmatism which Vanessa brought to life. She was large in effect, very little self-conscious:

> Few people have a more vigorous grasp or a more direct pounce than Nessa. Two little boys with very active minds keep her in exercise. I like the feeling that she gives of a whole nature in use. In working order I mean: living practically, not an amateur, as Duncan & Bunny both to some extent are of course. I suppose this is the effect of children & of responsibility, but I always remember it in her. A love of the actual fact, is strong in her.[8]

Like her mother, Vanessa shouldered for a time – not altogether successfully – the responsibility for educating her children at home, with the help of various inadequate tutors. The memory, romanticised, compelling and in part eidetic, of the paradise of their youth, Talland House at St Ives, was a profound and inextricable inspiration for her creation of Charleston. Years later Vanessa was to recognise that this was precisely what she had achieved: 'I often think that it's not unlike family life in my mother's home in the summer holiday, an odd mixture of people and all rather hurly-burly.'[9]

With the very real hardships of her first two years at Charleston behind her (years she was always loath to recall), the house interior and the garden began to flower, coming fully into bloom in the inter-war years. It was then that the house became a place for holidays, only becoming again Vanessa's full-time base in 1939, with the advent of the Second World War.

Vanessa, as did her mother before her, carried the final responsibility for everything: the hiring, humouring and firing of servants; the managing of the family's finances; the care, welfare and education of the children; the organisation of a large household (often swollen further with guests who might stay for weeks at a time) and all the provisions from firewood to pheasants that this entailed. The structural improvements and additions to Charleston; the decorations and furnishings of the house; the planting and maintenance of the garden: all fell to Vanessa. She had manual help from the servants – a

minimum of three were needed to keep Charleston running at all –
and variable moral support, suggestions and some financial help from
the men in her life: from Duncan Grant, from Clive and, at different
times, from Maynard Keynes and Roger Fry. But it was Vanessa alone
who carried the whole edifice of house, friends and family. It was she
who made it the unique and compelling hearth for Bloomsbury-by-
the-sea. Like her mother before her, she managed not only to balance
these disparate domestic demands, but she too had her vocation, her
art, the irresistible demands of which had to be answered if she herself
was to function happily – or even remain sane.

There were many times, particularly during the period when her
children were young, when Vanessa despaired of ever subduing the
demands of daily life enough to reclaim the longed-for time for
painting. Roger Fry was one person to whom she could express, with
little inhibition, her fears and frustrations. At the age of forty, as she
neared the end of her confinement with her daughter Angelica, she
gave vent to her desperation at being prevented from working, a
desperation shared by Virginia when illness or convalescence forbade
her writing. Vanessa's *cri de cœur* revealed the pent-up frustration
beneath her natural forbearance: 'Oh dear if you knew how difficult I
find it now to keep my head above domestic worries, housekeeping
for all this household without any competent servant so that I really
have to consider every detail myself & how I hate being a Martha ... I
can't paint you see which is the one infallible refuge from such
things.'[10]

Duncan Grant, the father of her baby, remained intimately
involved with her until her death, both as an invaluable painting
companion and as a recipient of the maternal care that Vanessa, so
naturally, was predisposed to give. Each was to respect the other's
needs and, while not meeting them always, was never to deny their
existence. Vanessa, however, unlike Duncan, contrived to deny and
sublimate her own longings. Her lapidary character became more
stoic and reserved with the years, and with the realisation that her love
for Duncan could never be reciprocated in equal measure. Inevitably,
a large part of her attraction to Duncan was the magnanimity, the
rock-like dependability she emanated, the indulgent comfort and
solace she endeavoured always to provide. But in the emotional arena,
where she had been rejected as a lover, Vanessa slipped into the
familiar but unsatisfactory role of the mother; admiring yet excluded,
self-deprecatory, yet needing still to direct and control.

Charleston fulfilled therefore many functions for Vanessa. It was above all a home for her family, for Duncan and her children, which was to exert a powerful seductiveness across time and distance. Her daughter Angelica remembered it, 'bathed it seemed in the glow of perpetual summer'.[11] For Julian the house, and his mother in it, was such a compelling emotional tie that he had to journey to the other side of the world in order to attain his independence. It was organised around the needs of the painter members of the family, but particularly of Duncan, whose genius Vanessa never doubted. With Charleston she created an added bond to draw him home from his erotic forays.

Charleston was not only a triumph of atmosphere, it was also an expression of Vanessa's decorative genius and inventiveness. Over the years, walls, furnishings, pieces of furniture came to bear the distinctive palette of lilac, grey and yellow, pale salmon and unripe apple-green, and the voluptuous shapes of nymphs and gods, bowls of flowers and fruit, circles and bars. Vanessa's and Duncan's decorations in the house were, more often than not, spontaneous and makeshift; walls were painted around pictures as they hung, curtains were home-made, and everywhere there were paintings, anything from the grand and valuable to the modest or sentimental.

Charleston became too, most importantly and increasingly so as Vanessa grew older, a sanctuary, a refuge from the demands and excesses of the outside world. There, in her enclosed world, Vanessa was high priestess and only the chosen could enter. She could be fierce in the protection of her privacy and autocratic in the exercise of her power. When in 1925 the refractory Keyneses chose as their country house, Tilton, a bare mile or so from Charleston down the farm track, she felt threatened and outraged, and even contemplated moving back to the remoter wilds of East Anglia. Vanessa decided, however, to remain at Charleston where her authority continued unchallenged, her superiority pre-eminent.

When Virginia bade farewell to her sister there, sometimes Charleston life seemed so surrounded by blowing roses, trees bowed with fruit and ruddy, rampageous children running free, that she was crushed by the evidence of Vanessa's fertility and power in all areas of life. As she returned to her smaller, silent house, to her childless marriage, her more orderly existence, the sense of her own barrenness in the face of Vanessa's fecund triumphs was unavoidable:

Here we toil, reading & writing, year in year out. No adventure, no travel; darker grows the fog. Here by some invisible rope we are bound With Nessa for example – I think she plumes & prides herself: I think she exists self-sufficient: I think her beauty is praised; I think she does not want me.[12]

In this irrational, desponding mood, a sense of failure welled from the deepest recesses of Virginia's mind, oblivious of her own worldly success, of the quantity and quality of the love that surrounded her; 'I'm unhappy unhappy. Down – God, I wish I were dead. Pause. But why am I feeling this? Let me watch the wave rise. I watch. Vanessa. Children. Failure. Yes: I detect that. Failure failure.'[13] And to high-light that failure she imagined her sister at the heart of Charleston, just a walk away over the Downs, as some great source of creative power, like the sun, pouring forth her benison on a different part of the world from that which Virginia inhabited 'there was Nessa humming & booming & flourishing over the hill;' while Virginia's less robust light could be eclipsed so easily by a criticism or intimation of neglect: 'I saw myself, my brilliancy, genius, charm, beauty (etc. etc. – the attendants who float me through so many years) diminish & dis-appear. One is in truth rather an elderly dowdy fussy ugly incom-petent woman vain, chattering & futile.'[14]

One of the most enduring sources of this feeling of inadequacy, of rejection, was contemplation of Vanessa's children. The familiar old jealousy she called it; jealousy of the delights and confirmation that children brought to life; but jealousy too of their intrusion in her own relationship with her sister, of the pre-eminence (she feared) in Van-essa's affections. In the absence of her own mother, Virginia had claimed always, in spirit at least, Vanessa as her mother, herself the special one, the most loved. In fact, she had been her mother's fifth child, her father's fourth, with no particular privileges in their large, heterogeneous family, except those she could win for herself by charm or wit. Inevitably, Vanessa could never answer fully that hunger that acompanied Virginia throughout her life, the un-assuageable need, she recognised herself, for a mother's love.

As for that other hunger, the longing for children of her own, it seemed at times to Virginia that the only consolation for the sacrifice of her own experience of motherhood was if her art was increasingly appreciated. More than that: the only fair compensation, she argued, was that her writing had to be more successful and given greater

recognition than Vanessa's painting. The territories had been marked out when they were girls and on numerous occasions Virginia would admit, quite candidly, that Vanessa had chosen motherhood and the instinctual life: she therefore, by rights, laid claim on intellect and fame. When the Fauvist painter Segonzac opined in 1935 that Vanessa was the best painter in England (Virginia's own reputation as one of the most esteemed writers of her generation was established securely by then, outstripping her sister's more modest fame), Virginia had to control a spasm of jealousy. She reflected ingenuously, 'Isn't it odd – thinking of gifts in her? I mean when she has everything else.'[15]

This direct opposition of art with children might well have contributed to the acute despair Virginia suffered on completing her major books and offering them to the world. Not only were they her children in a truly creative sense; products of her very self, lovingly, lengthily wrought through suffering, ecstasy and grinding tedium, but they were also her *raison d'être*. Her work had to be admired, had to be publicly declared by those whose opinions she valued to be worthwhile, for if she was not a writer she was nothing.

In a touching and affectionate letter Virginia wrote to Gwen Raverat, on hearing of the death of her husband, the French painter Jacques Raverat, she explained something of this connection. Knowing he was dying, Virginia had sent a proof copy of *Mrs Dalloway*, an act of courageous generosity for someone so naturally anxious and protective of her writing, even more so just prior to publication. It was therefore with considerable relief that Virginia received the Raverats' favourable response: 'I feel exquisitely relieved; not flattered: but one does want that side of one to be acceptable – I was going to have written to Jacques about his children, and my having none – I mean, these efforts of mine to communicate with people are partly childlessness and the horror that sometimes overcomes me.'[16]

Approaching her forty-first birthday, Virginia reminded herself again to 'never pretend that the things you haven't got are not worth having Never pretend that children, for instance, can be replaced by other things.'[17] But with age and increasing success, the sense of deprivation lessened and the compensations seemed more substantial. At Rodmell, looking out on their field from Monk's House, and seeing the village boys playing cricket, Virginia was aware both of the old longings and her new content: 'Children playing: yes, & interrupting me; yes & I have no children of my own; & Nessa has & yet I

dont want them any more, since my ideas so possess me & I detest more & more interruption; & the slow heaviness of life.'[18]

The continual support of friends, won for herself through her own talent for friendship and affection, was also a source of contentment at this time. The extended family of Bloomsbury that she and Vanessa had encouraged in their own need for a sense of identity and belonging, more than two decades before, stood up quite well to scrutiny and criticism, or so Virginia believed, and supported her still:

> If six people, with no special start except what their wits give them, can so dominate, there must be some reason in it [Virginia wrote to a friend in defence of Bloomsbury] And what Rupert [Brooke] never allowed for was that half of them were every bit as lacerated and sceptical and unhappy as he was. Where they seemed to me to triumph is in having worked out a view of life which was not by any means corrupt or sinister or merely intellectual; rather ascetic and austere indeed: which still holds, and keeps them dining together, and staying together, after 20 years; and no amount of quarrelling or success, or failure has altered this.[19]

As a lone voyager in her art, this solidarity of friends around her was an encouragement to risk all and write what she would. With the strong sense of the bargain she had made, Virginia felt she had given up the natural lot of womankind: children, a humming household, an instinctive centrality and grasp on the essentials of life, all so memorably illustrated by her mother and elder sister. Instead she had tied her colours to the mast of fiction and determined to journey alone on uncharted seas. If her small ship should prove leaky and ill-made she would be too far out to rescue. There would be nothing to which she could return. So much therefore was riding on her success, or at least on the affirmation that her vision was not so eccentric as to be of little worth or interest to others.

On the crest of the wave of public acclaim and financial reward that accompanied the publication of *Orlando*, Virginia greeted the new year of 1929 with the observation:

> How odd to think that I have given the world something that the world enjoys – I refer to the Manchester Guardian – Orlando is recognised for the masterpiece that it is. The Times does not mention Nessa's pictures [She was exhibiting in the London Group

Show] yet, she said last night, I have spent a long time over one of them. Then I think to myself, So I have something, instead of children, & fall comparing our lives.[20]

But such victories could be pyrrhic. Later that summer Virginia tried to deflate Vanessa, as she presided over her new dominion at Cassis, by countering her pride in Julian's achievements at Cambridge with her own success in making £2,000 from *Orlando*. As Virginia recorded, Vanessa – crushed – could only reply, '(in the same inaudible way) I am a failure as a painter compared with you, & cant do more than pay for my models. And so we go on over the depths of our childhood.'[21] The superiority in Vanessa which roused Virginia was personal and domestic, and Virginia could only attempt to restore the equilibrium by parading her greater success in the world.

With the seductive spectre of her mother as an ideal of womanhood, for which she felt both censure and veneration; with the memory of Talland House at St Ives reminding her always of that lost bounty of childhood where days were lived more variously and vividly than could ever be the case again: it was inevitable that Virginia should feel at times that her adult life was claustral; her own self denatured. Her breakdowns forced her for periods of time to limit the prodigality of her own life and experience. Leonard's vigilance and, at times, over conscientious control of her daily activities and health also made her life seem safer and meaner than she would have liked it to be.

Wishing to stay the night with Vanessa and her family in London after one New Year, she felt constrained to return to Monk's House, 'because L. on the telephone expressed displeasure. Late again. Very foolish. Your heart bad – & so my self reliance being sapped, I had no courage to venture against his will.'[22] But then she agreed that really she did need to limit the distractions and interruptions of life (and illness was one of them) in order to have time and energy for her art, the activity that was more necessary to her than anything else.

Vanessa on the contrary had managed somehow, miraculously, to attain the family ideal. She controlled her disparate household with the same ability and ease that their mother had employed, and she had conjured out of the air at Charleston something of the munificence and liberality which had enchanted their childhood summers at St Ives. It was therefore a shock for Virginia to realise that, far from being that imperturbable creative force, Vanessa was all too human

and afraid too that she might be a failure. Virginia noted in her diary, with surprise and some relief, that her elder sister's supremacy in life was not unassailable:

[I] cannot attack melancholy, save only to note that it was much diminished by hearing Nessa say that she was often melancholy & often envied me – a statement I thought incredible. I have split myself among too many stools she said.[23]

Not only was Vanessa authoritative, so Virginia felt, in her management of the practical demands of life, the creating of an atmosphere to which family and friends were irresistibly drawn, but her decorative skills, expressed in every house she had lived in since 22 Hyde Park Gate, showed up Virginia's own efforts, she feared, in a forlorn light. As a child, Vanessa had felt stifled by the Victorian clutter of her family . home. Her painterly spirit was crushed by the dark furnishings, the enclosed spaces, the absence of light. When, at last, she had gained control of her surroundings, she transformed them into something congenial to her way of life and eye. Walls were washed with colour, chair covers dyed, pictures painted and hung. Roger Fry was amazed at how inspired she seemed by her domestic environment: 'I wish you wouldn't always paint your best things just to decorate odd corners of yr. house,'[24] he wrote, seduced once again by Charleston and anxious that she should never give it up.

Virginia, inevitably, was competitive but felt ill-equipped, in this area, to compete. Whilst their houses suited her and Leonard well enough, she was aware always that her sister's sure decorative touch made her houses, Charleston in particular, the visually richer, the more individual, the more attractive to others. When Vanessa was about to move into Charleston, Virginia, still using Asheham, the house she and Vanessa had shared originally, as her and Leonard's country retreat, knew that now Vanessa's creativity would be focused on this new house the attractions of the old would dim: 'I see you're going to say that Charleston is better than Asheham – it cuts me to the heart.'[25]

She was intrigued by Vanessa's decorative schemes and both her London house at Tavistock Square and Monk's House were stamped with work by Bell and Grant. At 52 Tavistock Square, the rooms Leonard and Virginia had taken for themselves in 1924 were made distinctive with 'vast panels of moonrises and prima donna's

bouquets', which flourished until the house was bombed during the Blitz in the autumn of 1940. For Monk's House, at Virginia's request in 1929, Vanessa painted a dining-table which is there still. It had a central motif of webbed and overlapping circles, and the chairs were painted on the back with a monogram of Virginia's interlocked initials. Later that year, with the proceeds from *Orlando*'s success, Virginia and Leonard decided to make Monk's House more comfortable and spacious, building two more rooms and commissioning further decorative work from Vanessa (which she was loath to charge for, arguing that Virginia's books had given her so much pleasure, all of which had been free).

Virginia was diffident about her own attempts at decoration, expecting ridicule from the Charleston painters for her choice of shade of green in the dining-room, for her less bold ideas, less freely executed. Defensively she had told her sister, 'I have my own ideas, and my own taste, but its all ineradicably bad.'[26] And indeed Vanessa was inclined to be disparaging about Virginia's taste in such matters, for this area of competence most surely belonged to her. At Asheham, when the sisters still shared it, Vanessa could be determined in ensuring her schemes prevailed: 'The Woolves have completely ruined my ideas of the garden,' she wrote to Duncan Grant in 1914, 'two round beds in the front rather spoil the general effect to my eye ...' She was busy weeding and reorganising, 'I cant resist trying to undo some of their labours while they're away.'[27]

Vanessa had not been very impressed with Monk's House either. Prior to its refurbishment, finished in 1930, she considered it 'a queer poky jumbled cottage'[28] which to an unromantic eye was pretty much what it was. Virginia was an inspired house-hunter and Vanessa the inspired home-creator. It was Virginia who found Little Talland House in Firle, the sisters' first weekend house and named nostalgically after their childhood summer house at St Ives. Then, in 1912, she too found, Asheham, their magical, haunted house in a fold of the Downs. She discovered Charleston on one of her walks. Even Cassis was first visited by Virginia and Leonard in 1925 when they made the acquaintance of Colonel Teed, the expatriate Englishman who was to be an important element in Vanessa's and Duncan's escapes to paint abroad.

Virginia was liable always to fall in love with other houses, while Vanessa, once she had committed herself to Charleston, appeared never to look with longing on anything else – in England at least.

Much as Virginia might dream of somewhere more remote, or bigger, or with a less obstructed view or a more mysterious atmosphere, she usually returned to Monk's House content and grateful for its familiarity: 'half the beauty of a country or a house comes from knowing it'.[29]

Even given her rhapsodic appreciation of the life led at Charleston, that rival over the hill, Virginia felt increasingly that she could entertain an alternative – not necessarily inferior – vision:

Charleston is as usual [she wrote in the summer of 1922]. One hears Clive shouting in the garden before one arrives. Nessa emerges from a great variegated quilt of asters & artichokes; not very cordial; a little absent-minded. Clive bursts out of his shirt; sits square in his chair and bubbles. Then Duncan drifts in, also vague, absent minded, & incredibly wrapped round with yellow waistcoats, spotted ties, & old blue stained painting jackets. His trousers have to be hitched up constantly. He rumples his hair. However I can't help thinking that we grow in cordiality, instead of drifting out of sight. And why not stand on one's own legs, & defy them, even in the matter of hats & chaircovers? Surely at the age of forty....[30]

Vanessa's grasp on life also seemed to be so sure in the matter of foreign travel. A painter, she loved the light and the colour of the Mediterranean and the seriousness with which the visual arts were treated, in Paris particularly where, refreshingly, painting was as important and influential as literature. Despite the encumbrances of children and all the paraphernalia of a painter's trade, she would take off for France with an apparent sang-froid which Virginia could only admire. 'Nessa, though, who might so easily plead ties & circumstances, rides much more freely than we do,'[31] she noted, contemplating how she and Leonard allowed the responsibilities of the Press and their work to make their lives less carefree, less spontaneous.

Virginia and Leonard enjoyed holidays which involved touring on the Continent, but rather in the English manner, as self-contained observers and outsiders. On one occasion when they met up with Vanessa, Quentin and Angelica in Rome, the Bells had to give up their habit of experimenting with eating out in various bars and restaurants because, as Vanessa reported to Clive, Leonard 'cant bear trying new

& uncertain places. In fact Virginia is so difficult to feed that meals become rather an uneasy problem.'³²

It seemed that only on a memorable holiday in Greece, with Roger Fry and his sister in the spring of 1932, two years before he died, did Leonard and Virginia manage to enter fully into the experience of being abroad. Then, carried along on Roger's extraordinarily erudite enthusiasms and open-heartedness towards everyone he met, they began to be drawn too into the rhythm of the land and the people who lived there. In thinking on her return of 'the best holiday these many years', Virginia, at fifty, recalled the thrill of glimpsing a different way of living:

> I had the vision, in Aegina, of an uncivilised, hot new season to be brought into our lives – how yearly we shall come here, with a tent, escaping England, & sloughing the respectable skin; & all the tightness & formality of London; & fame & wealth; & go back & become irresponsible, livers, existing on bread yaot, butter, eggs, say in Crete. This is to some extent a genuine impulse ... London is not enough, nor Sussex either. One wants to be sunbaked, & taken back to these loquacious friendly people, simply to live, to talk, not to read and write.³³

Virginia thought she would grow to love Greece as an old woman, as she had loved Cornwall as a child. But Roger died, and war threatened, and she never managed to pick up her tent and go there again.

Vanessa, however, had been living exactly this kind of primitive, sun-baked life – although being much more practical she had acquired a house to do it in. She had visited the Villa Corsica at Cassis in 1927 and then the following year had leased from Colonel Teed, La Bergère, a tumbledown building used as an animal shelter that was to become, under her direction, the house she was to return to whenever she had the time, until war incarcerated them all in Sussex. In her inimitable style Vanessa made La Bergère into the perfect retreat for her family and a haven for herself and Duncan there to paint. She wrote to Clive, with some satisfaction and surprise, that she had managed somehow to 'set up another Charleston in France'.³⁴ Within just a year, Vanessa's ability to make domestic reality out of an utopian dream had been discovered by those who lacked this particular genius. To Roger Fry, she wrote: 'It is very odd. Duncan & I really intended this house as a place to come to more or less alone to work in, but whenever one

has succeeded in making a house habitable even rather in the teeth of difficulties as at Charleston people are inclined to come like a flight of locusts & complain that there isn't room enough!'[35]

Family and friends swarmed across France by boat and train, the intrepid by rickety motor, some of which, like Roger's, got there on faith or fluke. His car was literally held together with 'odd bits of string & stick & paper ... exactly what you'd expect in the White Knight's car',[36] Vanessa discovered to her mock horror when its refusing to go had meant she and Roger had to investigate what was under the bonnet.

In Virginia's lifelong need to try and share the things that mattered in Vanessa's life; in her fear of being excluded; in her longing, in theory at least, to live a looser, freer, more romantic life: when she visited her sister at La Bergère in the early summer of 1929, she decided, with the freedom of her new riches, to have a house there too. Although she leased La Boudarde, just a few hundred yards from Vanessa's own Charleston-in-France, the plan of setting up a Mediterranean Monk's House never came to fruition. Its demise was blamed on Leonard. But Virginia recognised also the impracticality of spending two months, as she had dreamed, away in the sun-soaked vicinity of Vanessa. She, in fact, had been slightly ill at ease at Cassis. Vanessa was so much in control, so much at her ease in living what she characterised as that 'purely sensual and unintellectual existence'[37] that Virginia felt herself out of her habitat and somehow diminished: 'talk with people who have never heard of me & think me older, uglier than Nessa, in every way inferior to her'.[38] It was a feeling she was not used to and did not like.

Virginia had already tried to reassert the claims of Sussex over Cassis by writing to her sister after visiting her there: 'It is suddenly full summer; everything is out; the garden blazing with lilac, apple, pear blossom and every flower you can imagine; and the country far far far away better than Cassis.'[39] And then in the spring after she had given up her own house there, Virginia tried again to undermine the supremacy of that colony. Writing to Quentin Bell from Brantôme in the Dordogne, she was partly in jest, partly wishing to mitigate the sense of being once more an outsider to her sister's life there: 'Why don't we live here – far lovelier, lovelier far, than Cassis – plains, heights, poplars, vineyards, of a subtlety and distinction like a moth's wing compared with the shell of a lobster.'[40]

As it was, Vanessa was in her element at Cassis, managing to bring

together life and art in one creative strand. It was only her love for Virginia and Roger, she said, which made her return at all to the benighted English shores. Back in England, Virginia was most at home. She was aware that although her dedication to her art might mean her life seemed to her less vivid and adventurous, she had no power to change it, no wish, in fact, to change. There was no choice but to write. Lily Briscoe, her artist protagonist in *To the Lighthouse*, expressed this reluctant compulsion: 'Here she was again, she thought ... drawn out of gossip, out of living, out of community with people into this formidable ancient enemy of hers – this other thing, this truth, this reality, which suddenly laid hands on her.'[41] She was made to exchange the fluidity of life for the concentration of her art, and that moment of transition left her naked and afraid. For Lily, Mrs Ramsay seemed to be able to make shape out of chaos just by being; to take life and make 'of the moment something permanent'.[42] This was what she in her art attempted too; to make something permanent from the fluidity, the fecundity of memories and ideas that continually assaulted her mind.

But life, for Virginia, did keep breaking through. The Hogarth Press, so often resented for its undoubted drain on her time and energies, a parallel of sorts with the domestic concerns which burdened Vanessa, enriched her too in every way. Thanks to the Press she was 'the only woman in England free to write what I like'.[43] The Press too, with increasing success during the 1920s, brought increasing wealth. This allowed Virginia to see life as an adventure, where anything was possible – in 1927 their first motor car, the greatest agent for freedom; and then weekends away; new rooms at Monk's House; even attempting to lead Vanessa's life of the senses in France.

The Press also brought other writers into her life. The younger poets, such as Stephen Spender, William Empson, W. H. Auden and C. Day Lewis, were published in 1932 with the collaboration of John Lehmann in *New Signatures*. Not only was Virginia making waves in the literary world with her own writing, but she and Leonard were instrumental in the wave-making of others, and this had its satisfactions. In the midst of writing the mad scene in *Mrs Dalloway*, Virginia, depressed and fearing failure, consoled herself with thoughts of her work for the Press; 'It entirely prevents brooding & gives me something solid to fall back on. Anyhow, if I can't write, I can make other people write: I can build up a business.'[44] And somehow to make a successful business, to provide creative outlet for the work of

others, from poets to the menial helpers at the Press, gave Virginia at times the sense of having combined most satisfactorily what was too often opposed: the rigour of art with the practicalities of life. 'For the first time we have made over £400 profit,' she wrote in the spring of 1929. 'I think with pride that 7 people depend, largely, upon my handwriting on a sheet of paper. That is of course a great solace & pride to me. Its not scribbling; its keeping 7 people fed & housed: a great big man like Percy; a carrot faced woman like Cartwright; they live on my words.'[45]

For Vanessa, the Omega Workshops represented something analogous to what The Hogarth Press, more significantly and over a longer time, meant to Virginia. The Omega came into existence in 1913, four years before Leonard and Virginia bought their Press. It began to fail just as The Hogarth Press started publishing its first books. Vanessa, Roger Fry and Duncan Grant were co-directors of this brain-child of Roger's, which was intended to encourage young artists in displaying their decorative skills in the spirit of Post-Impressionism, and to provide them with a common workshop, a showroom and a marketplace. But Roger was a visionary too. He had an ideological intent in setting up the Omega Workshops; he wanted to change the tenets of English taste in the messianic hope that through the Omega he could 'make art possible in England'.[46]

The Workshops were opened after the two Post-Impressionist exhibitions, organised by Roger, had prepared the cultured society a little for what was to come. Vanessa was closely involved, particularly at the beginning. She was to produce designs for fabrics, rugs and clothes. She painted screens, pottery and an animal mural for a Post-Impressionist nursery. The Omega was open to commission from the public for almost any decorative detail from stained-glass windows and mosaic floors to marquetry trays and hand-painted teapots. The mood was irreverent, witty and exhilarating, but occasionally the Omeganic style, consistently adhered to, became a little overpowering. Virginia, an amused and half-admiring outsider, drew the line at some of the clothes Vanessa had designed which their new sister-in-law, Karin Costelloe, step-daughter of Bernard Berenson, had had the courage to wear in public. She wrote to Vanessa:

My God! What clothes you are responsible for! Karin's clothes wrenched my eyes from the sockets – a skirt barred with reds and yellows of the violent kind, a pea-green blouse on top, with a gaudy

handkerchief on her head, supposed to be the very boldest taste. I shall retire into dove colour and old lavender, with a lace collar and lawn wristlets.[47]

Vanessa's involvement with the venture freed her personally and artistically. The impromptu, ubiquitous nature of most of the Omega decorative work, the lack of preciosity, was the impetus most probably for the decorative boldness and insouciance she and Duncan brought to Charleston, where they set up house in 1916.

The Omega Workshops were also the fulcrum for Vanessa's emotional life. There, working alongside Roger Fry and Duncan Grant, her allegiance was transferred gradually from one to the other. In a letter to Roger after their affair had ended, Vanessa explained that the constant working together setting up the Omega, in rather difficult and fraught circumstances, hastened her emotional disengagement from him. And all the while there was Duncan working on his wonderfully assured designs and exercising the magic of his singular charm. Although the Workshops survived until 1919, Vanessa had withdrawn most of her direct involvement by 1915 when she was preoccupied with the delicate juggling act of her personal life and Duncan's, and her increased desire to paint.

Two years later, reconciled a little to his loss of her to Duncan, Roger Fry was to pay Vanessa the highest compliment, his sentiments a virtual echo of Virginia's: 'You give one a sense of security of something solid and real in a shifting world.... You have genius in your life as well as in your art and both are rare things.'[48]

It was precisely that sense of something solid and real in a shifting world that characterised Mrs Ramsay, that emanated from Vanessa. Similarly Lily Briscoe – and Virginia – finding they could not command life as these women did, sought in their art to make permanent the fleeting idea, to capture the evanescent. In her memoir 'A Sketch of the Past', Virginia explained the extraordinary pleasure afforded her when, by writing, she detected the hidden structure beneath the surface currents of life. Her philosophy, she called it,

that behind the cotton wool is hidden a pattern that we – I mean all human beings – are connected with this; that the whole world is a work of art, that we are parts of that work of art. Hamlet or a Beethoven quartet is the truth about this vast mass that we call the world but there is no Shakespeare, there is no Beethoven; certainly

and emphatically there is no God; we are the words, we are the music, we are the thing itself.[49]

In writing, Virginia struggled to unite art with life. In the rapture of that embrace she could fling out in defiance of her mother's creed, 'children are nothing to this,'[50] and in defiance too of the triumph of her sister, whom she imagined at Charleston at the centre of life, looking on her children and thinking, 'this is what I have made by years of unknown work – my sons, my daughter.'[51]

These moments of unity were rare. More often Virginia felt she was propagating something subversive, the view of the woman, the outsider against the male point of view on which society and art were founded and by which they were upheld. Virginia's feminism was all-pervasive. It was born of personal experience and an unflinching clarity, based on sympathy for the lives of others, men and women. It found its most powerful expression in what she wrote, rather than in how she lived – for she had no great appetite for joining movements or for practical politics. Virginia preferred the image of herself as a lone raider, a solitary warrior, her pen her greatest weapon.

Virginia's feminism was a combination of common sense and rational argument, leavened with humour, and a romantic vision which showed a disregard and a dislike of the practicalities involved in revolutionary change. 'I became steadily more feminist,' she wrote at the beginning of 1916 to Margaret Llewelyn Davies, moving spirit of the Women's Co-operative Guild, 'owing to the Times, which I read at breakfast and wonder how this preposterous masculine fiction [the war] keeps going a day longer – without some vigorous young woman pulling us together and marching through it.'[52]

Virginia did attempt some practical work for the cause. Janet Case, her Greek teacher and a fervent supporter of women's suffrage, in 1910 encouraged Virginia to offer her talents to the Movement. Eschewing speech-making or writing, she chose to address envelopes, and did so for a few months that year. It was Janet who introduced her to Margaret Llewelyn Davies, an impressive, intellectually energetic woman who was to become even more truly Leonard's friend when he committed himself to work for the Co-operative Guild. Virginia for a time too was enthusiastic in organising speakers for the Richmond branch of the Guild. She was living at Hogarth House in Richmond at the time, and held the monthly meetings in her house for four years from 1916.

Admiring and touched by the dedication and integrity of women such as Janet Case and Margaret Llewelyn Davies, fully in concordance with the cause for which they worked, Virginia was just as likely at times to recoil from their lack of humour and the drudgery of their lives. She decried the limited experience and lack of true tolerance that could make them seem parochial, desiccated and cramped. When Margaret suggested that, to her and Janet's mind, Virginia's article on Charlotte Brontë was a better expression of her talents than her novels, due to 'something in my feeling for human beings – some narrowness – some lack of emotion', Virginia could not contain her indignation. 'I blazed up & let fly. So you go preaching humanity, was the gist of what I said, when you're withdrawn, & preserve only the conventional idea of it. But it's *you* that are narrow!'[53] Janet Case too, grateful and fond as Virginia was of her, had a 'smell of musty morality'[54] which suggested that literature should be nothing more than worthy and safe and respectable.

Vanessa had never been remotely interested in politics. She professed to 'utter incapacity',[55] in anything to do with it. And even Virginia, married to an active and committed socialist, was suspicious of politicians' motives (with the exception of Churchill) and bored by practical politics. On accompanying Leonard to a Labour party meeting at Brighton in 1935, Virginia was struck by the weight, literally, of the masculine point of view – all roast beef and beer, she thought – against which the few women delegates had to struggle. But she was most concerned with how it threw her off her stride in writing. She was in the middle of *The Years*, and how confusing was the personal politicking, the conflicting and flatulent policies for reform. She retreated into her favoured outsider's position: 'Happily, uneducated & voteless, I am not responsible for the state of society.'[56] At the jubilee for the Women's Co-operative Guild she longed to be back at home working: 'The P.s ['Pargiters', to be called *The Years*] is more real, truer harder, more veined with blood than all this.'[57]

Ultimately it was not with the toiling and worthy Janets and Margarets that Virginia sought communion. Her greatest love and admiration always was for that ideologically unsound, apolitical, sister: the caryatid willing to sacrifice herself and her work for the comfort of her men and her family; the upholder of the masculine point of view and detractor of the feminine. Vanessa was the woman who, for Virginia, towered above all others in her reality and the grasp she appeared to have on life. 'And whats the truth of life? – for I am

convinced it is lodged with you.'[58]

From the moment that they escaped the gloom of 22 Hyde Park Gate, Vanessa and Virginia contrived to combine dedication to their art with the fullest measure of life. There were times when each was to feel that the other had solved her own problems more satisfactorily. Vanessa, with her time for painting pressed in upon by the continual demands of family life, and Virginia, isolated within the fear and exaltation of her writing, longing suddenly to kick over the traces and set off with her sister, to France perhaps, to a freer life. But the quest, the longing and the despair were all necessary grist, for 'if we didn't live venturously, plucking the wild goat by the beard, & trembling over precipices, we should never be depressed, I've no doubt; but already should be faded, fatalistic & aged.'[59]

10

The Plunge into Deep Waters

'These glooms ... have a psychological interest which
the usual state of working & enjoying lacks. These 9
weeks give one a plunge into deep waters ... one goes
down into the well & nothing protects one from the
assault of truth. Down there I cant write or read; I
exist however, I am.'
Virginia Woolf, 28 September 1926, *Diary*, vol. III

INTIMATIONS OF MADNESS had shadowed the Stephen family from
childhood. The sound of their half-sister Laura's disturbed wailing
while they were still in the nursery; the unpredictable behaviour
when they were children of their brilliant cousin J. K. Stephen,
whose death from the injury which devastated his mind was a family
tragedy; the incestuous demands of their half-brothers which invaded
the sanctuary of family life; Virginia's periodic breakdowns and
attempts at suicide; Vanessa's own nervousness which, although well-
controlled, was recognised by Leonard and herself as being similar to
Virginia's; their younger brother Adrian who was prone to suicidal
despair: all this was the fabric of their lives.

Death too was their close companion dealing the most destructive
blows with brutal timing. The death of their mother in 1895, when
Vanessa was not yet sixteen and Virginia thirteen, from an apparently
straightforward bout of pneumonia, was followed two years later by
the death of Stella, their half-sister and substitute mother. The third
untimely death, of their brother Thoby from mis-diagnosed typhoid
in 1906, when he was just twenty-six, reasserted for them the cruel
inconstancy of life.

These early experiences of death, Virginia recalled, left her with the
sense all her life of being pursued; even when she was at her most
productive and content she was aware always how fragile that equani-
mity might be. That the great cat, as sometimes she characterised
malign fate, might pounce without provocation or warning. Whereas

Virginia recognised her pursuer and used that recognition construc-
tively as a spur to work, to life, it seemed that for Vanessa the fear of
catastrophic loss, unexorcised, caused more a contraction of spirit
into over-protectiveness towards her family and, at times, an un-
expressed yet stultifying possessiveness towards those she loved. 'In
spite of all the terrible things that happen how much one still has to
lose'[1] was a cry of despair in late middle age after the death of her son
Julian. It revealed too a pessimism engendered far earlier by the cruel
experiences of death and distorted emotions in her youth. In her
young womanhood, Vanessa remembered vividly the occasions when
she 'felt so utterly mean and despicable'[2] for no reason at all, and yet
certain that everyone around her must despise her too. Her work
became, particularly in later life, a refuge from these dark emotions
and the demands of her everyday life. She did not choose to confront
her ghosts as Virginia was to do so successfully: in her exploration of
their parents' characters and marriage in *To the Lighthouse*; of
Thoby's death in *Jacob's Room*. Vanessa, who once told Roger Fry
that she considered being emotional and irrational akin to having a
disease, preferred to evade, suppress and conceal.

If the sisters' early experiences of death left them with a sense of the
fugitive nature of happiness and the precariousness of even their most
intimate relationships, both were subject too to periods of emotional
instability, manifested more dramatically in Virginia, but sharing,
perhaps, a similar source. Ever since her first breakdown after their
mother's death in the summer of 1895, Virginia was likely to be
teasingly referred to by the family as 'mad'. She had five further
breakdowns in the remaining forty-six years of her life and herself
described these episodes variously as 'madness', 'insanities', 'illness',
'the glooms'.

Her state of mind during these times could be anything between
two extremes: highly agitated, raving, at times violent, and pro-
foundly depressed, refusing food, at times suicidal. Although this
behaviour could be called pathological in that it interfered with the
living of her everyday life, there is no great illumination to be gained
in labelling Virginia as manic-depressive or schizophrenic, conditions
ill-understood, widely applicable and still barely treatable. What is
important is what these episodes of breakdown meant to her and how
much Virginia may have shared a family susceptibility to nervousness
and depression with Vanessa – and with their younger brother
Adrian.

The mutual and artificial polarisation of the sisters' characters and abilities, which had protected them since childhood from the extremes of sisterly rivalry and had cast Vanessa as the sexual, maternal woman and Virginia as the intellectual and sterile one, was evident too in their allocation to each other of the attribute of sanity. From childhood Vanessa, the eldest of the new family born to Julia and Lesley Stephen, had been reasonable, motherly and, most of all, monumentally sane. It was Vanessa who could be relied on always, whose moral, literal, pragmatic approach to life had earned from Virginia the childish and wounding nickname of 'the Saint'.

Virginia, on the other hand, younger and from babyhood the most eccentric, imaginative and amusing member of the family was ready to accept the characterisation of non-saneness. The family epithet for her, as in their jesting 'Oh you know very well the Goat's mad,'[3] has amongst its many associations that of scapegoat. In the few periods of her life when she was in a psychotic state, Virginia surely could have been considered by family and friends to be mad, and thus carried for the rest of the family confirmation of their sanity.

Baldly catalogued the following were the periods of breakdown when Virginia slipped from public view: the summer of 1895 after her mother's death; the summer of 1904 following her father's death; the summer of 1910; in the spring of 1912 following Leonard's proposal of marriage, she retreated to a nursing home with 'a touch of my usual disease',[4] which developed into a major breakdown and a suicide attempt in the summer of 1913, recurring in 1914 and lasting the whole of that following summer. There were then only occasional periods of weeks, rather than months, when Virginia had to rest, limiting her social and working life until, in the summer of 1936, after intensive worry and work on her novel *The Years*, she collapsed into suicidal despair. By the end of the year she had recovered, only to suffer, just over four years later in March 1941, her final breakdown when she succeeded in ending her life. By her own calculation, Virginia lost to illness five years of a life that lasted nearly sixty years. It was a life characterised by extraordinarily hard work, clarity of intellect, joy in living and saneness of vision. But it was her madness more than her sanity, those five years more than the fifty-five, which have seemed more influential in her public's memory.

With Virginia cast as the unstable sister, therefore, Vanessa, naturally disinclined to emotional displays of any sort, was tied even more securely into the straitjacket of sanity. She lent herself very well to this

characterisation. On the surface, Vanessa exhibited a lapidary calm and control, her common sense and dry humour smoothing the daily lives of those she loved and with whom she lived. Yet those who knew her intimately knew that this judicious exterior hid something much less orderly and controlled.

Leonard in his autobiography, recalling the unique attraction of this woman with whom he had fancied himself in love during his youthful posting to Ceylon, confided his awareness of the darker side of her temperament. 'The tranquillity was to some extent superficial,' he wrote of Vanessa. 'It did not extend deep down in her mind, for there in the depths there was also an extreme sensitivity, a nervous tension which had some resemblance to the mental instability of Virginia.'[5] This remained an underlying strain in her life, to surface only in extremis. It was to be responsible for two instances of prolonged depressive breakdown when she could no longer cope with work and the disposition of everyday life. Only on these occasions, when Vanessa was forced to relinquish her cloak of competence and control, did the sisters' roles reverse. On these few occasions when they managed to break out of their self-imposed stereotypes in their relationship, Vanessa and Virginia were drawn closer together in their conspiracy.

Vanessa and Virginia may well have shared a similar mental instability, as Leonard suggested. Along with their younger brother Adrian, they certainly shared a similar genetic inheritance and a childhood notable for its intellectual privileges, personal bereavements and suppressed and cloying emotionalism. Each sister had to come to terms with her own experience of this family cauldron, and express it in her own way. It was here, in the area of the emotions perhaps, that the sisters were most unalike. Virginia turned up stones to see what was to be found underneath: Vanessa resolutely secured those slabs so that what teemed beneath them never saw the light of day. In being asked to contemplate her character, she confided once to Roger Fry, 'I cant stand however thinking about myself at all,'[6] whereas Virginia, in her diaries, her memoirs and her fiction, held herself and her family up to the light, attempting to find meaning in even the meanest experience, the darkest memories.

Where Virginia gazed unflinchingly into her past, seeking to give form to the familial relationships, the losses and anguish, the hidden springs of her life, Vanessa, equally haunted by the past, tended either to react extremely and unconsciously against it, as in her reluctance to

discipline her young children, or to confine the undifferentiated mass of feeling to some hidden recess of memory.

On at least one occasion, when attempting to read an auto-biographical paper at the Memoir Club, an informal gathering of later Bloomsbury figures, she was 'overcome by the emotional depths to be traversed',[7] and unable to continue. Occasionally some of this unexpressed feeling found eloquent outlet in her painting. Two portraits are perhaps most obvious examples and each seemed to cause Vanessa some surprise and embarrassment at the rawness of the emotion exposed. The first was of Mary Hutchinson, Clive Bell's vivacious and attractive mistress, whom Vanessa painted in 1914 in a powerful portrait which as a likeness was unmistakable – and unmistakably unflattering. Mary Hutchinson's wide eyes had become evasive slits with the whites painted a brilliant blue and the iris inky black. Her full mouth, of which she was proud, was exaggerated grotesquely by Vanessa into a brilliantly coloured and sulky pout. A vibrant portrait, Vanessa nevertheless, when exhibiting it, did not want to name the sitter in an attempt at protecting herself and Mary from public display of her deep antipathy for this fashionable and intelligent young woman who dominated Clive's affections at the time. Virginia shrewdly commenting on Vanessa's unexpressed hostility towards Mary, especially when introduced by Clive into Charleston life, noted: 'The situation is against nature. Nature outs, under disguise.'[8]

The following year Bunny Garnett, the hypotenuse in the erotic triangle that became the only way for Vanessa to secure Duncan's company and love, sat for the two painters. The portraits that resulted could not have been more tellingly different. Duncan painted his lover as muscular and classically handsome, his lips sensuously delineated, and his powerful head poised on shoulders of heroic proportions. Vanessa, on the other hand, immortalised a round-shouldered piggy-eyed youth with a fuchsia nose and a pale, porky body. In a later letter to Bunny she called it an 'absurd'[9] portrait and wished that it was more like him. For a painter who was skilled at catching likenesses, it may not have been so true on that level, but the portrait was more profoundly true, on a subconscious level, as a revealing representation of the emotions which Vanessa could never express in her daily life with the two men: emotions she was loath even to face herself.

Vanessa was afraid of powerful emotion in herself and in others and

attempted to control her feelings with a code of reasonableness so
rigidly adhered to in her daily life that she could only learn to absorb
her own suffering. Thus, seen as the sanest and most reasonable of
them all, Vanessa became the focus and comforter of others' pain.
Duncan, in his diary of 1918, mentioned how he would confide to
Vanessa his desire and frustrations and jealousy towards Bunny,
would weep on her shoulder and seek to be restored while she,
wordlessly and without hope, contained her own hurt and secret
longings. Duncan sensed the force of this suppressed feeling and it
frightened him, he admitted, into retreat. This control, this dislike of
emotional display, was due perhaps to natural inclination wrought
upon by the unique circumstances of her early life.

Both sisters were haunted by the claustral atmosphere of their
family life in those grim years before their flight to Bloomsbury. Only
days before her death, Virginia returned once more in her despair to
the memory of that emotional burden impressed on them more than
forty years before. Vanessa had learnt then to protect herself from
emotional demand with an adamantine unresponsiveness. Such a
training in emotional disengagement, however, was to take its toll in
her personal and artistic life.

After masterminding the move to Bloomsbury, Vanessa had experi-
enced a great access of happiness. At last they had rooms of their own.
Vast, empty, full of light, the physical symbol of their escape from the
closed-in, over-furnished house that had witnessed so much misery.
At last she was going to live the life she had longed for. Clive Bell was
attractive to her, she claimed, for the very qualities which were the
opposite of the melancholic, anti-social Stephens from whom she
thought she had escaped.

But although she had fled the cage of family duty at 22 Hyde Park
Gate she carried with her the legacy of low self-esteem and depressive
tendencies which the exuberance of youth and the exhilaration of her
newly won freedom were to mask only for a while. The birth of her
first baby; her husband's retreat from their former intimacy; his
resumption of his sexual liaison with Mrs Raven-Hill and his infatu-
ation with her own sister, which she weathered during the years
1908–1911: all preyed on her natural lack of confidence in herself as a
successful woman and as an artist of promise. Her letters to Clive and
to Virginia during this time showed her no longer caged, certainly, but
with wings clipped by marriage and maternity whose demands left her
little time to paint, while Clive's dedicated socialising showed up her

own social and sartorial inadequacies. From this low point Vanessa's life was to change dramatically, but not without pain.

In the April of 1911 Roger Fry joined Vanessa and Clive and another friend, the mathematician Harry Norton, on a journey to Turkey. During this expedition Vanessa discovered that gradually she was falling in love with Roger, who proved to be an absolutely 'enthralling companion'.[10] Starved as she had been of sympathetic understanding, she found him a man with superabundant sympathies for her person and her point of view. Afraid always that she was unexceptional and dull company, she found in him someone who believed her to be as fascinating and interesting as anyone he had met. It was such a surprise and a pleasure, Vanessa explained to her son Julian many years later, to have Roger appreciate her as a person entire, for every aspect of herself rather than just for her physical beauty. Neglected, no longer the centre of Clive's erotic life, here she was confronted by a man who found her wholly irresistible, who restored her sexual power.

But in their vulnerable youth, both Virginia and Vanessa had suffered reversals of fortune within the sanctuary of family life. Vanessa's fragile sense of security was to make any change in her emotional status quo alarming, with the potential for suffering. Falling in love with Roger meant accepting the failure of intimacy in her marriage to Clive. But there was no formal acknowledgment of this fact. Unwilling to relinquish anyone who contributed to her emotional security, Vanessa was careful not to alienate Clive, anxious to maintain her marital status and his friendship. Even when she had transferred her passionate feelings from Roger Fry to Duncan Grant, Vanessa maintained still the outward show of her marriage, with many weekends, holidays and Christmases spent *en famille*.

Before she managed this careful transfiguration of marriage into lifelong friendship; as she realised gradually the nature of her feelings for Roger; Vanessa was exhilarated, yet afraid. She had been more distressed than she could understand when, painting with Roger in a village in Turkey, she had lost Clive's engagement ring down a well. It had seemed to her to be fraught with symbolic meaning, and yet it was a meaning she did not wish to confront. Even Vanessa's obdurate refusal to look beneath the surface could not protect her from the sense that something deeper was to be lost, that things had to change. Almost immediately she fell ill, suffered a miscarriage, then slipped into a depression which, with few remissions, overshadowed her life

for about two years. This was a serious and significant period of illness. Only to Roger did she appear to feel free enough to describe her symptoms and ask for reassurance and help.

During much of this time, Virginia was struggling with her own anxieties over Leonard's proposal and distracted by her subsequent marriage, finally succumbing to one of the most frightening and prolonged breakdowns she ever suffered. Vanessa's description of what she herself experienced, given her natural circumspection and dislike of talking about herself, revealed an at times harrowing dislocation from reality which characterised a serious depression, similar in its debilitating effects to Virginia's.

> My nerves were in such a state that I could do nothing but lie in bed or sometimes be carried to the garden, terrified by any contact with the world around me, fearing at any moment to slip off into that horrible state where time seemed to have lost its moorings and space obeyed no accustomed rules. I cannot describe it but the horror was very great and real.[11]

However great the horror, this depression, this sense of unreality, distanced Vanessa from the even more frightening reality of those emotions she had learnt to distrust in her youth. In that family after Julia Stephen's death, the histrionics of a grief-stricken father, the gross emotionalism of her half-brother George, the general weight of suppressed, misdirected feeling, contaminated the lives of those two young women. They recoiled even from the free expression of their natural grief. Virginia, more than thirty-five years later, in *The Waves*, was to express something, perhaps, of her old horror at the family's false sentiment in an outburst which she could never have voiced then. Percival, the archetypal brother-figure in the novel, dies and, at one point, is compared to a lily: 'So the sincerity of the moment passed; so it became symbolical; and that I could not stand. Let us commit any blasphemy of laughter and criticism rather than exude this lily-sweet glue; and cover him with phrases, I cried.'[12]

This hermetic seal on emotions, imposed on a naturally reticent character, left Vanessa barely capable of expressing her own feelings (a regret she often voiced to Roger Fry, in particular) and intolerant of emotional behaviour in herself and others. The prolonged bout of depression, which she suffered during the transition of her marriage into friendship and the flowering of her love affair with Roger, was

blamed by Vanessa on her miscarriage and on her subsequent 'nerves'. Her descriptions to Roger of her symptoms, however, showed it to be much more a collapse, a deadening of her feelings, such as her mother described she had sought to do to her own emotions in order to protect herself from overwhelming grief at the death of her first husband. This was to be Vanessa's response always to pain and fear in her life. More than two decades later, she wrote some of her most anguished letters to Duncan, when she feared she was losing him to his current lover, George Bergen: their leitmotif was 'It seems better not to feel more than one can help.'[13] It was a harsh lesson learnt in her youth, and reinforced at every crisis in her life, where emotion threatened to engulf her and had to be controlled, absorbed, evaded, but could not be made to go away.

During the worst episodes of depression that struck intermittently between 1911 and 1913, Vanessa turned to Roger for help. She was plagued with lassitude, with nameless fears, with the frightening sense of unreality. For the first time the woman who, since she was a girl, had shouldered the responsibility and offered emotional support to her sister, to her husband and children, was now in need of some of the motherly care herself.

'Nessa you'll tell me if your nerves get bad and I shall come as soon as possible and nurse you'[14] was to be Roger's promise to her at this time. And Vanessa, at the height of her need for this protective element in his love, was to be full of gratitude and amazement at his generosity: 'I feel still such an unsatisfactory creature, full of egotistical broodings and without much energy to be nice and show my feelings, that it's wonderful that you can get such happiness out of being with me. I sometimes think what shall I ever do to make up to you for being so good to me now.'[15]

While Vanessa was weak and could accept Roger's strength the relationship flourished. But when she recovered her own strength and was able to assume once more her role as the universal mother, then she found Roger's passion and solicitude for her intrusive and demanding too. Virginia had complained that her sister was a selfish woman who could only give and never receive. Roger knew that Vanessa's return to health meant the balance shifted in their relationship and no longer would he be needed in the same way. As he nursed her, encouraging her painting, celebrating her beauty; as he led her into her first true appreciation of her own voluptuousness and the erotic power she exerted over him, as he built her confidence and

enhanced her meagre view of herself as a woman and as a painter: Roger recognised he was hastening his own displacement.

During this time of Vanessa's illness and love affair with Roger, Virginia was more preoccupied than usual. These years were probably the most eventful, decisive and traumatic of her life. The year 1911 had brought Leonard Woolf back to England on leave and by the end of the year his intention of marrying Virginia was clear. His proposal at the beginning of 1912 found her hesitant and perturbed; her initial answer was a recurrence of the sort of mental instability that resulted in a couple of weeks' prescribed rest at a nursing home. She had been trying to complete her first novel *The Voyage Out* which she had been working and reworking for nearly five years.

By the summer, Virginia had accepted Leonard, had married and was embarked on their exhausting six-week honeymoon travelling in France, Spain and Italy. But towards the end of 1912, she was beginning to show signs of a deterioration in her state of mind which was to slide into the catastrophic breakdown of the summer of 1913, with a further major collapse in the spring and summer of 1915. Fifteen years later, in a letter to her new friend Ethel Smyth, Virginia referred to this terrible period with a studied flippancy – that yet interestingly points up the correspondence between her marriage and her madness: 'What about marriage? I married Leonard Woolf in 1912, I think, and almost immediately was ill for 3 years. Nevertheless we have nothing to complain of.'[16]

The lives of both sisters were entering a period of tremendous change and with their history of familial peripeteia and blighted hopes, change came veiled with menace. Vanessa's marriage was altering its character for ever, and after more than three years of unremitting maternity her own needs for work and independence were struggling to surface. Virginia's own marriage too threatened to deprive Vanessa of that lifelong supremacy in her younger sister's life which, although at times a burden, was an identity, an enhancement, and a source of great emotional sustenance. All these changing circumstances, however, contrived to unsettle the old order of behaviour and the balance of relationships.

Despite her own troubles, Virginia was able to appreciate Vanessa's plight. As this seemingly so stable elder sister was submerged in her particular nightmare of depression, Virginia could in turn offer her a rare sympathy and understanding born of her own suffering. On one such occasion, when she responded to Vanessa's despair and did her

best to cheer her, Vanessa, touched by this generosity of spirit, wrote to Roger of her sister's 'most extraordinary sense of bigness of point of view'.[17] In the same letter she wondered, a little sheepishly, whether she did not laugh at Virginia too much. From her unfamiliar position of weakness, she had seen clearly how her volatile younger sister, who had so readily carried for them all the stigma of the family's instability, 'the black Stephen madness'[18] as Vanessa's son Julian called it, was consummate in her sanity and generosity, with an awareness of the true nature of things.

Those years marked a less personal and more fundamental change which affected them both, their lives and their work. With the death that year of Edward VII, Victorianism was finally in retreat. With the dawning of the new Georgian age, however, was an event which had energising repercussion in the sisters' creative lives and in the cultural climate of the time. Roger Fry had organised the first Post-Impressionist exhibition – 'Manet and the Post-Impressionists' – and stirred up a ferment of excitement for Vanessa and the other young artists who were suddenly aware of a new freedom of expression. The exhibition ran from November 1910 to the New Year and was followed two years later with what was then formally named as the Second Post-Impressionist Exhibition. As her health improved during 1913 and her love affair with Roger waned, Vanessa started to paint again with renewed vigour and confidence, to produce some of the most spirited and distinctive paintings of her career.

Virginia was less closely involved, less immediately enthused, but, where once before her bolder, elder sister had led, she was to follow, trying to understand what it was which so excited the artists, and attempting to apply it to her own art. But she was more aware, perhaps, of the extraordinary furore these pictures provoked. Venerable opinion thundered that all Post-Impressionist artists and the critics who supported them were certifiably insane. Emotional words like contamination, pathological, lunatic were tossed around. Women artists were inveighed against for operating outside their decreed domestic roles, their degeneracy threatening even the health of future unborn generations. This kind of vilification from sections of the establishment made it easier to understand Virginia's fear of offering her more experimental fiction to the public; she was aware of the spectre of her own madness, how terrible if her vision be proved incoherent and worthless, merely the outpourings of a deranged mind.

The next period of dramatic collapse for Vanessa was after her son Julian was killed, having just arrived in Spain as an ambulance driver in the Civil War in the summer of 1937. He had insisted on going, dead against the pleadings of his mother, the pacifist beliefs of his parents, his aunt and the 'Old Bloomsbury' generation. On hearing the dreaded news, Vanessa was prostrate. For more than a week she was too distraught to be transported from her London studio back to Charleston. Reduced to such despair, Vanessa was forced, once again, to accept someone else's love and strength. This time it was Virginia who dispensed the daily affection and support that encouraged her to live through each day. Only then, in the extremity of grief, could Vanessa allow her sister to support her as she had been supported; only then could she admit her dependence on her, rather than stress her independence. It could be argued that this depressive element in Vanessa's character was never truly to leave her after this loss. The consequent deadening of her feelings and further retreat from life took its toll in her personal and artistic life. She lost confidence, her self-esteem sank even lower; she became more reclusive, more fearful of loss, seeking to bind her remaining children and Duncan even closer to her.

Virginia's terrifying experiences of more catastrophic mental breakdown, of 'intense depression ... which does not come from something definite, but from nothing',[19] were somehow, in her maturity at least, transmuted through extraordinary fortitude into something intrinsically interesting, informative, even restorative.

One goes down into the well & nothing protects one from the assault of truth. Down there I cant write or read; I exist however. I am. Then I ask myself what I am? & get a closer though less flattering answer than I should on the surface – where, to tell the truth, I get more praise than is right.[20]

Thus Virginia reflected in her diary for 1926 after a summer and early autumn of recurring depressions.

Although hard work, with little time for idleness or reflection, could ward off these plunges of despair, there were times when Virginia could only meet them and submit, however terrifying the ordeal might be. She noted the creative rather than purely personal revelations that enduring such 'glooms' could bring: 'It is not oneself but something in the universe that one's left with. It is this that is

frightening & exciting in the midst of my profound gloom, depression, boredom, whatever it is: One sees a fin passing far out,'[21] a glimpse, she believed, of the essence of reality. And to Ethel Smyth, whose own energetic candour and voracity for anything Virginian meant Virginia in return sent her some of her most self-analytical letters, she wrote: 'Madness is terrific I can assure you, and not to be sniffed at; and in its lava I still find most of the things I write about.'[22]

This courage in the face of sometimes terrorising emotions from which death could seem the only release, this lack of fear of feeling, this avidity for experience, contributed to her youthfulness and vitality, her curiosity and sympathy with others and the energy she poured into her friendships and work throughout her life. At the age of fifty, she wrote in her diary: 'I don't believe in ageing. I believe in forever altering one's aspect to the sun,'[23] and indeed this responsiveness, this organic growth, was expressed in every part of her life. There is little sense, in her nature or in her work, of stagnation, repetition or self-protection.

Publicly she declared her feminism in two books, *A Room of One's Own*, published in 1929, and then more assertively in *Three Guineas*, published in the summer of 1938. Virginia also allied herself publicly and courageously with homosexuality. She made clear her affection for Vita Sackville-West by dedicating to her the biography of the ambisexual *Orlando* (1928), and illustrating it with her photographs. That same autumn she was willing to certify in court as to the merits of the notorious sapphist novel, *The Well of Loneliness*, written by the eccentrically mannered Radclyffe Hall.

But while Virginia breasted new challenges out in the world, Vanessa, once the bolder and braver of the sisters, was increasingly inclined to withdraw. The beginning of a gradual retreat, perhaps, can be dated from the period around Angelica's birth in December 1918, when the full hopelessness of her one-sided passion for Duncan was brought home to her and painfully underlined on many subsequent occasions. Vanessa's prodigious energies, however, were still expressed in the maternal and domestic sphere, and in her painting too. But the excitement and courage of her earlier pictures, for instance *A Conversation*, painted between 1913 and 1916, *Lytton Strachey*, 1911, *Studland Beach*, 1912–13, and *Still Life on Corner of a Mantelpiece* painted in 1914 was gone. Her creative self-doubt and effacement set in as she resigned herself to the uncertainties and emotional imbalance at the centre of her life.

Thus it was that Virginia could continue to voyage out alone and return for the maternal sustenance she needed to survive; the practical loving care from Leonard and the spiritual and creative fertilising from Vanessa. But Vanessa, choosing to shoulder this demanding and powerful role for all the people whom she loved, had no one to restore her equilibrium. She used her painting, increasingly, to protect and secure her peace of mind rather than to risk and explore. As she told Roger Fry, it was 'the only real cure for unhappiness'.[24]

It is there, at the fulcrum of each sister's balancing of life and work, of expressiveness and absorption, of selfhood and motherhood, of taking and giving, of risking and protecting, of expansion and contraction, of open-mindedness and prejudice, that we find that most influential symbol of all, the Mother.

Although sharing this same creative source, both sisters diverged more profoundly than in any other area of their relationship in how they assimilated and expressed the personal and archetypal idea of the feminine, drawn from the image of their own mother. But with Julia's death, her natural qualities were magnified to mythological proportions. Not yet adults, Vanessa and Virginia found themselves motherless and deprived even of her memory, so eclipsed was her reality by the family's hagiolatry and adulterated emotion. Both sisters were left tantalised, haunted.

But whereas Vanessa accepted wholesale the image of their mother, and lived it out in her domestic and emotional life; modelling her houses and everyday life on the utopia of their childhood summers in Cornwall; offering an atmosphere of serene hospitality to her family and her selected friends; valuing men and the male often at the expense of herself and other women: Virginia analysed it, celebrated it in the embodiment of her sister, and rejected it in her own life. She was to explore in *To the Lighthouse* the many layers of her mother's character and what it meant for a daughter who chose to flout her authority. An authority in her mother's case, that was credal in its intolerance of dissent, that declared that a woman had missed the best of life if unmarried, childless and independent of her feminine destiny.

Virginia's obsession with her mother and her attraction for, and yet necessary rejection of, her fundamental values was the inspiration of this masterpiece. The writing of *To the Lighthouse* was to exorcise that obsession with both her parents which, as Virginia herself realised, had shadowed every day of her life since their deaths.

This book affected Vanessa profoundly too, but she responded

more to the portrayal of their mother's compelling character than to the ambivalence felt by the daughter who could not aspire to her powerfully seductive image of womanhood. Vanessa wrote an uncharacteristically emotional letter to Virginia: 'It is almost painful to have her so raised from the dead. You have made one feel the extraordinary beauty of her character.'[25] She confessed herself so shaken by the experience of coming face to face with her parents again all these years later that she had thought of nothing else for two days. Virginia had spent a lifetime trying to elicit more expression of feeling from her resolutely unemotional sister, now the sight of Vanessa so moved was 'almost upsetting'.[26]

Duncan Grant, who was with Vanessa in the Villa Corsica, in Cassis, was seduced too by Virginia's re-creation of this paragon of maternity which had proved, in different ways, so irresistible to her daughters. He felt that Adrian, his former lover, and this mother's baby and favourite, might be helped by Virginia's novel to come to better terms with his life. In his tormented preoccupation with the past, suicidal depressions at times would overwhelm him. Duncan wrote to Virginia: 'Its effect on Adrian (if he reads it) may affect a cure',[27] sensing perhaps that it might restore to him too something essential he had lost.

Their mother fitted so seductively the archetypal image of womanhood as universal mother, as a regal, austere goddess. It was an image made all the more powerful for her daughters by their very lack of intimacy with her. She was, as Virginia recalled, spread too thin for her daughters to ever have enough of her, answering as she did all the demands on her time and spirit. A part of her heart had always been inaccessible to them, chilled with grief at the loss of her first husband, the only man, her children believed, to conjure up a spontaneous passion in her.

Her premature death suspended that image and inflated it with romance. Her daughters, tentatively approaching womanhood themselves, were left with this remote, unappeasable icon as their only initiatrix into the mysteries of their sex. Virginia's most poignant piece of unpublished autobiographical writing described the sense of being cast prematurely into a hostile world; she was the butterfly or moth, defenceless within the broken chrysalis, her wings still damp and creased, dazzled by the light and incapable of flight.

In a letter to Ethel Smyth, at a time when she was nearly fifty and had been acclaimed universally for *Mrs Dalloway*, *To the Lighthouse*,

Orlando and *A Room of One's Own*, Virginia returned once more to this feeling of abandonment, her unpreparedness for life: 'I feel at the moment a helpless babe on the shore of life, turning over pebbles ... so the ocean tosses its pebbles, and I turn them over, naked, a child, and no one helps me.'[28] In another letter the following month, June, in that summer of 1930, Virginia made a similar point, seeing the female part of herself, perhaps, as that uninitiated, flightless creature, that baby on the shore: 'I was always sexually cowardly My terror of real life has always kept me in a nunnery.'[29]

Throughout her life, Virginia was to be quite candid about her search for the mother figure in her relationships: Vanessa, the most enduring and important; Violet Dickinson, the love of her girlhood; her husband Leonard; Vita Sackville-West; and the indomitable, bossier elements of mother-love from the composer Ethel Smyth. The qualities Virginia sought were more the qualities of the archetypal mother than those specifically personal to her own mother. Virginia longed for the nourishment, the fecundity of the feminine, the lack of which she felt so acutely when Vanessa was absent from her for long. She longed for the protective generosity of care and re-ordering of chaos which Leonard and Vita offered her, and the outlandish vitality, the courage and iconoclasm of the lion-hearted Ethel Smyth.

In the language of mythology, which Virginia would employ at times to add force to the plight of mere mortals in this world (she once likened herself to Prometheus chained to his rock 'doomed to let every worry, spite, irritation & obsession scratch & claw & come again'),[30] she herself longed for a Demeter whose love for her daughter would prove the power of maternal passion over all else. Demeter's maternal power had won for her daughter the right to return, from marriage and the underworld, to her mother – and the light and beauty of the earth. In the process of being restored, she redeemed her lost innocence and became a virgin and a daughter again. Even in the grip of anguish at not having children, of envy at Vanessa's apparent mastery of the womanly life, Virginia recognised that her spiritual integrity, her essential chastity, conserved and concentrated her energies for the consummation of her art. Like Persephone, Virginia never quite cast off the chrysalis of daughterhood to assume full sexual maturity, and with it the burden of motherhood.

Virginia was as happy to employ the language of psychoanalysis; discussion of this revolutionary branch of medicine raged about her. In the decade before 1924 (when The Hogarth Press embarked on the

brave publishing enterprise of bringing all Freud's works, in trans-
lation, before an English public), her friends had shown great interest
in Freud. Four members of Bloomsbury's extended circle had even
committed themselves to the lengthy and rigorous training: her
brother Adrian and his wife Karin qualified first as doctors so that
they could then train under Freud; and James Strachey, Lytton's
brother, and his wife Alix also became professional psychoanalysts.

From 1924 onwards it was James Strachey, assisted by his wife,
who was responsible for translating and editing for The Hogarth
Press all Freud's work. So Virginia was undoubtedly aware of Freud's
work and ideas, although she kept her own psyche secure from the
probing of the tyro analysts. She was much impressed by the old
master when finally she met him in January 1939, in exile in Hamp-
stead and already dying from cancer of the jaw. (He gave her as a
present a single narcissus.) Previously, however, Virginia had had no
compunction in gaining comic mileage from his revolutionary the-
ories and the esoteric rituals of his disciples. To Vanessa she reported:
'I creep up and peer into the Stephens' dining room where any
afternoon, in full daylight, is to be seen a woman in the last agony of
despair, lying on a sofa, burying her face in the pillow, while Adrian
broods over her like a vulture, analysing her soul.'[31]

Vanessa herself was unsympathetic to any such attempt at analysis
and revelation of character and motivation. So alarmed was she by any
display of emotion that, as her daughter Angelica was aware, even
childish exhibitions of temper or tears upset her. Perhaps the nearest
Vanessa came to Freud and psychoanalysis was when Roger Fry
wrote to her, 'Virginia's anal & you're erotic.'[32] Gripped by a book
explaining one of Freud's main tenets of the evolution of sexuality
from infancy to adulthood, he meant that Vanessa had attained sexual
maturity, while her younger sister had remained at the pre-pubescent
stage. There is no evidence of Vanessa's response.

Virginia, however, was naturally analytic about her own character
and those of her family and friends. She accepted, and expressed in
both her fiction and non-fiction, the seminal importance of one's
earliest experiences of love, rejection and the things one did not say.
She wrote to Janet Case in 1919, explaining part of her motivation
behind *Night and Day*: 'The whole question which interests me of the
things one doesn't say; what effects does that have? and how far do
our feelings take their colour from the dive underground? What is the
reality of any feeling?'[33] She speculated on the psychological effects

on Vanessa and herself of having their mother die so unexpectedly, so young. And she considered seriously the information relayed to her during Adrian's own intensive psychoanalysis about the damage done to him by the family; 'suppressed as a child'[34] and isolated by Virginia's refusal to pair with him, determined as she had been to make her place in the Vanessa/Thoby ménage. Virginia did admit to Ethel Smyth that she and Leonard sometimes discussed each other's idiosyncrasies 'in the light of psycho-analysis'.[35]

Involved significantly in the dissemination of Freud's ideas through The Hogarth Press, Virginia took to reading him more seriously. Her intellectual curiosity, certainly, was engaged; at dinner with her brother Adrian, his wife Karin and a distinguished analyst, Dr John Rickman, Virginia mentioned in her diary, 'A good deal of p[sycho] a[nalysis] talked; & I liked it. A mercy not always to talk politics.'[36]

That month, November 1936, she began writing the book she had first conceived in great excitement nearly six years before. *Three Guineas* was a personal and impassioned polemic for freedom from sexual stereotypes; for greater creativity in men and women's lives; for opportunity and equality; for rationality and humanity to triumph over prejudice and fear. Here Virginia employed terms borrowed from psychoanalysis – 'Oedipus complex', 'castration complex', 'infantile fixation' and 'subconscious' – in an attempt to explain something of the mainspring of the powerful emotions between men and women, and in relationships in private and public life. Virginia was 'gulping up Freud',[37] she recorded in her diary, acknowledging that he enlarged the circumference of her ideas, that she read him, 'to give my brain a wider scope: to make it objective; to get outside'.[38]

There was a more oblique correspondence, too, of psychoanalytic theories with Virginia's attempts in her fiction to transcend the personal, to lift the veil on the particular which separated people, and thereby illuminate the universal. In abandoning the traditional structures of plot and character in her novels, Virginia attempted a collective view of character and the continuum of the common life. It was in *Between the Acts* that she attempted most centrally to dissolve the barriers between audience and players. Writing in the shadow of the Second World War, she sought a general embrace of the idea that we are all connected, that the world is a work of art and all of us make up the whole.

There is a similarity in what Virginia was trying to achieve in her art and the theory of the psyche explored by Freud's favourite student

and one-time associate, Carl Gustav Jung. She and Vanessa were almost exact contemporaries of his and there was, arguably, a shared cultural shift in the evolution of their art away from the personal, the narrative, and his own central theory of the collective unconscious where individuals, through dreams, memories and images, bring to consciousness the resources of the distillation of all human experience.

Virginia had been fascinated by a conversation she had had in 1930 at Lady Ottoline Morrell's with Yeats and Walter de la Mare. Unselfconscious talk of the soul, poetry, and the significance of dreams had caught her imagination. She was enormously impressed by Yeats' intellectual vitality: 'Wherever one cut him ... he poured, spurted fountains of ideas.'[39] She felt 'alarmingly' ignorant in the face of his theory of psychology, exhilarated by the intricacy and seriousness of his approach to poetry. To that down-to-earth old termagant, Ethel Smyth, she expressed something of her striving after his outrush of ideas: 'What do I know of the inner meaning of dreams, I whose life is almost entirely founded on dreams (yes, I will come to the suicide dream one of these days).'[40]

In the final pages of *A Room of One's Own*, published in 1929, Virginia revealed a further consonance with Jung's ideas. She put forward the theory, which Coleridge had explored too, that a poet or novelist should express both the male and the female mind, that both existed inside each one of us and that the poles should come together in creation. Her 'plan of the soul' was that 'in the man's brain, the man predominates over the woman, and in the woman's brain, the woman predominates over the man.'[41] Jung expressed this important thesis: each man has an anima, his female side, the image of woman, and each woman an animus, her male side, carrying the ideal of masculinity. Like Virginia, Jung argued that to be psychically healthy and creative the individual had to integrate and collaborate with this opposing energy. Virginia pursued her speculation: 'It is when this fusion takes place that the mind is fully fertilised and uses all its faculties.'[42]

To Jung these archetypes, impersonal, universal symbols, are shared and find expression in everyday relationships and in art. Most rawly, they occur in myths and fairy-tales. Perhaps it is partly for this reason that *To the Lighthouse* is such a haunting piece of fiction; although about the intimacy of a particular man and woman, a particular marriage, it is also about the experience of all men and all women. In explaining the positive and negative expressions in women's lives of the Mother archetype, that most powerful force

from the unconscious which endues the merely human mother with the transcendent qualities of goodness and evil, Jung could have been describing the contrary and complementary dispositions of Vanessa and Virginia, expressed here in their fundamentally opposed attitudes to the maternal principle and the heart of femaleness.

Vanessa, from the moment she had younger siblings to care for, identified with her mother and the maternal in general. On the death of that mother and then of her half-sister Stella, she was propelled into taking premature responsibility for her family and the household, while the reality of her own mother's character was lost for ever in the apotheosis which ensued. Julia Stephen became for her daughter a deified memory of the perfect mother, the perfect woman, and what she stood for – maternity, self-sacrifice, the valuing of men over women, the need for order and control – was assumed uncritically by Vanessa. In *To the Lighthouse* Virginia explored, amongst other things, their mother's distinction and power. Vanessa saw the character of Mrs Ramsay as an almost miraculous reincarnation of Julia Stephen; Roger Fry recognised it as a moving portrait of Vanessa, and Virginia accepted that probably she did base parts of her portrayal of their mother on her elder sister too. For Jung, such identification with the image of the Mother, both one's own and the larger universal concept, meant that a woman's feminine and maternal instincts became exaggerated at the expense of her own intellect and personality.

There are positive results of this over-identification with the maternal; and Vanessa clearly exhibited them in her life. The ability to turn even the most unpromising of houses into a home, to nurture and refresh those who came under her care, to be at the centre of daily life, to make things grow and the pieces to fit. It is the selfless mother-love which is at the heart of all life and has been celebrated across continents and cultures, throughout the millennia.

The negative side, however, reveals a woman who lives her life through others, notably her children and those in her care, and therefore will cling to them. For she has no independent existence, she fears, without them. And where a woman's Eros is not integrated, but rather is expressed in the maternal relationship, there is created an unconscious will to power. This, together with the possessiveness toward her children and those she loves, can destroy not only her own personality but the personal lives of those in her care.

For Vanessa, the fact that Duncan Grant could not reciprocate her

passion meant that she had to express it increasingly as a working collaboration and in a maternal concern for him; while her fierce maternal feelings for her children, with Julian at least, carried some of that unconscious and unexpressed Eros. As Virginia rightly recognised, underneath her maternal demeanour Vanessa felt a profound longing just to paint. But her painting seemed to decline as she concentrated more and more closely on Duncan and his work. She appeared to lose her confidence and independent vision.

Vanessa's uneasiness and fear in the face of the intellectual, the high ground where her brilliant younger sister, all their lives, had dazzled and dominated; her own idiosyncratic and uneradicable prejudices; her unerring instincts and insights: all are part of this over-development of the maternal. Jung's explanation applies to Vanessa directly:

The mind is not cultivated for its own sake but usually remains in its original condition, although primitive, unrelated, and ruthless, but also as true, and sometimes as profound, as Nature herself. She herself does not know this and is therefore unable to appreciate the wittiness of her mind or to marvel philosophically at its profundity.[43]

It was left for others to recognise Vanessa's penetrating, but unconscious, powers of insight. Virginia was moved to admit, 'I am always on the look out for some huge revelation lurking in the boscage about life in your letters.'[44]

Virginia was drawn irresistibly to the positive aspects of both Vanessa's and their mother's authoritative womanliness. She, like Lily Briscoe, her artist and observer in *To the Lighthouse*, gazed in admiration and longing at the way her sister, her mother, her Mrs Ramsay, held triumphant sway at the centre of the family, orchestrating into a unique symphony the whole impossible discordance of family life; husbands, lovers, children, relations, friends, servants, pets and their clamour for attention and care. She referred often to Vanessa in archetypal images: she was a goddess in her fertility and power to transform; she was 'a bowl of golden water which brims but never overflows'.[45]

But Virginia was highly critical too, and wary of the will to power in Vanessa and of her 'maternity ... of the tigress kind – splendid, devouring, unscrupulous.'[46] Vanessa recognised this criticism too and

admitted she was in the grip of a great subconscious force: 'Of course it is one of the worst of passions, animal and remorseless. But how can one avoid yielding to these instincts if one happens to have them?'[47]

Virginia recoiled from the controlling, prescriptive side of her own mother's nature, which was much as she portrayed Mrs Ramsay, 'presiding with immutable calm over destinies which she completely failed to understand'; promulgating her unshakeable belief that 'an unmarried woman has missed the best of life'[48] and thereby diminishing and devaluing that other kind of life where work and art demanded a selfishness and detachment of which Mrs Ramsay, and perhaps Julia Stephen too, could never approve. They were committed to the faith that the needs of her men were a woman's first and sacred concern.

Virginia, however, like her artist protagonist in *To the Lighthouse*, and unlike her sister Vanessa, was caught in this painful conflict of feeling. For in arguing for art and independence she felt overwhelmed with the seductiveness and vitality of its opposite, the life of consummated womanhood. Her life, her art, 'seemed so little, so virginal, against the other'.[49] And this desire for the secret of Mrs Ramsay's wealth made the virginal Lily Briscoe long to be merged with this icon: 'Could loving, as people called it, make her and Mrs Ramsay one? For it was not knowledge but unity that she desired, not inscriptions on tablets, nothing that could be written in any language known to men, but intimacy itself, which is knowledge.'[50] Similarly, Virginia, denied such intimacy with her own mother, sought it primarily from Vanessa, in whose life she demanded to be central, with her claim to be her 'first-born', a longing for oneness, for a merging of the two.

When a woman projects maternal qualities on to an external figure, her own feminine instincts can be paralysed, Jung's clinical experience led him to believe. Not only does the maternal instinct tend to remain unconscious but the erotic too: 'Everything which reminds her of motherhood, responsibility, personal relationships, and erotic demands arouses feelings of inferiority and compels her to run away – to her mother, naturally, who lives to perfection everything that seems unattainable to her daughter.'[51]

Lily Briscoe, Virginia's woman artist in *To the Lighthouse*, struggled to maintain her vision of a life separate from the service of men, maternity and the disposition of households; of a life necessarily detached from that fluidity and dispersal, a life concentrated on her

art. But then Lily, just as Virginia did herself, would look at the house 'full of children sleeping and Mrs Ramsay listening; of shaded lights and regular breathing'.[52] She would feel how meagre and barren her life seemed, even though enriched with her art, compared to the richness and variety of such triumphant female instinct. Pondering the reasons for one such mood, Virginia wrote in her diary at the beginning of 1923 when she was almost forty-one:

A desire for children, I suppose; for Nessa's life; for the sense of flowers breaking all around me involuntarily. Here's Angelica – here's Quentin & Julian. Now children dont make yourself ill on plum pudding tonight. We have people dining. There's no hot water. The gas is escaping in Quentin's bedroon – I pluck what I call flowers at random. They make my life seem a little bare sometimes.[53]

Resistance to the mother, Jung argued, resulted too in a daughter's developing her intellect for the express purpose of breaking the mother's power. Virginia was surprised and relieved to find any opinion of her mother's qualities which contradicted the panegyrics with which she had been sanctified. 'We had the photographs out. Lytton said, "I don't like your mother's character. Her mouth seems complaining," & a shaft of white light fell across my dusky red past.'[54]

In the symbiosis of the relationship between Vanessa and Virginia, the realm of the intellect was where Virginia aimed to dominate absolutely and Vanessa, as the mother-figure, was for ever cowed. This overcompensation of Virginia's could produce an uneasiness in the realm of the emotional and instinctual. She showed an acute awareness of this problem in herself when she admitted to Ethel Smyth: 'The trouble is, I'm so at sea with other people's feelings that I very often appear egotistical and unsympathetic because I'm afraid to discharge my sympathy when it is out of place and therefore offensive. That is I think a true note upon my own psychology.'[55]

With the rejection of the maternal and erotic, however, there were some significant compensations in return. A part of life is lost but the meaning of life is salvaged, for such a woman could bring to her maturity a vision of the world, 'embellished', Jung believed, 'with all the colours and enchanting wonders of youth, and sometimes even of childhood. It is a vision that brings knowledge and discovery of truth,

the indispensable prerequisite for consciousness.' Such a woman too is capable of making most successful, intellectual, relationships with men, 'because she builds bridges for the masculine mind over which he can safely guide his feelings to the opposite shore. Her clarity of understanding inspires him with confidence.'[56]

This is what Leonard Woolf found enchanting when he first met Virginia. She had a rare combination of unmistakable femininity and hard-edged intellect which could engage any men in their circle. As a young man he was scathing of the intellectual vacuity of the average young woman. In middle age he was unpleasantly surprised by the force and unreason of maternal passion. He prided himself on his Apostolic mind and liked to conduct everything in life on rational principles. The passionate side of his nature was not easily expressed and it was only because Virginia built the bridge for this most masculine of intellects that Leonard was able to reveal, to himself and to her, the depth of his feelings.

Reassuring as this must have been for Leonard, conducive too to the success of their marriage, of their work together and of her art separately, this resistance in Virginia towards the maternal, and therefore towards everything instinctual and obscure, everything that cherished and sustained, left her at times feeling desiccated and starved of that central fertilising force. With images of her spiritual starvation, of her self becoming like a dried-up sponge, or like barren earth that longs for spring, Virginia turned to Vanessa, her own figurative mother, the source of light, warmth, the very water of life itself: 'Mercifully, Nessa is back. My earth is watered again.... She is a necessity to me.'[57] And in this way, Vanessa lived out for Virginia the maternal role which she herself, so tellingly, had rejected.

Delighting in her relationships with her nephews and niece as siblings and sometimes rivals, Virginia could be a fantastical spirit of mischief and enchantment. Revelling too in her friendships with women, but always as daughter rather than equal or mother, as inspiratrix rather more than comforter, she relaxed into the safety and structure of her marriage, where maternal care was not required of her, but unfailingly was forthcoming from the staunchly loving and severely parental Leonard.

Yet this denial of the feminine was to cause Virginia spasms of despair over her own inadequacy. Just as she was contemplating spending more time in the painters' world at Cassis, in the South of France, her deep-seated lack of confidence came to the surface and

focused once more on her rivalry with Vanessa. People, she felt, who did not know of or value her status as a writer would judge her solely as a woman beside her sister and think her in every way inferior. After all she was used to unfavourable comparisons with her mother: '"Hm, you're all very well my dear, but you're not a patch on your mother." I seldom meet any one who knew her without having this tribute paid her.'[58]

Virginia nevertheless could be essentially nourished with the very qualities by which she felt so diminished. For even the houses where Vanessa presided, the atmosphere she created there, seemed to her younger sister to be at the magical, restorative, heart of life. She imagined Charleston, with Vanessa in residence, humming and booming over the hill; she imagined it in spring, the windows open, family and friends perhaps sitting by the pond, Vanessa surrounded by her children, creative and content; she imagined it in winter as a 'red cave in the profound winter hollow'.[59]

Vanessa had assumed the mantle of Victorian womanhood, that their mother had fashioned in her glamour and then relinquished so prematurely, and she lived the ideal triumphantly. With a looser, less conventional style but as indomitable a discipline and hard work over the decades, Vanessa created her kingdom, at Charleston significantly, but at Cassis and her London houses too. There her sovereignty was implicit and unassailable; there she created a unique sanctuary for the men she loved and for her children; there increasingly she retreated from the world, losing confidence in her ability to operate away from her own closed and self-protective suzerainty.

The external world was left to Virginia where, declining their mother's enthralling cloak, she would have to voyage alone on unknown waters. It took great courage to defy such powerful and cumulative images of her female destiny. The success of her work, therefore, carried the added burden of justification for having abandoned her mother's vision, but also precious confirmation of her own identity outside that expected and exalted sphere. In *To the Lighthouse* Lily Briscoe could only stand up to Mrs Ramsay's authoritative vision of a woman's greatest work ('Marry, marry!' and caring for some poor man with 'nothing nice in his house – no one to arrange the flowers')[60] if her own art, her alternative passion, was recognised. Here was the heart of the despair that could roll up and threaten to annihilate her:

I'm beginning to think that I'd better stop writing novels, since no one cares a damn whether one writes them or not [she wrote to Vanessa, awaiting the birth of her third baby]. Do you ever feel that your entire life is useless – passed in a dream ... or are you always certain that you matter, and matter more than other people? I believe having children must make a lot of difference; and yet perhaps its no good making them responsible for one's own inefficiency – but I mean rather transparency – nonentity – unreality.[61]

This fear of non-being was to spread its tentacles through Virginia's life. To awake and find oneself a fraud was a recurring nightmare. Or even, perhaps, her outsider's viewpoint, which she felt was an invaluable yet vulnerable position, would be shown to be nothing more than the ravings of a madwoman. Lacking the familial badge of success, this fear of two-fold failure gripped most tellingly at that vulnerable moment when the labour of creation was over and her work had to be sent defenceless into the world. Having no physical children of her own, she brought to birth her children of the mind. In talking of the writing of her books, Virginia used images of conception, labour and childbirth to explain in part the intensity of the emotions they engendered, and to give them a significance and correspondence, perhaps, alongside Vanessa's own children.

But along with the fear of such abject failure came the freedom of the outsider. Unfettered by domesticity and imperative female instinct, Virginia's energies could embrace a wider family, expressing outraged concern, and a recipe for reform; first for the constrained lives of her own sex, in *A Room of One's Own*, and then in *Three Guineas*, for the whole of humanity which, as it was published in 1938, appeared to be fixed in the headlights of chauvinism and tribal ritual as the Second World War thundered nearer.

Whereas Vanessa had unequivocal and immanent proof in her children of her success as a woman, however many times she may have doubted her success as an artist, Virginia was never to feel adequate before her mother's and sister's example. Therefore the possibility of failure as an artist threatened destruction of her very identity. She had risked everything by hanging her flag on the mast of intellectual, creative endeavour, while looking to Vanessa for maternal nourishment and reassurance. In her own imagery, she was the joey to Vanessa's kangaroo. She was the parched land to Vanessa's rain. She was a child outside, in the cold, drawn to Vanessa's red cave.

She was a green twig to the transmuting fire of Vanessa's power. And when the aridity of her life proved too much, Virginia merely needed to seek out her sister wherever she might be living, the South of France, Sussex or London: 'I go there [to Vanessa's room at 50 Gordon Square] & find that astonishing brightness in the heart of darkness.'[62]

Only in the area of her emotional life did Virginia seek this amplification. Intellectually, she was confident and sufficient. Contemplating a rumpus on the reception of her feminist polemic *Three Guineas*, she claimed, 'I can sit calm as a toad in an oak at the centre of the storm,'[63] and with the publication of her non-fiction that was largely what she managed to do. Even with her fiction, usually there came a point, after the fear of revelation and ridicule had run its course, when she was capable of clinging to 'the fact of my own pleasure in the art'.[64] From her madness, too, her curiosity, robustness and solitary courage salvaged some brightness even out of that most abysmal night.

In *Mrs Dalloway*, Virginia drew on her own experiences of plunging depressions and the ecstasy of mania: 'I am now in the thick of the mad scene in Regents Park. I find I write it by clinging as tight to fact as I can.'[65] By facing the horrors of the dark cupboard of illness, as she once described her experience to Ethel Smyth, Virginia was able to create the poignant, tortured character of Septimus Warren Smith, whose suffering, mirroring her own, at the hands of an ignorant and arrogant medical profession, ended in despair and escape through suicide:

> Suddenly he said, 'Now we will kill ourselves,' when they were standing by the river, and he looked at it with a look which she had seen in his eyes when a train went by, or an omnibus – a look as if something fascinated him; and she felt he was going from her and she caught him by the arm. But going home he was perfectly quiet – perfectly reasonable.... Then when they got back he could hardly walk. He lay on the sofa and made her hold his hand to prevent him from falling down, down, he cried into the flames! and saw faces laughing at him, calling him horrible disgusting names, from the walls and hands pointing round the screen. Yet they were quite alone. But he began to talk aloud, answering people, arguing, laughing, crying, getting very excited and making her write things down. Perfect nonsense it was.[66]

Virginia had reservations about including the 'mad chapters' as she called them, and yet the tenderness and truth of her depiction of Septimus's state of mind, and the unsparing clarity of her indictment of the doctors, are amongst the most significant passages in the book.

Madness threatened family relationships; it frightened, it separated, it isolated. Beneath the humour and evasion, it distributed shame and guilt. But along with the terrors of such malaise came revelation and illumination – for Vanessa too. During her long depression that lasted for most of 1911 to 1913, it was extremely hard for her to find the energy and confidence to paint. Perhaps the unaccustomed self-reflection, emotional dependence and access of feeling, which the illness enforced on Vanessa's busy and well-controlled life, were responsible partly for the fact that the paintings she did struggle to create during this period were particularly impressive and distinctly her own. Three at random, all painted in 1912, were *Studland Beach*, with monumental, isolated figures; the powerful portrait of Virginia, faceless, in a deckchair, her gracefully tilted head framed with a hat, and her hands folded in her lap, somehow peculiarly evocative and revealing of character; the humorous and substantial *Landscape with Haystack, Asheham*, where the small house is almost obliterated from view by the jolly rotundity of a massive haystack built beside a sweep of pond.

Vanessa's love affair with Roger Fry undoubtedly had a liberating effect on her personally, sexually and artistically. It was her break-down, however, which shattered the well-learnt controls and self-protective rigidity and made her more vulnerable, more expressive, and therefore open to such a relationship. With the partial breaking down of Vanessa's old modes of reaction and self-protection wrought by these two years of sometimes alarming depression, the sisters relaxed their polarised positions of sane versus insane, giving versus receiving, independent versus dependent. With surprise and some delight, Vanessa seemed to recognise how refreshing it could be to have the lifelong sisterly roles occasionally reversed. To Roger Fry she wrote, in the New Year of 1913: 'She saw that I was depressed yesterday & was very good – & cheered me up a great deal I think she has in reality amazing courage & sanity about life.'⁶⁷

But they had barely seen each other, with Vanessa's painful and prolonged recuperation and Virginia's marriage and peripatetic honeymoon the previous autumn. Even as Virginia showed such sympathy for her depressed elder sister that January day, she was

entering a period of annihilation of her own self. Depressions, hallucinations and desperate, terrified, resistance to food, to doctors, to treatment, to Leonard, all of which assailed her; culminating in an attempt at suicide with a drug overdose in the September of 1913. With a further violent recurrence in the spring of 1915, Virginia was not to recover fully until the end of that year. 'Oh God. I cant help being rather worried lest I ought to have done more,'[68] Vanessa was to write of her misgivings to Roger, once more shouldering her familiar role.

In Vanessa's and Virginia's lives, death had always reconfirmed the vitality and importance of their sisterly bond. During their own vulnerable adolescence and early adulthood, the catalogue of catastrophic and untimely deaths had violated their closest family ties. The sisters' conspiracy, 'us against them'; against the step-brothers, the aunts, even their father, and the whole of society with its constraints and expectations: that conspiracy was tempered in those death-shadowed years. It survived through the vicissitudes of each sister's life, diluted at times by other claims of work and love and by mental collapse, only to be resurrected in full force with a further spate of deaths. But this time, although vulnerable still, their lives were established and they had reached their maturity. This time, each sister could bring her tempered strength to the other's aid.

I I

Debts Repaid

'How do I mind death ... there is a sense in which the
end could be accepted calmly. That's odd, considering
that few people are more immensely interested in life:
& happy.'
Virginia Woolf: 18 December 1937, *Diary*, vol. V

'Nessa said, "What would one like if one died oneself?
that the party should go on." '
Virginia Woolf: 22 January 1932, *Diary*, vol. IV

VIRGINIA HAD WHAT she called a 'brush with death' when she
fainted in the garden at Monk's House in the early autumn of 1930,
and for that moment feared she might be dying. The experience
seemed to her 'instructive & odd. Had I woken in the divine presence
it wd. have been with fists clenched & fury on my lips "I dont want to
come here at all." '[1] This incident, her biographer Quentin Bell
believed, might have been what gave Virginia the idea for the defiant
ending of *The Waves*. More immediately it prompted a retrospective
mood of contentment. Looking back on the summer, 'the happiest ...
the most satisfactory'[2] since she and Leonard had bought Monk's
House eleven years before, Virginia recalled that this was the month
when Thoby would have been fifty.

Virginia herself was forty-eight, Vanessa fifty-one and, as both
admitted, they still considered themselves sometimes to be the young-
est people on the omnibus. In the great creative momentum of the
previous five years Virginia had published *Mrs Dalloway*, *To the
Lighthouse*, *Orlando* and *A Room of One's Own*. She was well
advanced too with *The Waves* which she was to finish triumphantly in
February the following year. Virginia was at the height of her fame and
for the first time in her life well enough off not to worry about
spending money, although she – and Leonard particularly – could
never be accused of being spendthrift, even when there was money at

last to spare.

Virginia too could contemplate some extramarital excitement. Her adventure with Vita Sackville-West, at its romantic height three years previously when *Orlando* was conceived, had matured into an affectionate and lasting friendship. This was followed by the tempestuous entry into her life in the spring of 1930 of the septuagenarian composer Ethel Smyth, who declared she had fallen in love with Virginia on reading *A Room of One's Own* the previous autumn. She continued to stride through Virginia's ascetically ordered life for a decade, in her tricorn hat and hairy tweed suits, with her emphatic opinions and indefatigable enthusiasms. Her devotion and energy, when not exhausting, were fuel for endless amusement, and life confirming to Virginia herself. Although she never returned Ethel's feelings in kind, she found her passion gratifying, even peculiarly liberating.

That summer, too, Virginia felt perhaps that she had dislodged the old demon illness from her back. Writing to Ethel Smyth, her confidence and gratitude for this protracted peace was evident: 'It is 10 years since I was seeing faces and 5 since I was lying like a stone statue, dumb to the rose (no it should be blind, but I write in a hurry). In fact I am now very much stronger than ever since I was a small child.'[3]

From this hard-won vantage-point of contentment and achievement, Virginia could look back on her life with a kind of quiet triumph. She had been a late starter, as, she believed, had been all the Stephens. But, at nearly fifty, she could feel that she had managed with hope and tenacity to combine all the difficult strands of her life into a satisfactory whole: her art, her marriage, her passionate friendships, her uneasy and spasmodic public life, her need for occasional coruscating society, her central sustaining love for her sister and her sparring affection for Vanessa's children. This contentment she saw, that reflective summer, as being nearer Vanessa's 'Bohemianism' than ever before: 'I am more & more attracted by looseness, freedom & eating one's dinner off a table anywhere, having cooked it previously. This rhythm (I say I am writing the Waves to a rhythm not to a plot) is in harmony with the painters' [Duncan and Vanessa]. Ease & shabbiness & content therefore are all ensured.'[4]

Vanessa's life was centred increasingly at Charleston where, within the charms of her country house and garden, Virginia liked to imagine her sister living the artist's utopian ideal, of love and work and life in a

fertile continuum. Sadly, however, in the heart of this apparent ease and contentment was hidden the worm of despair. For even as Vanessa prepared her own show, at the Cooling Gallery, to open in the first week of February 1930, she was distracted by the fear that had underlined the sixteen years of her loving Duncan, the fear that his current inamorato, or the next, would be the one to take him from her.

Vanessa had invested so much of her creative and emotional life in Duncan and in securing his presence with her at Charleston, that the contemplation of the loss of him could bring a disintegration of spirit which at times, by her own admission, would verge on 'some kind of almost insanity'.[5] Yet she would hide her misery from everyone, including Virginia, to surprise her sister occasionally with an oblique glimpse of the despair beneath her self-protective dispassion. 'Hearing Nessa say she was often melancholy & often envied me a statement I thought incredible'[6] revealed both Vanessa's characteristic dissimulation, and a lack of percipience in Virginia towards any element that diverged from the vivid picture she had created of her sister's life, so picturesquely contrary and complementary to her own. The following spring when Margery Snowden, the friend of their youth, paid a visit, Virginia imagined her envious response to the glamour of their lives: ' "I have missed everything. There are Vanessa & Virginia. They have lives full of novels & husbands & exhibitions. I am fifty & it has all slipped by." '[7]

They had lived productive, independent and successful lives, lives of prodigious work and some sacrifice. Their fears and regrets were never revealed to the casual onlooker. Even Virginia, uneasy about her understanding of others' emotions in situations outside her own experience, and secure herself within her eighteen-year marriage to the rock-like Leonard, seemed unaware of the subterranean strains in her elder sister's less orthodox liaison. As Virginia explained that summer to Ethel Smyth:

As a psychologist I am myopic rather than obtuse. I see the circumference and the outline not the detail. You and Nessa say I am so frightfully stupid because I don't see that fly on the floor: but I see the walls, the pictures and the Venus against the pear tree, so that the position and surroundings of the fly are accurately known to me.[8]

The fly she did not choose to focus upon was Vanessa's task of accommodating Duncan's love affairs with other men. This time the American artist George Bergen caused her more anxiety than most. He was a young man whose exoticism and unpredictability had the older man enthralled, so much so that Vanessa feared that she faced the greatest threat to the security of her life with Duncan since Bunny Garnett's attractions had meant a reluctant *ménage à trois*. Unlike Bunny Garnett, however, George Bergen was not sympathetic to Vanessa and unwilling to acknowledge her importance in Duncan's life. So he sequestered Duncan, drawing him away from his life with Vanessa, and leaving her in an agony of apprehension. There was even talk of the two men setting up house together in Hampstead; the ultimate rejection of Vanessa and her household and their collaborative painter's life.

Four days before Vanessa's show was due to open, Duncan, obsessed by his new love, left Vanessa in London alone while he took George Bergen down to Charleston. Virginia was closely involved in Vanessa's life at this time. She had written a short appreciation in the catalogue of her sister's exhibition. She was present at the lunch party Duncan gave for her before he disappeared again to Sussex. She dined with her that night. But throughout, Virginia remained unaware of Vanessa's anxiety, which for a time became so extreme that she dreaded being alone.

Vanessa's stoicism extended even to her relations with Duncan, to whom she wrote that evening, 'I have tried very hard to write and tell you what I feel, but I can't yet. I get too involved.'[9] She apologised for getting 'stupid', in other words emotional; she apologised in a subsequent letter for treating him so badly. She tried to explain the accesses of feeling, which at times overwhelmed her and which she feared were 'unreasonable', 'unnecessary' and 'absurd', as being due to the tragic inequality of the situation, 'when one is in love & cant have what one wants.'[10]

Vanessa abhorred anger and the expression of any powerful emotion; she attempted always to contain her fear and pain. Love, even, had become difficult to express, for in attempting to suppress one set of feelings the others were driven underground. But both her daughter Angelica and Duncan described how alarming it could be to sense the force of that concealed emotion.

Towards the end of the year, Clive had divined something of Vanessa's unhappiness and mentioned it when he wrote to Lytton

Strachey, adding that of course he had been told nothing. At the same time, however, Virginia was writing: 'As for Nessa & Duncan I am persuaded that nothing can be now destructive of the easy relationship, because it is based on Bohemianism.'[11] Where Virginia did not choose to find the fly in Bohemia, Vanessa was disinclined to reveal it, for in that lifelong sisterly rivalry how could she admit to any kind of failure in the area which she had claimed as her own?

Virginia, however, was quick to protect and defend her sister when the attack was openly expressed and clearly apprehended. Just as Virginia, when a girl, had sprung to Vanessa's side when she was under pressure from their half-brother George and the interfering aunts to abandon her irregular love affair with her dead sister's husband Jack Hills, so she sprang fully armed to defend her again against the hypocritical sensibilities of their cousin Dorothea Stephen.

Dorothea, at fifty, was then ten years or so older than Vanessa and Virginia, and due to visit Virginia and Leonard in the winter of 1921. She had made the mistake of voicing her disapproval of Vanessa's living with (and rumour had it, having a baby by) a man who was not her husband. Virginia's riposte was withering:

My dear Dorothea;
. . .

Your view that one cannot ask a friend who has put aside the recognised conventions about marriage to one's house because of outsiders and servants seems to me incomprehensible. You, for example, accept a religion which I and my servants, who are both agnostics, think wrong and indeed pernicious. Am I therefore to forbid you to come here for my servants' sake? Yet I am sure you agree with me that religious beliefs are of far greater importance than social conventions. I am quite willing to suppose that all you said to Vanessa was dictated by kindness and good will, though I do not think it struck her quite in the same way. Anyhow, my point is different it is simply that I could not let you come here without saying first that I entirely sympathise with Vanessa's view and conduct since, for your own reasons, you have drawn attention to them. If after all this you like to come with Katharine, by all means do; and I will risk not only my own morals but my cook's.[12]

And Dorothea's opposition was effectively crushed. She came.

There was a further occasion, three years later, when Virginia was

witness to the kind of anguish that was usually beyond her experience and Vanessa's expression. She was in the studio with Vanessa, who was quietly painting, when she had to pass on to her sister the terrible message that Angelica, then only five, had been run over by a motor car and was in hospital. When they arrived at the hospital the staff were ominously non-committal, and for a time Vanessa and Virginia believed Angelica was fatally injured; 'I saw again that extraordinary look of anguish, dumb, not complaining,' Virginia recalled later in her diary. 'The feelings of the people who don't talk express themselves thus ... What I felt was not sorrow or pity for Angelica but that now Nessa would be an old woman & this would be an indelible mark & that death & tragedy had once more put down his paw, after letting us run a few paces.'[13]

Angelica was found to be unhurt, and the sisters felt that this time they had escaped death's depredations. But Virginia knew they could never truly escape their early experiences of catastrophe and in consequence would always feel pursued. It was an incident, however, which illuminated for her how vulnerable Vanessa was to suffering, while Virginia's own mythology of her sister had dwelled more on her unassailable creative power and heroic executive ability. In her unorthodox relationship with Duncan, there was 'nothing binding.' Vanessa had admitted bleakly to Virginia: 'It's quite different from yours.'[14] As well as being in effect solely responsible for her three children, she was burdened, too, by an inarticulate and consuming passion for them: there were so many conduits for her suffering.

In 1931, the year following her distress at the arrival of George Bergen in Duncan's life, Vanessa was to face the possibility of losing another male for whom she felt a disproportionate passion and possessiveness. Her elder son Julian, by now twenty-three and a postgraduate student at Cambridge, was contemplating marriage to his girl-friend. He knew his mother well enough to know that the idea of his marrying would be more alarming – 'I hope this won't be upsetting to you,' he wrote from China four years later. 'No, I've not got married'[15] – than, for instance, his involvement in a homosexual affair with Anthony Blunt, which she accepted with equanimity when he confided in her when he first went up to Cambridge. Vanessa's fierce maternal possessiveness meant that although they were allowed tremendous freedom within her sphere of influence, she feared their passing from her control. Julian was caught in a conflict: feeling the compelling attraction of family life at Charleston, and particularly of

Vanessa, whom he admitted would always be the most important woman in his life; and yet seeking to reject some of the most dearly held tenets of his parents' generation. He wanted to forge an independent, more active life for himself, different from theirs.

In his confusion, Julian wrote to his mother for advice, but above all for her approval of this move towards adulthood and autonomy: 'I know that I am still very violently in love, though perhaps not very romantically ... In a great many ways I should very much like to be married. It would put an end to all the nervous strain of the life I lead, and judging from the past I think we should probably be very happy. On the other hand I hate losing my freedom.'[16] Vanessa mustered her powers of reasonable persuasion. He, like all Stephens, would develop slowly, she argued. She wanted him to be free to be himself. And then consider the young woman herself: was not she too emotional, not reasonable enough?

To Virginia, Julian's proposed marriage was hardly the disaster it threatened to be for Vanessa; in fact, it could be that Virginia considered such a necessary loosening of the emotional ties between that coveted sister and her beloved son would be beneficial to her own relationship with Vanessa. She had always found irritating in the extreme Vanessa's uncritical admiration for her children, especially Julian, that blind loyalty that protected them from even constructive criticism. 'She ruffles like a formidable hen' at any suggestion that Julian's poems were not all brilliant; 'Why does it irritate me so, this maternal partiality? ... Most of all I hate the hush & mystery of motherhood. How unreal it all is!'[17] was her exasperated response.

During the toing and froing of advice and counter-advice on Julian's prospective marriage, Virginia admitted in a letter to Quentin that she would welcome the young woman as a niece and urged her nephews to get on with life: 'One can only be young once: and love not so many times. Take warning.'[18] Julian, however, preferred to heed his mother's warning and the relationship was ended. He was never to get close to marrying any other woman. Thus Vanessa retained her pre-eminence in his emotional life, and her influence even across continents. Julian wrote from China, when he was nearly twenty-nine, explaining something of the constraints of reasonableness which she applied to his own volatile temperament: 'I don't know how I should have been able to endure my emotional life and stay sane and rather hard really if it weren't for you.'[19]

But even if Vanessa had managed to defer, for a few more years, her

37 *Charleston* by Leonard McDermid

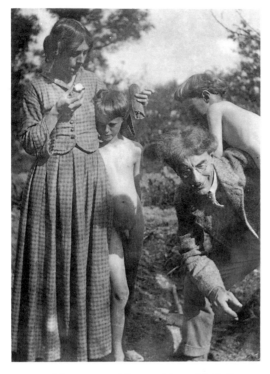

38 Vanessa and Roger Fry with Julian
 and Quentin Bell, Charleston 1917

39 Quentin, Angelica and Julian Bell,
 Charleston 1922

40 Vanessa and Angelica Bell,
 Charleston 1928

41 Julian, Vanessa and Quentin Bell,
 Charleston 1928

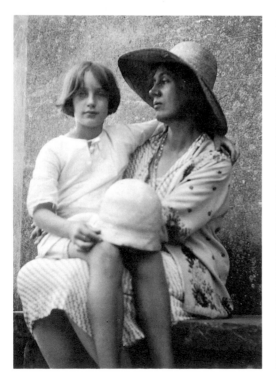

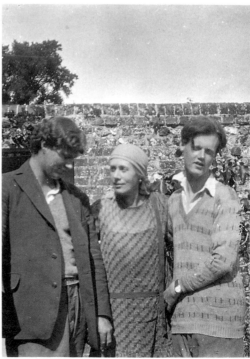

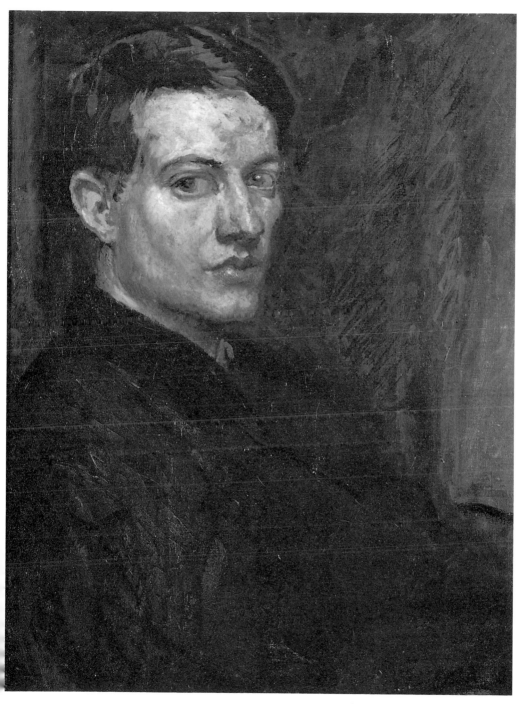

42 *Self-portrait* Duncan Grant 1909 (National Portrait Gallery, London)

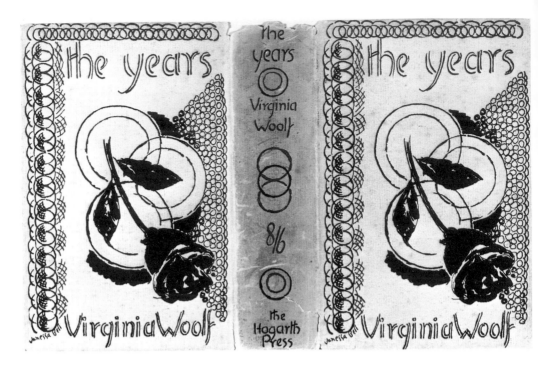

43-48 Dust-jackets by Vanessa Bell for Virginia Woolf works published by
 The Hogarth Press

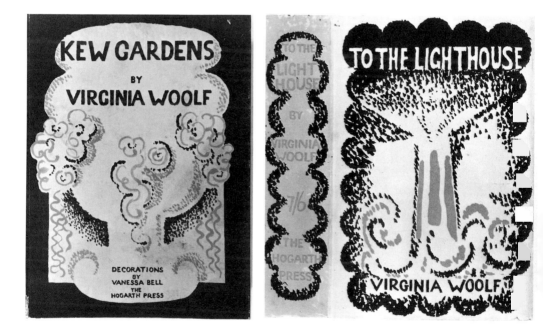

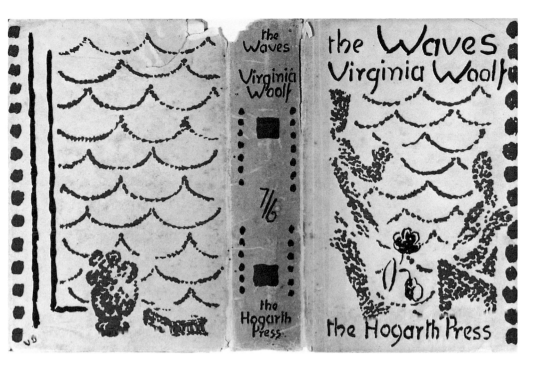

the Waves
Virginia Woolf

the Waves
Virginia Woolf

7/6

the Hogarth Press

the Hogarth Press

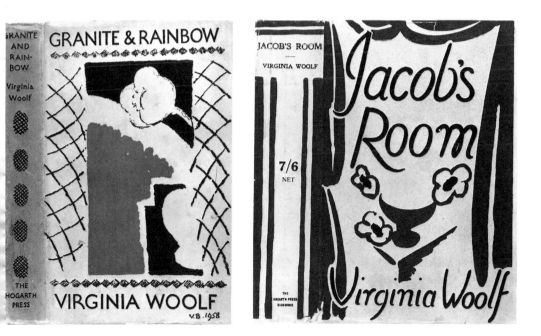

GRANITE & RAINBOW

GRANITE AND RAIN-BOW.

Virginia Woolf

THE HOGARTH PRESS

VIRGINIA WOOLF

V.B. 1958

JACOB'S ROOM

VIRGINIA WOOLF

7/6
NET

THE HOGARTH PRESS RICHMOND

Jacob's Room

Virginia Woolf

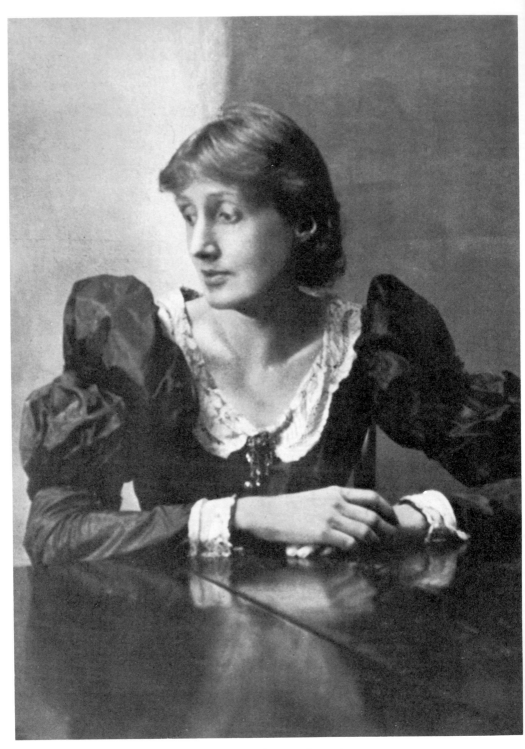

49 Virginia in her mother's dress

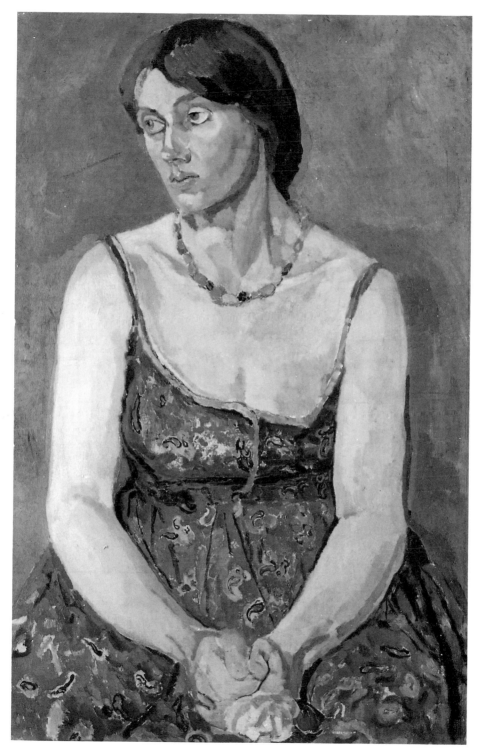

50 *Vanessa Bell* Duncan Grant 1918 (National Portrait Gallery, London)

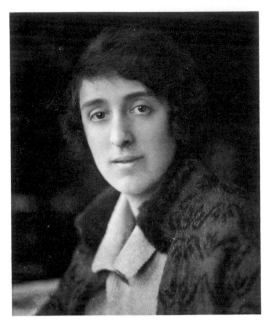

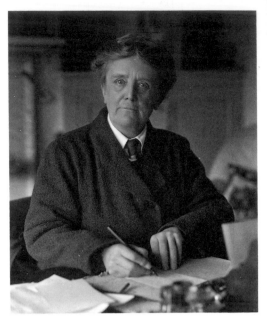

51 Vita Sackville-West 1924
52 Dame Ethel Smyth 1927
53 *Monk's House* by Leonard McDermid

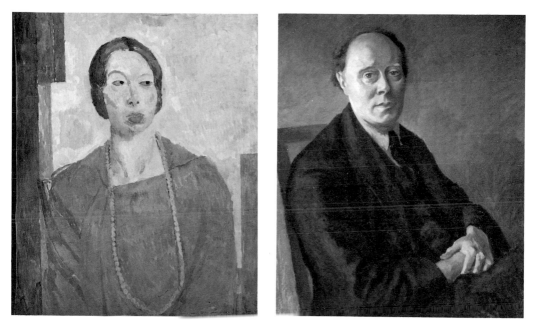

54 *Mrs St. John Hutchinson* Vanessa Bell 1914 (The Tate Gallery, London)

55 *Clive Bell* Roger Fry c.1924 (National Portrait Gallery, London)

56 *The Tub* Vanessa Bell 1917 (The Tate Gallery, London). Mary Hutchinson was the model

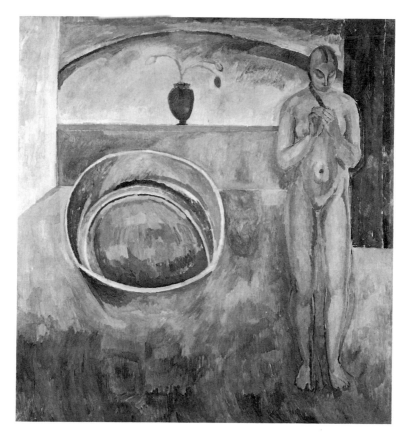

57 Duncan Grant, Cassis 1932

58 Vanessa, Charleston 1930

59 *Julian Bell and Roger Fry Playing Chess* Vanessa Bell *c*.1933
(King's College, Cambridge)

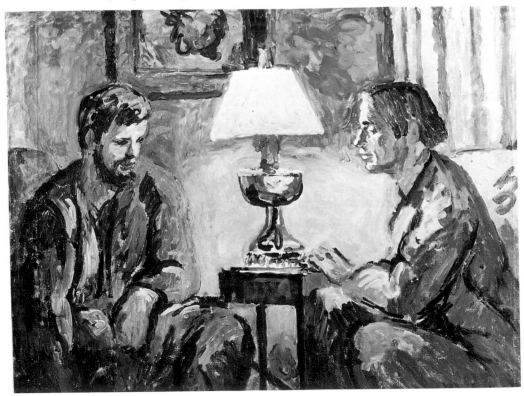

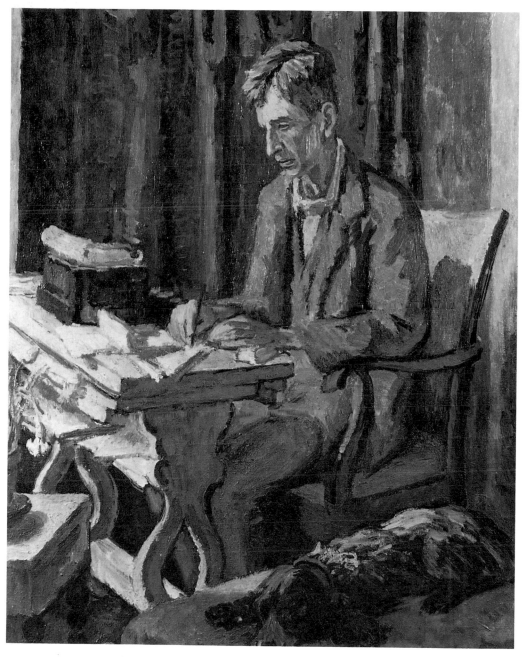

60 *Leonard Woolf* Vanessa Bell 1940 (National Portrait Gallery, London)

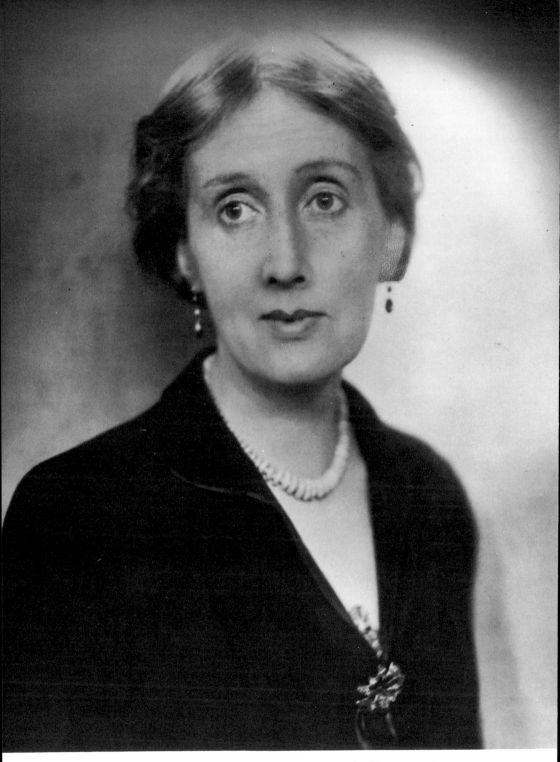

61 Virginia, late 1920s (photographed by Lenare)

loss of Julian, no one could prevent the raids that illness, age and eventual death were to make on their closest circle. Two men, who had long been part of the sisters' romantic and creative lives, were to die within three years of each other and leave Vanessa and Virginia bereft, their lives impoverished by their passing. Lytton Strachey, the most individual and obviously gifted of the young men among Thoby Stephen's friends at Cambridge, had first met Thoby's sisters in 1904. Despite irritations at his self-centredness, and disappointment in his failure to live up to the dazzling promise of this youth, Virginia was to be drawn to him always; the fascinating 'old serpent' whom she loved 'to talk to, to laugh at, to abuse'.[20] Occasionally she would speculate still on why she had loved him; what might have happened if she had married him – 'I should never have written anything.'[21] Vanessa and Lytton were never to share such a sympathy, but in his connections with Thoby, with Duncan, with Virginia, he was inextricably part of their youth and one of the members of their particular family of friends, 'Old Bloomsbury'.

News of Lytton's illness in December 1931 began a vigil for his family and friends that strung their nerves and dominated their thoughts until nearly the end of January. Vanessa and Virginia were involved in the almost daily bulletins which alternately revived and dashed their fragile hopes for his recovery. They were both reminded of their brother Thoby, the harrowing fluctuations in the progress of his illness, twenty-five years before, while doctors procrastinated and misdiagnosed. They remembered too Lytton's kindness and tact to them both then, after Thoby's death; defenceless, bewildered young women whose natural aegis of parents, elder half-sister and brother had been torn away.

Perhaps the confusion, the waiting, the fading hopes of these long weeks of Lytton's illness recalled for them both the similarly faltering but inexorable decline in the health of Stella, whose death at the end had seemed unbelievably cruel to the two sisters left behind. Certainly, on hearing on 21 January that Lytton's fight was finally over, Vanessa and Virginia, so seldom allowing themselves such shared and naked emotion, wept together. Virginia, speaking for them both, perhaps, defended to Ethel Smyth her usual reticence on emotional matters: 'Because everyone I most honour is silent Nessa, Lytton, Leonard, Maynard: all silent; and so I have trained myself to silence; induced to it also by the terror I have of my own ultimate capacity for feeling.'[22]

Their emotions unloosed, their memories revived, Vanessa was to feel once more the shadow of their old pursuer fall over them: 'He is the first of the people one has known since one was grown up to die.'[23] This release of feeling, the shedding of long-restrained tears, allowed Vanessa to write with great warmth and spontaneity to Dora Carrington, whose absolute devotion to Lytton had left her unable to contemplate a future without him. Her letter, compared with Virginia's, was uncharacteristically the more emotional and expressive. Perhaps the depth of sympathy in her response to Carrington's loss was a result in part of a sudden recognition of the younger woman's situation: a talented painter, she had fallen passionately in love with a homosexual who could never reciprocate her passion. She dedicated her life to him, running the houses they lived in, doing everything to promote his happiness, to the detriment of her own work and individuality.

Vanessa's and Virginia's generous letters were the first time that they acknowledged to Carrington, and themselves, the importance of her place in Lytton's life. Accepting the women of the men in their circle had always been a problem, particularly for Vanessa who was predisposed to be indulgent towards men and exclusive towards her own sex. Virginia was moved to remark, contemplating her sister's reserve with Vita and Harold Nicolson: 'As a family we distrust anyone outside our set, I think. We too definitely decide that so & so has not the necessary virtues.'[24] And that exclusivity of the Stephen sisters, born perhaps out of the painful insecurity in their young adulthood of being outsiders themselves – social failures, so they thought – was one of the distinctive qualities of 'Old Bloomsbury' itself.

But no amount of acceptance and proffered affection could secure Carrington to this world and two months later she took her own life. Leonard and Virginia saw her the day before and the pathos of Carrington's position, bereft and alone in the house she had created for Lytton, the loneliness of her death, haunted Virginia. Could she have done more; should she have 'said more in praise of life'?[25] Virginia admitted there were times when she disliked Lytton, when she reflected on how he had absorbed Carrington's personality and therefore was partly responsible for her death. Nevertheless, she was to miss him, at times acutely. So much had been said between them, but how much more there remained to say. On many occasions after his death, Virginia mentioned in her diary a continuing sense of his

loss, when she longed to share a joke, or an enthusiasm for a book, with that singular, subtle, genius.

Criticising each other was a feature of any group and when James Strachey, Lytton's brother and executor, warned Virginia that Lytton's letters contained some very unpleasant comments about them all, Virginia wrote to Vanessa with no little nonchalance: 'As we all do that, I dont see that it matters.'[26] But this sang-froid existed only where brickbats were flung within the privacy and security of their own society; criticism from outside met a closing of ranks, with all the biased loyalty of a family.

Roger Fry was another member of that intimate family of Bloomsbury. Not only was he endowed with more than his fair share of the necessary virtues, but he had also an immunity from any but a fondly amused backbiting from his friends. Roger's human qualities had been brought home to Virginia when he had stayed a few nights at Hogarth House a decade before, while he was completing the gruelling restoration of nine enormous Mantegnas in the royal collection at Hampton Court: 'I think he has the nicest nature among us so open, sincere, & entirely without meanness; always generous, I think & somehow hearty.'[27]

After the shock of Lytton's then Carrington's deaths, Vanessa went to Cassis with Duncan and Angelica, and Virginia and Leonard, in the company of Roger and his sister Margery, set off in the spring of 1932 for a holiday in Greece. Thanks largely to Roger's presence, Virginia declared it by far the best holiday they had had for years. Despite being sixty-five and suffering terribly from piles, so painful that at times he could neither walk nor sit, Roger's unfailing good humour and encyclopaedic enthusiasms enlarged their daily delights of landscape and artefacts and human concerns. He would point out the line, the allusions, of a painting of a Christ – or a family of Greek pots – with what was to become his theme on that holiday, 'Awfully swell, Oh awfully swell.'[28]

Virginia reported back to her sister, herself enjoying at Cassis the light and warmth of a Mediterranean spring, the endearing qualities of the man who had been drawn into their closest circle of friends by his love affair with Vanessa twenty years before. That summer, on hearing of the death of Goldsworthy Lowes Dickinson, a contemporary of Roger's at Cambridge and friend of them all, Vanessa suffered a spasm of fear that Roger too might die. She wrote to him urgently expressing her love for him in her own inexpressive way: 'You do

know don't you, how terribly important you are. I say terribly for sometimes one is really terrified when one realizes what a lot people mean to me & death makes one realize it even more than usual.'[29]

Three years after George Bergen had entered Duncan's life, Vanessa was still suffering the emotional raids he could make on her peaceful life with Duncan at Charleston. She confessed to Roger something of her misery, and his affectionate, concerned letter came back with the admission of more than two decades of devotion: 'I don't think I shall ever stop being in some queer profound way in love with you.'[30]

This enduring source of support, inspiration and love was to be cruelly snatched from Vanessa's emotional landscape. In 1934, just over a year after that declaration, Roger returned home from a summer holiday in France and slipped on a rug, damaging his hip. He died unexpectedly three days later in hospital. The news was broken to Vanessa over the phone while she was at Monk's House visiting Virginia and Leonard. She came out on to the terrace with a terrible cry, 'He's dead.'[31] Virginia was to recall that cry weeks later and how it marked the end of summer for them all.

Vanessa collapsed. She was taken home to Charleston and Angelica was told. The following night Angelica heard her awesomely reserved mother howling uncontrollably behind her bedroom door. The emotion that had swept aside Vanessa's control seemed to her daughter to be so alien she feared that there might be someone, something, other than her own mother behind that door.

But the two sisters would allow themselves to cry together in the days that followed, Virginia cheated of the richness that 'large sweet soul'[32] had brought to their lives, but, most of all, feeling the agony of Vanessa's suffering. She saw how submerged Vanessa could become, 'infinitely mournful & struck, like a statue, something frozen about her'.[33] And her own imagination poignantly recognised at times the 'dumb misery'[34] of her sister's life without Roger.

Vanessa's grief was intense and drawn out. She seemed to be grieving not only for the loss of Roger, the friend and lover, but perhaps for a series of losses which had been in part assuaged by Roger's wealth of affection. Perhaps only with his death was she able to mourn for the mother whom she had had so little chance to know or grieve; for Stella; for Thoby, the brother whose death she had effaced by immediately acceding to Clive; for the sacrifice of her sexual life in choosing Duncan rather than Roger; for the insecurity

and loneliness of her position; for the passing of youth. For now Roger had abandoned her too.

Roger's death brought an added responsibility to Julian's relationship with Vanessa. A year later, he had travelled more than a world apart from his mother and home, to China and a professorship in English. In an early letter to him Vanessa was to reveal, inadvertently perhaps, the vacuum in her life that she contrived to fill with Julian: 'In an odd way now you & he [Roger] have become very much joined together for me. It's partly because you helped me when he died & understood so much & partly your going away was like some dim reflection of his death.'[35]

She had always enjoyed seeing Roger and Julian together, for the two had a mutual respect and understanding which to Vanessa, who loved them both, was enormously gratifying. Certainly, she liked to think that Roger felt Julian and Quentin were more his children than were his own, and perhaps Vanessa had chosen to imagine in return that she shared her children more intimately with Roger than with Clive. With Roger's death, however, neither Duncan nor Clive could provide Vanessa with the erotic devotion, the emotional sympathy, the parental care, that had flowed so abundantly from that source. Only Julian had the emotional capacity to meet her needs in part. But inevitably it increased the pressure of implicit expectations in a mother-son relationship which was already recognised by the females in the family, Angelica and Virginia, as lover-like in its intensity. Vanessa concluded this letter with an ironic remark that nevertheless placed her oddly on a level with his girl-friends, 'Well I suppose I mustnt simply write you love letters you'll get plenty of them from others.'

Much as Virginia envied Vanessa her children: much as she had enjoyed vicariously their childish curiosity and clarity of vision, had watched them grow up into spirited individuals (although to her eyes never achieving the exalted standards of their Stephen forebears); much as Virginia could boast about their beauty or height or character as if they were a part of her; much as she loved them; there was a friction always between the sisters over what to Virginia appeared to be Vanessa's blind maternal prejudice and what to Vanessa appeared to be Virginia's jealousy and possessiveness. With no one was it more marked than with Julian.

Vanessa's uncritical acceptance of everything he did, her overbearing belief in his brilliance, polarised Virginia's position and made

her artificially extreme in opposition. She felt that he was intel-
lectually ill-disciplined, rather arrogant, at time boorish. There was a
sense of vindication of her view, and some pleasure, in her recording
that Julian's dissertation on Pope, in his attempt to become a Fellow
of King's College, Cambridge, was rejected by the Electors for being
'no good, quite uneducated'.[36] Nor did she care for it when Vanessa
started promoting her son as a writer. Would he not make a better
lawyer, she suggested. One writer was enough in that sisterly rivalry.

But there was love and admiration too for this big-hearted, ener-
getic, interesting boy. Only she had to be careful when discussing him
with his mother. The combination of admiration, guarded reserva-
tions and percipience was evident in what she had written to Vanessa
when Julian was twenty-one: 'The Bell sociability is so odd, mixed
with the Stephen integrity. I daresay he'll give you a lot of trouble
before he's done. He is too charming and violent and gifted alto-
gether: and in love with you, into the bargain. It is very exciting the
extreme potency of your Brats.'[37] Vanessa's other two brats caused
much less trouble between the sisters. Quentin, affable, artistic, was
the more temperate second son. Virginia's letters to him were
amongst her most affectionately witty and provocative. And then
there was Angelica, admirably female, beautiful, whimsical, with
whom Virginia could play fantastical games and treat to gifts of
ribbons and art paper, and an eventual allowance for clothes and other
diversions.

But Julian had been since childhood the most expressive and intrac-
table of them all, had caused his mother always the most concern, and
in the end was to be the source of irredeemable heartbreak. Vanessa
had explained to him how his departure for China was in a way like a
death. His sister Angelica saw the distance that he was to travel as
symbolic of the importance of this attempt to be free of the emotional
bonds that bound him so firmly to home and to Vanessa. Virginia
recognised the pain of the loss for Vanessa, but felt it was a necessary
striving in Julian for independence.

Julian himself had considered it a break from the physical comfort
and philosophical confusions of his life in Cambridge and Sussex, of
his fear, as an epigone of Bloomsbury, of being second-rate. To a
girl-friend, he had described this decampment to China as 'a genteel
form of suicide',[38] a severance from the easy continuum of the past,
with the sense perhaps of dead-endness for the future.

During the year and a half that Julian was in China Vanessa was

doubly bereaved; missing 'constantly'[39] Roger Fry's sympathy both personal and artistic. Deprived of his unconditional and enduring love, she could not even turn for reassurance to the son who had fulfilled so much of her emotional need and had come to embody, in her eyes, some of the best qualities of her old lover. With her son so distant from her care and control, Vanessa's lifelong fear of untimely loss of those she loved was bravely kept in check. Her letters to Julian at this time were full of exhortations to conserve his health, with the recurrent anxiety about any precipitate marriage he might make.

But life for Vanessa continued on the surface to be busy and satisfactory, lived, as Virginia reported to Julian, according to her lights: 'She's taken her own line in London life; refuses to be a celebrated painter; buys no clothes; sees whom she likes as she likes; and altogether leads an indomitable, sensible and very sublime existence.'[40]

During this period 1935–37, Virginia was struggling with rewriting *The Years*, the novel originally called 'The Pargiters', conceived as part of a sequel to *A Room of One's Own* in that, in following the lives of the Pargiter children from 1880 to the present (1936) ('its to take in everything, sex, education, life &c'), it explored specifically the constraints on the lives of women, and the eventual stasis in the lives of them all. It was a factual novel, as *Night and Day* had been, rather than poetic like *The Waves*, although in the beginning Virginia had intended to combine the styles of the two. It caused Virginia more anguish than any of her works. She was dogged by a persistent sense of its failure and the drudgery of reworking it into something that would approximate her original intention – born of an abiding anger against the stupidities, the vanities and inequalities of a male-dominated society – and yet conform to her idea of how fiction should be free of personal emotion.

In the struggle to reconcile these elements, in the relentless hard work on the rewriting and then, finally, the proofs, Virginia was once again on the brink of a nervous collapse, which, during the summer of 1936, virtually brought her work and her life to a standstill. Over everything too hung the accumulating threat of war. The beginning of the Spanish Civil War that summer, and Hitler's excesses in the Rhineland, threatened the more terrific conflagration of a global war.

Even Vanessa, resolutely indifferent to politics as she was, was uneasy at the progression of events – given her elder son's natural bellicosity and his distance from her care. Her worst fears were

realised in the spring of 1937, when she heard via a friend that Julian was determined to go to Spain to fight, and she begged him in her despair to come home and discuss the matter first.

Virginia saw once again in her sister that terrible unexpressed suffering which made her so remote and inaccessible. Her own instinct, on the other hand, was more combative, perhaps learnt through the suffering and isolation of her periodic manias and depressions with which she had battled intermittently throughout her life: 'Nessa was in one of her entirely submerged moods. Always that extraordinary depth of despair. But I must fight, thats my instinct.'[41] And one of the most powerful ways she could resist Julian's determination to go to war was by investing that anger in the pacifist/feminist tract she was already absorbed in writing: *Three Guineas*, her non-fiction companion volume to her novel *The Years*. Virginia explained in her diary that the inspiration for both books had been 'sizzling' since the early summer of 1932 when she and Leonard were on holiday in Greece with Roger and his sister. Then she had thought 'that the male virtues are never for themselves, but to be paid for'.[42]

Julian returned home on 17 March 1937. He seemed more mature, leaner, more detached but unshakeable in his resolve to go to Spain. His only concern was to reason Vanessa into giving him permission to go. He had written to a friend at the beginning of the year: 'I know I shall have a bad time of it dealing with Nessa, for I can't really go until I've got her to agree more or less. The consequence of which is some rather exhausting soulsearching and the winnowing leaves not much behind but maggots.' His determination, though, was such that he had convinced himself that 'unless I go I shall be good for nothing'.[43]

Julian's obstinacy met extensive rational and emotional opposition from his mother and from everyone who cared for her. Virginia, responsive to Vanessa's anguish, invited Kingsley Martin and the young poet Stephen Spender, who had just returned from Spain, to dinner with Julian. As their talk ranged over war and weapons and politics, Virginia found her arguments in *Three Guineas* 'flame up in me'.[44] But Julian was not to be deflected. He compromised, however, by agreeing to join the Spanish Medical Aid as an ambulance driver which although non-combatant, and with an excellent record so far for safety, nevertheless involved its men in missions right into the heart of the battle zone. Virginia was impatient of what she saw as

selfishness in her nephew: 'Julian is dog obstinate about driving an ambulance; which casts a shadow over Nessa, & us too. There he'll be keeping us all on tenterhooks.'[45]

On 7 June Julian left England for Spain. His letters home were brief and infrequent but full of high spirits. He was in the thick of the action and enjoying immensely this full engagement of his energies and senses, living life to the limit. His mother and his aunt, committed pacifists all their adult lives, were to be ever puzzled, ever angry at his going. But Julian, however much he may have sought to justify his actions rationally – 'there'll never be peace until Fascism is destroyed'[46] – had reasons more personal and emotional. He was big and rumbustious, a man of action rather than contemplation; even his intellectual processes were robust and combative rather than logical and allusive. Virginia admired his broadness and generosity, his physical splendour, but baulked sometimes at his crudeness, his lack of refinement and discipline. Here was a man brought up at the heart of rational, civilised, aesthetic Bloomsbury when, naturally, he had certain qualities entirely opposed to them.

By going to war, Julian chose to make the most dramatic stand against his parents' generation and what they believed in, and to fulfil a significant part of his own nature which could not be expressed easily in the safe, self-centred world of English letters. None of the men of Bloomsbury, men whose attitudes had so shaped his youth, had fought in the First World War; through invalidism, physical impairment or political manoeuvring they had evaded call-up. During that war Julian's father, in part ashamed perhaps of his status as a conscientious objector, partly to safeguard his Bell inheritance, wrote to Vanessa asking if it was possible 'that the little boys should share the almost universal opinion that I am medically unfit ... it's worth taking some trouble to preserve our heir on the Bell millions. Julian I'm sure may say terribly indiscreet things and it would be much better to disarm than to warn him.'[47]

So this boy who enjoyed shooting, wholesale, the small birds at Charleston, yet abhorred tyranny; the youth who was an Apostle at Cambridge, yet whose intellectual processes were ill-disciplined and confused with emotion; the poet who was able to contemplate with equanimity, even excitement, the use of force and the inevitable killing of men; the young man over-passionately dependent on his mother and his home, yet who had already tried to gain his independence in China and now sought war in Spain: so Julian, at twenty-

seven a man of contradictory impulses, had left for Spain aware that he might be killed there.

His mother, aunt and sister were all sure he would not return. Julian had just five weeks of concentrated experience of war: the hard driving, ingenious improvisation of equipment, rescuing and evacuation of the wounded from the heat of battle, the robust masculine camaraderie, the casual courage, the necessary combination of strategy and instinct. All made him feel effective, exhilarated and alive. On 18 July 1937, he was hit by a fragment of shell while on active duty. He was still cheerful when they received him back at the hospital, where he slipped into a coma from which he never recovered.

Two days later the news of Julian's death reached Vanessa in her studio in Fitzroy Street. No anguish can equal that of a mother whose child dies before her; with a cry that expressed the agony of that loss, Vanessa collapsed. Angelica hurried back from the theatre where she was acting, to find her mother white and swollen with tears, almost incapable of speech. Virginia was summoned to Vanessa's side and barely left her during the nine days it took to restore her enough to travel to Charleston. It was Virginia, more than Duncan or her children, who had the sympathetic imagination to provide what Vanessa needed most to cling to in the abyss of her grief.

The sisters had shared a lifetime of intimacy and loss and Vanessa had willingly been 'always the eldest', motherly and true. Although she had battled courageously in the past, she seldom had relinquished her control and asked for help herself. Now, at the nadir of her life, there was little energy left for concealment, and Virginia was able to repay at last the debt of protective care and love that Vanessa had extended to her over the years. In *The Wise Virgins*, Leonard Woolf's novel which so closely and controversially characterised Vanessa, Virginia, himself and Clive, Leonard portrayed the emotional bond between the two sisters, a relationship he had witnessed at first hand:

> Between Katharine and Camilla there was that curiously strong love which often binds sister to sister ... It outlives years and happiness and separation, violent quarrels, mutual knowledge, and knowledge of faults, vices and meannesses. It may be doubted whether it does not rest upon the first and the last feeling to flicker through the embryonic and the dying body of everyone, love of

oneself ... if [sisterly love] begins in and rests on selfishness, it manifests itself often with great beauty in supreme unselfishness.⁴⁸

This was just such an occasion when Virginia's love for Vanessa, so often demanding and self-centred, became saintly in its unselfishness and devotion. Her writing was abandoned, her diary lay fallow. She only wrote the briefest letters informing friends and thanking others on Vanessa's behalf for their letters of condolence. Virginia's note to Vita was a paradigm of the simple messages she sent in that aftermath: 'I wired to you because Julian was killed yesterday in Spain. Nessa likes to have me and so I'm round there most of the time. It is very terrible. You will understand. V.'⁴⁹

On 29 July, it was Virginia and Leonard who drove Vanessa home to Charleston and installed her on a day-bed in the studio looking out on the garden. Angelica was still only a girl of eighteen and felt isolated from her mother by her grief; Duncan was deeply sympathetic but detached; Clive evaded the agony with an inappropriate and jarring jocularity. Only Virginia's unflagging generosity of feeling could provide what necessary comfort there was.

From Monk's House she came to her sister's side most days, and on days she was not with her she wrote a series of highly affectionate letters. This tragedy had neutralised the resentments, rivalries and reserve between them and called upon the strength of more than half a century's love. Recalling their nursery days, and using again her nickname for the young Vanessa, at the time when they were in closest conspiracy against the world, Virginia wrote from Monk's House: 'I wish dolphin were by my side, in a bath, bright blue, with her tail curled. But then I've always been in love with her since I was a green eyed brat under the nursery table, and so shall remain in my extreme senility.'⁵⁰

All of Virginia's creative energy was directed towards Vanessa. She could not even collect her wits to write a proper letter during most of August, for, as she explained to Ethel Smyth, she was feeling 'wooden yet enraged'.⁵¹ There were times when she dreaded witnessing any more of her sister's suffering; it was like watching someone bleed, she explained. There was a dreadful sense of helplessness and anger too. What weight Julian's principles and self-expression when it meant destroying in this manner the person one loved most? 'To see what she has to suffer makes one doubt if anything in the world is worth it.'⁵²

But through the heat of that terrible summer and the horror of Vanessa's prostration, Virginia sacrificed herself and her writing to a more important cause, and by doing so, perhaps, she expiated an old sin. Her niece Angelica had recognised a tension between the sisters characterised by what seemed to be Virginia's unspoken plea for forgiveness, and a withholding of favours by Vanessa. She surmised that this dated back to Virginia's prolonged flirtation with Clive just after Julian's birth, when Vanessa had been deeply hurt by this betrayal of their sisterly compact and yet had said nothing. Now the catastrophe of Julian's death allowed Virginia to make amends.

In a letter to Vita, just after Virginia's own death, Vanessa expressed something of what her younger sister's devotion had meant to her then: 'I remember all those days after I heard about Julian lying in an unreal state & hearing her voice going on & on keeping life going as it seemed when otherwise it would have stopped & later every day she came to see me here [at Charleston], the only point in the day one could want to come.'[53]

Vanessa, finding it always so difficult to express her deepest feelings to those she loved, had not been able to tell Virginia herself how life-restoring her care had been. Instead she asked Vita, with whom she was not close, to pass the message on to Virginia for her: 'I cannot ever say how Virginia has helped me. Perhaps some day, not now, you will be able to tell her it's true.'[54] It could be that Vanessa's inability to tell Virginia directly what she had meant was not due entirely to emotional reticence, but to her recognition of the sea change within the sisters' relationship. It was discomforting to have the patterns of a lifetime reversed. She could no longer think of Virginia as untrustworthy, lacking in honesty, and basically selfish, all qualities she had ascribed to her in the past, when her younger sister had exhibited such devotion, sensitivity and practical help in nursing her back to life.

For Virginia, the change was unsettling but welcome. She had received Vanessa's affecting message via Vita, and recorded in her diary how it had been 'so profoundly touching'[55] to have it. It was a spontaneous, if oblique, assertion of her sister's love and dependence. During this summer and autumn of mourning, Virginia found the constant company of Vanessa, the rawness of her unassuageable grief, revived again the need she had felt always. She wrote to her:

> You cant think how I depend upon you, and when you're not there the colour goes out of my life, as water from a sponge; and I merely

exist, dry and dusty. This is the exact truth: but not a very beautiful illustration of my complete adoration of you; and longing to sit, even saying nothing, and look at you.[56]

Virginia was still angry and bewildered by Julian's death. She had often argued with him, she said, on her walks, abusing his selfishness, 'but mostly feel floored by the complete muddle and waste'.[57] These arguments, this anger, were with her still as she went back to writing and revising *Three Guineas*. Vanessa also could not avoid the sense of the futility of Julian's death. It was that which made it even harder to bear: 'I think there is one thing I want to say to any one who will listen – if only I could – and that is simply that I am quite sure, reasonably and definitely sure, that the loss of people like Julian *is* a waste.'[58]

Part of the practical solace that Virginia could offer Vanessa was the suggestion that she and Leonard publish at The Hogarth Press a collection of Julian's essays, poems and letters. The compiling of this was therapeutic, though painful. The reading of his words again conjured up vividly for them both his character and mannerisms, and brought to the public the facts of his existence, his promise and his death.

The day before Julian would have turned thirty, Virginia, who had lived through all those years so intimately with Vanessa, picked up her pen: 'I was thinking tomorrow is Julian's birthday and how I saw him in his cradle. You know I would do anything I could to help you, and its so awful not to be able to: except to adore you as I do.'[59] Vanessa answered immediately, 'You do know how much you help me. I cant show it and I feel so stupid and such a wet blanket often but I couldnt get on at all if it werent for you –'[60]

Virginia was to be even more intimately and effortfully involved in restoring the other loved male to Vanessa when she embarked, the following spring, on her biography of Roger Fry. But, in the meantime, she was needed as a nurse and comforter by the other maternal presence in her life. Leonard had been confined to bed with suspected kidney or prostate trouble and his health continued to cause Virginia extreme anxiety for almost a month over Christmas and the New Year of 1938. Distracted from working, yet having to deal with the Press business and the household affairs, Virginia was afraid that the great cat was playing with them once again. Roger's and Julian's deaths still fresh, she was made to contemplate the possibility again of other

deaths and, with less equanimity, of life without Vanessa or Leonard. She was not sure whether even the opiate of work would help.

Leonard's symptoms improved and Virginia continued with her final revision of *Three Guineas* with a great sense of reprieve. Vanessa had returned from her Christmas holiday at Cassis with Duncan and Angelica. Still mourning and melancholic she, nevertheless, became involved with Duncan that spring in what was to be called the Euston Road School, offering advice and occasionally teaching painting. But whatever the sisters' private griefs and anxieties, with Hitler's annexation of Austria on 11 April 1938, the fear of war asserted itself increasingly over the daily preoccupations of life. 'The public world very notably invaded the private at M[onk's] H[ouse] last weekend,' Virginia wrote in her diary. 'Almost war: almost expected to hear it announced. And England, as they say, humiliated. And the man in uniform exalted. Suicides. Refugees turned back from Newhaven. Aeroplanes droning over the house. L. up to his eyes in the usual hectic negotiations. The Labour Party hemming and hawing. And I looked at Quentin & thought They'll take you.'[61]

Three Guineas had been Virginia's protest against this coming war and all the wars before; it was her outsider's stance against those exalted men in uniform, both military and civilian. She looked forward to its publication with unusual equanimity, even though Leonard's response had been less than enthusiastic and Vanessa's was equivocal. It had been a book she had been compelled to write, she felt, a fact she had to communicate rather than a poem, and therefore she was free to say to the world 'take it or leave it'.[62]

Virginia told Vanessa she had thought of Julian while she was writing the book. Even though it was nearly a year after Julian's death, Vanessa still could barely speak about him. 'What matters compared with that?'[63] Virginia asked herself, recognising the insignificance of her own literary travail in the face of Vanessa's tragedy. In the next diary entry, however, in a direct analogy with birth and babies, she compared her books with the flesh and blood children of her sister: 'This is the mildest childbirth I have ever had.'[64] About *Three Guineas*: 'No book ever slid from me so secretly & smoothly.'[65]

Then writing the biography of Roger Fry, which had been at times such a drudgery, became a labour of love, a gift from Virginia to Vanessa. She admitted it was written again in the presence of Julian's memory. It was another debt repaid, its pricelessness acknowledged

by Vanessa's letter: 'Since Julian died I haven't been able to think of Roger. Now you have brought him back to me. Although I cannot help crying, I cant thank you enough.'[66] The fact that this book was more a gift for her sister than purely an expression of her own creative vision meant Virginia could be extraordinarily detached from Leonard's quite destructive criticism. 'Merely analysis ... dull to the outsider' had been his uncompromising verdict; she felt his 'hard strong beak'[67] pecking deep. But then there was Vanessa's response; the only one that really mattered: 'I always feel I'm writing more for you than for anybody.'[68]

Old impulses and past emotions were involved for Virginia too. In writing the life of the man who had loved Vanessa passionately and been loved in return, she seemed to wish to enter somehow into that intimacy with Vanessa which Roger had known. Much as she had wanted all those years past to be part of the nursery conspiracy between Thoby and Vanessa; much as she had invaded the exclusive territory of her sister's marriage; Virginia appeared to wish to share in part the love affair between Vanessa and Roger. Reading his voluptuous love letters to her sister, Virginia found herself sharing his sentiments and appreciating anew the adoration Vanessa could arouse in herself and others. She wanted to be involved too in the passionate intimacy experienced by her sister: 'I feel very much in [Roger's] presence at the moment: as if I were intimately connected with him; as if we together had given birth to this vision of him: a child born of us.'[69] Vanessa seemed to accept this connection Virginia made between books and babies, giving her sister's creative efforts an equal emotional weight with her own experience of childbearing. Reading *The Waves* prompted this spontaneous accolade: 'Its quite as real an experience as having a baby or anything else, being moved as you have succeeded in moving me.'[70]

Much as Virginia might like to compare her books with Vanessa's children, Vanessa's children of flesh and blood and wills of their own were capable of causing more anguish than those born of the mind. In 1938 Angelica was nearly twenty, extraordinarily beautiful, artistic, but unworldly and immature. She was particularly precious to Vanessa. Not only was she one of her two surviving children, she was the fruit of her love for Duncan and carried the inheritance of that preternaturally beautiful and charming genius. Vanessa had wanted and expected a third son, partly because she realised Duncan would have felt more committed to a boy, partly because she had always

wanted sons. But Angelica arrived and was to enchant her mother with the unexpected delights of the feminine.

To Julian, Vanessa had explained that having a daughter had been 'in a way the most terrific experience of my life.'[71] But her reaction to this lovely daughter was to protect and shield and suppress. If she had been a boy, not only would she have been treated more robustly, she would have been treated with more respect. The deprivation which, by her own admission, had harmed Angelica most, the keeping from her until she was grown up that Duncan, not Clive, was her father, might never have happened if she had been a son. Along with Vanessa's emotional inheritance from her mother came the conviction that men were more interesting, more valuable even, than women; and like her mother, she would sacrifice herself, and any other woman, to the interests of her men. Angelica's right to know her father and be entrusted with the truth were not as important as Duncan's and Clive's imagined delicacy of feeling on the subject. Honesty in Bloomsbury relationships was not necessarily extended to daughters.

Upon her older brother's death and the withdrawal of her mother into remoteness and despair, Angelica began to turn for consolation to David Garnett, the 'Bunny' of her parents' generation and now an old friend of the family, married with children of his own. Unbeknownst to her, he had been her father's lover, and for a time sexually attracted to her mother, more than twenty years before: the third party in an unorthodox and strained triangle, which only Vanessa's self-control, tolerance and desperate desire to keep Duncan, had been able to maintain for more than three years.

As Bunny's friendship with Angelica turned into a courtship, the man, whose presence in Vanessa's intimate life with Duncan a quarter of a century before had caused her so much grief, preyed once again on the most delicate area of her family relationships. Blighted by her code of reasonableness and her inability to express her feelings directly, Vanessa attempted to evade the complicated issues involved by claiming it might be useful for Angelica to be initiated into love by an older man. What she did not confront was how emotionally involved she and Duncan had been with Bunny, and how the legacy of their intimacy now threatened to taint and enmesh the innocent product of those years. Bunny had pledged by Angelica's crib-side, wholly in jest, it had seemed at the time, that he would marry the child when she grew up. Angelica later believed there was an element of revenge against Vanessa for rejecting his sexual advances all those years ago;

there was a need too perhaps to try and restore that old intimacy with both Duncan and Vanessa, to recapture the memory of his youth (he was forty-seven when Angelica turned twenty-one). But these powerful and obscured motives were left unchallenged, unexamined, unexpressed.

Vanessa confided her anxiety at first only to Duncan, to whom she looked, belatedly, for some expression of fatherly protest. He, though, was absorbed in his own confused emotions of jealousy and betrayal. The last thing Vanessa could do was to talk openly with Angelica. The unease between mother and daughter had petrified into an impenetrable reserve; the central issues in their lives could never be broached, but lay as deep water between them. Even Virginia was kept ignorant of the situation and Vanessa's own unhappiness. Only when Bunny's wife died in the spring of 1940, of disseminated cancer after a long decline, was Virginia told what Vanessa characterised as a 'very tiresome piece of family news'.[72]

Virginia was astonished and then angered: 'Pray God she may tire of that rusty surly slow old dog with his amorous ways & primitive mind.' But she shared too the emptiness Vanessa felt, losing Angelica to Bunny, 'old eno' to be her father'.[73] Here, she recognised, was another death for Vanessa – and for Virginia, too, an echo of Julian's death. It made them both feel old. Virginia missed her past intimacy with Angelica, who had been plucked away into another adult's world. No one now to hoard gossip for, Virginia lamented: 'So the land recedes from my ship which draws out into the sea of old age. The land with its children.'[74]

In the whole unhappy episode, however, it was Virginia rather than Duncan or Vanessa who was able to express any protest naturally: 'D. can only say to him Pass the salt. He would not begin upon his anger, as I expressed mine. Nessa said, One must look on the good side. She might have loved an airman.'[75] And Angelica meanwhile was longing for some clarification of their past which would have illuminated some of the subterranean emotions of the present.

In her memoir written more than forty years later, Angelica recognised how unaware, how unconscious she was of her own self and her needs. Bunny was the much longed-for father figure who, not content with that implicit responsibility to stand by and encourage Angelica's emergence into adulthood, wanted to possess her and harness her youth and beauty for his own regeneration. His private diary, written during his courtship of Angelica, was punctuated with

exclamations of how young and virile she made him feel. Angelica recognised in retrospect that her love for him was 'a dream which I have not the strength to sacrifice'.[76] Her aunt Virginia, whose forthright views on the matter seem not to have been expressed to Angelica – perhaps through an unwillingness to encroach on Vanessa's maternal territory – understood the lack of reality in this love affair: 'A.'s position, with B. as her mentor, struck us both [her and Leonard] as almost grotesque – a distortion: a dream; for how can she endure Bottom. And when will she awake?'[77]

Vanessa, less detached and more distressed, was reduced to having to rely on Bunny for any but the most superficial news of Angelica's state of mind and health. She and Angelica had grown so distant over the things that really mattered that, when Angelica was being treated for a minor ailment and Vanessa was afraid that in fact she might be pregnant, it was Bunny whom she asked and not her own daughter. He had interposed himself once again in one of Vanessa's most intimate and important relationships, this time with the daughter of the lover they had both shared. Once again, Bunny, in some respects the enemy, had become the only agency that held Vanessa in contact with the one she loved.

These private strains were set against the unrelenting battery of war. By the end of the summer of 1940 London was under almost constant night-time bombardment, and Sussex, in effect now the permanent home of Vanessa and Virginia, under threat of imminent invasion. Both sisters heard and often saw the planes overhead, heavy-laden with their bombs, on their way to destroy London. There were air battles overhead as the RAF intercepted the German bombers along the Sussex coast.

A sense of menace seeped into the everyday activities of village life: an unexpected peal of church bells – were they about to be invaded? A bomber droned overhead in an otherwise peaceful evening, and Virginia, out walking on the marsh, took two steps closer to Leonard, 'preferring to die together'.[78] The soft English countryside was the setting for destruction and death and the eruption of primitive passions. Virginia and Leonard, in their garden at Rodmell, saw a wisp of smoke rising behind their familiar hill. Then came the news that a German plane had been shot down: 'The country people "stomped" the heads of the 4 dead Germans into the earth.'[79] Civilisation could not be taken for granted any more.

Leonard and Virginia talked more than once of committing suicide

together, should the Germans invade. One option they considered was asphyxiation by car exhaust, and Leonard kept a stock of petrol in the garage for the purpose; Adrian promised a prescription for a lethal drug which would as surely help them evade the concentration camps. Leonard considered this his likely fate as a Jew, and Virginia's too as his wife and someone with a history of mental illness.

Over the hill at Charleston, Vanessa was listening to the news bulletins of reports from the front, feeling that nothing seemed to be able to halt Hitler's advance across Europe that grim summer. 'How can anyone or anything one cares for survive such ruthlessness,'[80] she wrote to Duncan who was in Plymouth on a war-artist's commission and having a wonderful time. His letters back to her were exuberant; he was impressed by the efficiency and confidence of the navy, had lost his heart, so he joked, to the Admiral who was everything an admiral should be and engaged Duncan in a discussion of tiger shooting. And he loved the sailors. Duncan wrote to Vanessa about one of the young men he befriended, 'he is rather intelligent & handsome & ['but' had been crossed out here] married,'[81] revealing in that deletion that, although at fifty-five well into middle age, he was as youthful and irrepressibly opportunist as ever.

At Charleston Vanessa, though, was feeling the encroachments of war. Shortage of petrol meant she could only visit Virginia on days she went shopping to Lewes. She was worried about increasing rationing of food, and was planning to grow more vegetables and breed chickens to eat. Her life was drawing in.

The devastation of London appeared a terrible and tangible proof too of Hitler's intent to destroy the creation of centuries of art and endeavour, and to break its independent-minded, courageous people.

> What touched and indeed raked what I call my heart in London was the grimy old woman at the lodging house at the back, all dirty after the raid, and preparing to sit out another ... And then, the passion of my life, that is the City of London – to see London all blasted, that too raked my heart.[82]

So Virginia wrote to Ethel Smyth as London endured the Blitz.

Bloomsbury was particularly badly hit and both Virginia's and Vanessa's London houses were destroyed or made uninhabitable. Leonard and Virginia had not long moved into 37 Mecklenburgh Square when a time bomb in the square in September 1940 brought

down the ceilings and blew out the windows. Their books, letters, Virginia's diaries, all had to be salvaged and transported to Sussex.

Vanessa's and Duncan's studios too, in Fitzroy Street, were reduced that month to smouldering ruins, some of their pictures burnt. This was the trump card, as Virginia saw it, played by Vanessa in a sisterly dispute over the prospective evacuation of the Anreps – Helen Anrep and her two children had lived with Roger Fry during the last years of his life – to a cottage in Rodmell. Virginia already found the intrusiveness of village life frequently more than she could bear, and at these times especially longed to be in some isolated house on a hill. The prospect of anyone she knew being on her doorstep, invading her privacy, filled her with dread.

When Vanessa had suggested the cottage to Helen Anrep, Virginia had lost her temper. Vanessa retaliated by silent withdrawal and Virginia intended to counter this with an invitation to the Anreps and the Bells to a joint tea-party. At the height of this battle of wills, Vanessa played her trump; studios destroyed, pictures burnt, all more significant than the damage suffered to her sister's flat at Mecklenburgh Square. Thus Virginia was silenced. These sisters could be competitive even in defeat.

Yet amongst the fears and desolations of war, the monotony and necessary constraints of their lives, there was exhilaration and a certain freedom too. Everything was pared down to essentials; no travel, no holidays, few visitors, no luxuries, little distraction. Vanessa, hearing of the destruction of her canvases in the studio fire, said she could always paint some more, and Virginia, bombed out of Mecklenburgh Square, wrote in her diary of the exhilaration she felt in being relieved of her possessions: 'I shd like to start life, in peace, almost bare – free to go any where.'[83] But then, when Vanessa came to tea that afternoon and described a remote Sussex farmhouse she had found for Angelica and Bunny, Virginia, always open to the seduction of new houses, and thinking herself the favoured child of Vanessa, immediately longed to live there herself.

War brought a return to a simpler and harder way of life which had its attractions for both sisters. Virginia, without live-in servants, felt the deepest relief, despite the increase in domestic work: 'Fish forgotten, I must invent a dinner. But its all so heavenly free & easy – L. & I alone.'[84] Virginia bottled their own honey, baked bread and made butter from their rationed milk. Vanessa too, who had valiantly and ingeniously fed her enormous household through the grim years of

the First World War, turned her thoughts again to growing more vegetables and raising fowl to keep her now diminished family from deprivation.

On her occasional forays into London, Virginia was brought up against ordinary people, who barely impinged on her life in peace time, but now vividly filled her with affection. To Ethel Smyth she explained:

What I'm finding odd and agreeable and unwonted is the admiration this war creates – for every sort of person: chars, shopkeepers, even much more remarkably, for politicians – Winston at least, and the tweed wearing sterling dull women here, with their grim good sense: organising First Aid, putting out bombs for practice, and jumping out of windows to show us how ... I'd almost lost faith in human beings, partly owing to my immersion in the dirty water of artists envies and vanities while I worked at Roger [the biography]. Now hope revives again.'[85]

Sequestered at Rodmell, Virginia had been writing with enjoyment 'Pointz Hall', or *Between the Acts*, as she was to call it, her last novel. In it Miss La Trobe, the solitary artist, the outsider, stages a pageant in the grounds of a country house, which, with the villagers and their children as actors, attempts to give a sketch of England through the ages, using the voices of the outsiders, the unheard and unseen, the common people. Written during some of the grimmest months of the war when, in the summer and autumn of 1940 alone, Hitler's onslaught seemed irresistible with the fall of France, the Battle of Britain, the Blitzing of London, and the constant threat of invasion, this book expressed a longing for unity. A unity of the players with the audience; of them all with their history; a unity through time, across class and country. The vicar haltingly attempted an explanation of the pageant: 'We act different parts; but are the same.' Even the village idiot was 'part of ourselves'.[86] 'But not a part we like to recognise,'[87] one of his parishioners thought silently, watching a villager's recoil at the vicar's words.

Virginia had searched all her life for that unity, that intimacy, primarily with her mother, enduringly with Vanessa. In *To the Lighthouse*, through the artist Lily's ambivalent passion for Mrs Ramsay, she expressed something of her own longing to be 'one with the object one adored';[88] her need for that inexpressible merging, on

some secret, intuitive level. Vanessa's daughter Angelica remembered vividly how Virginia would sit on a low stool next to Vanessa so that her elder sister loomed larger than her and had to be looked up to, so that, perhaps metaphorically, Virginia too, like the chaste artist Lily, was 'leaning her head on Mrs Ramsay's knee'.[89] And like Mrs Ramsay, Vanessa, in her reticence and inexpressiveness, could seem thus remote, inaccessible and awesome.

Virginia's own lifelong yearning for intimacy perhaps remained uppermost in her mind as she revised *Between the Acts*, for, at the end of 1940, Virginia had been reading her parents' love letters and had been 'swept away' by emotion and memory. She told Octavia Wilberforce, a friend and doctor who was consulted informally by Leonard when he became anxious about Virginia's state of mind in the New Year, that she was thinking again about her parents, her childhood, the deaths of her mother and Stella, the damage done to her and Vanessa by the excessive emotional demands of their father, of their half-brother George, whom nevertheless 'she evidently adored'.[90] Virginia was aware that this obsession with her past made Leonard uneasy: 'Poor Leonard is tired out by my interest in my family & all it brings back.'[91]

But in the midst of this thraldom to the past and the tragedies that loomed vividly still in memory, Virginia could experience that unity with the essential landscapes and buildings of the England she loved. Perhaps she knew something of what Mrs Swithin, the intuitive visionary in *Between the Acts*, which Virginia was revising at the turn of that year, meant when she murmured, 'But we have other lives, I think, I hope ... we live in others ... We live in things.'[92] Certainly, on Christmas Eve 1940 Virginia was arrested, in the act of drawing the curtain at Monk's House, by the sight of the two elms she called Leonard and Virginia, standing so black against the evening sky. In remembering the farmhouse at Alciston, where she and Leonard had visited the Anreps that afternoon, her own spirit seemed to have flowed out to meet the spirit of the land and been restored by the communion: 'How England consoles & warms one, in these deep hollows, where the past stands almost stagnant. And the little spire across the fields ... So back through Lewes. And I worshipped the beauty of the country, now scraped, but with old colours showing.'[93] A land in conspiracy with herself, and as valiant in adversity.

The greatest consolation, however, was to be found in her relationship with the two people who mattered most to her in the world,

Leonard and Vanessa. The tenderness between Virginia and Leonard was unmistakable, as was her pride in the enduring affection of their marriage. Looking back on a quarter of a century of a marriage which had triumphed, for richer for poorer, in sickness and in health, Virginia, in realising Leonard would rather she stay with him than go to Paris for the weekend, 'was overcome with happiness. Then we walked round the square love making – after 25 years cant bear to be separate ... you see it is an enormous pleasure, being wanted: a wife. And our marriage so complete.'[94]

With Leonard, however, Virginia could not merge consciousnesses; he was so different from her, so alien. ('How I hated marrying a Jew,'[95] she wrote to Ethel Smyth in recollection eighteen years later.) His intellect and temperament too were austere, uncompromising, so contrary to her own:

> His extreme rigidity of mind surprises me; I mean in its relation to others: his severity: not to myself but then I get up & curse him. What does it come from? Not being a gentleman partly: uneasiness in the presence of the lower classes; always suspects them, is never genial with them ... His desire, I suppose, to dominate. Love of power. And then he writes against it ... It goes with great justice, in some ways; & simplicity too; & doing good things; but it is in private a very difficult characteristic.'[96]

Virginia could fight for her point of view, as she had over the merits of *Roger Fry*, but she would never persuade Leonard to meet her there. He was a man who prided himself on his decisiveness and lack of compromise, a man who found it virtually impossible to admit he was wrong, or to say he was sorry.

But with Vanessa it was different. There was always the tantalising prospect of this absolute intimacy Virginia craved. Her elder sister could be silent, inflexible and judgmental too, but she belonged to Virginia's 'garden of beautiful women'[97] and was peerless among them; while the masculine world, in which Leonard inevitably belonged, Virginia described, continuing her horticultural metaphor, as 'an arid garden ... What avenues of stone pavements and iron railings!'[98] But more important even than her femaleness, her motherliness, her beauty, Vanessa shared the past that haunted Virginia; no words were necessary, for so much of their understanding of each other was visceral and based on a lifetime's conspiracy as sisters. 'Kiss

your mother,' Virginia wrote to Quentin when she and Vanessa were over fifty, 'and tell her that in spite of everything I adore her. There is a world of meaning in that which she alone will understand.'[99]

And so, as the profoundest depression began to take hold of Virginia during the dark days of February and March that 1941, her mind returned once again to thoughts of the past and the family that obsessed her. Dr Octavia Wilberforce, invited over from her home in Brighton by Leonard, was well-meaning, but crass and uncomprehending in her treatment of Virginia.

She had begun to hear voices, perhaps of her long-dead parents, her brother – 'that queer ghost,' she had called him when re-reading his letters, 'I think of death sometimes as the end of an excursion which I went on when he died.'[100] She was afraid too that she had lost her art and could not write; that 'buried down here'[101] at Rodmell, denied the stimulation of other people, she could no longer conjure up the excitement and flow of ideas. Writing gave her purpose and identity. Without it she was nothing.

Impelled by a longing for synthesis, for undividedness, Virginia wrote of the terror of this loss, through the voice of Bernard in *The Waves*:

> I spoke to that self who had been with me in many tremendous adventures. . . . This self now as I leant over the gate looking down over fields rolling in waves of colour beneath me made no answer. He threw up no opposition. He attempted no phrase. His fist did not form. I waited. I listened. Nothing came, nothing. I cried then with a sudden conviction of complete desertion. Now there is nothing. No fin breaks the waste of this immeasurable sea. Life has destroyed me. No echo comes when I speak, no varied words. This is more truly death than the death of friends, than the death of youth . . .
>
> The woods had vanished; the earth was a waste of shadow. No sound broke the silence of the wintry landscape. No cock crowed; no smoke rose; no train moved. With dispassionate despair, with entire disillusionment I surveyed the dust dance; my life, my friends' lives, and those fabulous presences, men with brooms, women writing, the willow tree by the river – clouds and phantoms made of dust too . . . mutable, vain, I, carrying a note-book, making phrases, had recorded mere changes; a shadow. I had been sedulous to take note of shadows. How can I proceed now, I said, without a

self, weightless and visionless, through a world weightless, without illusion?'[102]

In her desperation to keep these terrors at bay, Virginia had taken to beating carpets and scrubbing floors. Octavia Wilberforce's reaction was hearty and extrovert: 'I said I thought this family business was all nonsense, "blood thicker than water" balderdash.'[103] But no amount of jolly good sense could save her when the memories came to claim her. Virginia's very last entry in her diary echoed her yearning for intimacy, 'to be one with the object one adored,' when, in thinking of Vanessa at Brighton that windy day, she imagined 'how it would be if we could infuse souls.'[104]

It is possible that six days earlier on 18 March, Virginia had already determined to kill herself and had written her first suicide note to Leonard. She had returned to Monk's House from one of her walks, wet through and shaken, having fallen in a dyke she said. Two days later, Vanessa came to tea and, concerned by her sister's state of mind but not expecting such a rapid deterioration, wrote that evening what was to be her last letter to Virginia. She urged her to rest, to trust her and Leonard to know this time what was best: 'You must not go and get ill just now. What shall we do when we're invaded if you are a helpless invalid.' Vanessa has been criticised for the insensitivity of the wording of that sentiment, but she was writing to a sister who had loved her passionately since babyhood and who understood the deeper meanings behind her elder sister's inexpressiveness. It was what Vanessa wrote next which mattered most: 'What should I have done all these last 3 years if you hadnt been able to keep me alive and cheerful. You dont know how much I depend on you.'[105]

Even that rare declaration of love and dependence from the one person whose love mattered most of all could not secure Virginia to life. She began her farewell letter to Vanessa acknowledging her gratitude for that affection: 'Dearest, You cant think how I loved your letter.' She continued reasonable, loving, at great pains to protect Leonard from any feelings of negligence or guilt, and requesting that Vanessa should reassure him of the fact that no one could have done more for her, or been 'so astonishingly good'. That done, Virginia's thoughts turned to Vanessa herself. After a lifetime of letters fulsome in praise and love for her, the simplicity of the last two lines she addressed to her sister expressed the extent of the journey they had travelled together, the intimacy between them that left nothing more

to be said: 'If I could I would tell you what you and the children have meant to me. I think you know.'[106]

Sixteen years previously Virginia had written about the death of a friend: 'That is what I should like for myself, that there should be no breach, no submission to death, but merely a break in the talk.'[107] Here, with Vanessa, there was no breach, death would not subdue her; fifty-nine years of talk had merely come to an end.

Virginia left the letter to Vanessa in the house when, five days later, on 28 March, she walked the half mile or so to the River Ouse. If she had attempted and failed before, this time she was determined to succeed. Virginia filled the pocket of her coat with stones and waded in her gumboots into the water. 'Above, the air rushed; beneath was water. She stood between two fluidities ...' had been Lucy Swithin's thought as she gazed into the pool after the pageant was over in *Between the Acts*. She would escape the cold rationality of the outside world; 'Silenced, she returned to her private vision; of beauty which is goodness; the sea on which we float. Mostly impervious, but surely every boat sometimes leaks?'[108] In a memoir written at the time she had likened herself to a sealed vessel afloat on reality. Water had always been for Virginia an all-embracing, creative force, symbol of maternal love and goodness. She had not wanted to die in her garage, cornered by the invading Germans, or to take poison provided by her doctor brother. Virginia had protested the previous summer that she had another ten years left and at least one more book to write. But when her life, on her own terms, had become too painful and burdensome she decided to end it with all the courage and dignity with which she had lived.

Leonard found Virginia's walking-stick on the bank of their river. She had left him two letters, written, it is argued, ten days apart but similar in their complete lack of self-pity and the loving concern for him. Both carried the message that he had done everything to promote her health and happiness. 'Everything has gone from me but the certainty of your goodness ... I don't think two people could have been happier than we have been,'[109] that last line a haunting echo of her mother's sentiment on the death of her first husband.

Vanessa was told on the phone by the Woolfs' gardener that Virginia had disappeared and was feared drowned. She immediately went to Rodmell where she found Leonard 'amazingly self-controlled and calm'[110] and insisting on being left on his own. It was the tragedy he and Vanessa had half expected since they had both sat in exhausted

vigil by Virginia's bedside after her desperate attempt to kill herself in 1913. Vanessa met this now with her long-rehearsed stoicism: 'Now we can only wait till the first horrors are over which somehow make it almost impossible to feel much.'[111] She felt it would be better perhaps if Virginia's body was never found, for that would be just a further horror to endure. But three weeks later on 18 April, some children found a body floating downstream and Leonard was summoned to identify her. Vanessa's heart went out to him, but he told her, 'It was no more horrible than all the rest.'[112]

Vanessa too was bereft: the moving spirit was gone. Their weekly family meetings were abandoned: 'They would be so pointless without her.'[113] She did not go to Virginia's cremation which Leonard attended alone. He asked Vanessa's advice, however, about their private memorial to her. It seems appropriate to have Vanessa's voice describe Virginia's final return to the earth.

Leonard told me that there are two great elms at Rodmell which she always called Leonard and Virginia. They grow together by the pond. He is going to bury her ashes under one and have a tablet on the tree with a quotation – the one about 'Death is the enemy. Against you I will fling myself unvanquished and unyielding. O Death!' [the last lines of *The Waves*] ... Poor Leonard – he did break down completely when he told me. He was afraid I'd think him sentimental but it seems so appropriate that I could only think it right.[114]

Afterword

VIRGINIA'S DEATH BROUGHT Angelica over to Charleston from the farmhouse she was sharing with Bunny. When Vanessa broke the news to Duncan, on his return that evening from London, all three clung together in a rare embrace.

Her death brought Vita and Vanessa together in a fleeting intimacy. Vanessa, in writing to her the day after, generously admitted she was 'the person Virginia loved most ... outside her own family'.[1] She invited Vita to lunch at Charleston (it would be only the second time Vita had been there), but both women were uneasily aware of how it was Virginia who was the bond between them, and how much they missed her: 'I could hardly believe Virginia wasnt there too talking to us,' Vanessa wrote, 'for I think I've hardly ever seen you without her.'[2] With the absence of the person they both had loved, there was little impetus to the friendship and their contact dwindled.

Leonard was living on alone at Monk's House. Vita visited him some ten days later and was distressed to see him there so solitary and austere, still surrounded by Virginia's most intimate things: her unfinished needlework, lying where she had left it on a chair; her writing paper with her handwriting on it. Both Vita and Virginia hated to think of Leonard alone in that house filled with the over-whelming sense of Virginia's absence. But when taxed with it by Vita, he 'turned those piercing blue eyes on me and said its the only way'.[3]

Life continued at Charleston in its old routines, further constricted by the war. Duncan still escaped periodically to London, but his need for Vanessa and his desire not to be the cause of any more pain to her brought him back. John Lehmann, who was partner and general manager of The Hogarth Press at the time, came over to Charleston with Leonard and left a memorable image of the stasis that seemed to have submerged Vanessa:

> Vanessa and Clive and Duncan Grant and Quentin were all there. It was strange to happen on them together like that: it increased the

impression I had during the whole weekend, of visiting ghosts, of entering a dream, particularly as Vanessa was very silent, all too obviously still suffering under Julian's as well as Virginia's death. She can only have been in her early sixties at the time, but she looked much older.[4]

In the summer of 1944, Vanessa faced alone the ordeal of a diagnosis of breast cancer and the resultant mastectomy. Again, she was silent on the extent of her suffering.

With the end of the war, life expanded once more with the possibility of foreign travel and easier access to friends and London. Vanessa continued to paint, but increasingly for herself, rather than for any public; as an escape into an impersonal world and as a continuing and comforting bond with Duncan. The pleasures of her life were centred simply on Charleston, the garden, occasional trips abroad, and particularly on her grandchildren, who began to arrive regularly, with Angelica's marriage to Bunny and Quentin's to Anne Olivier Popham.

She continued, too, the old working association with Virginia, designing the jackets for her books published posthumously by The Hogarth Press. Flowers seemed to be their dominating motif: climbing up theatre curtains for *Between the Acts*, the novel published the year of Virginia's death; springing out of vases for *The Moment and Other Essays* and *The Captain's Death Bed and Other Essays*; singly and solidly present against the curve and emphatic cross-hatching of *Granite and Rainbow*. Her last portrait of her sister was an elegant silhouette, reminiscent of a head of one of the Three Graces, for a collection of Virginia's letters to her 'old snake' charmer Lytton Strachey, published in 1956.

The essential silence and reticence of Vanessa's nature became even more marked as she entered her seventies. There had always been something detached and mysterious about her character and this quality intensified with age and suffering into a remoteness which few, apart from her grandchildren, could penetrate. Grace Higgens, 'the angel of Charleston', who had worked for Vanessa for forty years in the most intimate circumstances as nanny, cook and housekeeper, was struck, as she tended her in her last illness, by how little she knew her, how distant she had always been. Angelica, her daughter, recalled also the indefinable barrier she sensed existed between even herself and her mother: a barrier which made for coolness and unease, which

both longed to but could not overcome.

There was something essentially unknowable about Vanessa. An enigma Virginia had spent a lifetime trying to fathom. But in her old age, she was courageous and fatalistic; working to the end, as independent as possible, accepting her lot with neither self-pity nor complaint. She never sought the comforts of religion, with a hope of another life where that loved mother, brother, son and sister might be restored to her. She had made her life as she had wanted it, notably at Charleston, with her painting, her children, her men.

Almost fifty years had passed since Virginia had written, 'Vanessa's character remains very hard, and calculated to outlast the Sphinx.'[5] Virginia had always believed that the secret of the eternal riddle of life was lodged with her sister – and would probably die with her. But the Sphinx's answer, she might well have agreed, was to be found in the atmosphere at Charleston.

In their middle age, Virginia had imagined her in spring, at the heart of her kingdom there: 'Nessa is at Charleston. They will have the windows open: perhaps even sit by the pond. She will think This is what I have made by years of unknown work – my sons, my daughter. She will be perfectly content....'[6]

It was spring again, but 1961. Vanessa was eighty-one and Charleston was little changed. She had lost Julian and Virginia, but had gained seven grandchildren who brought a new delight to her life. Then, in April, she fell ill with bronchitis. Virginia had remembered with gratitude how it was Vanessa who, in league with her, had taken on the world. Virginia had long ago recognised her sister's indomitableness and had sheltered herself within her shade:

> How proud I am of her triumphant winning of all our battles: as she [battles] her way so nonchalantly modestly, almost anonymously past the goal, with her children round her; & only a little added tenderness (a moving thing in her) which shows me that she too feels wonder surprise at having passed so many terrors & sorrows safe—[7]

Perhaps Vanessa alone could battle no longer. Within three days her heart was failing. On the 7th of April 1961, she died at Charleston. It was two decades, almost to the day, after Virginia had walked into the River Ouse, just five miles distant, over the hill.

Notes

I HAVE ABBREVIATED Vanessa Bell and Virginia Woolf to VB and VW throughout, even with references to them when they were unmarried and both VS.

The material from unpublished sources: the Virginia Woolf papers in the Berg Collection in the New York Public Library (Berg); the Vanessa Bell papers lodged in the Tate Gallery in London (Charleston); the Leonard Woolf papers in the University of Sussex (Monk's House); the family papers in the possession of Professor Quentin Bell (QB) and Angelica Garnett (AG); the Duncan Grant papers held by Henrietta Garnett (HG); and Vanessa Bell letters to Vita Sackville-West in the possession of Nigel Nicolson (NN).

Virginia Woolf's letters and diaries have been published in six- and five-volume editions and in the Notes references to them are as *Letters*, followed by the volume number, and *Diary*, followed by the volume number. The collection of Virginia Woolf autobiographical writing called *Moments of Being* is referred to throughout the Notes as *M.o.B.* Sir Leslie Stephen's autobiographical *Sir Leslie Stephen's Mausoleum Book* is referred to as *The Mausoleum Book*. All these works are given their full titles and publishing details in the Bibliography.

Where there are references to Virginia Woolf's novels and non-fiction works, I have given the page references to the paperback versions (see Bibliography) as the new Hogarth Press editions were published too late for me to take account of them.

Where there are different quotes from the same source occurring in the same paragraph, then the reference number, referring to all, is placed at the end of the last relevant quote.

INTRODUCTION

1 VB to VW, 27 August 1908 (Berg).
2 VW to Clive Bell [May 1908], *Letters*, vol. I.
3 VW to QB, 28 October [1930], *Letters*, vol. IV.
4 Leonard Woolf, *An Autobiography*, vol. I (OUP edn), p. 119.

5 Ibid., p. 117.
6 VW to Ethel Smyth, 22 June [1930], *Letters*, vol. IV.
7 VW to VB 17 August 1937, *Letters*, vol. VI.
8 VW to VB 17 March 1821, *Letters*, vol. II.
9 VW to VB (10 August 1909], *Letters*, vol. I.
10 'A Sketch of the Past', *M.o.B.*, p. 73.
11 *Flush*, p. 20.

1 ONENESS

1 Leslie Stephen, *The Mausoleum Book*, p. 53.
2 Leslie Stephen to Julia Stephen, 28 January 1891 (Berg).
3 Leslie Stephen, *The Mausoleum Book*, p. 47.
4 Ibid., p. 40.
5 VW unpublished autobiographical fragment, 1940 (Berg).
6 Vanessa Bell, *Notes on Virginia's Childhood*, no page numbers.
7 Stella Duckworth to Julia Stephen, 13 April 1884 (Berg).
8 Leslie Stephen to Julia Stephen, 5 April 1884 (Berg).
9 Leslie Stephen to Julia Stephen, 13 April 1884 (Berg).
10 Leslie Stephen to Julia Stephen [? (Tuesday) July 1893] (Berg).
11 Leslie Stephen to Julia Stephen, 22 November 1887 (Berg).
12 Enclosed in a letter from Leslie Stephen to Julia Stephen, April 1884 (Berg).
13 Leslie Stephen to Julia Stephen, 21 October 1884 (Berg).
14 'Reminiscences', *M.o.B.*, p. 28.
15 'A Sketch of the Past', *M.o.B.*, p. 83.
16 Leslie Stephen, *The Mausoleum Book*, p. 74.
17 *To the Lighthouse*, p. 186.
18 Leslie Stephen to Julia Stephen, 24 April 1886 (Berg).
19 '22 Hyde Park Gate' from *M.o.B.*, p. 143.
20 Leslie Stephen to Julia Jackson, 18 July 1877 (Berg).
21 Leslie Stephen, *The Mausoleum Book*, p. 16.
22 *To the Lighthouse*, p. 112.
23 VB to Roger Fry, 6 August [1930] (Charleston).
24 'A Sketch of the Past', *M.o.B.*, p. 78.
25 VW to VB [5th August 1937], *Letters*, vol. VI.
26 'Reminiscences', *M.o.B.*, p. 30.
27 Vanessa Bell, *Notes on Virginia's Childhood*, no page numbers.
28 Ibid.
29 'A Sketch of the Past', *M.o.B.*, p. 78.
30 Leslie Stephen to Julia Stephen, 11 October 1882 (Berg).

31 'A Sketch of the Past', *M.o.B.*, p. 89.
32 Ibid., p. 69.
33 VW to Ethel Smyth, 12 January 1941, *Letters*, vol. VI.
34 'Reminiscences', *M.o.B.*, p. 29.
35 'A Sketch of the Past', *M.o.B.*, p. 78.
36 Vanessa Bell, *Notes on Virginia's Childhood*, no page numbers.
37 'A Sketch of the Past', *M.o.B.*, p. 64.
38 Leslie Stephen to Julia Stephen, 25 July 1893 (Berg).
39 Leslie Stephen to Julia Stephen, 31 July 1893 (Berg).
40 'Reminiscences', *M.o.B.*, p. 30.
41 Leslie Stephen to Julia Stephen, 3 August 1893 (Berg).
42 Leslie Stephen, *The Mausoleum Book*, p. 85.
43 *To the Lighthouse*, p. 61.
44 Leslie Stephen, *The Mausoleum Book*, p. 60.
45 *To the Lighthouse*, p. 57.
46 Leslie Stephen to Julia Stephen, 22 January 1891 (Berg).
47 Vanessa Bell, *Notes on Virginia's Childhood*, no page numbers.
48 *Diary*, vol. IV, 29 February 1932.
49 VB to VW, 14 April 1906 (Berg).
50 VB to VW, 2 September 1909 (Berg).
51 'Reminiscences', *M.o.B.*, p. 65.
52 Vanessa Bell, *Notes on Virginia's Childhood*, no page numbers.
53 'A Sketch of the Past', *M.o.B.*, p. 128.
54 Ibid., p. 129.
55 Vanessa Bell, *Notes on Virginia's Childhood*, no page numbers.
56 Ibid.
57 'Reminiscences', *M.o.B.*, p. 29.
58 VW to Janet Case [19 November 1919], *Letters*, vol. II.
59 VB to Roger Fry [? April 1917] (Charleston).
60 *Night and Day*, p. 40.
61 Vanessa Bell, *Notes on Virginia's Childhood*, no page numbers.
62 Ibid.
63 Ibid.
64 Stella Duckworth to Julia Jackson [? January 1882] (Berg).
65 'Reminiscences', *M.o.B.*, p. 42.
66 Elizabeth Robins to VW, 4 May 1928.
67 'A Sketch of the Past', *M.o.B.*, p. 84.
68 Leslie Stephen, *The Mausoleum Book*, p. 96.
69 'A Sketch of the Past', *M.o.B.*, p. 114.

2 THE CHRYSALIS IS BROKEN

1 'A Sketch of the Past', *M.o.B.*, p. 84.
2 'Reminiscences', *M.o.B.*, p. 39.

3 'A Sketch of the Past', *M.o.B.*, p. 84.
4 Leslie Stephen, *The Mausoleum Book*, p. 97.
5 'A Sketch of the Past', *M.o.B.*, p. 95.
6 'Reminiscences', *M.o.B.*, p. 32.
7 Autobiographical fragment, Virginia Woolf papers (Berg).
8 'Reminiscences', *M.o.B.*, p. 31.
9 VB to Roger Fry [?1915] (Charleston).
10 VB to VW, 20 April 1928 (Berg).
11 'A Sketch of the Past', *M.o.B.*, p. 136.
12 *The Waves*, p. 179.
13 'Reminiscences', *M.o.B.*, p. 29.
14 VW to Violet Dickinson, 2 October [1903], *Letters*, vol. I.
15 '22 Hyde Park Gate', *M.o.B.*, p. 147.
16 VB to VW, 8 September 1904 (Berg).
17 VW to Ethel Smyth [14 July 1936] *Letters*, vol. VI.
18 VW to VB [?25 July 1911] *Letters*, vol. I.
19 '22 Hyde Park Gate', *M.o.B.*, p. 155.
20 Octavia Wilberforce to Elizabeth Robins, 14 March 1941 (Monk's House).
21 Leslie Stephen, *The Mausoleum Book*, p. 41.
22 'Reminiscences', *M.o.B.*, p. 48.
23 'A Sketch of the Past', *M.o.B.*, p. 92.
24 Leslie Stephen, *The Mausoleum Book*, p. 58.
25 'Reminiscences', *M.o.B.*, p. 46.
26 VW to VB, 23 July [1927], *Letters*, vol. III.
27 VW to Mary Hutchinson [15 February 1924], *Letters*, vol. VI.
28 *The Years*, p. 25.
29 16 February 1930, *Diary*, vol. III.
30 'Old Bloomsbury', *M.o.B.*, p. 161.
31 14 September 1925, *Diary*, vol. III.
32 VW to VB [27 October 1919], *Letters*, vol. III.
33 VW to George Duckworth [22 April 1900], *Letters*, vol. I.
34 'Reminiscences', *M.o.B.*, p. 55.
35 Ibid., p. 46.
36 Ibid., p. 49.
37 Leslie Stephen, *The Mausoleum Book*, p. 101.
38 Ibid., p. 103.
39 'Reminiscences', *M.o.B.*, p. 57.
40 9 April 1897, unpublished diary (Berg).
41 'Reminiscences', *M.o.B.*, p. 51.
42 Memoir by VB, 'Life at Hyde Park Gate 1897–1904' (AG).
43 8 April 1897, VW unpublished diary Jan. 1897–8 (Berg).
44 Ibid., 10 April 1897.
45 *To the Lighthouse*, p. 94.

46 'A Sketch of the Past', *M.o.B.*, p. 105.
47 12 April 1897, VW unpublished diary, Jan. 1897–8 (Berg).
48 'A Sketch of the Past', *M.o.B.*, p. 105.
49 VW unpublished diary, Jan. 1897–8 (Berg).
50 Memoir by VB, 'Life at Hyde Park Gate 1897–1904' (AG).
51 'Reminiscences', *M.o.B.*, p. 45.
52 Memoir by VB, 'Life at Hyde Park Gate 1897–1904' (AG).
53 VW unpublished autobiographical fragment, 1940 (Berg).

3 US TWO AGAINST THEM

1 'A Sketch of the Past', *M.o.B.*, p. 117.
2 VB to VW, 20 April 1908 (Berg).
3 *To the Lighthouse*, p. 12.
4 'A Sketch of the Past', *M.o.B.*, p. 124.
5 'Reminiscences', *M.o.B.*, p. 59.
6 VW to Violet Dickinson [? February 1903], *Letters*, vol. I.
7 *A Room of One's Own*, p. 37.
8 *Three Guineas*, p. 45.
9 'Reminiscences', *M.o.B.*, p. 30.
10 Ibid., p. 54.
11 '22 Hyde Park Gate', *M.o.B.*, p. 149.
12 Memoir by VB, 'Life at Hyde Park Gate 1897–1904' (AG).
13 VB to VW, 8 September 1904 (Berg).
14 'A Sketch of the Past', *M.o.B.*, p. 130.
15 Fragment of memoir by VB, 'A Brother as Chaperone: A Visit to the Chamberlains' (QB).
16 VW to Violet Dickinson, 27 December 1902, *Letters*, vol. I.
17 VW unpublished diary, 30 June–1 October ?1903 (Berg).
18 Ibid.
19 '22 Hyde Park Gate', *M.o.B.*, p. 152.
20 VW to Emma Vaughan, 8 August [1901], *Letters*, vol. I.
21 'A Sketch of the Past', *M.o.B.*, p. 126.
22 VW to Thoby Stephen [May 1903], *Letters*, vol. I.
23 '22 Hyde Park Gate', *M.o.B.*, p. 155.
24 'A Sketch of the Past', *M.o.B.*, p. 135.
25 VB to VW, 26 December 1909 (Berg).
26 'A Sketch of the Past', *M.o.B.*, p. 124.
27 Memoir by VB, 'Life at Hyde park Gate 1897–1904' (AG).
28 'A Sketch of the Past', *M.o.B.*, p. 125.
29 Ibid.
30 Ibid., p. 126.
31 *Jacob's Room*, p. 42.
32 *Collected Essays*, vol. II, p. 36.
33 12 May 1923, *Diary*, vol. II.

34 3 December 1923, *Diary*, vol. II.
35 VW to Emma Vaughan, 12 August 1899, *Letters*, vol. I.
36 VW to George Duckworth [22 April 1900], *Letters*, vol. I.
37 VW to Emma Vaughan, 19 April [1900], *Letters*, vol. I.
38 Ibid.
39 26 August 1922, *Diary*, vol. II.
40 8 December 1929, *Diary*, vol. III.
41 VW to Emma Vaughan [?17 June 1900], *Letters*, vol. I.
42 VW to Emma Vaughan, 23 April [1901], *Letters*, vol. I.
43 'A Sketch of the Past', *M.o.B.*, p. 124.

4 DEATH AND FREEDOM

 1 'How Should one Read a Book?', *The Common Reader*, vol. II, p. 269.
 2 *To the Lighthouse*, p. 156.
 3 Ibid., p. 158.
 4 14 May 1925, *Diary*, vol. III.
 5 *To the Lighthouse*, p. 158.
 6 28 November 1928, *Diary*, vol. III.
 7 VB to VW, 11 May 1927 (Berg).
 8 VW to Janet Case [?26 February 1904], *Letters*, vol. I.
 9 VW to Violet Dickinson [31 March 1904], *Letters*, vol. I.
10 Ibid.
11 VW unpublished diary (no. 2) 30 June–1 October ?1903 (Berg).
12 VW to Violet Dickinson [March 1904], *Letters*, vol. I.
13 VW to Violet Dickinson [March 1904], *Letters*, vol. I.
14 VB to Margery Snowden, 18 April [1903] (Charleston).
15 3 September 1922, *Diary*, vol. II.
16 VB to Margery Snowden, 9 April [1904] (Charleston).
17 VW to Emma Vaughan, 25 April 1904, *Letters*, vol. I.
18 VB to Margery Snowden [early April 1904] (Charleston).
19 VW to Emma Vaughan, 25 April 1904, *Letters*, vol. I.
20 VW to Violet Dickinson, [?6 May 1904], *Letters*, vol. I.
21 Ibid.
22 VB to Margery Snowden, 3 May 1904 (Charleston).
23 18 December 1937, *Diary*, vol. V.
24 VW to Violet Dickinson [?22 September 1904], *Letters*, vol. I.
25 Ibid.
26 'A Sketch of the Past', *M.o.B.*, p. 123.
27 Quentin Bell, *Virginia Woolf: A Biography*, vol. II, p. 18.
28 VB to VW, 4 November 1904 (Berg).
29 VB to VW, 20 November 1904 (Berg).
30 VB to VW, 7 December 1904 (Berg).
31 Ibid.
32 Ibid.

33 Vanessa Bell, *Notes on Virginia's Childhood*, no page numbers.
34 'Memoir: Monday June 26th 1916', Lytton Strachey, reprinted *The Bloomsbury Group*, ed. S. P. Rosenbaum, p. 6.
35 *The Voyage Out*, p. 134.
36 Clive Bell to VW [? February 1909] (Monk's House).
37 VW to Violet Dickinson [September 1904], *Letters*, vol. I.
38 VW to Violet Dickinson [?22 September 1904], *Letters*, vol. I.
39 VB to VW, 31 March 1905 (Berg).
40 VW to Violet Dickinson [31 December 1903], *Letters*, vol. I.
41 VB to VW, 22 October 1904 (Berg).
42 VW to Violet Dickinson 30 October [1904] (Berg).
43 VB Memoir, 'Notes on Bloomsbury' (AG).
44 23 October 1918, *Diary*, vol. I.
45 VB lecture given at Leighton Park School, 1926 or 1927 (AG).
46 VB Memoir, 'Notes on Bloomsbury' (AG).
47 VW to Violet Dickinson, 26 September [1904], *Letters*, vol. I.

5 MARRIAGE AND BETRAYAL

1 Quoted in Spater and Parsons, *A Marriage of True Minds*, p. 61.
2 'Old Bloomsbury' from *M.o.B.*, p. 169.
3 Ibid., p. 167.
4 VW to VB, Christmas Day [1909], *Letters*, vol. I.
5 'Old Bloomsbury', *M.o.B.*, p. 170.
6 VW to VB [19 August 1909], *Letters*, vol. I.
7 'Old Bloomsbury', *M.o.B.*, p. 165.
8 Fragment of biography of Clive Bell, VW unpublished diary, 14 September [1906]–25 April 1909 (Berg).
9 Clive Bell to VW [9 April 1909] (Monk's House).
10 VB to Margery Snowden, 11 August 1906 (Charleston).
11 VB to Clive Bell, 30 July 1906 (Charleston).
12 VB to Clive Bell, 8 November 1906 (Charleston).
13 VW to Violet Dickinson [12 December 1906], *Letters*, vol. I.
14 VB to Madge Vaughan, 11 December [1906] (Charleston).
15 VW to Violet Dickinson [3 January 1907], *Letters*, vol. I.
16 VB to Julian Bell, 9 May 1936 (QB).
17 VW to Violet Dickinson [?30 December 1906], *Letters*, vol. I.
18 VW to VB [6 February 1907], *Letters*, vol. VI.
19 VW to Violet Dickinson, 31 December 1906, *Letters*, vol. I.
20 VB to VW, 14 December 1906 (Berg).
21 VW to Violet Dickinson [22 December 1906], *Letters*, vol. I.
22 VW to Violet Dickinson 12 April [1907], *Letters*, vol. I.
23 VB to VW, 22 March 1907 (Charleston).
24 VW to Violet Dickinson [25 August 1907 (?1908)], *Letters*, vol. I.
25 VW to Violet Dickinson [1 September 1907], *Letters*, vol. I.

26 VW to Violet Dickinson, 3 June [1907], *Letters*, vol. I.
27 VW to Violet Dickinson [7 July 1907], *Letters*, vol. I.
28 From earliest version of *The Voyage Out*, quoted in Jane Marcus (ed.), *New Feminist Essays on Virginia Woolf*, 'Some Female Versions of Pastoral' by Madeline Moore, p. 86.
29 VW to Clive Bell [May 1908], *Letters*, vol. I.
30 *Flush*, p. 38.
31 Ibid.
32 VB to VW, 25 August 1908 (Berg).
33 VB to Clive Bell [spring 1910] (Charleston).
34 VB to VW, 21 August 1908 (Charleston).
35 VW to Violet Dickinson, 13 May [1908], *Letters*, vol. I.
36 Quoted in Michael Holroyd, *Lytton Strachey: A Biography*, p. 404.
37 Clive Bell to VW, 3 February 1909 (Monk's House).
38 Leonard Woolf, *The Wise Virgins*, p. 96.
39 VW to Violet Dickinson [3 January 1907], *Letters*, vol. I.
40 VW to Clive Bell [February 1907], *Letters*, vol. I.
41 VW to Clive Bell [15 April 1908], *Letters*, vol. I.
42 VW to Clive Bell [6 May 1908], *Letters*, vol. I.
43 *The Voyage Out*, pp. 290–1.
44 Ibid., p. 295.
45 Ibid., pp. 360–1.
46 VB to VW, 11 August 1908 (Berg).
47 Duncan Grant's Diary, 11 January [1918] (HG).
48 VB to VW, 7 August 1908 (Berg).
49 VB to VW, 11 April 1908 (Berg).
50 VB to Clive Bell, 3 November 1908 (Charleston).
51 VB to VW, 8 August 1909 (Berg).
52 VW to Gwen Raverat, 22 March [1925], *Letters*, vol. III.
53 Angelica Garnett, *Deceived with Kindness*, p. 28.
54 VB to VW, 7 February 1909 (Berg).
55 VB to VW, 16 May 1909 (Berg).
56 VW to Lytton Strachey, 1 February [1909], *Letters*, vol. I.
57 VW to Clive Bell [May 1908], *Letters*, vol. I.
58 VB to Clive Bell [June 1910] (Charleston).
59 VB to VW [June 1910] (Berg).
60 VB to Clive Bell [June 1910] (Charleston).
61 VB to VW, 14 September 1909 (Berg).
62 VW to VB, 16 August 1909, *Letters*, vol. I.
63 Clive Bell to VW, 4 November 1908 (Monk's House).
64 Clive Bell to VW, 9 April 1909 (Monk's House).
65 VB to Margery Snowden, 10 May 1909 (Monk's House).
66 12 May 1919, *Diary*, vol. I.

6 WORK IS THE REAL THING

1 Leslie Stephen, *The Mausoleum Book*, p. 93.
2 9 August 1897, VW unpublished diary 1897 (Berg).
3 Ibid., 1 January 1898.
4 August 1903, VW unpublished diary (no. 2) (Berg).
5 Ibid., 'Retrospect', p. 62. (Berg).
6 VW to Emma Vaughan, 27 November [1904], *Letters*, vol. I.
7 VW to Madge Vaughan, 11 December [1904], *Letters*, vol. I.
8 VW to Violet Dickinson 11 November [1904], *Letters*, vol. I.
9 10 January 1905, VW unpublished diary (no. 3) (Berg).
10 VW to Violet Dickinson [May 1905], *Letters*, vol. I.
11 30 June 1929, *Diary*, vol. III.
12 VW to Madge Vaughan, 1 December [1904], *Letters*, vol. I.
13 VB to VW, 13 April 1906 (Berg).
14 VB to VW, 4 April 1905 (Berg).
15 VB to VW, 15 April 1906 (Berg).
16 29 April 1905, VW unpublished diary (no. 3) (Berg).
17 VW to Violet Dickinson, 30 April [1905], *Letters*, vol. I.
18 Untitled VW ms. (Berg), reprinted in 'The Pargiters',
 Mitchell A. Leaska (ed.).
19 VW to VB, 10 August 1908 , *Letters*, vol. I.
20 Ibid.
21 3 January 1905, unpublished diary (no. 3) (Berg).
22 VW to Violet Dickinson, 9 November 1905, *Letters*, vol. I.
23 Leonard Woolf, *An Autobiography*, vol. I (OUP edn),
 p. 102.
24 'Old Bloomsbury', *M.o.B.*, p. 173.
25 VW to Violet Dickinson [20 July 1907], *Letters*, vol. I.
26 VW to Clive Bell, 19 August [1908], *Letters*, vol. I.
27 VW to Violet Dickinson [7 July 1907], *Letters*, vol. I.
28 VW to Clive Bell, 15 April 1908, *Letters*, vol. I.
29 VW to Clive Bell [May 1908], *Letters*, vol. I.
30 Clive Bell to VW [?Summer 1908] (Monk's House).
31 Clive Bell to VW [?October 1908] (Monk's House).
32 VW to Clive Bell [?7 February 1907], *Letters*, vol. I.
33 VW to Clive Bell [24 July 1917], *Letters*, vol. II.
34 VW to Clive Bell [?7 February 1907], *Letters*, vol. I.
35 VW to Elinor Monsell [22 September 1907], *Letters*, vol. I.
36 VW to Clive Bell [22 March 1907], *Letters*, vol. I.
37 VB to Clive Bell, 25 June 1910 (Charleston).
38 VW to Violet Dickinson [3 January 1907], *Letters*, vol. I.
39 VB to Roger Fry, 1 January 1916 (Charleston).
40 VW to VB [12 August 1908], *Letters*, vol. I.
41 VB to VW, 13 August 1908 (Berg).

42 Review of Angelica Garnett, *Deceived with Kindness*, in *Books and Bookmen*, reprinted in *Charleston Newsletter*, no. 9.
43 VW to Lytton Strachey, 28 April [1908], *Letters*, vol. I.
44 VW to Violet Dickinson, 13 May [1908], *Letters*, vol. I.
45 VB to VW, 20 April 1908 (Berg).
46 VB to VW, 12 April 1908 (Berg).
47 VB to VW, 11 March 1909 (Berg).
48 VB to VW, 27 August 1908 (Berg).
49 VB to VW, 2 September 1908 (Berg).
50 VB Memoir of Roger Fry (AG).
51 'Mr Bennett and Mrs Brown', *The Captain's Death Bed and Other Essays*.
52 VB Memoir of Roger Fry (AG).
53 Quoted in *Roger Fry: A Biography*, p. 157.
54 VB to Roger Fry, 6 November 1911 (Charleston).
55 VB Memoir of Roger Fry (AG).
56 VB to Roger Fry, 17 August 1911 (Charleston).
57 *Roger Fry: A Biography*, p. 172.
58 'Mr Bennett and Mrs Brown', *The Captain's Death Bed and Other Essays*.
59 3 November 1918, *Diary*, vol. I.
60 VW to Lady Ottoline Morrell [19 February 1938], *Letters*, vol. IV.
61 *The Waves*, p. 74.
62 VB to VW, 3 May 1927, quoted in Quentin Bell's *Virginia Woolf*, vol. II, p. 126.
63 VW to VB, 8 May 1927, *Letters*, vol. III.
64 VB to VW [October 1931] (Charleston).
65 VB to Roger Fry [?May 1915] (Charleston).
66 VW to VB, 17 March 1921 (Berg).
67 VW to Julian Bell, 28 June 1936 reprinted in *Modern Fiction Studies*, vol. 30, no. 2, summer 1984.
68 VB to Julian Bell, 1 November 1936 (QB).
69 VW to Quentin Bell, 6 May [1928], *Letters*, vol. III.
70 VW to Violet Dickinson, 24 December [1912], *Letters*, vol. II.
71 VB to Roger Fry [? April 1915] (Charleston).
72 VB to Roger Fry [April 1915] (Charleston).
73 VB to Roger Fry [April 1929] (Charleston).
74 2 November 1917, *Diary*, vol. I.
75 11 August 1921, *Diary*, vol. II.
76 VW to VB, 5 March 1927, *Letters*, vol. III.
77 *To the Lighthouse*, p. 48.
78 VW to VB [?8 June 1927], *Letters*, vol. III.
79 20 July 1925, *Diary*, vol. III.
80 VW to Roger Fry, 27 May 1927, *Letters*, vol. III.

81 7 November 1928, *Diary*, vol. III.
82 VW to VB [15 October 1931], *Letters*, vol. IV.
83 VW to VB [5 June 1939] reprinted in Frances Spalding, *Vanessa Bell*, p. 309.
84 VW to VB, 8 May 1927, *Letters*, vol. III.
85 VW to VB, 25 May 1927, *Letters*, vol. III.
86 VB to VW, 11 May [1927] (Berg).
87 Reprinted in *The Bloomsbury Group*, ed. S. P. Rosenbaum, pp. 169–73.
88 VW to VB, 29 January 1918, *Letters*, vol. II.
89 VW to VB, 12 May [1928], *Letters*, vol. III.
90 VB to Roger Fry [?September 1917] (Charleston).
91 VW to VB [18 June 1919], *Letters*, vol. II.
92 Quoted in John Lehmann, *Thrown to the Woolfs*, p. 27.
93 VW to Duncan Grant, 6 March 1917, *Letters*, vol. II.
94 VW to VB, 14 April [1927], *Letters*, vol. III.
95 VW to VB, 22 April 1918, *Letters*, vol. II.
96 VW to VB, 2 June 1926, *Letters*, vol. III.
97 Quoted in Quentin Bell, *Virginia Woolf*, vol. II, p. 140.
98 21 September 1929, *Diary*, vol. III.

7 HUSBANDS AND SISTERS

 1 'Old Bloomsbury', *M.o.B.*, p. 166.
 2 22 January 1919, *Diary*, vol. I.
 3 VW to VB [21 July 1911], *Letters*, vol. I.
 4 Quentin Bell, *Virginia Woolf*, vol. I, p. 129.
 5 'Old Bloomsbury', *M.o.B.*, p. 172.
 6 VW to Molly MacCarthy [March 1912], *Letters*, vol. I.
 7 Lytton Strachey to Duncan Grant, 11 October 1905, quoted in Michael Holroyd, *Lytton Strachey: A Biography*, p. 268.
 8 VW to VB [?8 June 1911], *Letters*, vol. I.
 9 VB to VW, 17 July 1910 (Berg).
10 VB to VW [11 August 1908] (Monk's House).
11 VB to VW, 30 July 1908 (Berg).
12 Lytton Strachey to Leonard Woolf, 19 February 1909, quoted in Michael Holroyd, *Lytton Strachey: A Biography*, p. 405.
13 17 October 1924, *Diary*, vol. II.
14 VB to Clive Bell, 29 November 1909 (Charleston).
15 VB to Clive Bell, 7 October 1910 (Charleston).
16 *The Voyage Out*, p. 152.
17 VW to Molly MacCarthy [March 1912], *Letters*, vol. I.
18 5 February 1921, *Diary*, vol. II.
19 VB to Roger Fry, 15 November 1911 (Charleston).
20 VW to VB, 21 July 1911 (Berg).
21 VB Memoir of Roger Fry (AG).

22 Roger Fry to VB, 18 July 1916 (Charleston).
23 Roger Fry to VB, 15 September 1912 (Charleston).
24 Roger Fry to VB [?1911] (Charleston).
25 VB to Roger Fry, 9 August 1911 (Charleston).
26 VB to Roger Fry, 12 October 1912 (Charleston).
27 VB to Roger Fry, 15 August 1911 (Charleston).
28 VB to Roger Fry, 5 September 1911 (Charleston).
29 VW to Roger Fry, 2 November [1921], *Letters*, vol. II.
30 VB to Roger Fry, 3 July 1911 (Charleston).
31 VW to Roger Fry, 2 November [1921], *Letters*, vol. II.
32 *To the Lighthouse*, p. 49.
33 Ibid., p. 141.
34 Ibid., p. 143.
35 VW to VB, 10 August 1908, *Letters*, vol. I.
36 VW to Molly MacCarthy [March 1912], *Letters*, vol. I.
37 Ibid.
38 VB to Clive Bell, 11 October 1911 (Charleston).
39 Leonard Woolf to VW, 12 January 1912 (Monk's House).
40 VW to Leonard Woolf, 1 May [1912], *Letters*, vol. I.
41 VB to Roger Fry, 12 October 1912 (Charleston).
42 *The Voyage Out*, p. 79.
43 '22 Hyde Park Gate', *M.o.B.*, p. 150.
44 *The Voyage Out*, p. 73.
45 Ibid., p. 74.
46 '22 Hyde Park Gate', *M.o.B.*, p. 147.
47 Ibid., p. 150.
48 'A Sketch of the Past', *M.o.B.*, p. 69.
49 VW to Katherine Cox, 7 February 1912, *Letters*, vol. I.
50 *Night and Day*, p. 73.
51 VW to Violet Dickinson, 22 May [1912], *Letters*, vol. I.
52 VW to Violet Dickinson [4 June 1912], *Letters*, vol. I.
53 VB to VW [12 June 1912] (Berg).
54 *The Voyage Out*, p. 269.
55 Clive Bell to VW [May/June 1912] (Monk's House).
56 27 July 1918, *Diary*, vol. I.
57 VB to VW, 26 September 1912 (Berg).
58 VW to VB, 2 June 1926, *Letters*, vol. III.
59 VB to Leonard Woolf, 29 August 1912 (Monk's House).
60 VB to VW, 19 August 1912 (Berg).
61 VW to Molly MacCarthy, 28 September 1912, *Letters*, vol. II.
62 VW to Katherine Cox, 4 September 1912, *Letters*, vol. II.
63 VB to Clive Bell, 27 December [1912] (Charleston).
64 Leonard Woolf to Lytton Strachey, 2 October 1908 (Monk's House).
65 Leonard Woolf to Lytton Strachey, 17 November 1907 (Monk's House).

66 Leonard Woolf to Lytton Strachey, 25 November 1908 (Monk's House).
67 Leonard Woolf to Lytton Strachey, 19 May 1907 (Monk's House).
68 Quoted in Spater and Parsons, *A Marriage of True Minds*, pp. 61–2.
69 VW to Ethel Smyth, 15 August 1930, *Letters*, vol. IV.
70 23 July 1927, *Diary*, vol. III.
71 VW to Roger Fry, 27 May 1927, *Letters*, vol. III.
72 VW to Violet Dickinson [?29] October 1912, *Letters*, vol. II.
73 VW to Violet Dickinson, 11 April [1913], *Letters*, vol. II.
74 VB to VW, 26 January 1913 (Berg).
75 VW to Ethel Sands [9 February 1927], *Letters*, vol. III.
76 VW to Gwen Raverat, 1 May [1925], *Letters*, vol. III.
77 *Mrs Dalloway*, p. 89.
78 [5 September 1926], *Diary*, vol. III.
79 Vita Sackville-West to Harold Nicolson, 17 August 1926, quoted in Nigel Nicolson, *Portrait of a Marriage*, p. 206.

8 SONS AND LOVERS

1 Roger Fry to Helen Anrep, quoted in Frances Spalding, *Vanessa Bell*, p. 210.
2 VB to Clive Bell, 8 January [1913] (Charleston).
3 13 October 1929, *Diary*, vol. III.
4 *To the Lighthouse*, p. 42.
5 VB to Roger Fry, 8 September [1913] (Charleston).
6 VB Memoir IV, (AG).
7 VB to Roger Fry [May 1915] (Charleston).
8 VB to David Garnett, 7 December 1915 (HG).
9 VB to Duncan Grant [15 March 1916] (HG).
10 VB to Duncan Grant [1916] (HG).
11 2 January [1918] Duncan Grant's diary (HG).
12 Ibid., 19 February [1918].
13 Ibid., 11 January [1918].
14 Ibid., 3 February [1918].
15 Duncan Grant to Clive Bell, 26 December 1918 (Charleston).
16 VW to VB [27 February 1919], *Letters*, vol. II.
17 VW to VB, 29 April 1927, *Letters*, vol. III.
18 VB to Duncan Grant, 5 February 1930 (HG).
19 VB to Duncan Grant, 13 February [1930] (HG].
20 VW to VB, 14 April [1927], *Letters*, vol. III.
21 VB to VW, 23 April [1927] (Berg).
22 VB to Duncan Grant [1923] (HG).
23 VW to Roger Fry, 16 September 1925, *Letters*, vol. III.
24 23 January 1927, *Diary*, vol. III.
25 Duncan Grant to VB, 21 April 1922 (HG).
26 20 June 1928, *Diary*, vol. III.

27 17 August 1937, *Diary*, vol. V.
28 11 January [1918], Duncan Grant's Diary (HG).
29 10 September 1921, *Diary*, vol. II.
30 VB to Duncan Grant, 7 February [1930] (HG).
31 VW to Leonard Woolf, 25 September 1928, *Letters*, vol. IV.
32 VB to Julian Bell, 4 March 1936 (QB).
33 VW to VB [?16 October 1928] *Letters*, vol. IV.
34 VW to VB, 22 May 1927, *Letters*, vol. III.
35 15 December 1922, *Diary*, vol. II.
36 VW to VB, 13 June [1926], *Letters*, vol. III.
37 VB to VW, 16 June 1926 (Berg).
38 Vita Sackville-West to VW, 14 February [1926].
39 VW to Vita Sackville-West [14 June 1927] *Letters*, vol. III.
40 VB to VW, 31 January 1927 (Berg).
41 Vita Sackville-West to VW, 11 October 1928, *Letters*, vol. III, Appendix.
42 VB to VW, 27 April 1935 (Monk's House).
43 VW to Vita Sackville-West, 5 April [1929], *Letters*, vol. IV.
44 23 February 1926, *Diary*, vol. III.
45 31 May 1928, *Diary*, vol. III.
46 20 June 1928, *Diary*, vol. III.
47 30 June 1926, *Diary*, vol. III.
48 Quoted in Victoria Glendinning, *Vita*, p. 163.
49 30 June 1926, *Diary*, vol. III.
50 26 July 1930, *Diary*, vol. III.
51 19 August 1929, *Diary*, vol. III.
52 VW to VB, 21 April 1927, *Letters*, vol. III.
53 VB to Roger Fry [1924] (Berg).
54 8 April 1925, *Diary*, vol. III.
55 28 July 1939, *Diary*, vol. V.
56 VB to Julian Bell, 7 March 1937 (QB).

9 ART VERSUS LIFE

1 VB to Roger Fry, 27 April 1916 (Charleston).
2 VW to VB, 30 July 1910, *Letters*, vol. I.
3 *Night and Day*, p. 10.
4 Ibid., p. 39.
5 VW to VB, 14 May [1916], *Letters*, vol. II.
6 VW to VB, 24 September 1916, *Letters*, vol. II.
7 VB to Roger Fry [October/November 1916] (Charleston).
8 2 November 1917, *Diary*, vol. I.
9 VB to Roger Fry, 29 September [1930] (Charleston).
10 VB to Roger Fry, 2 November [1918] (Charleston).
11 Angelica Garnett, *Deceived with Kindness*, p. 90.
12 17 February, 1931, *Diary*, vol. IV.

13 15 September 1926, *Diary*, vol. III.
14 28 September 1926, *Diary*, vol. III.
15 15 June 1935, *Diary*, vol. IV.
16 VW to Gwen Raverat, 11 March [1925], *Letters*, vol. III.
17 2 January 1923, *Diary*, vol. II.
18 8 August 1928, *Diary*, vol. III.
19 VW to Gwen Raverat, 1 May [1925], *Letters*, vol. III.
20 4 January 1929, *Diary*, vol. III.
21 15 June 1929, *Diary*, vol. III.
22 2 January 1923, *Diary*, vol. II.
23 19 August 1929, *Diary*, vol. III.
24 Roger Fry to VB, 3/4 September 1920 (Charleston).
25 VB to VW [?19 October 1916], *Letters*, vol. II.
26 VW to VB, 22 May 1927, *Letters*, vol. III.
27 VB to Duncan Grant, [1914] (Charleston).
28 VB to Clive Bell, 4 March 1930 (Charleston).
29 14 August 1928, *Diary*, vol. III.
30 26 August 1922, *Diary*, vol. II.
31 2 January 1923, *Diary*, vol. II.
32 VB to Clive Bell, 26 May 1935 (Charleston).
33 8 May 1932, *Diary*, vol. V.
34 VB to Clive Bell, 17 February 1928 (Charleston).
35 VB to Roger Fry, 13 April 1929 (Charleston).
36 VB to Clive Bell, 1 June 1931 (Charleston).
37 VB to Clive Bell [late July 1929] (Charleston).
38 15 June 1929, *Diary*, vol. III.
39 VW to VB, 29 April [1928], *Letters*, vol. III.
40 VW to QB, 24 April 1931, *Letters*, vol. IV.
41 *To the Lighthouse*, p. 148.
42 Ibid., p. 151.
43 22 September 1925, *Diary*, vol. III.
44 2 August 1924, *Diary*, vol. II.
45 13 April 1929, *Diary*, vol. III.
46 Roger Fry to Lady Fry, 14 June 1913, *Letters of Roger Fry*, ed. Denys Sutton, 2 vols, Chatto & Windus, 1972.
47 VW to VB, 16 August [1916], *Letters*, vol. II.
48 Roger Fry to VB [summer 1917] (Charleston).
49 'A Sketch of the Past', *M.o.B.*, p. 72.
50 28 March 1930, *Diary*, vol. III.
51 1 April 1930, *Diary*, vol. III.
52 VW to Margaret Llewelyn Davies [23 January 1916], *Letters*, vol. II.
53 15 November 1919, *Diary*, vol. I.
54 3 November 1918, *Diary*, vol. I.
55 VB to Roger Fry, 6 August [1930] (Charleston).

56 2 October 1935, *Diary*, vol. IV.
57 20 June 1933, *Diary*, vol. IV.
58 VW to VB, 19 April 1928, *Letters*, vol. III.
59 2 August 1924, *Diary*, vol. II.

10 THE PLUNGE INTO DEEP WATERS

1 VB to Ling Su-Hua, July 1939, quoted in Frances Spalding, *Vanessa Bell*, p. 338.
2 VB to Margery Snowden, 3 May 1904 (Charleston).
3 Hearsay from Leonard Woolf, quoted in Quentin Bell, *Virginia Woolf*, vol. II, p. 18.
4 VW to Katherine Cox, 7 February [1912], *Letters*, vol. I.
5 Leonard Woolf, *An Autobiography*, vol. 2 (OUP edn), p. 14.
6 VB to Roger Fry, 2 May 1915 (Charleston).
7 6 March 1920, *Diary*, vol. II.
8 19 July 1922, *Diary*, vol. II.
9 VB to David Garnett, 22 September 1915 (HG).
10 VB memoir of Roger Fry (AG).
11 Ibid.
12 *The Waves*, p. 179.
13 VB to Duncan Grant, 5 February [1930] (Charleston).
14 Roger Fry to VB [c.1911–12] (Charleston).
15 VB to Roger Fry, 6 September 1911 (Charleston).
16 VW to Ethel Smyth, 17 March [16, 1930], *Letters*, vol. IV.
17 VB to Roger Fry, 7 January 1913 (Charleston).
18 Julian Bell to VB, 22 November [1935].
19 28 September 1926, *Diary*, vol. III.
20 Ibid.
21 30 September 1926, *Diary*, vol. III.
22 VW to Ethel Smyth, 22 June 1930, *Letters*, vol. IV.
23 2 October 1932, *Diary*, vol. IV.
24 VB to Roger Fry [April 1924] (Charleston).
25 VB to VW, 11 May [1927] (Berg).
26 16 May 1927, *Diary*, vol. III.
27 DG to VW [May 1927] (Monk's House).
28 VW to Ethel Smyth, 13 May [14, 1930] *Letters*, vol. IV.
29 VW to Ethel Smyth, 22 June [1930] *Letters*, vol. IV.
30 18 August 1921, *Diary*, vol. II.
31 VW to VB, 22 May 1927, *Letters*, vol. III.
32 Roger Fry to VB, 17 March 1919 (Charleston).
33 VW to Janet Case [19 November 1919] *Letters*, vol. II.
34 VW to VB, 24 May 1923, *Letters*, vol. III.
35 VW to Ethel Smyth, 29 November 1930, *Letters*, vol. IV.
36 11 November 1936, *Diary*, vol. V.

37 8 December 1939, *Diary*, vol. V.
38 2 December 1939, *Diary*, vol. V.
39 8 November 1930, *Diary*, vol. III.
40 VW to Ethel Smyth, 14 November 1930, *Letters*, vol. IV.
41 *A Room of One's Own*, pp. 93–4.
42 Ibid.
43 *Collected Works of C. G. Jung*, vol. 9, para. 167.
44 VW to VB, 21 April 1927, *Letters*, vol. III.
45 VW to VB, 14 April 1927, *Letters*, vol. III.
46 VW to VB, 16 February 1919, *Letters*, vol. II.
47 VB to VW, 3 May [1927] (Berg).
48 *To the Lighthouse*, pp. 49, 50.
49 Ibid., p. 49.
50 Ibid., pp. 50–1.
51 *Collected Works of C. G. Jung*, vol. 9, para. 169.
52 *To the Lighthouse*, p. 49.
53 2 January 1923, *Diary*, vol. II.
54 17 March 1923, *Diary*, vol. II.
55 VW to Ethel Smyth, 19 September 1930, *Letters*, vol. V.
56 *Collected Works of C. G. Jung*, vol. 9, para. 185.
57 20 June 1928, *Diary*, vol. III.
58 VW to Ethel Smyth, 10 March [1930], *Letters*, vol. IV.
59 2 January 1931, *Diary*, vol. IV.
60 *To the Lighthouse*, pp. 162, 163.
61 VW to VB [13 November 1918], *Letters*, vol. II.
62 10 November 1920, *Diary*, vol. II.
63 30 May 1938, *Diary*, vol. V.
64 12 May 1919, *Diary*, vol. II.
65 15 October 1923, *Diary*, vol. II.
66 *Mrs Dalloway*, pp. 60–1.
67 VB to Roger Fry, 7 January 1913 (Charleston).
68 VB to Roger Fry, [July 1913] (Charleston).

11 DEBTS REPAID

1 2 September 1930, *Diary*, vol. III.
2 8 September 1930, *Diary*, vol. III.
3 VW to Ethel Smyth, 1 July [1930], *Letters*, vol. IV.
4 2 September 1930, *Diary*, vol. III.
5 VB to Duncan Grant, 13 February [1930] (HG).
6 19 August 1929, *Diary*, vol. III.
7 [20 February] 1930, *Diary*, vol. III.
8 VW to Ethel Smyth, 15 August 1930, *Letters*, vol. IV.
9 VB to Duncan Grant [4 February 1930] (HG).
10 VB to Duncan Grant, 13 February [1930] (HG).

11 2 September 1930, *Diary*, vol. III.
12 VW to Dorothea Stephen [?28 October 1921], *Letters*, vol. II.
13 5 April 1924, *Diary*, vol. II.
14 4 February 1922, *Diary*, vol. II.
15 Julian Bell to VB, 16 July [1935], *Julian Bell: Essays, Poems and Letters*, Quentin Bell (ed.).
16 Quoted in Stansky and Abrahams, *Journey to the Frontier*, p. 100.
17 [27 November] 1934, *Diary*, vol. IV.
18 VW to Quentin Bell, 11 April 1931, *Letters*, vol. IV.
19 Julian Bell to VB, 31 October–1 November 1936, *Julian Bell: Essays, Poems and Letters*, Quentin Bell (ed.).
20 27 December 1931, *Diary*, vol. IV.
21 14 December 1929, *Diary*, vol. III.
22 VW to Ethel Smyth, 29 December [1931], *Letters*, vol. IV.
23 22 January 1932, *Diary*, vol. V.
24 22 June 1927, *Diary*, vol. III.
25 VW to Ethel Smyth [21 March 1932], *Letters*, vol. V.
26 VW to VB, 11 April 1932, *Letters*, vol. V.
27 8 April 1921, *Diary*, vol. II.
28 21 April 1932, *Diary*, vol. IV.
29 VB to Roger Fry, 4 August [1932] (Charleston).
30 Roger Fry to Vanessa Bell, 30 January 1933 (Charleston).
31 2 October 1934, *Diary*, vol. IV.
32 15 September 1934, *Diary*, vol. IV.
33 18 September 1934, *Diary*, vol. IV.
34 6 Feb. 1935, *Diary*, vol. IV.
35 VB to Julian Bell, 1 November 1935 (QB).
36 26 February 1932, *Diary*, vol. IV.
37 VW to VB, 24 April 1929, *Letters*, vol. IV.
38 Quoted in Stansky and Abrahams, *Journey to the Frontier*, p. 200.
39 VB to Julian Bell, 13 December [1935] quoted in Frances Spalding, *Vanessa Bell*, p. 284.
40 VW to Julian Bell, 11 March 1936, *Letters*, vol. V.
41 12 February 1937, *Diary*, vol. V.
42 2 May 1932, *Diary*, vol. IV.
43 Julian Bell to Eddie Playfair, 4 January 1937, *Julian Bell: Essays, Poems and Letters*, Quentin Bell (ed.).
44 15 April 1937, *Diary*, vol. V.
45 21 April 1937, *Diary*, vol. V.
46 Julian Bell to VB [April 1936], quoted in Stansky and Abrahams, *Journey to the Frontier*, p. 294.
47 Clive Bell to VB [June 1918] (Charleston).
48 Leonard Woolf, *The Wise Virgins*, p. 84.
49 VW to Vita Sackville-West [21 July 1937], *Letters*, vol. VI.

50 VW to VB [15 August 1937], *Letters*, vol. VI.
51 VW to Ethel Smyth, 5 August [1937], *Letters*, vol. VI.
52 VW to W. A. Robson, 26 July [1937], *Letters*, vol. VI.
53 VB to Vita Sackville-West, 2 April 1941 (NN).
54 VB to Vita Sackville-West, 16 August [1937] (Berg), quoted in Frances Spalding, *Vanessa Bell*, p. 299.
55 26 September 1937, *Diary*, vol. V.
56 VW to VB, 2 October [1937], *Letters*, vol. VI.
57 17 August 1937, *Diary*, vol. V.
58 Letter to Julian's girl-friend, 24 August [1937], quoted in Frances Spalding, *Vanessa Bell*, p. 300.
59 VW to VB [13 February 1938], *Letters*, vol. VI.
60 VB to VW, 4 February 1938 (Berg), quoted in *Letters*, vol. VI, p. 211.
61 22 March 1938, *Diary*, vol. V.
62 12 April 1938, *Diary*, vol. V.
63 3 June 1938, *Diary*, vol. V.
64 5 June 1938, *Diary*, vol. V.
65 11 June 1938, *Diary*, vol. V.
66 VB to VW, 13 March 1940 (Berg).
67 20 March 1940, *Diary*, vol. V.
68 VW to VB, [15 October 1931], *Letters*, vol. IV.
69 25 July 1940, *Diary*, vol. V.
70 VB to VW [October 1931] (Berg).
71 VB to Julian Bell, 9 May 1936 (QB).
72 6 May 1940, *Diary*, vol. V.
73 Ibid.
74 Ibid.
75 [3 June 1940], *Diary*, vol. V.
76 Angelica Garnett, *Deceived with Kindness*, p. 157.
77 23 November 1940, *Diary*, vol. V.
78 6 October 1940, *Diary*, vol. V.
79 23 November 1940, *Diary*, vol. V.
80 VB to Duncan Grant [May 1940] (HG).
81 Duncan Grant to VB, 24 May 1940 (Charleston).
82 VW to Ethel Smyth [12 September] 1940, *Letters*, vol. VI.
83 20 October 1940, *Diary*, vol. V.
84 12 October 1940, *Diary*, vol. V.
85 VW to Ethel Smyth, 25 September 1940, *Letters*, vol. VI.
86 *Between the Acts*, p. 139.
87 Ibid., p. 141.
88 *To the Lighthouse*, p. 50.
89 Ibid., p. 51.
90 Octavia Wilberforce to Elizabeth Robins, 14 March 1941 (Monk's House).

91 Octavia Wilberforce to Elizabeth Robins, 23 December 1940 (Monk's House).
92 *Between the Acts*, p. 55.
93 24 December 1940, *Diary*, vol. V.
94 22 October 1937, *Diary*, vol. V.
95 VW to Ethel Smyth, 2 August [1930], *Letters*, vol. IV.
96 25 June 1935, *Diary*, vol. IV.
97 VW to Violet Dickinson [22 September 1907], *Letters*, vol. I.
98 VW to VB, 22 May 1927, *Letters*, vol. III.
99 VW to Quentin Bell [30 August 1933], *Letters*, vol. IV.
100 26 December 1929, *Diary*, vol. III.
101 Octavia Wilberforce to Elizabeth Robins, 20 March 1941 (Monk's House).
102 *The Waves*, p. 244.
103 Octavia Wilberforce to Elizabeth Robins, 20 March 1941 (Monk's House).
104 24 March 1941, *Diary*, vol. V.
105 VB to VW, 20 March 1941 (Monk's House).
106 VW to VB, [?23 March 1941] *Letters*, vol. VI.
107 VW to Gwen Raverat, 8 April 1925, *Letters*, vol. III.
108 *Between the Acts*, pp. 148, 149.
109 VW to Leonard Woolf [?18 March 1941], *Letters*, vol. VI.
110 VB to Vita Sackville-West, 29 March 1941 (NN).
111 Ibid.
112 VB to Vita Sackville-West, 22 April [1941] (NN).
113 Ibid.
114 VB to Vita Sackville-West , 29 April [1941] (NN).

AFTERWORD
1 VB to Vita Sackville-West, 29 March [1941] (NN).
2 VB to Vita Sackville-West, 8 April [1941] (NN).
3 Quoted in Victoria Glendinning, *Vita*, p. 315.
4 John Lehmann, *Thrown to the Woolfs*, pp. 112–13.
5 VW to Katherine Cox [April 1912], *Letters*, vol. I.
6 1 April 1930, *Diary*, vol. III.
7 22 December 1927, *Diary*, vol. III.

Select Bibliography

Annan, Noel. *Leslie Stephen: The Godless Victorian* (London: Weidenfeld & Nicolson, 1984; University of Chicago Press, 1984)

Anscombe, Isabelle. *Omega and After* (London: Thames and Hudson, 1981)

Bazin, Nancy Topping. *Virginia Woolf and the Androgynous Vision* (New Brunswick, NJ: Rutgers University Press, 1973)

Bell, Clive. *Old Friends: Personal Recollections* (London: Chatto & Windus, 1956)

Bell, Quentin (ed.). *Julian Bell: Essays, Poems and Letters* (London: The Hogarth Press, 1938)

Bloomsbury (London: Weidenfeld & Nicolson, 1968; New York: Basic Books, 1969)

Virginia Woolf: A Biography, 2 vols (London: The Hogarth Press, 1972; New York: Harcourt Brace Jovanovitch, 1972)

Bell, Vanessa. *Notes on Virginia's Childhood: A Memoir*. Richard F. Schaubeck Jr. (ed.) (New York: Frank Hallman, 1974)

Vanessa Bell's Family Album. Compiled by Quentin Bell and Angelica Garnett (London: Jill Norman & Hobhouse, 1981)

Brewster, Dorothy. *Virginia Woolf* (New York University Press, 1962)

Burstyn, Joan N. *Victorian Education and the Ideal of Womanhood* (London: Croom Helm, 1980; Totowa, NJ: Barnes & Noble, 1980)

Cameron, Julia Margaret. *Victorian Photographs of Famous Men and Fair Women*, intro. Virginia Woolf and Roger Fry (London: The Hogarth Press, 1926; New York: Harcourt Brace & Co., 1927)

Clark, Kenneth. *Another Part of the Wood* (London: John Murray, 1974)

The Other Half (London: John Murray, 1977)

Collins, Judith. *The Omega Workshops* (London: Secker & Warburg, 1983; University of Chicago, 1984)

DeSalvo, Louise. *Virginia Woolf's First Voyage: A Novel in the Making* (London: Hutchinson, 1980; Totowa, NJ: Rowman & Littlefield, 1980)

(ed.) with Mitchell A. Leaska, *The Letters of Vita Sackville-West to Virginia Woolf* (London: Hutchinson, 1985; New York: William Morrow, 1985)

Virginia Woolf: The Impact of Childhood Sexual Abuse on Her Life and Work (London: The Women's Press, 1989; Boston: The Beacon Press, 1989)

Edel, Leon. *Bloomsbury: A House of Lions* (London: The Hogarth Press, 1979; New York: Avon Books, 1979)

Forster, E. M. *Virginia Woolf* (Cambridge University Press, 1942; New York: Harcourt Brace, 1942)

Fry, Roger. *Vision and Design* (London: Chatto & Windus, 1920)

Furbank, P. N. *E. M. Forster: A Life*, 2 vols (London: Secker & Warburg, 1977, 1978; OUP paperback, 1 vol. 1979)

Garnett, Angelica. *Deceived with Kindness: A Bloomsbury Childhood* (London: Chatto & Windus, 1984; Harcourt Brace Jovanovitch, 1985)

Garnett, David. *The Golden Echo* (London: Chatto & Windus, 1954)
 The Flowers of the Forest (London: Chatto & Windus, 1955)
 The Familiar Faces (London: Chatto & Windus, 1962)
 Great Friends (London: Macmillan, 1979)

Gerin, Winifred. *Anne Thackeray Ritchie: A Biography* (Oxford University Press, 1985)

Gernsheim, Helmut. *Julia Margaret Cameron: Her Life and Photographic Work* (London: Gordon Fraser, 1975)

Gillespie, Diane Filby. *The Sisters' Arts: The Writing and Painting of Virginia Woolf and Vanessa Bell* (Syracuse University Press, 1988)

Glendinning, Victoria. *Vita: A Biography of Vita Sackville-West* (London: Weidenfeld & Nicolson, 1983; New York: Alfred A. Knopf, 1983)

Gordon, Lyndall. *Virginia Woolf: A Writer's Life* (Oxford University Press, 1984; New York: W. W. Norton, 1984)

Harrod, Roy. *The Life of John Maynard Keynes* (London: Macmillan, 1951)

Heilbrun, Carolyn G. *Towards a Recognition of Androgyny* (New York: Alfred A. Knopf, 1964)

Holroyd, Michael. *Lytton Strachey: A Biography* 2 vols (London: Heinemann, 1967, 1978)

Johnstone, J. K. *The Bloomsbury Group* (London: Secker & Warburg, 1954)

Jung, C. G. *Memories, Dreams, Reflections* (London: Collins, 1963; New York: Random House, 1961)
 The Archetypes and the Collective Unconscious, vol. 9, part 1 of *Collected Works* (London: Routledge & Kegan Paul, 1968)

Keynes, John Maynard. *Two Memoirs* (London: Macmillan, 1949)

Leaska, Mitchell A., *The Pargiters* (London: The Hogarth Press, 1978; New York: Harcourt Brace Jovanovich, 1978)

Lehmann, John. *The Whispering Gallery: Autobiography* (London: Longmans, 1955)
 Thrown to the Woolfs (London: Weidenfeld & Nicolson, 1978)

Levy, Paul. *Moore: G. E. Moore and the Cambridge Apostles* (London: Weidenfeld & Nicolson, 1978)

Select Bibliography

Maitland, Frederick William. *The Life and Letters of Leslie Stephen* (London: Duckworth, 1906)

Marcus, Jane (ed.). *New Feminist Essays on Virginia Woolf* (London: Macmillan, 1981)

McNaron, Toni A. H. (ed.). *The Sister Bond* (London and New York: Pergamon Press, 1985)

Nicolson, Nigel. *Portrait of a Marriage* (London: Weidenfeld & Nicolson, 1973)

Noble, Joan Russell (ed.). *Recollections of Virginia Woolf* (New York: William Morrow, 1972)

Partridge, Frances. *A Pacifist's War* (London: The Hogarth Press, 1978)
Memories (London: Victor Gollancz, 1981)

Poole, Roger. *The Unknown Virginia Woolf* (Cambridge University Press, 1978)

Rose, Phyllis, *Woman of Letters: A Life of Virginia Woolf* (London: Pandora Press, 1986; New York: Oxford University Press, 1978)

Rosenbaum, S. P. (ed.) *The Bloomsbury Group: A Collection of Memories, Commentary and Criticism* (London: Croom Helm, 1975; University of Toronto Press, 1975)

Shone, Richard. *Bloomsbury Portraits* (Oxford: Phaidon Press, 1976)

Spalding, Frances. *Roger Fry: Art and Life* (London: Elek/Granada, 1980)
Vanessa Bell (London: Weidenfeld & Nicolson, 1983; New Haven: Ticknor & Fields, 1983)

Spater, George and Parsons, Ian. *A Marriage of True Minds: An Intimate Portrait of Leonard and Virginia Woolf* (London: Jonathan Cape and The Hogarth Press, 1977; New York: Harcourt Brace Jovanovitch, 1977)

Stansky, Peter and Abrahams, William. *Journey to the Frontier: Julian Bell & John Cornford: Their Lives and the 1930s* (London: Constable, 1966; New York: Little, Brown & Co., 1966)

Stephen, Sir Leslie. *Sir Leslie Stephen's Mausoleum Book* intro. Alan Bell (Oxford University Press, 1977)

Trombley, Stephen. *All That Summer She Was Mad: Virginia Woolf and her Doctors* (London: Junction Books, 1981)

Warner, Eric (ed.). *Virginia Woolf: A Centenary Perspective* (London: Macmillan, 1984; New York: St Martin's Press, 1984)

Watney, Simon. *English Post-Impressionism* (London: Studio Vista, 1980)

Woolf, Leonard. *The Wise Virgins* (London: Edward Arnold, 1914)
Sowing: An Autobiography of the Years 1880–1904 (London: The Hogarth Press, 1960; New York: Harcourt Brace Jovanovitch, 1960)
Growing: An Autobiography of the Years 1904–1911 (London: The Hogarth Press, 1961; New York: Harcourt Brace Jovanovitch, 1962)
Beginning Again: An Autobiography of the Years 1911–1918 (London: The Hogarth Press, 1964; New York: Harcourt Brace Jovanovitch, 1964)

Downhill All The Way: An Autobiography of the Years 1919–1939
(London: The Hogarth Press, 1967; Harcourt Brace Jovanovitch, 1967)
*The Journey not the Arrival Matters: An Autobiography of the Years
1939–1969* (London: The Hogarth Press, 1969; New York: Harcourt
Brace Jovanovitch, 1970)
All 5 volumes published in 2 volume paperback:
An Autobiography, vols 1 and 2 (Oxford University Press, OUP, 1980)
Woolf, Virginia. *The Letters: Vol. 1: The Flight of the Mind 1888–1912*,
Nigel Nicolson and Joanne Trautmann (eds) (London: Chatto &
Windus, 1975; New York: Harcourt Brace Jovanovitch, 1975)
The Letters: Vol. 2: The Question of Things Happening 1912–1922, Nigel
Nicolson and Joanne Trautmann (eds) (London: Chatto & Windus,
1976; New York: Harcourt Brace Jovanovitch, 1976)
The Letters: Vol. 3: A Change of Perspective 1923–1928, Nigel Nicolson
and Joanne Trautmann (eds) (London: Chatto & Windus, 1977; New
York: Harcourt Brace Jovanovitch, 1977)
The Letters: Vol. 4: A Reflection of the Other Person 1929–1931, Nigel
Nicolson and Joanne Trautmann (eds) (London: Chatto & Windus,
1978; New York: Harcourt Brace Jovanovitch, 1978)
The Letters: Vol. 5: The Sickle Side of the Moon 1932–1935, Nigel
Nicolson and Joanne Trautmann (eds) (London: Chatto & Windus,
1979; New York: Harcourt Brace Jovanovitch, 1978)
The Letters: Vol. 6: Leave the Letters till we're Dead 1936–1941, Nigel
Nicolson and Joanne Trautmann (eds) (London: Chatto & Windus,
1980; New York: Harcourt Brace Jovanovitch, 1980)
The Diary of Virginia Woolf, Vol. 1. 1915–1919, Anne Olivier Bell (ed.)
(London: The Hogarth Press, 1977; New York: Harcourt Brace Jova-
novitch, 1977)
The Diary, Vol. 2. 1920–1924, Anne Olivier Bell (ed.) (London: The
Hogarth Press, 1978; New York: Harcourt Brace Jovanovitch, 1978)
The Diary, Vol. 3. 1925–1930, Anne Olivier Bell (ed.) (London: The
Hogarth Press, 1980; New York: Harcourt Brace Jovanovitch, 1980)
The Diary, Vol. 4. 1931–1935, Anne Olivier Bell (ed.) (London: The
Hogarth Press, 1982; New York: Harcourt Brace Jovanovitch, 1982)
The Diary, Vol. 5. 1936–1941, Anne Olivier Bell (ed.) (London: The
Hogarth Press, 1984; New York: Harcourt Brace Jovanovitch, 1984)
Moments of Being. Unpublished Autobiographical Writings, Jeanne Schul-
kind (ed.) (London: The Hogarth Press, 1985; New York: Harcourt
Brace Jovanovitch, 1985)
The Common Reader (London: The Hogarth Press: 1925; New York:
Harcourt Brace & Co., 1925)
Woolf, Virginia. *The Voyage Out*. (London: Duckworth, 1915; New York:
George H. Doran, 1920, Harcourt Brace & Co., 1926; paperback:
Grafton, 1978)

Kew Gardens. (Richmond: The Hogarth Press, 1919, illustrations by Vanessa Bell, 1927)

Night and Day. (London: Duckworth, 1919; New York: George H. Doran, 1920, Harcourt Brace & Co., 1931; paperback: Grafton, 1978)

Jacob's Room. (London: The Hogarth Press, 1922; New York: Harcourt Brace & Co., 1923; paperback: Grafton, 1976)

Mrs Dalloway. (London: The Hogarth Press, 1925; New York: Harcourt Brace & Co., 1925; paperback: Grafton, 1976)

To the Lighthouse. (London: The Hogarth Press, 1927; New York: Harcourt Brace & Co., 1927; paperback: Grafton, 1977)

Orlando. (London: The Hogarth Press, 1928; New York: Harcourt Brace & Co., 1928; paperback: Grafton, 1977)

A Room of One's Own. (London: The Hogarth Press, 1929; New York: Harcourt Brace & Co., 1929; paperback: Grafton, 1977)

The Waves. (London: The Hogarth Press, 1931; New York: Harcourt Brace & Co., 1931; paperback: Grafton, 1977)

Flush. (London: The Hogarth Press, 1933; New York: Harcourt Brace & Co., 1933; paperback: Penguin, 1977)

The Years. (London: The Hogarth Press, 1937; New York: Harcourt Brace & Co., 1937; paperback: Grafton, 1977)

Three Guineas. (London: The Hogarth Press, 1938; New York: Harcourt Brace & Co., 1938; paperback: Penguin, 1977)

Roger Fry: A Biography. (London: The Hogarth Press, 1940; New York: Harcourt Brace & Co., 1940)

Between the Acts. (London: The Hogarth Press, 1941; New York: Harcourt Brace & Co., 1941; paperback: Grafton, 1978)

The Moment and Other Essays. (London: The Hogarth Press, 1947; New York: Harcourt Brace & Co., 1948)

The Captain's Death Bed and Other Essays. (London: The Hogarth Press, 1950; New York: Harcourt Brace Jovanovich, 1973)

Granite and Rainbow. (London: The Hogarth Press, 1958; New York: Harcourt Brace & Co., 1958)

Woolf, Virginia and Strachey, Lytton. *Virginia Woolf & Lytton Strachey: Letters*. edited by Leonard Woolf and James Strachey (London: The Hogarth Press, 1956; New York: Harcourt Brace & Co., 1957)

Index

Vanessa Bell and Virginia Woolf have been abbreviated to VB and VW when they occur separately in other entries, V & V when they occur together.

Anrep, Helen: 294, 296
Asquith, Herbert Henry, Earl of Oxford
 and Asquith: 134, 147
Auden, W. H.: 233

Bell, Angelica: 163; birth, 200, 251; at
 Charleston, 218, describes, 223, 289–90;
 alarmed by VB's unexpressed feeling,
 271; run over, 273; VW's delight in, 280;
 and Julian Bell's death, 284, 285; courted
 by David Garnett, 290–2, marries, 303;
 VB finds farmhouse for, 294; and VW's
 death, 302
Bell, Clive: 2; introduces V & V to café life,
 84, 139; thinks 'Helen Ambrose' like VB,
 88; visits Gordon Sq., 91, 96; description,
 96, 100–1, 114, 139; flamboyance, 97; not
 an 'Apostle', 100; VW writes biographical
 sketch, 100–1; loves both V & V, 101,
 125; proposes to VB, 102, eventually
 accepted, 103; interest in art, 108, 139,
 140; Julian Bell born, 108, 146; flirtation
 with VW, 108, 109, 112–23, 244;
 continues bachelor existence, 111; to St
 Ives, 112; susceptible, 112, 113;
 emotionalism, 115; helps VW with
 writing, 117, 139, 141, first to recognise
 VW's talent, 142; portrayed in The
 Voyage Out, 117; VW's romantic
 initiation, 118, 180; enchanted by VW,
 119–20; letter-writing game, 122; wants
 to kiss VW, 125; argumentative, 138;
 collaborates decoratively with VB, 140;
 vanity, 142; conspiracy with VW, 144;
 marriage unravels, 170; and Mrs
 Raven-Hill, 170–1, 244; jealous of
 Leonard Woolf, 176, 183; and Mary
 Hutchinson, 183–4, 213; Leonard Woolf
 jealous of, 188, 210; spurned by VW,
 189–90; talks of love, 200; considered

Angelica Bell's father, 200; laughs at VW,
 212–13; at Charleston, 218; helps VB,
 222; unlike Stephens, 244; recognises
 VB's unhappiness, 271; on Julian Bell's
 death, 285; after VW's death, 302.
Bell, Julian: birth, 108, 144, 146; demands
 on VB, 120; 151; description, 203, 280,
 283; VB's passion for, 203; VW's jealousy
 of, 203–4; wants to be writer, 204, 280;
 VB explains, 215; at Charleston, 218;
 contemplates marriage, 273–4; and
 Anthony Blunt, 273; VB's uncritical
 adoration, 280; fails Fellowship, 280; to
 China, 279, 280–1; to Spain, 250, 282–4;
 death, 250, 284; writings published, 287
Bell, Quentin: birth releases VB's maternal
 feelings, 120, 144; VW suggests should be
 a writer, 152; on Lytton Strachey, 166; at
 Charleston, 218, 232, 268; VW advises,
 274; affable, 280; marries Anne Olivier
 Popham, 303
Bell, Vanessa (née Stephen): Life, Character,
 Relationship with Virginia, Other
 Relationships, Work
 Life: motherless state, 2, 252; parents'
 marriage, 7; birth, 8; life at 22 Hyde Park
 Gate, 8–9, 16–20, 25–9; early interest in
 drawing, 10; nursery days, 17–19, 22–5;
 divide between Duckworth and Stephen
 children, 20; Talland House, 22–5;
 bug-hunting, 24; education: by parents,
 25–6, social skills, 27–8; death of mother,
 33–6; attempts to absorb grief, 36; Stella
 takes over, 41–3; menstruation, 44–5;
 Stella's marriage, 49–50; at Cope's School
 of Art, 49; Stella's illness and death, 51–2;
 V & V last surviving women, 53; 'seven
 unhappy years', 53–76; grows closer to
 Jack Hills, 54–5; wins prize, 57; in
 Academy Schools, 57, 63, 74, 76, 132;

330

Index

Lamb, Walter: 165
Lehmann, John: 161, 218, 233, 302–3
Lehmann, Rosamund: 218
Lowell, James Russell: 31

MacCarthy, Desmond: 61, 94, 98, 218
MacCarthy, Molly: 98, 169, 176, 185, 218
Maitland, F. W.: 91, 132
Mare, Walter de la: 257
Marshall, Frances: 218
Martin, Kingsley: 282
Maxse, Kitty: 50, 87, 97, 136
Moore, G. E.: 1, 137, 138
Morrell, Lady Ottoline: 257
Mortimer, Raymond: 218

Nicolson, Harold: 276
Norton, Harry: 170, 245

Pater, Clara: 63
Paul, Herbert: 132
Popham, Anne Olivier: 303
Prinsep, Val: 30

Raven-Hill, Mrs: 111, 170–1, 244
Raverat, Gwen: 225
Raverat, Jacques: 225
Rickman, Dr John: 256
Ruskin, John: 129

Sackville-West, Vita (Mrs Harold
 Nicolson): 193, 206, 276; and VW,
 208–12, 269; VB jealous of, 209, 210–11;
 Orlando, 211, 251; after Julian Bell's
 death, 285, 286; after VW's death, 302
Savage, George, Dr (later Sir): 41, 91, 190,
 191
Segonzac, Andre Dunoyer de: 225
Seton, Dr.: 46
Sheepshanks, Miss: 136
Smyth, Dame Ethel: 20, 248, 251, 252, 257,
 265; character, 189, 208–9, 269; love for
 VW, 269
Snowden, Margery: 84, 102, 270
Spender, Stephen: 233, 282
Stephen, Adrian: 3, 256; birth, 8; mother's
 favourite, 13, 253; effect of mother's
 death, 35, 72, 253; to school, 63; most
 isolated, 72, 'suppressed as a child', 256;
 to Cambridge, 72, described, 72–3; to
 Venice, 83; nervous disorders, 86, 239,
 253; member of 'Bloomsbury', 98;
 exasperated at V & V's closeness, 111; to
 Bayreuth, 121; disparages VW, 141;
 moves in 29 Fitzroy Sq., 164; and Lytton
 Strachey, 168; and Duncan Grant, 194;
 psychoanalyst, 255
Stephen, Caroline Emelia (Aunt): 91;
 'twiddles her thumbs', 131

Stephen, Dorothea: 272
Stephen, J. K. (James Kenneth): 19, 51, 239
Stephen, Julia (formerly Duckworth, née
 Jackson): and Leslie Stephen, 7, 14–15;
 and first husband, 8, 20, 118; character,
 11–13, 14, 31, 79; opposed to women's
 suffrage, 13; and Stella, 13, 23, 32, 41;
 care for men, 13; portrait in To the
 Lighthouse, 25, 78, 79, 174, 240, 252, 258;
 central to family, 32; death, 33–4, 79,
 239; children's memory of, 37, 118, 127,
 227, 252, 258; inaccessible to daughters,
 55, 252–3; insisted on vocation, 56,
 126–7; Notes from Sick Rooms, 127;
 biography, 145
Stephen, Laura: 7, 11, 18–19, 239
Stephen, Leslie: marries Julia Duckworth, 7;
 bond with VW, 9, 37; as father, 10, 67,
 79; as husband, 11, 33; attitude to
 education, 14; attitude to Laura, 18–19;
 discovers Talland House, 22; wife's
 death, 33–5; The Mausoleum Book, 36,
 43, 48; emotional demands, 36–7;
 character, 37, 64, 67–8, 69–70, 126–9; and
 Stella, 42, 48; and daughters, 56, 62–3,
 68–70; portrait in To the Lighthouse, 56,
 77–8, 128; spoiled by women, 70;
 Dictionary of National Biography, 73,
 128; knighted, 76; illness, 76, 128; dies,
 79; biography, 91, 132; legacy of hard
 work, 126–8; editor of Cornhill
 Magazine, 128; History of English
 Thought in the Eighteenth Century, 128;
 Science of Ethics, 128; biography of
 Johnson, 128
Stephen, Thoby: birth, 8; V & V's rivalry
 over, 9, 16, 123; goes to prep school, 25;
 introduces VW to classics, 27; mother's
 death, 35; and sisters, 39, 55, 70;
 character, 70–1, 81, 138; memorialised in
 Jacob's Room, 71; and VW, 64, 71; at
 Cambridge, 71; emotionally reticent, 81;
 to Venice, 83; in Bloomsbury, 91;
 Cambridge friends, 95–8, 165; 'Thursday
 Evenings', 96–100; member of
 'Bloomsbury', 98; illness and death,
 102–3, 188, 239; Leonard Woolf
 compared with, 177
Strachey, Alix and James: 255
Strachey, Lytton: under V & V's spell, 3;
 description, 96, 100, 165–6; member of
 'Bloomsbury', 98; and VW, 112–13, 166,
 167, 168; in letter-writing game, 122; on
 VB, 124; breaches sexual taboo, 138; and
 Carrington, 160, 276; as 'St John Hirst' in
 The Voyage Out, 169; letters from
 Leonard Woolf, 187; at Charleston, 218;
 VB's portrait of, 251; criticises V & V's
 mother, 261

334

Woolf, Virginia *cont.*
approval, 29, 173; defenceless, 35, 193;
open to influence, 37; honest, 37–8, 95,
138; reticent, 39, 122, 137, shame of
body, 40, 178; troubled by sexual
identity, 44, 106, 118; cannot suppress
feeling, 45–6; easily irritated, 50, 91;
powerless, 51, 62, 68, 193;
embarrassments of dress, 60; outsider,
60–2, 67, 109, 164, 236, 264; longing to
belong, 61; willing to please, 66;
outraged, 68–70; wants to avoid marriage,
75, 95, 106, 164, 176; fearless, 82;
fatalistic, 85; made a scapegoat, 86, 241;
violent, 89; love of freedom, 91;
possessive, 94, 99, 105, 203; recoil from
sexual passion, 95, 118, 167, 169, 177,
178, 189, 210; unsentimental, 95; wary
and disconcerting, 97–8, 99; prefers
women, 98, 174, 207, 209–10, 262; witty,
99, 112, 138; affectionate, 99, 105, 201;
critical, 99; generous, 105, 201; childlike,
108; deprived of mother's love, 115, 208,
224; self-centred, 119, 122, 145, 173;
'sapphism', 122, 168, 208–10, 211–12;
dangerous, 125, 173; hard-working, 126;
confident, 136; bold, 138, 139, 210;
iconoclastic, 138; hates narrow intellect,
138, 141; marriage an adventure, 165,
177; wants children, 166, 167; needs
affection, 167, 173, 210; little interest in
food, 178, 231; fears failure, 182, 192,
193, 224; sexually inexperienced, 185–6,
188; 'Olympian', 188; grief at
childlessness, 191, 192, 193, 223–6; anger
at doctors, 191–2; 266; depressed, 193,
217, 224, 240, 265–7, 298–300; vicariously
maternal, 201; 'few women happier',
213; feminism, 151–2, 236–7, 251, 256,
264; 'madness', 239–40, 241, 250;
courage, 251; 'babe on the shore of life',
254; eternal daughter, 254, 262; terror of
capacity to feel, 275; combative, 282
Relationship with Vanessa: symbiotic, 1,
115, 261; central force of 'Bloomsbury',
1, 97–9, 188; similarity of looks, 2;
complementary, 3, 113; her 'firstborn', 4,
108, 203; conspiracy, 14–15, 41, 171, 217,
even closer, 54, 62, 242, strained, 77,
108–9, 139, crucial, 96, loosened, 105;
depends on, 16, 85, 91, 123, 208; rivalry,
9, 16, 86, 88, 117, 130, 162, 173, 186, 214,
217, 226–7, 263; designation of roles to
mitigate, 29; recognises her commitment
to art, 30; 'Katharine Hilbery' inspired
by, 30, 159, 162, 219; demands 'pettings'
from 40; stable point of contact, 46; poise
and counterpoise, 46–7; fear for her
sacrifice, 53; shared dream, 54, 164;

resents intrusion in, 54–5, 201, 203, 224;
cannot bear exclusion from, 55, 105,
108–11, 115, 123, 125, 173, 232; 'secret
revolutionaries', 57; protected by, 68–70,
90, 91, 123; stuck with for life, 74; cannot
confide in, 80–2; encourages her painting,
83, 129, 135, 156; alienated by, 83; turns
against, 86, 192; 'victimised' by, 88;
'Helen Ambrose' inspired by, 88, 117–18,
157, 183; passionate, 88, 111–12, 124,
162, 171, 189, 209; more tentative, 91;
erotically possessive of, 94, 100, 105, 115,
119, 189, 201; cannot trust her not to
marry, 100; loss of, 103; amazed by,
104–5; invades her relationship with
Clive Bell, 108, 109, 112–13, 141–4; her
marriage alters, 109, less threatening, 171;
preoccupation with, 116, 143, 208–9;
necessary separation from, 118; seeks to
control through fictionalising, 118, 162;
betrays, 119; 'mythologizes', 119, 143,
167; asks forgiveness from, 122, and
makes amends, 286; 'sapphist tendencies'
suggested in VW, 122, 168; diary a record
for both, 130; easier to be a writer than
painter, 135; intimacy with Clive Bell
excludes, 142, 144; offers flattery, 144;
fascinated by, 145, 151, 162; balance
reversed, 146; writing superior to
painting, 151; writes for VB more than
anyone, 155–6, 289; admiration of, 157,
219; artistic collaboration, 159, 161;
protected by VB's dust-jacket, 159, 161;
'fame belongs to me', 163, 184, 225; VB's
genius, 163; feels diminished by, 173,
185–6, 209, 226–7, 263; male v. female,
174, 207; bases 'Mrs Ramsay' on, 175,
195, 235, 260; VW's engagement upsets
VB, 182; sense of control by VB, 183,
184; VW's frigidity suggested by VB,
186; VW's childlessness, v. VB's fertility,
192, 223–6, 226–7, 261; both have sexless
unions, 198, but different results, 205–6;
delights in VB's children, 200–1, 279;
unrequited passion, 207; incestuous, 201,
207; VB as maternal figure, 208–9, 254;
VB necessary to life, 212; alarmed by
VB's prejudices, 214–15, 279; relieved
that not infallible, 227–8; feels inferior to
VB as a decorator, 228–30; 'older and
uglier' than, 232; VB knows 'the truth of
life', 238; shared susceptibility to
depression, 240–3, sympathy with, 248–9,
250; and the Mother archetype, 258–65;
longing to merge with, 260, 295, 297;
defends, 272; assuages VB's grief, 284–9;
characterised by Leonard, 284–5; devoted
to, 285–9; as part of 'garden of women',
297; wants to 'infuse souls', 299

46, Gordon Square, Tuesday
Bloomsbury.

My Billy —

I had a charming long
letter from you this morning
with flattering hints of
rose-gardens & daylight
round corners & I don't
know what all. I puss
all down my back
when I get such jems
of imagery thrown at
my feet, & reflect how
envied I shall be of —
the world some day when
it learns on what terms
I was with that great
genius the creator of